DADA AND AFTER .extremist modernism and english literature

FOR MY WIFE, IRENE

dada and after

extremist modernism and english literature

ALAN YOUNG

 MANCHESTER UNIVERSITY PRESS

USA: HUMANITIES PRESS, New Jersey

© Alan Young 1981 *all rights reserved*

published by MANCHESTER UNIVERSITY PRESS
Oxford Road, Manchester M13 9PL

British Library cataloguing in publication data
Young, Alan
 Dada and after.
 1. Arts, British
 2. Arts, Modern – 20th century – Great Britain
 3. Surrealism – Europe – History
 I. Title
 700′.941 NX543.a1
 ISBN 0–7190–0822–0

published in the USA, 1981, by HUMANITIES PRESS Inc.
Atlantic Highlands, N.J. 07716
 ISBN 0-391-02359-4

typeset by Bookworm Typesetting, Manchester
printed in Great Britain
by Redwood Burn Limited, Trowbridge

CONTENTS

PREFACE

Over a period of several years many people have provided information and discussed ideas with me. Professor C. B. Cox has given helpful criticism and continually cheerful encouragement. Others whom I wish to thank include Alfred Alvarez, Dr R. G. Cox, Andrew Crozier, Professor Donald Davie, Hugh Sykes Davies, Walford Davies, Ian Hamilton Finlay, the late George S. Fraser, David Gascoyne, J. F. Hendry, Dr Richard Huelsenbeck, Jack Lindsay, Norman McCaig, George Melly, Nicholas Moore, Rollo H. Myers, Sir Roland Penrose, Gordon Phillips, Dr. Edgell Rickword, Anthony Rudolf, Michael Schmidt, the late Harry Sherwood, Sir Sacheverell Sitwell and Derek Stanford.

I owe much to Sandy Neil, Librarian of Didsbury School of Education, Manchester Polytechnic; to Geoffrey Soar, of the Periodicals Library at University College, London; to Mrs Kath Foster of the Language and Literature Library, Manchester Central Library; to Ellen S. Dunlap, Research Librarian of the Humanities Research Centre, the University of Texas; and to other libraries, including particularly The British Library, London, Cambridge University Library, Bibliothèque Nationale, Paris and John Rylands University Library, Manchester.

Some of the material in this book has appeared in articles, comment or reviews in *Critical Quarterly, English in Education, Poetry Nation, PN Review, Studio International, Tarasque* and *The Times Literary Supplement*. Part of Chapter 8 appeared in *British Poetry Since 1970*, edited by Peter Jones and Michael Schmidt, Carcanet, Manchester, 1980.

the beginnings of dada

PART I

dada 1915–1920

NEW YORK

Historians of the Dada movement, including the original Dadaists, agree that Zürich was the real birthplace of Dadaism, but New York may with justice be said to have shown strong enthusiasm, both critical and creative, for those elements in twentieth-century art which led directly to Dadaism. The American search for a new and indigenous art, free from the European tradition, produced some extremely odd enterprises in the early years of the century. Moreover, during the period from 1914 to 1917, when the United States of America was still a neutral country, several artists who had been working in Paris before the outbreak of World War I found New York a congenial city in which to live and work, and something approaching the spirit of Zürich Dadaism in scope and achievement – at least as far as the visual and plastic arts were concerned – took place in the American city. Some of the artists living in New York during this period, particularly the exiles from Europe, Marcel Duchamp and Francis Picabia, but also the American-born painter and photographer, Man Ray, were to be influential in the later stages of European Dadaism.

During the first decade of the twentieth-century New York had been developing as a centre of considerable activity in sympathy with the European avant-garde. The 'Camera Work' gallery (later renamed '291') of the American photographer Alfred Stieglitz, at 291 Fifth Avenue, had become a meeting-place for American and European

L'amiral cherche une maison à louer

Poème simultan par R. Huelsenbeck, M. Janko, Tr. Tzara

HUELSENBECK, chant	Ahoi ahoi Des Admirals gwirktes Beinkleid schnell	macht Rewagen patiently in der Nacht
JANKO, chant	Boum boum boum Where the honny suckle wine twines	Terrpappe mine is waiting for me du
TZARA	déshabilla sa chair quand les grenouilles humides	mint mis the door a swetheart à bruler

HUELSENBECK, chant	und der Conciergenbäuche Klapperschlangengrün sind milde ach	chrza my great room is
JANKO, chant	can hear the weopour arround amis dorénavant et	prrrza chrrrza
TZARA	serpent à Bucarest on dépendra mes	c'est très intéressant les griffes des morsures et

HUELSENBECK, chant	prrrza chrrrza prrrza Wer suchet dem said wird	Wer Wasser love find
JANKO, chant	mine admirably admirabily Grandmother deux éléphants	Schwan the ladies assassine
TZARA	Dimanche:	Der Ceylonlöwe ist kein I Le télégraphiste braucht

aufgetan Der Journal de Genève au restaurant

HUELSENBECK	hihi *ff* Yabomm *p* hihi *ff* Yabomm hihi hihi hihiiiii *ff*
TZARA	rouge *p* bleu rouge bleu *f cresc* rouge bleu rouge bleu rouge bleu *fff*
SIFFLET (Janko)	*p* ———— *cresc* ——— *fff*
CLIQUETTE (TZ)	rrrrrrrr rrrrrrrr *decrsc* rrrrrrrr rrrrrrrr *cresc* rrrrrrrr rrrrrrrr *fff*
GROSSE CAISE (Huels.)	0 0 0 0 0 0 0 0 0 0 0 0 0 *uniform* 0 0 0 0 0 0

Intermède rythmique

HUELSENBECK (chant)	im Kloset zumeistens was er nötig hatt ahoi iuché ahoi iuché	Find was er nötig
JANKO (chant)	I love the ladies I love to be among the girls	And when it's five
TZARA	la concierge qui m'a trompé elle a vendu l'appartement que j'avais loué	Dans l'église après la messe le pécheur dit à la comtesse: Adieu Mathilde

HUELSENBECK (chant)	hätt' O süss gequolines Stelldichein des Admirals im Abendschein uru uru	uro uru uru uru uro uru uro uri uro
JANKO (chant)	o'clock and tea is set I like to my tea with some brunet shai shai	shai shai shai shai shai Every body is doing it Every body is
TZARA	Le train traine la fumée comme la fuite de l'animal blessé aux	uro intestins écrasés

HUELSENBECK (chant)	Der Affe brüllt die Seekuh belllt im Lindenbaum der Schräg zerschellt tara-	tata taratata tatatata In Joschiwara dröhnt der Brand und knalli mit schnellen
JANKO (chant)	doing it see that ragtime couuple over there tara-see	that throw there shoulders in the air She said the raising her heart oh dwelling Oh!
TZARA	Autour du phare tourne l'auréole des oiseaux bleuills en moitiés de lumière vis-	sant la distance des batteaux Tandis que les archanges chient et les oiseaux tombent mon

HUELSENBECK (chant)	Peitschen um die Lenden im Schlafsack gröhlt der	alte Oberpriester und zeigt der Schenkel volle Tastatur
JANKO (chant)	oh yes yes yes yes yes yes yes yes yes	yes oh yes oh yes oh yes oh yes oh yes oh yes sir
TZARA	cher c'est si difficile La rue s'enfuit avec mon bagage à travers la ville Un métro mêle	son cinema la prore de je vous adore était au casino du sycomore

L'Amiral n'a rien trouvé
L'Amiral n'a rien trouvé
L'Amiral n'a rien trouvé

NOTE POUR LES BOURGEOIS

Les essais sur la transmutation des objets et des couleurs des premiers peintres cubistes (1907) Picasso, Braque, Picabia, Duchamp-Villon, Delaunay, suscitaient l'envie d'appliquer en poésie les mêmes principes simultanés. Villiés de l'Isle Adan en avait dans les intentions dramatiques les prédécesseurs dans le théâtre, où l'on essaya que les tendances vers un simultanéisme schématique; Mallarmé essaya une reforme typographique dans son poème: Un coup de dés n'abolira jamais le hazard; Marinetti qui popularisa cette subordination par ses „Paroles en liberté"; les intentions de Blaise Cendrars et de Jules Romains, dernièrement, amenèrent par Mr Apollinaire aux idées qu'il développa en 1912 au „Sturm" dans une conférence.

Mais l'idée première fut extériorisée par Mr H. Barzun dans un livre théorique: Voix, Rythmes et chants Simultanés" où il cherchait une rélation plus étroite entre la symphonie polyrythmique et le poème. Il opposait aux principes successifs de la poésie lyrique une idée vaste et parallèle. Mais les intentions de compliquer en profondeur cette technique (avec le Drame Universel et en exagerant sa valeur au point de lui donner une idéologie nouvelle et de la cloître dans l'exclusivisme d'une école, — échouèrent.

En même temps Mr Apollinaire essayait un nouveau genre de poème visuel, qui est plus intéressant encore par son manque de système et par sa fantaisie tourmentée. Il accentue les images centrales typographiquement, et donne la possibilité de commancer à lire un poème de tous les côtés à la fois. Les poèmes de Mrs Barzun et Divoire sont purement formels. Ils cherchent un effort musical, qu'on peut imaginer en faisant les mêmes abstractions que dans une partition d'orchestre.

Je voulais réaliser un poème basé sur d'autres principes. Qui consistent dans la possibilité que je donne à chaque écoutant de lier les associations convenables. Il retient les éléments caractéristiques pour sa personalité, les entremêle, les fragmente etc, restant tout-de-même dans la direction que l'auteur a canalisé.

Le poème que j'ai arrangé (avec Huelsenbeck et Janko) ne donne pas une description musicale mais tente à individualiser l'impression du poème simultan auquel nous donnons pour la première fois une naissance scénique. La lecture parallèle que nous avons fait le 31 mars 1916, Huelsenbeck, Janko et moi, dut la première réalisation scénique de cette esthétique moderne.

TRISTAN TZARA

Hyperbole of the Crocodile's Hairdresser and the Walking-Stick'). The Surrealists later christened this kind of poetry 'Automatic Poetry'. Automatic Poetry springs directly from the poet's bowels or other organs, which have stored up reserves of usable material . . . The poet crows, curses, sighs, stutters, yodels, as he pleases. His poems are like Nature. Unregarded trifles, or what men call trifles, are as precious to him as the sublimest rhetoric, for in Nature, a tiny particle is as beautiful and important as a star. Man was the first who presumed to judge what was beautiful and what was ugly.[11]

The Rumanians, Tristan Tzara and Georges and Marcel Janco, added an extra degree of aggression and zany humour to the Zurich scene. Tzara was soon to become the leading spirit behind the Dadaist activities and publications, as well as the main propagandist of the movement. He had introduced himself to Ball on 6 February 1916, and had read some of his poems that evening at the first performance of the Cabaret Voltaire. Having learned some of the techniques of 'provocation' from Futurism, he made striking use of this knowledge in his poetry and manifestoes, though Huelsenbeck, Ball and the others were often able to match even his most lunatic moments, as the simultaneous poem by Huelsenbeck, Marcel Janco, and Tzara which appeared in *Cabaret Voltaire* demonstrates. This poem, called 'L'Amiral cherche une maison à louer', is composed for three voices which declaim together. In the version printed in *Cabaret Voltaire* Huelsenbeck speaks in German, Tzara in French, while Janco croons an American popular song, rendered in print in a strange phonetic spelling. There is also a rhythmic interlude (shouts, whistles, the repetition of the words 'red' and 'blue', a rolled 'r' sound, and a big drum). There is even some indication of phrasing and other 'musical' interpretation.

Within a short time of the coming together of this strangely assorted, cosmopolitan and talented group of artists, the Dada movement in Zürich reached a fever point of frenzied collective performance. Their sense of the madness of the war, and of the culture which produced that war, grew into a rage of fear, astonishment, and embittered idealism. The fury of the Zürich group was intensified by their own feelings of isolation, helplessness, and guilt in a Europe which had gone completely insane.

The sustained, angry intensity generated by the Zürich group was directed against the institutions and values of the Western world: nationalism, patriotism, militarism, capitalism, and culture in the form of art. They were enraged by what they considered to be the smug self-satisfaction of bourgeois institutions, especially the deep-rooted belief in natural order, authority, and progress.

Although the social, political, religious, legal, and academic values of Western Europe were all targets for their inventive abuse, the conventional roles of art and the artist came in for the most violent assault. Art, the embodiment of all the culture of Western man, was pronounced dead, and through their smashing up of traditional forms

In September 1916 another German, Hans Richter (1888–1976), the painter and film-maker (and also one of the best-known historians of the Dada movement), joined the group. He had been discharged from the German army earlier that year after being seriously wounded. Like the other Germans, Richter had been a member of prewar artistic circles in Berlin and other cities, working in close contact with the most avant garde movements.

Hans (sometimes Jean) Arp (1887–1966), a painter, sculptor and poet, had travelled widely in Europe before the war, and he had met many important contemporary artists and critics in Paris, Cologne, Munich, and Berlin. Arp was born in Alsace (then, as so often before and since, disputed territory between France and Germany) and, like many of the central European members of the Dada movement in Zürich, his failure or refusal to identify with either side in the war led him to reject the chauvinistic nationalism prevalent in most European countries at the start of hostilities. In 1914 he left Paris for Switzerland where he had lived for some years before the war, and in 1916 he too joined Hugo Ball in Zürich.

Arp had already – in November 1915 – exhibited designs of a completely abstract nature, and his interest in the workings of chance in the visual arts and in poetry was soon to become an important force in the development of Dadaism. He and his future wife, Sophie Taeuber (1889–1943), a Swiss painter and sculptor, worked together on the production of very pure geometrical forms in which all signs of human intervention were carefully avoided. They even managed to produce 'abstract' puppets, and Arp aimed to capture as far as possible the impersonality of the machine. In many ways Arp was always more hopeful and positive than most other Dadaists in his attitude towards art, seeing new art forms (or a return to basic ones) as a possible force in the defence of human values. Of this time he wrote:

Revolted by the butchery of the 1914 World War, we in Zürich devoted ourselves to the arts. While the guns rumbled in the distance, we sang, painted, made collages and wrote poems with all our might. We were seeking an art based on fundamentals, to cure the madness of the age, and a new order of things that would restore the balance between heaven and hell.[10]

Arp found no contradiction between such a view and his contribution towards the development of 'automatic poetry' which, he claimed, he first produced in co-operation with Tristan Tzara (1896–1963) and Walter Serner (1889–1922), an Austrian writer who was described by Arp in terms reminiscent of the Dada hero Arthur Cravan, as 'adventurer, author of detective stories, drawing-room dancer, dermatologist and gentleman burglar'. Here is Arp's own description of yet another Zürich contribution to the possibilities of modern poetry:

In the Café de la Terrasse, Tzara, Serner and I wrote a cycle of poems entitled *Die Hyperbel vom Krokodilcoiffeur und dem Spazierstock* ('The

word held for us.

'Let's take the word dada,' I said. 'It's just made for our purpose. The child's first sound expresses the primitiveness, the beginning at zero, the new in our art. We could not find a better word.'[8]

Huelsenbeck, who had known Ball in prewar Berlin, was fascinated at this time by 'negro' and jazz rhythms, and he was to develop strongly rhythmical forms of utterance as his most characteristic contribution to the various manifestations of 1916 and early 1917. The use of vowel and consonant sounds abstracted from normal linguistic usage to suggest the primitive noises of 'negro' rhythms, though no more primitive than the jazz music which was beginning to arrive in Europe from the USA just before the war, is closely related to phonic poetry, which Ball is sometimes credited with having introduced to Dadaism.

Several critics have pointed out[9] that such techniques had already been used by the Futurist poets in Italy, Russia, and Paris before the war. Indeed, even this was only a more systematic development of a poetic technique found in much earlier nonsense verse, for example, as well as in the writings of the Germans, Paul Scheerbart and Christian Morgenstern. Morgenstern (1871–1914) had already produced in his 'Fish's Nightsong' ('Fisches Nachtgesang') a 'poem' composed of characters even more elemental than the sounds comprising the Zürich Dadaists' basic materials.

But there is little doubt that Ball's phonic poems represent a new and important stage in the development of a technique which was to be explored during the 1920s by several other European poets.

declared. Ball, who had been a producer at the Munich Kammerspiele before the war, had begun by arranging entertainments at various *cafés chantants* in Switzerland, but he soon became the chief organiser of the Cabaret Voltaire, the club which first channelled the multiplicity of avant-garde talents which had begun to arrive in the Swiss capital. His wife, who also wrote poetry, had been a well-known cabaret singer and *diseuse* in Berlin. Often accompanied by Ball at the piano, she was the most popular artiste of the Cabaret Voltaire in the early months, while there was still some attempt to present relatively conventional and commercially viable 'cabaret' there.

In one rented room, part of a local inn, the Cabaret Voltaire was a clubhouse, an artistic cabaret, and an exhibition hall showing works by leading artists of the European avant-garde, including Picasso, Marinetti, and Modigliani, as well as works by the Dadaists themselves. The only issue of the magazine *Cabaret Voltaire* (June 1916), edited by Ball, contained contributions from leading Cubist and Futurist artists and poets, as well as probably the first mention in print of the word 'dada', and the promise of a new magazine to be called *Dada*.

Soon after the Cabaret Voltaire opened, another German pacifist, Richard Huelsenbeck (b. 1892), joined the group. Huelsenbeck claimed (a claim supported by Ball's diary) that he and Ball discovered the word 'dada', and although this was disputed later there is little doubt that Ball and Huelsenbeck gave the Zürich group its most serious anti-war and anti-art spirit. Twenty years later, writing especially for *transition*,[7] Huelsenbeck recalled the circumstances:

One day Hugo Ball was seated in his modest room in a Zürich tenement flat. Besides his wife, I was the only person present. We were discussing the question of a name for our idea, we needed a slogan which might epitomize for a larger public the whole complex of our direction. This was all the more necessary since we were about to launch a publication in which all of us wanted to set forth our ideas about the new art.

We were conscious of the difficulty of our task. Our art had to be young, it had to be new, it had to integrate all the experimental tendencies of the Futurists and Cubists. Above anything, our art had to be international, for we believed in an Internationale of the Spirit and not in different national concepts.

Hugo Ball sat in an armchair holding a German—French dictionary on his knees. He was busy in those days with the preliminary work for a long book in which he wanted to show the deleterious changes German civilisation had undergone as a result of Luther's influence. Consequently, he was studying countless German and French books on history.

I was standing behind Ball looking into the dictionary. Ball's finger pointed to the first letter of each word descending the page. Suddenly I cried halt. I was struck by a word I had never heard before, the word dada.

'Dada,' Ball read, and added: 'It is a children's word meaning hobby-horse'. At that moment I understand what advantages the

and, a year later, his lecture on the 'new art' in New York at the time of the Exhibition of Independent Painters. Before an audience of society ladies, Cravan, swearing forcibly and again drunk, took off most of his clothes before the police could arrest him. Duchamp, whose 'Fountain' was meant to have scandalised the same exhibition, was reported to have commented that this was 'a wonderful lecture',[6] a view of Cravan's performances which harmonises with that of the German Dadaist, Hans Richter: 'Because he lived wholly according to his nature, wholly without constraint, and paid the full price, which is death, he became a nihilist hero in an age already long beset by nihilism.'

Picabia had also returned to New York in 1917; indeed, he and Duchamp had been responsible for organising Cravan's 'lecture'. Three more issues of Picabia's *391*, (Nos. 5–7) were produced in New York between June and August 1917 but the USA had declared war in April 1917 and, consequently, the spirit of the country inevitably became less amenable to such nihilistic and scandalous antics as the New York group had been performing. It is interesting that the last issue of *391* to be published in New York contained a piece of automatic writing by Walter Conrad Arensberg ('Partie d'échecs entre Picabia et Roché'). Picabia and his wife left for France and then Switzerland, where, in February 1918, they made contact with the Zürich Dadaists for the first time.

It could be argued that the Dadaist/Surrealist heritage has been greatest in New York, in painting as well as in literature and music. After the mid-1930s especially, New York became the Surrealist capital, and there is much evidence to show that genuine Surrealist activity has survived, and even developed, only there. This view was boisterously and amusingly argued by John Bernard Myers in 'The Impact of Surrealism on the New York School' in *Evergreen Review* (IV, 12, March/April 1960, pp. 75–85):

The life-giving energy, the essence of all that which is avant-garde apparently needs a more ebullient society, a society more anarchic than that which obtains in France, or indeed throughout Europe. For whatever the causes (and they are many and tragic), the avant-garde spirit seems largely to continue in New York. (p. 76)

ZÜRICH

Zürich was a place of refuge for many Europeans during World War I. Swiss neutrality and the cosmopolitan character of Zürich itself made the city a natural goal for those who for some combination of political, artistic, or ethical reasons (or for the satisfaction of the instinct of self-preservation) found their native countries intolerable. By early 1916 nearly all the main contributors to Zürich Dada had arrived there.

The pacifist and poet, Hugo Ball (1886–1927) and his wife Emmy Hennings (1885–1948) had arrived from Germany soon after war was

1914, the bottle-rack (original title lost) which he bought from a Paris store and signed.

Picabia had first visited New York as an unofficial 'representative' of Cubism at the time of the Armory Show, and some of his work had been exhibited by Stieglitz in March 1913. During 1915 he made his way to New York from whence he was supposed to be going to Cuba on an official mission for the French government to purchase molasses. However, he stayed for some time in New York where he worked with Stieglitz on the magazine *291*. Picabia brought to all the groups with which he worked a witty and fantastic imagination, which appeared in the main as painting and drawing, though there were some poems and some very biting anti-art broadsides. These latter, on the whole, were beyond the general scope of the Stieglitz group, who were prepared for 'new art' but not for such consistently aggressively destructive attitudes as Picabia, in particular, held.

In 1916 Picabia travelled to Barcelona where another small and short-lived but vigorous group formed around him. Here he produced the first four monthly issues of *391* (January–March 1917) in which the intensity of Picabia's anti-art attitudes, as revealed in his strange 'machine-drawings' *(dessins méchaniques)*, had developed considerably. The literary contributions by others (including Apollinaire's ex-mistress, the painter and occasional poet, Marie Laurençin) were not particularly Dadaist in outlook, but the Barcelona group did number among its members one man who had an odd, mythic reputation with Dadaist critics, the boxer and writer Arthur Cravan.

Cravan, whose real name was Fabian Lloyd, was responsible for five issues of *Maintenant*, an amusing, provocatively abusive review, in Paris between 1912 and 1915. In one of these issues he described himself:

Confidence-man – sailor in the Pacific – muleteer – orange-picker in California – snake-charmer – hotel thief – nephew of Oscar Wilde – lumberjack – ex-boxing champion of France – Grandson of the Queen's Chancellor (of England) – chauffeur in Berlin – etc..[3]

Much, perhaps all, of this appears to be literally true. Cravan's preference for 'life' (especially the athletic life) to art, expressed with a certain wild panache, has endeared him to many Dada and post-Dada writers, including André Breton[4] and Hans Richter, and his temperament and life-style attracted Picabia too. This attractiveness seems to have come as much from his colourful personality, and his capacity for living in the way he chose, as from his thorough contempt for most contemporary art and artists.[5]

Cravan disappeared in 1918 after setting out in a small boat to cross the Caribbean from Mexico. Before this final act, he performed his two most famous exploits, namely, his fight with the world heavy-weight champion (the negro boxer, Jack Johnson) in Madrid in 1916, when Cravan, apparently very drunk, was knocked out in the first round,

artists, and had been greatly influential in preparing the way for the famous International Exhibition of Modern Art (the 'Armory Show') of February–March, 1913. Stieglitz himself appears to have some of the necessary openness and enthusiasm to welcome the spirit of creative optimism which the 'new art' seemed to represent. Always alongside this spirit there had been a strong cavalier dismissal of the European art of the past, particularly the recent past, and, inevitably, this critically destructive force appeared on the American scene. In their *Dada: Monograph of a Movement*, Hans Bolliger and Willy Verkauf acknowledged that the magazine *291*, which was edited by Stieglitz between 1915 and 1916 (twelve issues), and which published many works by Picabia, 'foreshadowed Dadaism'.[1] But the genuine 'Dadaist' spirit was introduced by Duchamp and Picabia in their own New York publications.

The French artist, Marcel Duchamp, whose painting 'Nude Descending a Staircase' (number 2, painted in 1912) had been the scandalous centre of attention of the Armory Show, arrived in New York from Paris in June, 1915. From the start he produced works which were later generally accepted as truly Dadaist in spirit. Such works include his 'readymades' – for example, the snow shovel purchased from a New York hardware store in 1915 and entitled 'In Advance of the Broken Arm', and the perhaps more infamous urinal, which he called 'Fountain', and which he submitted, signed 'R. Mutt', to the exhibition organised by The Society of Independent Artists in New York in 1917. Though the 'Fountain' was rejected by the hanging committee (on 'moral grounds') it became the subject of much controversy. Beatrice Wood (helped by Duchamp) argued for its worthiness in *The Blind Man* (edited by Wood, Duchamp, and Pierre Roché):

Whether Mr. Mutt with his own hands made the fountain or not has no importance. He CHOSE it. He took an ordinary article of life, placed it so that its useful significance disappeared under a new title and point of view – created a new thought for that object.[2]

Such implied rejection of traditional views about the role and status of art and artist, in particular the insistence on the importance of the workings of chance and the relative unimportance of the artist's individuality or uniqueness, were forcibly argued in *The Blind Man* (1917), and also in Duchamp's *Rongwrong* (one issue, 1917) and Picabia's *391*.

Duchamp and Picabia had been closely acquainted in prewar Paris where their mutual friends included several Cubist and Futurist artists, as well as the poet Guillaume Apollinaire, champion of many avant-garde art movements of his time (particularly Cubism and Futurism). In those days too Duchamp had introduced works which set the same challenges as his later 'Fountain', including, in 1913, the bicycle wheel fastened to a kitchen stool ('Roue de Bicyclette') and in

and attitudes towards art, the Dadaists could most effectively express their sense of disgust and start what most of them considered to be their principal task – to sweep away all the European past. Such radical nihilism was by no means new, of course, but the general acceptance of the central role of art as both medium and target was.

From the beginning the fundamental paradox inherent in Dadaism is clear. That in fact new forms were developed from the ruins of the prewar avant-garde movements was usually regarded as an ironic irrelevance, and few of the Dadaists regarded their task as one primarily inside the fields of art and aesthetics. Yet it was disagreement about whether Dada was to be seen as new art or total rejection of art which was to enlarge the already growing rift between Hugo Ball and Tristan Tzara in 1917. During that year, when Ball moved to another part of Switzerland and Huelsenbeck returned to Berlin, Tzara became the undisputed leader of the Zürich group. Close details of the wrangles inside the Dada group during 1917 are beyond the scope of this chapter, but quite obviously the resemblance between the methods of Dadaism and those of other prewar avant-garde movements were confusing enough for the Dadaists themselves. Futurism, particularly, the movement which had been first organised in Italy in 1909 by Filippo Tommaso Marinetti (1876–1944), who had been noisily active in Paris, London, and Berlin between 1910 and 1914, was very easily confused with Dadaism.

The history of Futurism has been traced in detail by many art-historians, and its relationship to Dadaism and to other movements has been fully examined and documented; the most important aspects of its relationship to English Vorticism and Imagism, for example, are recorded in W. C. Wees' *Vorticism and the English Avant-Garde* (1972), and that to Surrealism by Herbert S. Gershman in his short study 'Futurism and the Origins of Surrealism' (1962).[12] An interesting discussion on the 'proto-Dada' theory and activities of Futurism is to be found in Marianne W. Martin's fully documented *Futurist Art and Theory 1909–1915* (1968). Two extracts from Futurist manifestoes should be sufficient here to demonstrate the closeness of Futurism and Dadaism in some of their attitudes of rejection. The first of these, from the 'First Futurist Manifesto' as it appears in *Le Figaro* of 20 February 1909, also demonstrates essential differences between Futurists and Dadaists in their attitudes towards war:

The Past is balsam for prisoners, invalids, men on their deathbeds who see the Future close to them.

We will have none of it. We are young, strong, living – We are Futurists.

Museums are cemeteries – public dormitories . . .

We are out to glorify War – the only health-giver of the world

On then Good Incendiaries! Fire the libraries! Turn the floods into the museums! Let the famous pictures float! We cast our challenge to the stars.[13]

The curious ambivalence towards the war – characterised by what one might term an 'aesthetic stoicism' which amounted at times to detached indifference – exhibited by artists such as Apollinaire, Gaudier-Brzeska and T. E. Hulme, probably stems from this attitude. I believe that it may also help to account for the strangely remote tone of several of Isaac Rosenberg's war poems and, to take a later example, Wyndham Lewis's descriptions of wartime battles in *Blasting and Bombardiering*.

The second example, from the Futurists' 1910 Manifesto, shows more of their attitudes of rejection which they shared with the Dadaists:

1. **That all forms of imitation should be held in contempt and all forms of originality should be glorified.**
2. **That we should rebel against the tyranny of the words harmony and good taste. With these expressions, which are too elastic, it would be an easy matter to demolish the works of Rembrandt, Goya and Rodin.**
3. **That art criticisms are either useless or detrimental.**
4. **That a clean-sweep should be made of all stale and thread-bare subject-matter in order to express the vortex of modern life – a life of steel, fever, pride and headlong speed.**
5. **That the accusation 'madmen', which has been employed to gag innovators, should be considered a noble and honourable title.**[14]

Most of the Dadaists would have read Guillaume Apollinaire's 'L'Antitradition Futuriste' of 1913 in which there is a rude dismissal of all academic art and artists including Dante, Shakespeare, Tolstoy, Goethe, Wagner, Beethoven, and even Baudelaire. Only the newest art and criticism was to be praised, which is why Roger Fry managed to get an honourable place alongside such names as Picasso, Picabia, and Marcel Duchamp!

'The New Futurist Poetic', as first expressed by Marinetti (and which appeared in English, translated by Arundel del Re, in Harold Monro's *Poetry and Drama* I, for September 1913) advocated the abandonment of conventional syntax ('words at liberty'), the introduction of 'onomatopoeic chords, in order to render all the sounds and even the most cacophonous noises of modern life' and an avoidance of 'the typographical harmony of the normal printed page of verse':

Our revolution is directed against the so-called typographical harmony of the page, which is opposed to the flux and reflux, the jerks and the bursts of style that are represented on it. We shall use, therefore, in the same page, *three or four different colours of ink*, and, if necessary, even twenty different forms of type.[15]

Such techniques were all practised by the Dadaist poets in Zürich, who, as Hans Richter expressed it 'had swallowed Futurism – bones, feathers and all'. But, as Richter goes on to say, Dadaists and Futurists held fundamentally different principles about the role of art:

Motion, dynamism, *'vivere pericolosamente'*, 'simultaneity', did play a part in Dada, but not as elements in a programme. Here is the fundamental difference. Futurism had a programme and produced works designed to 'fulfil' this programme. Whether the result was a work of art or a mere illustration of the programme depended on the talent of the artist.

Dada not only had *no* programme, it was against all programmes. Dada's only programme was to have no programme ... and, at that moment in history, it was just this that gave the movement its explosive power to unfold *in all directions*, free of aesthetic or social constraints. This absolute freedom from preoccupations was something quite new in the history of art. The frailty of human nature guaranteed that such a paradisal situation could not last. But there was to be a brief moment in which absolute freedom was asserted for the first time. This freedom might (and did) lead either to a new art – or to nothing.[16]

Between 1916 and 1919 the Zürich Dadaists engaged in a variety of activities, the most typically outrageous of which was the public 'manifestation'. This was yet another technique previously practised by the Futurist, Marinetti, in Italy, and in Paris, London, and Berlin. At the first 'Dada Evening', which took place on 14 July 1916 in the Zunfthaus zur Waag in Zürich, the posters announced an assortment of 'music, dance, theory, manifestoes, verse, pictures, costumes and masks'. Among the items to be performed were negro songs (*'chants nègres'*), a simultaneous poem called 'Puerperal fever', and a wordless poem ('Verse ohne Worte'), as well as three 'Dada-dances' and a 'Cubist-dance'.[17]

Luckily for posterity, some of the quality of these performances and the reaction of the audience may be gathered from contemporary records, albeit by the Dadaists themselves. In his *Zürich Chronicle*[18] (first published in 1920) Tzara described the evening:

In the presence of a compact crowd Tzara demonstrates, we demand the right to piss in different colours, Huelsenbeck demonstrates, Ball demonstrates, Arp *Erklärung* (statement), Janco *meine Bilder* (my pictures), Heusser *eigene Kompositionen* (original compositions) the dogs bay and the dissection of Panama on the piano on the piano and dock – shouted poem – shouting and fighting in the hall, first row approves second row declares itself incompetent to judge the rest shout, who is the strongest, the big drum is brought in, Huelsenbeck against 200, Hoosenlatz accentuated by the very big drum and little bells on his left foot – the people protest shout smash windowpanes kill each other demolish fight here come the police interruption. Boxing resumed: Cubist dance, costumes by Janco, each man his own big drum on his head, noise, Negro music/trabatgea bonooooooo oo ooooo/5 literary experiments: Tzara in tails stands before the curtain, stone sober for the animals, and explains the new aesthetic: gymnastic poem, concert of vowels, bruitist poem, static poem chemical arrangement of ideas, Burribum burribum saust der Ochs im Kreis herum (the ox runs down the circulum) (Huelsenbeck) vowel poem aao, ieo, aii, new interpretation of the subjective folly of the arteries the dance of the

heart on burning buildings and acrobatics in the audience. More outcries, the big drum, piano and cannon impotent, cardboard costumes torn off the audience hurls itself into puerperal fever interrupt. The newspapers dissatisfied simultaneous poem for 4 voices + simultaneous work for 300 hopeless idiots.

A performance by Ball of the sound poem which he read on this occasion – and which doubltess helped to stir the audience into the fever described by Tzara – is recorded in his *Flucht aus der Zeit*:

I had a special costume designed for it. My legs were covered with a cothurnus of luminous blue cardboard, which reached up to my hips so that I looked like an obelisk. Above that I wore a huge cardboard collar that was scarlet inside and gold outside. This was fastened at the throat in such a manner that I was able to move it like wings by raising and dropping my elbows. In addition I wore a high top hat striped with blue and white. I recited the following:

 gadji beri bimba
 glandridi lauli lonni cadori
 gadjam bim beri glassala
 glandridi glassala tuffm i zimbrabim
 blassa galassaatuffm i zimbrabim

The accents became heavier, the expression increased an intensification of the consonants. I soon noticed that my means of expression (if I wanted to remain serious, which I did at any cost) was not adequate to the pomp of my stage-setting. I feared failure and so concentrated intensely. Standing to the right of the music, I recited Labada's Chant to the Clouds, then to the left, The Elephant Caravan. Now I turned again to the lectern in the centre, beating industriously with my wings. The heavy vowel lines and slouching rhythm of the elephants had just permitted me to attain an ultimate climax. But how to end up?

Ball's solution to finale and exit was to chant in church-style, and then to be carried from the blacked-out room 'like a magical bishop'. To his performance Ball added some explanatory words which were to have a significant influence on experimental writing (particularly in the magazine *transition*) during the late-1920s and the 1930s:[19]

With these sound poems we would renounce the language devastated and made impossible by journalism.

We should withdraw into the innermost alchemy of the word, and even surrender the word, in this way conserving for poetry its most sacred domain. We should stop making poetry second-hand; we should no longer be content to achieve poetic effects with means which in the final analysis, are but the echoes of inspiration or simply surreptitiously proffered arrangements of an opulence in cerebral and imagistic values.

Perhaps the most significant contribution to the evening (Bastille Day in France) was the first Dada Manifesto, Tzara's *Manifeste de monsieur Antipyrine*. The Paris Dadaists were to become fervent admirers of Tzara's synthesis here of all the attitudes of Dadaism, including near-incomprehensibility:[20]

DADA is not madness, or wisdom, or irony, take a look at me, kind bourgeois.

Art was a trivial game, children collected words with chiming endings, then they wept and shouted stanzas, and put dolls' bootees on them and the stanzas became a queen to die a little and the queen turned into a whale, the children ran until they were out of breath.

Then came the great ambassadors of sentiment who cried historically in chorus:

Psychology Psychology Psychology
Science Science Science
Long live France
We are not naive
We are successive
We are exclusive
We are not simple
and we are capable of discussing the intelligence.

But we, DADA, we are not of their kind, for art is not serious, I assure you, and if we exhibit crime by saying learnedly ventilator, it is to give you pleasure, kind listeners, I love you so, I assure you and I adore you.

This first 'Dada Evening' was the signal for a spate of similar performances in Zürich, as well as many 'new art' exhibitions, and a continuous stream of dada books, journals and pamphlets. Such activities were maintained with unflagging vigour until the end of 1919 when Tzara left for Paris.

From early 1917 Tzara became the acknowledged leader of the Zürich group which he dominated by a mixture of boyishly comic high spirits, inexhaustible inventiveness, and single-minded aggressive energy. In January 1917 Huelsenbeck returned to Germany where he was shortly to be a leading figure in the formation of Berlin Dada which, from its inception, was more politically involved than either Zürich Dada had been or Paris Dada was to be. 'Dada is German Bolshevism', wrote Huelsenbeck in his *En Avant Dada* (published in Germany in 1920), where he also showed that he regarded the remaining Zürich Dadaists as a mild and ineffectual aesthetic coterie:

While Tzara was still writing: *'Dada ne signifie rien'* – in Germany Dada lost its art-for-art's-sake character with its very first move. Instead of continuing to produce art, Dada, in direct contrast to abstract art, went out and found an adversary. Emphasis was laid on the movement, on struggle. But we still needed a programme of action, we had to say exactly what our Dadaism was after.[21]

In fact, Dadism in Germany became whatever its members decided. In the political struggles of the postwar period in Berlin it would be Bolshevist, anarchist, or even Fascist in nature. Early in the 1920s Huelsenbeck left for the USA where he became eventually a successful Jungian analyst. Huelsenbeck's voice was not the only one to be heard in German Dada, however; by the early 1920s there were other groups

in Berlin, Cologne, Hanover, and other German cities, many of which had strong links with former Zürich Dadaists, some of whom kept up friendly relationships with Tzara. By the end of 1917, Hugo Ball, disillusioned with the anarchistic tendencies of Zürich dada, had also left, at first to work in Berne as co-editor of the *Freie Zeitung*, an anti-Kaiser pro-republican newspaper, then retiring to Ticino where he entered the Catholic Church again and led an extremely simple life until his death in 1927.

Even before Huelsenbeck and Ball left the group, the 'Collection Dada' had produced works by Dadaist writers, including, in 1916, Tzara's *La Première aventure céleste de M. Antipyrine* and *Vingt-cinq poèmes* and Huelsenbeck's *Phantastische Gebete (Fantastic Prayers)* and *Schlaben Schalomai Schalamezomai*. However, the main vehicle for Dada work was to be Tzara's magazine *Dada* which became the prototype for a large number of short-lived magazines which mushroomed all over Europe in the immediate postwar years. The first four issues, *Dada 1*(July 1917); *Dada 2* (December 1917); *Dada 3* (December 1918), and *Dada 4/5* (May 1919), were printed in Zürich by the radical Swiss typographer, J. Heuberger. Different type-faces, differently coloured pages, and strikingly disordered layouts were some of the features of these issues.

The first two issues of *Dada* represent a mixture of styles, as though the magazine were still seeking a separate identity. There were contributions from Futurist artists and writers as well as from the Dadaists, but in *Dada 3*, the cover of which bore the message, 'Je ne veux même pas savoir s'il y a eu des hommes avant moi' (I do not even wish to know if there have been men before me), there appeared the text of Tzara's *1918 Manifesto*.[22] This manifesto had been delivered at a 'Tristan Tzara Evening' at the Meise Hall in Zürich on 23 July 1918, and it was to be perhaps the most influential of all the Zürich publications. In this work, even more than in the Bastille Day manifesto of 1916, Tzara crystallised all the essential elements of Dada. He proclaimed again the utter rejection of all values traditionally held in Western society, of Western art, of reason and all rational systems – 'the most acceptable system is on principle to have none'. The only positive aims were those of complete spontaneity and individual attainment:[23]

To complete yourself, to make yourself perfect within your own littleness, to fill the vessel of your self-hood, courage to fight for and against thought, mystery of bread sudden release from a hellish spiral into economic illness: DADAIST SPONTANEITY . . .

In the final paragraph of the *1918 Manifesto* Tzara proclaimed the doctrine of active disgust that was to receive such immediate and sympathetic assent among young writers in postwar France:

Every product of disgust capable of becoming a negation of the family is *dada*; protest with all the strength of one's being in destructive action: *DADA*; knowledge of all the methods rejected up to this time by the prudish sex of easy compromise and civility: *DADA*; abolition of logic (the dance of those who are creatively impotent): *DADA*; of every social hierarchy and degree instituted for the sake of value by our valets: *DADA*; each object, all objects, sentiments and obscurities, apparitions and the precise opposition of parallel lines, these are the weapons for the battle: *DADA*; abolition of memory: *DADA*; abolition of archeology: *DADA*; abolition of prophets: *DADA*; abolition of the future: *DADA*; absolute and unquestionable belief in every deity produced on the instant by spontaneity: *DADA*; elegant and unprejudiced leap from a harmony to the other sphere; trajectory of a word thrown like a gramophone record shriek; to respect all individualities in their passing follies: serious, fearful, timid, ardent, vigorous, determined, enthusiastic; to strip one's church of every useless and meaningless property; to spit out disobliging or amorous ideas like a luminous waterfall, or to cherish them — with the same intensity in the bushes of one's being — unsullied by insects through well-born blood, and gilded by flights of archangels. Freedom: DADA DADA DADA, howls of thrilling colours, interlacing of opposites and all contradictions, utter absurdities, inconsistencies; LIFE.[24]

In February 1918 Picabia, by this time an uncompromising nihilist, had joined forces with the Zürich group. The first fruit of the new alliance was described by Picabia's widow in lively terms, and with some interesting details of methods used at this stage:

The meeting of *391* and Dada was celebrated in new issues of *391* and *The Dada Review*. *391* appeared on bright pink paper. Arp, Tzara, Picabia and myself contributed to the two magazines, not only with individual work but by the execution in common of an illustration for *Dada* Nos. 3 and 4. [Actually *Dada* 4/5 (*Réveil matin*)] Every detail of this illustration is still fresh in my mind. The medium was an old alarm clock which we bought for a few cents and took apart. The detached pieces were bathed in ink and then imprinted at random on paper. All of us watched over the execution of this automatic masterpiece. The magazine was printed in the awe-inspiring lair of a revolutionary Swiss printer who happened to be out of prison, and who at last restored my conception of the anarchist type, which had been quite upset by my experience of the anarchist club in New York.[25]

The final issue of *Dada* in Zürich contained several poems and drawings by Picabia as well as pieces by Tzara and other members of the group of 1918 (including Gabrielle Buffet, Viking Eggeling, and Hans Arp), but, significantly, there were poems and other items by several French writers including Jean Cocteau, Philippe Soupault, Georges Ribemont-Dessaignes, Louis Aragon, Pierre Reverdy, Raymond Radiguet, and Pierre Albert-Birot. Some of these writers had appeared in earlier issues of *Dada,* but the French had never had such strong representation before. In November 1919 the last publication of the Zürich group, *Der Zeltweg*, edited by Otto Flake, Serner, and

Tzara, appeared. This magazine contained no work by the younger French writers. Already there was some tension between Tzara and other Zürich Dadaists who resented Tzara's claims to be the principal spokesman for the movement. But Tzara had already made contact with the Paris group associated with the magazine *Littérature*, founded in March 1919 by Louis Aragon, André Breton and Philippe Soupault. At the end of that year Tzara left for Paris where he found an atmosphere perfectly suited to the destructive and hysterical nihilism of Dadaism.

PARIS

In wartime Paris two literary journals had emerged to continue the spirit of restless invention which had been the principal quality of the decade before 1914. From January 1916 until December 1919 *SIC* was edited by Pierre Albert-Birot (1876–1967), himself a talented writer of experimental prose and verse. He was a friend of Apollinaire and several other avant-garde artists and writers of the prewar scene, but his journal was important for its encouragement of younger writers, notably Louis Aragon, André Breton, Paul Dermée, Pierre Reverdy, and Philippe Soupault – all of whom were to become members of both the Dada and Surrealist groups in Paris. Albert-Birot contributed to Tzara's *Dada 3*, the issue which contained the *1918 Manifesto*, and from 1917 onwards he printed several pieces by Tzara in *SIC*. The general mood of the journal, however, was Cubist and Futurist (its contributors included several Italian Futurist poets and painters), with a special link with the work of Guillaume Apollinaire, whose death just before the Armistice led to a special double issue of *SIC* with contributions from most of the Paris art-world.

In 1917 Pierre Reverdy (1889–1960), who also contributed to *Dada 3*, founded the journal *Nord–Sud*. Like Albert-Birot, Reverdy was a friend of Apollinaire, but his journal reflected a wider range of literary interest than did *SIC*, though both journals had several contributors in common, including Apollinaire, Louis Aragon, André Breton, and Philippe Soupault.

In March 1919 some of the younger contributors to these journals founded *Littérature*. Aragon (b. 1897), Breton (1896–1967), and Soupault (b. 1897) were co-editors, and though the title of the journal was intended to be ironic, they began by printing contributions from French writers who were generally regarded as fairly traditional – including Valéry, Gide and Jules Romain. Increasingly, however, the young French writers of *Littérature* were growing angrily impatient at the general apparent return to unquestioning normality of postwar France, and as they turned against their traditional foe, the 'bourgeoisie', they also turned violently against their literary elders. The *Littérature* group were inevitably drawn into Dadaism for many reasons, though doubtless the complex psychic disturbance created by

World War I and its aftermath was the immediate and, probably, the principal moving force.

In his *André Breton, Arbiter of Surrealism* (1967)[26] Clifford Browder demonstrated the extraordinary authority with which Breton led his young French contemporaries through the three or four years of negative and destructive French Dadaism into Surrealism. Through incredibly bitter feuds, at first with almost every real or imagined representative of the French bourgeoisie and the political, critical, and artistic establishment, then, within a very short time, with those Dadaists who refused conversion to Surrealism under Breton's leadership. Breton's influence was clearly crucial in guiding his followers both into and away from Dadaism, but the personality of one man – no matter how unusual that man may be – cannot in itself adequately account for the speed of the process by which at the beginning of 1920 *Littérature* had completely assumed the Dadaist spirit.

Like the Zürich Dadaists, the *Littérature* group had developed an interest in techniques of creative spontaneity including automatism. Throughout 1919 Breton and Soupault had experimented with completely 'automatic' writing which was first published in part between October and December 1919, in *Littérature*. Breton's experiences with the French Second Army at the psychiatric centre of Saint-Dizier where he had experimented with Freudian analyses, employing such techniques as free 'stream of consciousness', may have encouraged him personally to try automatic writing as a literary method. In 1920 Breton and Soupault published a volume of these texts under the title *Les Champs Magnétiques*.[27] The following extract reveals something of the curious effects, hovering around the edges of ordinary meaning, which this work sometimes attains:

Je crois que nous nous écoutions penser mais le machinal 'A rien' qui est le plus fier de nos refus n'eut pas à être prononcé de tout ce voyage de noces. Moins haut que les astres il n'y a rien à regarder fixement. Dans quelque train que ce coit, il est dangereux de se pencher par la portière. Les stations étaient clairement reparties sur un golfe. La mer qui pour l'oeil humain n'est jamais si belle que le ciel ne nous quittait pas. Au fond de nos yeux se perdaient de jolis calculs orientés vers l'avenir comme ceux des murs de prisons.[28]

The artistic heroes of *Littérature* had included several ' anti-art' French writers of whom the Dadaists certainly approved, particularly Arthur Rimbaud (1854–1891) who gave up poetry for gun-running in Africa, and Alfred Jarry (1873–1907), the creator of *Ubu Roi* (1896). Initially, however, the most influential contemporary French figure was Jacques Vaché (1896–1919), a close friend of Breton, who is known entirely through his war-letters[29] and Breton's reminiscences of him.[30] Vaché, who committed suicide and simultaneous multiple murder of his friends by poisoning in 1919, had alternately, or paradoxically together, advocated to Breton both the abandonment of

all art as a bore and the view that the task of 'new art' was 'former la sensation personnelle à l'aide d'une collision flamboyante de mots rares'.[31] Vaché's total world-weariness and black-humoured cynicism had a profound effect on Breton and, through him, on the French Dadaist and Surrealist movements. Sarane Alexandrian had gone so far as to suggest that '. . . it was Vaché's nihilist humour that Breton was to seek to recapture in his temporary involvement with dadaism'.[32] In some of his lists of Surrealist precursors Breton gave Vaché central credit for the character of his own Surrealist attitude: 'VACHÉ (is surrealist) in me'.[33] One intriguing instance of what Breton may have meant by this is to be found in J. H. Matthews's *An Introduction to Surrealism*:

> **Breton has related how, during the war, he and Jacques Vaché would go to one of the local cinemas in Nantes, taking care not to note the times of performances so as to arrive at no prearranged hour. They would leave the cinema of their arbitrary choice at the first sign of boredom and, without taking the trouble to ascertain the film they had just sampled, enter another where they behaved in the same way. The result was a succession of unrelated visual impressions, juxtaposed entirely according to chance. But their effect, Breton tells us, was 'magnetizing'. 'What was important was that we came out 'charged' for a few days.'**[34]

It is worth noting that this account of an experiment with the stimulating possibilities of arbitrariness or chance by the future Surrealist differs fundamentally in motivation and effect from, for example, Marcel Duchamp's declared attitude towards his 'ready-mades':

> **A point that I want very much to establish is that the choice of these 'readymades' was never dictated by aesthetic selection.**
> **The choice was based on a reaction of *visual* indifference with at the same time a total absence of good or bad taste . . . in fact a complete anaesthesia.**[35]

Despite differences of emphasis, however, the Paris *Littérature* group and the Zürich Dadaists, led by Tzara and Picabia, found enough in common during the early postwar years to develop very quickly a sympathetic exchange of contributions, critical and creative, between the two cities. As is to be expected, Picabia had brought to Zürich a strong sense of the French (as well as the American) 'anti-art' tradition. His cover for the eighth issue of *391* (Zürich 1919), while explicitly rejecting the art of Cézanne ('j'ai horreur de la peinture de Cézanne elle m'embête') included among its honoured names most of the French artists who had worked with Picabia in New York, as well as Apollinaire and Georges Ribemont-Dessaignes (1884–1974), the writer and painter who was to become secretary of the Paris Dada group for a time. A drawing by Picabia made in Zürich in 1919 of a

'Mouvement Dada' time-bomb[36] shows an even stronger dependence on the French past. Wires leading to the bomb come from painters and poets such as Corot, Ingres, Mallarmé, and Matisse – and these wires lead through many names from the immediate prewar avant-garde in Paris including the musicians Erik Satie and Edgar Varèse, and artists such as Braque, Picasso and, inevitably, Apollinaire.

Picabia's return to Paris in 1919, where he published the ninth volume of *391* in November, containing three texts by Tzara, brought a more direct awareness of Tzara's brand of Dadaism, and he acted enthusiastically to prepare the way for the Romanian's first appearance in the city. In July 1919 Duchamp had also returned to Paris and, with Picabia, he began to meet the French Dada group which gathered at the Café Cértà. 1920 was to be the year of the high-tide of French Dadaism. At the beginning of that year occurred the first of the series of events – riotous manifestations and other performances, exhibitions and publications – which mark a major irrecoverable change of identity in European modernist art.

It is unnecessary to go into great detail about the processes by which these activities culminated in what Tzara called 'cannibalistic' disorders within the Dada movement in Paris. Opinions about these internal feuds have been written from several points of view, including those who see the whole point of Dadaism in its preparation for Surrealism, those who see Dadaism betrayed by Breton and the Surrealists, those who (like Michel Sanouillet in his *Dada à Paris*[37]) see Dadaism and Surrealism as different waves of the same floodtide, or even those present day Surrealists who see such historical discussion as academic, pointless, and divisive for a living movement.[38] It is sufficient to note here that within three or four years of its beginning, Paris Dada as an organised movement was dead. The fierce negativism of Dada and its refusal to accept any discipline or principles (rational or irrational), made it unacceptable to Breton and his followers who were seeking new 'truth'. On the other hand, the unrelenting anarchism of Picabia and Tzara meant that neither could accept any compromise with the other's individual view of the meaning of 'anarchism' or, at first, with any form of Surrealism either. It may be difficult now to understand the savagery of the personal insults and apparently paranoid hatreds of the early 1920s in Paris, but that such hatred was real, not simply another Dadaist publicity stunt, is confirmed by Georges Hugnet's account of the infamous 'Soirée du coeur à barbe' in July 1923 which came at the end of a long series of attacks and counter-attacks within a constantly changing kaleidoscope of shifting individual and group loyalties. This event effectively marked the end of Paris Dada:

> **I remember that evening which ended with an uproar that came close to carnage. When the time came for the performance of (Tzara's) *Le coeur à gaz*, the actors ... were suddenly interrupted by violent protests from the stalls. Then an unexpected interlude: Breton hoisted himself**

on to the stage and started to belabour the actors. The latter, hampered by Sonia Delaunay's solid cardboard costumes, were unable to protect themselves and made efforts to flee with tiny steps. Breton boxed Crevel's ears roundly and broke Pierre de Massot's arm with his walking stick. Recovering from its stupefaction, the audience reacted. The implacable demonstrator was brought down from the stage. Aragon and Péret joined him and all three were shaken, dragged away and forcibly expelled, their jackets torn apart. Hardly had order been restored when Eluard climbed on to the stage in his turn. This action seemed surprising in one who was a friend of Tzara. But the members of the audience were not concerned with such subtleties, and the author of *Répétitions* was at once leapt on by a group of spectators inflamed by the preceding rough and tumble. Overwhelmed by their numbers, Eluard collapsed into the footlights, breaking several lamps. While his friends sought to save the gentle poet from reprisals, the uproar in the hall brought the intervention of the police. When the melée had dispersed and the pushing subsided, the silence seemed unnatural. I can still hear the director of the Théâtre Michel, tearing his hair at the sight of the row of seats hanging loose or torn open and the devasted stage, and lamenting, 'My lovely little theatre!'[39]

However, at the beginning, in 1920, all these artists were united in a number of aims: to destroy completely and by every possible method the traditional concept of Reason in all its many guises; to express their total disgust with the bourgeois attitudes responsible for the war; and to attack without mercy the bourgeoisie now complacently at peace. On 23 January, a 'Dada Matinée' took place at the Palais des Fêtes. For the first time Tzara appeared in public, and he has written the most vivid account of this occasion:

The debut of Dadaism in Paris took place on the twenty-third of January, at the matinee organised by the Dadaist review *Littérature*. Louis Aragon, a slender young man with feminine features, A. Breton, whose behaviour displays the stigmata of the religious sectarians, G. Ribemont-Dessaignes, a man whose simple appearance conceals the fiery temper of the great accusers of humanity, and Philippe Soupault, whose facility of expression flows forth in bizarre images, gave readings from their works. Picabia, who has undergone so many influences, particularly those of the clear and powerful mind of Marcel Duchamp, exhibited a number of pictures, one of which was a drawing done in chalk on a blackboard and erased on the stage; that is to say, the picture was valid for only two hours. As for me, announced as 'Dada', I read aloud a newspaper article while an electric bell kept ringing so that no one could hear what I said. This was very badly received by the public who became exasperated and shouted: 'Enough! Enough!' An attempt was made to give a futuristic interpretation to this act, but all that I wanted to convey was simply that my presence on the stage, the sight of my face and my movements, ought to satisfy people's curiosity and that anything I might have said really had no importance.[40]

Another such event – the reading of dada manifestos by Picabia, Ribemont-Dessaignes, Breton, Dermée, Eluard, Aragon, Tzara and

others – took place on 5 February in a 'Matinée' at the Salon des Indépendents, and this ended (as the Dadaists had intended that it should) with uproar among the audience who pelted the stage with rubbish. Several other Dada arrangements took place in the early months of 1920, including one at the Club de Fauborg on 7 February and another at the Université Fauborg St Antoine on 18 February. *Littérature* published twenty-three 'manifestes du mouvement dada' in the May 1920 issue, and the critical backlash, to the Dadaists' delight, began to increase. On 25 February the 'Section d'Or (The Golden Section) – the society to which Apollinaire had once belonged, and which now included several leading Cubists and abstract artists, including Albert Gleizes (1881–1953) who had been a member of the New York and Barcelona groups – had expelled the Dadaists for their riotous support of Max Ernst, again amid triumphant Dadaist-approved confusion and disorder.

A 'Manifestation Dada' on 27 March at the Salle Berlioz of the Maison de l'Oeuvre included Tzara's *La Première Aventure Céleste de M. Antipyrine* ('. . . a boxing match with words. The characters, confined in sacks and trunks, recite their parts without moving, and one can easily imagine the effect this produced – performed in a greenish light – on the already exited public. It was impossible to hear a single word of the play'[41]). Tzara has also provided the description of a successful production of audience participation at the 'Festival Dada' at the Salle Gaveau on 26 May where his *La Deuxième Aventure Céleste de M. Antipyrine* was performed:

At the Salle Gaveau, at the Dada Festival, the scandal was also great. For the first time in the history of the world, people threw at us, not only eggs, salads and pennies, but beefsteaks as well. It was a very great success. The audience were extremely Dadaist. We had already said that the true Dadaists were against Dada. Philippe Soupault appeared as a magician. As he called the names of the Pope, Clemenceau and Foch, children's balloons came out of a large box and floated up to the ceiling. Paul Souday in his notice in *Le Temps* said that really, at a certain distance, the faces of the persons actually appeared on the surfaces of the balloons. The audience was so excited and the atmosphere so overcharged that a number of other ideas merely suggested took on the appearance of reality. Ribemont-Dessaignes did a motionless dance and Mlle. Buffet interpreted some Dadaist music. A flashlight taken by the newspaper *Comoedia* during a performance of a play by me shows everybody in the house waving their arms and with their mouths open shouting.

All the Paris celebrities were present. Mme. Rachilde had written an article in a newspaper inviting some *poilu* to shoot us with a revolver. This did not prevent her a year later from appearing on the stage and defending us. She no longer regarded us as a danger to the *esprit français*. They did not kill us in the Salle Gaveau, but all the journalists tried to do so in their notices. Columns were written declaring that Dada wasn't to be talked about any more – which suggested this observation to Jean Paulhan (the following is in English in the original):

'If you must speak of Dada you must speak of Dada. If you must not speak of Dada you must still speak of Dada.'[42]

Many exhibitions and displays were also arranged, usually at the 'Au Sans Pareil' Gallery, and a profusion of little magazines and periodicals mushroomed in this frenzied atmosphere. In February and March 1920 Tzara's *Dada 6 (Bulletin Dada)*, which contained the programme of the Matinée of 5 February as well as a list of 'Quelques présidents et présidentes' of the dada movement and *Dada 7 (Dadaphone)*, the final issue of the periodical in Paris, which contained Breton's poem 'Pièce fausse'. Picabia, having produced three more numbers of *391*, numbers 10–12 (the last of which included the infamous moustached 'Mona Lisa' by Duchamp), now issued *Cannibale* (two issues 25 April 1920 and 25 May 1920): the first issue of this magazine contained the equally infamous 'Portrait de Cézanne (Portrait de Rembrandt, Portrait de Renoir, Nature Mortes)', a collage in which a stuffed monkey represents all these artists and their work. Tzara noted the great success of *Cannibale* and added:

> **It developed the absolutely anti-literary point of view which will be the relativist point of view of future generations. The superabundance of life of these future generations will find its place in the movement, and they will forget the rigid conventions, the paralysed ideas, of a tradition which is nothing but laziness.[43]**

In February Paul Eluard had published the first of six issues of *Proverbe*, a distinctively literary Dadaist magazine, and in March the poet Paul Dermée – who had been editor of the periodical *L'esprit nouveau* (1919) – published the only issue of *Z*, containing contributions from most of the Dadaists.

By the autumn of 1920 the spirit of Dadaism had captured Paris. The 'absolutely anti-literary point of view' and the prospect of an anarcho-nihilistic 'relativist point of view of future generations' as promised by Tzara had to be taken seriously by European critics. In August of the same year Breton was able to defend Dadaism in the great French liberal-classical review *La Nouvelle Revue Française*, which was edited by Jacques Rivière (1886–1925), a critic much respected in England. Breton's article 'Pour Dada',[44] became a major debating piece of the time, not only in the pages of *La Nouvelle Revue Française* but throughout Europe. By the end of the year 1920 it could no longer have been possible for any serious writer in England who was concerned about the direction of the modern movement in art, literature or music to be completely unaware of Dadaism.

NOTES

1 Willy Verkauf (ed.), *Dada: Monograph of a Movement* (Tiranti, London, 1957), p. 171.

2 Beatrice Wood [with Marcel Duchamp], 'The Richard Mutt Case', *The Blind Man*, No. 2, New York (May 1917). Quoted in Calvin Tomkins, *The World of Marcel Duchamp* (Times Inc., New York, 1966), p. 39.

3 Arthur Cravan; quoted in Hans Richter, *Dada: Art and Anti-art* (Thames & Hudson, London), 1964, p. 85.

4 See André Breton, *Anthologie de l'humour noir*, revised edition, ed. Jean-Jacques Pauvert (Livre de Poche, Paris, 1966), pp. 323–5.

5 See Arthur Cravan, 'Exhibition at the Independents' (1914), in Robert Motherwell (ed.), *The Dada Painters and Poets: An Anthology* (Wittenborn, Schultz, New York), 1951 (second printing 1967), pp. 3–13.

6 Gabrielle Buffet-Picabia, 'Arthur Cravan and American Dada', in *transition* 27, ed. Eugene Jolas, Paris (spring, 1938), p. 319.

7 Richard Huelsenbeck, 'Dada Lives', *transition* 25, (ed.) Eugene Jolas, (Paris, Fall 1936), pp. 77–80, translated by Eugene Jolas.

8 *Ibid.*, pp. 77–8.

9 See Hans Richter, *Dada: Art and Art*, pp. 118–21; Edward Lucie-Smith (ed.), *Experimental Poetry I 1870–1922* (Rapp & Whiting, London, 1971), p. 61.

10 Hans Arp, *On My Way*; quoted in Herbert Read, *Arp* (Thames & Hudson, London, 1968), p. 30.

11 Hans Arp; quoted in *Dada: Art and Anti-art*, pp. 30–1.

12 William C. Wees, *Vorticism and the English Avant-Garde* (Manchester University Press, Manchester, 1972); Herbert S. Gershman, 'Futurism and the Origins of Surrealism', *Italica*, xxxix, 2 (June 1962), pp. 114–23.

13 'First Futurist Manifesto', quoted in Rollo H. Myers, *Modern French Music: Its Evolution and Cultural Background from 1900 to the Present Day* (Blackwell, Oxford, 1971), p. 14.

14 Umberto Boccioni, 'Manifesto of Futuristic Painters' (1910); quoted in Herbert Read, *A Concise History of Modern Painting* (Thames & Hudson, London, 1959), p. 110. See also 'L'Antitradition Futuriste' (1913); reproduced in Francis Steegmuller, *Apollinaire: Poet Among the Painters*, Hart-Davis, London, 1963), pp. 264–5.

15 Filippo Tomasso Marinetti, 'Typographical Revolution', in 'Wireless Imagination and Words at Liberty', *Poetry and Drama* I (September 1913), p. 325, translated by Arundel del Re.

16 *Dada: Art and Anti-art*, pp. 33–4.

17 See Willy Verkauf, *op. cit.*, p. 26 (poster, 1st Dada evening).

18 Tristan Tzara, 'Zürich Chronicle', translated by Ralph Manheim, in Motherwell, *op. cit.*, pp. 235–42; also in Hans Richter, *Dada: Art and Anti-art*, pp. 223–8. The translation is from a French version of the original.

19 Hugo Ball; quoted in Motherwell, 'Introduction', *op. cit.*, pp. xix–xx.

20 Tristan Tzara, 'Manifeste de M. Antipyrine', *Tristan Tzara: Sept manifestes Dada*, Jean-Jacques Pauvert (Paris, 1963), pp. 11–12, translated by Alan Young.

21 Richard Huelsenbeck, *En Avant Dada: Eine Geschichte des Dadaismus*, 1920, translated by Ralph Manheim, in Motherwell, *op. cit.*, p. 41.

22 Tristan Tzara, 'Manifeste Dada 1918'. The full text is given in *Tristan Tzara: Sept manifestes Dada*, pp. 13–35.

23 *Ibid.*, pp. 26–7, translated by Alan Young.

24 *Ibid.*, pp. 33–5, translated by Alan Young.

25 Gabrielle Buffet-Picabia, 'Some Memories of Pre-Dada: Picabia and Duchamp', translated by Ralph Manheim, in Motherwell, *op. cit.*, p. 266.

26 Clifford Browder, *André Breton: Arbiter of Surrealism*, (Librarie Droz, Geneva, 1967).

27 André Breton and Philippe Soupault, *Les Champs Magnétiques* (Au Sans Pareil, Paris, 1920). Georges Hugnet claimed that *Les Champs Magnéti-*

ques was 'the first of all surrealist works' (Georges Hugnet, '1870 to 1936', in (ed.) H. Read, *Surrealism* (Faber, London, 1936), p. 210).

28 André Breton, *Selected Poems*, translated by Kenneth White (Cape, London, 1969), pp. 12–13.

29 Jacques Vaché, *Lettres de Guerre*, (Au Sans Pareil, Paris, 1919); also published in *Littérature* 5, 6, and 7 (July, August, and September 1919).

30 See André Breton, *Anthologie de l'Humour Noir* (Pauvert, Paris, 1966), pp. 375–83. See also 'La Confession Dédaigneuse' in *Les Pas Perdus* in *La Nouvelle Revue Française* (1924).

31 Jacques Vaché; in *Anthologie de l'Humour Noir*, p. 381.

32 Sarane Alexandrian, *Surrealist Art* (Thames & Hudson, London, 1970), p. 29, translated by Gordon Clough.

33 André Breton, *Manifeste du Surréalisme*, (Gallimard, Paris, 1924), p. 39. Also in André Breton, 'Surrealism, Yesterday, To-day and Tomorrow', in *This Quarter*, ed. Edward W. Titus (Paris, September 1932), p. 17.

34 J. H. Matthews, *An Introduction to Surrealism* (Pennsylvania State University Press, University Park, Pa., 1965), pp. 101–2.

35 Michel Sanouillet and Elmer Petersen, (ed.), *The Essential Writings of Marcel Duchamp* (Thames & Hudson, London, 1975), p. 141.

36 Francis Picabia, *Mouvement Dada* (drawing) in *Dada 4–5 (Anthologie Dada)* (Zürich, 1919). This drawing is reproduced in *Dada: Monograph of a Movement*, p. 40.

37 Michel Sanouillet, *Dada à Paris* (Pauvert, Paris, 1965).

38 There is a brief interesting discussion of the attitude of present-day, self-styled French 'Surrealists' to such debate in Mary Ann Caws, *The Poetry of Dada and Surrealism* (Princeton University Press, Princeton, N.J., 1970), pp. 7–10.

39 Georges Hugnet, *L'aventure Dada, 1916–1922* (Galerie de l'Institut, Paris, 1957). A full report of this event was given in the *Little Review* (spring 1923), pp. 27–9.

40 Tristan Tzara, 'Memoirs of Dadaism', in Edmund Wilson, *Axel's Castle: A Study in the Imaginative Literature of 1870–1930* (Scribner's, New York, 1931), appendix II, p. 304.

41 *Ibid.*, p. 307.

42 *Ibid.*, p. 308.

43 *Ibid.*, p. 309.

44 André Breton, 'Pour Dada', *La Nouvelle Revue Française*, XV, 1 (August 1920) pp. 208–15.

dadaism
and england

reactionaries and rebels

In recent years important historical and critical studies have provided a much sharper, more detailed picture than existed previously of the English literary scene before, during, and after World War I. Two such studies are C. K. Stead's *The New Poetic* (1964) and Robert H. Ross's *The Georgian Revolt, Rise and Fall of a Poetic Ideal, 1910–1922* (1967). In both these books there is a strong reliance on primary source material – particularly contemporary periodical literature – and though the focus and balance of sympathies in each book are different, there are several important areas of agreement.

Professor Stead showed a good deal of sympathy for the 'Georgian' poets who were the main subject of Professor Ross's study. Stead demonstrated how the Georgians attempted to encourage a more serious attitude towards poetry after 1909 ('perhaps the lowest point of a long decline in the quality of English poetry')[1] by demanding a more honest and direct confrontation of experience by poets, and by helping to create a more intelligently informed reading public. Stead's primary intention was to show how the Georgians helped to make the way smoother for 'modern' poetry, particularly that of T. S. Eliot; of Rupert Brooke, for example, Stead wrote: 'The point is simply that Brooke, a representative Georgian, was moving in a direction which was advantageous to the development of English poetry. He helped to prepare the ground for the work of better poets.'[2] Nevertheless, Stead shared Ross's view that the Georgian poets were successful in producing poems of distinctive merit, as well as in breaking away from

the stultifying effects of late-Victorian sentiment which, long after Victoria's death, still characterized English poetry and literary criticism. This deadweight of unimaginatively conservative, 'Imperialist' (Stead) or 'Right-wing' (Ross) establishment was to be the target of Georgian and Modern alike who saw it as the source of poetry possessing little intelligence, sensitivity or, indeed, any other merit. This poetry was matched by a literary criticism with no standards whatsoever. Stead quoted Ezra Pound's view that 'the general tendency of British criticism at the time was towards utter petrification or vitrefaction, and Henry Newbolt [for Stead, a truly representative 'Imperialist' poet and critic] was as good an example of the best *accepted* criteria as can be unearthed'.[3] Between them Stead and Ross gave massive evidence of the real and felt existence of this literary establishment, and of its stifling effects on English literary life.

What also emerges from reading both Stead and Ross is the enormous differences which existed (and, *pace* Stead and Ross themselves, continue to exist) within the poetic ideals opposed to this establishment. English literature of the period was essentially a 'coterie' affair, and many quasi-political subdivisions characterise the anti-establishment coteries. Ross divided this opposition into 'Left' and 'Centre', and showed how, particularly after 1918, it became essential for the more eclectic literary journals to move towards a relatively conservative ('Rightist') or towards a relatively modernist ('Leftist') position:

> **Caught in the crossfire, and impecunious in the extreme, most of the little magazines of the Centre, like Monro's *Chapbook*, were eventually forced either to stretch a tentative foot towards one of the coteries or to suspend publication. Only a few were able to survive long enough or to find sufficient worth-while material to print to render them noteworthy. Almost by the nature of things in the post-war literary world, neutralism meant death.[4]**

But here Ross was discussing the situation as it had hardened into staleness and cliché – which it did very quickly – in the early nineteen-twenties (when in fact the creative ethos was to give way to a more 'critical' one). During the immediate postwar years there were still a sufficient number of identifiable differences among many little magazines and their contributors to make the 'coterie' warfare complex and interesting. In the present chapter it is my intention to examine English reaction to Dadaism in a way that acknowledges some of this complexity in the English postwar literary world.

The easiest assumption – one that has been made frequently – is that English failure to comprehend and employ ideas and techniques developed on the continent of Europe stems from a permanent, massive general ignorance and wilful, provincial Philistinism on the part of English artists and critics. Such an assumption about any nation may be supported, naturally, by almost any cultural individuality posses-

sed by that nation. But the lateness and timidity of the general English response to 'modernism', particularly in literature and especially in its more extreme manifestations, have convinced some critics that in confronting twentieth-century life, English writing has demonstrated a failure of nerve which has seriously limited its achievements.

In his article 'The Other Poets of the First World War' (1969),[5] Edward Lucie-Smith argued that a comparison of 'the poetry written in Europe by Europeans in the years 1914–18, and that produced by the English soldiers who went there to fight in the trenches' reveals some similarities but more striking differences. The similarities ('confined to a few poets on each side') may be found in the German Expressionist, Georg Trakl, and the Italian Modernist, Ungaretti, on the one hand, and Wilfred Owen and Isaac Rosenberg on the other. Indeed, according to Lucie-Smith, Owen and Rosenberg had ('probably without knowing it') placed themselves 'on a footing with the Expressionist movement, and Expressionism . . . can be regarded as a component of the first phase of European modernism'. For Lucie-Smith, Owen and Rosenberg (rather than Eliot and Pound) are 'the genuine pioneer modernists to whom the tradition now leads back'.

However, he continued, there is no real parallel in English war-poetry for the work of Apollinaire, Cocteau, and Marinetti, all of whom had been exposed to (and, it may be added, had helped to create) the prewar explosion in the arts from which their war-poetry developed its distinctive energy. A comparison of poems by Sassoon and Tzara reveals fundamental differences in their outlooks on the world:

> **Though the two sets of lines are very nearly contemporary, the assumptions which inform them are quite different. Sassoon protests within the established order of things: Tzara is out to overturn that order and to make us apprehend reality in a different way.**[6]

Finally, from this evidence of the inability of the English poetic medium to cope adequately with the experience of World War I, Lucie-Smith was able to foresee a relatively lean future for English poetry in the nineteen-twenties:

> **The different fates of English and European poetry during the twenties can already be deduced from what was happening during the war. The decorative modernism of the Sitwells, the more radical modernism of Eliot, were mild indeed compared to the way in which literature was to go on the continent. Eliot's _The Hollow Men_ (1925) and Edith Sitwell's _Gold Coast Customs_ (1929) are mild echoes indeed, and belated ones, of the successive explosions which had taken place in Zürich, in Berlin, and in Paris. Many of the more outstanding oddities of English modernism can, I think, be related to the belated and provincial character of the movement in England.**[7]

The article repeated many of the charges made against English

modernism in recent years, and implied further the curious assumption that the Dadaist 'explosion' itself was a necessary and needful development of the genuinely modernist sensibility of European literature. This comes dangerously near to asserting both that the world is basically absurd in the deepest nihilistic (and metaphysical) sense, and that Dadaism is *therefore* the artist's only adequate or true response. That I am not completely distorting Edward Lucie-Smith's actual viewpoint may be verified by considering the implications of his comparison of lines from poems by Owen and Rosenberg with others by Jean Cocteau:

> **It may seem almost blasphemous to compare Rosenberg and Owen, those deeply serious, deeply compassionate men, unfavourably with Cocteau, whose *mondain* reputation currently serves to obscure us from the full extent of his gift. If I do so here it is for the purpose of pointing out, not a difference of talent, so much as one of centrality.[8]**

This 'centrality', it seems to me, begs the whole question (as does the word 'oddities' in the earlier passage which I have quoted from Lucie-Smith's article), since what was being claimed throughout was the eccentricity of English modernism. Lucie-Smith's examples — ranging from Trakl to Tzara, and from Cocteau to Brecht — do not suggest for me anything like a superior apprehension of reality, or even a more fully human or 'expressive' response to the horrors of World War I, than one finds in the war poems of Owen, Rosenberg, and Sassoon.

The all-important possibility that Edward Lucie-Smith and other critics of modern English poetry have usually failed to consider is that far from being simply a result of narrow-minded and bigoted ignorance on the part of the English, the rejection of both an extremist sensibility and what are regarded as the appropriate techniques for the expression of that sensibility could be an informed and thoroughly cogent act. That it may also be sometimes wrong-headed and mistaken is a different possibility which I also intend to discuss.

THE REACTIONARIES

Inevitably, as within every other national culture, especially at a time of threat to national security, there existed in England after 1918 some strong, uninformed, prejudiced, and unreasoning contempt for anything new and foreign in the arts, and, inevitably too, these attitudes found strongest expression in the popular press and in some of the more conservative organs of the entrenched literary establishment. Discussing the immediate postwar scene in London Robert Ross asserted that by 1918, 'many of the landmarks of the pre-war poetic renaisance had been swept away. Marinetti and Futurism were dead issues.[9] In so far as Ross meant that Futurism *as a movement* active on the English scene was defunct by 1918 this assertion is obviously true.

Indeed, Futurism in England was a dead issue even before the outbreak of the war.[10] Marinetti had aroused some interest in London during his prewar visits there, but he had been regarded only as an amusing diversion by most English poets and critics, and there was little, if any, attempt to emulate his public performances, even if some of the younger generation of English poets and critics approved of his capacity to shock.

As far as literature was concerned, what had been absorbed by the English Vorticists – amounting to little more than a not very startling use of different typefaces for the heavy-handed (and anti-Futurist) manifestoes of Percy Wyndham Lewis in the two issues of *Blast* (No. 1, 20 June 1914; No. 2, July 1915) – had vanished with Vorticism itself during the first year or two of the war.

Clearly though, the popular image of postwar European art was built around the retained impression of prewar Futurism and Vorticism as well as other, even more influential, earlier art movements, expecially Cubism. These movements, together with that postwar import of 'barbarous' modernism, American 'negro' jazz, were the principal targets in this country for popular satirists and serious self-conscious defenders of the English cultural tradition.

The continuing decline in critical and creative acumen of the once-powerful *English Review* is reflected in the gradual narrowing of its attitudes towards almost anything new or foreign in the arts.[11] At the end of 1920, for example, a long poem in two parts by the actor and verse-writer W. R. Titterton entitled 'The Madness of the Arts' appeared in consecutive issues.[12] For Titterton, whose poem displays throughout an almost unbelievable degree of boorishness, one of the principal functions of the recent war had been to keep England safe from the threat of modern art:

> But you, you prate of intervals Chinese;
> Experiment in tom-toms, nigger howls;
> Study your plastic in the Cannibal seas;
> And chant your dissonant verse with heaving bowels.
>
> Is it the end of all? Old Chaos come again?
> Has all we fought for, died for, been in vain?[13]

'The Madness of the Arts', apparently delivered as a 'lecture' at the Tomorrow Club, was published in book form with other verses by Titterton in 1921. In a Preface written for this edition Titterton argued for a limit to toleration of the kind of experiment which leads to 'barbaric destruction', though his examples reveal a complete inability to discriminate:

> The barbarians have a case. Art is always topical, is always representative of its epoch, and since this is the epoch of chaos and the machine, the chaotic yet machine-made work of the *vers librists* in word, in music, and in picture, is the truly representative art of our time.

> Jazz bands, daily journalism, the Third International, industrial capitalism, Aldous Huxley, Wyndham Lewis, Stravinsky and popular revue are all of a piece. 'We are the twentieth century' — they have the right to add that to their barbaric yawp over the roofs of the world . . . But the artists 'who are born too soon' are, no less, and in a very special sense of their epoch; and we must have less respect for those who traffic in the mire than for those who strive to find a way out of it.[14]

Perhaps Titterton would deserve more sympathy if only his own verse, several volumes of which had appeared before *The Madness of the Arts*, were not representative of all the very worst features of both 'traditional' and 'non-Georgian' versifying, and also exhibits unpleasant deep-rooted prejudice against not only foreign cultures, but also foreign persons (Jewish ones in particular).

This treatment of all 'modernisms' and 'modernists' as one, along with a failure to distinguish between the prewar and the postwar, could also be found in what purported to be more informed literary journalism. One of the most influential 'conservative' publications of the postwar years was J. C. Squire's *London Mercury* which first appeared in November, 1919. The narrow conservatism of the *London Mercury*'s editorials and reviews was not always found in its creative contributors who included Robert Graves, Aldous Huxley, Siegfried Sassoon, and Edgell Rickword. However, from its inception the *Mercury* was stingingly abusive about most 'avant-garde' writings, foreign or home-produced. Like most of the serious literary periodicals of the time, the *Mercury* gave some of its space to a literary newsletter from Europe. Responsibility for such letters was often the province of native-born foreign correspondents. In the issue for March 1920, for example, 'A Letter from France' (dated February 1920) by Albert Thibaudet[15] gave a straightforward, brief report on little magazines in Paris after the war, including a short reference to *Littérature* (which Thibaudet found 'rather slender and curious') as well as to *Phalange* and *L'Elan*, two avant-garde journals which had failed to survive the war. On the whole, however, the *Mercury* refused to entertain much general and certainly no detailed discussion of new experiments in literature. In his 'Editorial Notes' to the issues of *Mercury* for February 1920, Squire made his position quite plain. 'Stunts' (by which he seemed to mean all experimental methods) were merely the last refuge of the untalented many who wished to write, and such stunts had spread from the prewar antics of Futurism and Vorticism:

> Just before the war that vivacious Southerner, Signior Marinetti introduced us to the type-page, which consisted of capital letters and notes of exclamation tumbled about in apparent confusion. The first large English enterprise of the Futurist—Vorticist—Cubist kind was (though it contained normal patches) the magenta magazine *Blast* — it succumbed shortly after a hostile critic, consulting his Webster, had discovered the definition: 'Blast — a flatulent disease of sheep'. But it died to give place to countless smaller magazines and books containing bewildering designs and extraordinary poems.[16]

Squire refused to take any of the experimental work originating in France seriously, just as he rejected recent *vers libre* ('a diet of wind and sawdust'). It is hardly surprising, therefore, that with such closed and sweeping attitudes towards experimental methods of all kinds, the *Mercury*'s only direct reference to a Dadaist publication was to be a good-humoured but routine dismissal of something thought to be *déjà-vu*. In the review of 'New and Recent Periodicals' for February 1921 the following note appeared: 'The publisher of a Dadaist organ apparently called '391' has sent us a copy of it, for which we are profoundly grateful. The price seems to be two francs, but this figure may possibly be one of the poems.'[17]

THE REBELS

The favourite 'modernist' target of the *Mercury*'s editorials and of much of the literary 'Right' was the English would-be-avant-garde coterie publication. Edith Sitwell's *Wheels*, the six issues of which appeared between 1916 and 1922, was under continual assault. The *Mercury*'s review of *Wheels: A Fourth Cycle* (1919) is typical:

> **The end-papers of this volume bear a charming design of athletes throwing darts at targets, and it is to be observed that no one of them as yet has hit the bull's eye. We do not know if the symbolism was deliberate, but it is apt, for the volume is full of pot-shots so wayward that we are usually uncertain as to which target these erratic slingers wish to hit. Music at least is not desired: most of the verses consist of strings of statements – if they are not disconnected the connections between them are not apparent to us – interesting neither severally nor jointly, and entirely without beauty of sound.[18]**

Chaman Lall's quarterly *Coterie*, seven numbers of which appeared between May 1919 and winter 1920/21, and which included Aldous Huxley, T. S. Eliot, A. E. Coppard, Wyndham Lewis, and Edith Sitwell among its contributors, was also savaged by the *Mercury*, which reserved its special bull-like vituperation for work which it regarded – often with justice – as pretentiously modernist. In this instance the red rag was one of Herbert Read's first published poems:

> **In the latest number of *Coterie* (No. 5) the most interesting things are a poem by Conrad Aiken and a story by Aldous Huxley. It also contains a poem by a Mr. Herbert Read ending:**
>
> > **He cannot disentangle**
> > **The genesis of any scope.**
> >
> > **His limbs**
> > **Dangle**
> > **Like marionettes**
> > **Over**
> > ** a**
> > ** mauve**
> > **Sea.**

> Lest it be thought that this loses by being detached from its context, we may say that it does not. It is a pity so much paper should be wasted on such rubbish.[19]

Most popular humourists were rarely quite so crude as the *English Review* or so earnestly worried as the *London Mercury*. As always, at this time *Punch* (in line with sensible but ignorant middlebrow conceptions about modern art) could be relied upon to supply some of the funniest commentary on contemporary poetry. An issue of *Punch* in July 1920 printed a verse which characteristically lumped together neo-Georgians, the Futurists and the Sitwells as devotees of 'free verse':

A Tragedy of Reaction

It was a super-poet of the neo-Georgian kind
Whose fantasies transcended the simple bourgeois mind,
And by their frank transgression of all the ancient rules
Were not exactly suited for use in infant schools.

But holding that no rebel should sink from fratricide,
His gifted brother-Georgians he suddenly defied,
And in a manifesto extremely clear and terse
Announced his firm intention of giving up free verse.

The range of his reaction may readily be guessed
When I mention that for BROWNING his devotion he confessed,
Enthroned above the SITWELLS the artless muse of 'BAB',
And said that MARINETTI was not as good as CRABBE.

At first, the manifesto was treated as a joke,
A boyish ebullition that soon would end in smoke,
But when he took to writing in strict and fluent rhyme
His family decided to extirpate the crime.

Two scientific doctors declared he was insane,
But likely under treatment his reason to regain;
So he's now in an asylum, where he listens at his meals
To a gramophone recital of the choicest bits of *Wheels*.[20]

Though unsigned, this verse has many of the entertaining qualities and some of the misconceptions of E. V. Knox ('Evoe'), who was one of the most talented and deservedly popular writers for *Punch* at this time. Knox's 'parodies' of well-known contemporaries (many of which were collected together under the title *Parodies Regained*) were often wickedly accurate and shrewd. His satire on Edith Sitwell and *Wheels*, yet again, is a more tasteful than usual example of the kind of abuse which *Wheels* and its young contributors, especially Edith Sitwell herself, regularly received:

Spokes: or an Ode on Ebullitions of Eccentricity That Ought to Have Been Overcome in Early Childhood

I have a mind where meadow, grove and stream
And common things like cats and bricks
 To me do seem
 Much as they might to lunatics,
The strange hallucinations of a dream,
 Think whatso'er they may
 I see and say
That *is* a pea-green monkey climbing up the door.[21]

The conclusion of this parody makes it clear that it was Knox's impression that Futurism was to some extent responsible for Miss Sitwell's fairly tame and rather precious periodical, which was, by any standards, far from Futuristic:

And publish me at once, and publish soon.
Thanks to the Vogue of Futuristic things
And constant tumult of a negroid band,
To me a chocolate eclair often brings
Thoughts that not even nurse can understand.[22]

It is not simply by chance that the name of Edith Sitwell comes up so frequently in anti-modernist satire and criticism. Edith and her brothers, Osbert and Sacheverell, carried on unceasing warfare with the literary establishment and the popular middlebrow press.

In his *Meetings with Poets* (1968), Jack Lindsay recalled several of his conversations with Edith Sitwell, with whom he had become acquainted after she had written to thank him for a favourable review of her *Shadow of Cain* (1947) which Lindsay had written for his magazine, *Our Time*, in 1948. In the review Lindsay suggested that Edith Sitwell's position in England after World War I had been very similar to that taken up by Tristan Tzara in continental Europe. Lindsay argued that her unrelenting attacks on Victorianism and the Georgians ('the final stage of Victorianism') represented 'a determination to make faces and throw bricks at the world of the 1914–18 war. In that situation anger was the way to love, and chaos the only clue to a new cosmos'.[23] For Lindsay, Edith Sitwell and her brothers had played a decisive role in changing the climate of English literary life:

The first act of the Sitwells, with Edith at the head, was to start a fronde against these vulgarisers. Often the main point may have seemed obscured in the dust of jeers and the delight of tripping up pontifical reactionaries like Squire; but the good work went on, and after the dust cleared, it became clear what a drastic and necessary work of demolition the Sitwells had done. For a while it may have appeared primarily a destructive process, like Tzara's Dada on the continent; but as one gets it all into something like a clear focus, one sees that the poets who could feel the need to launch these attacks had behind them a deep love of life, of all that bit cleanly into the truth of man.[24]

Some critics have detected signs of the influence of both Dadaism and Surrealism in Edith Sitwell's poetry,[25] but although she was (as

Lindsay pointed out in *Our Time*) 'deeply aware of the French Symbolist tradition, of Rimbaud, of the ferment of experimental methods in Paris', there is no evidence of the Sitwells' having any great awareness of the Dada movement, or much involvement with its participants or its methods.

This is not to say that the Sitwells were totally ignorant of Dadaism or its precursors. Sir Sacheverell Sitwell has informed me in a letter that while at Eton, in 1913, he corresponded with Marinetti, and that he met Tristan Tzara on several occasions after World War I. Nobody so responsive to current artistic fashions as the Sitwells were could have failed to notice Dadaism. Sacheverell Sitwell contributed a 'London Letter' to the Dutch periodical *De Stijl* at a time (June 1921) when its editor, Theo van Doesburg, was showing much interest in Dadaism. In the next issue of *De Stijl* – also in June 1921 – there appeared an editorial which noted the activities of Picabia and 'Paris–New York Dada', and subsequent issues contained contributions from several prominent Dadaists. Sacheverell Sitwell's article, however, consisted of a characteristic list of complaints about the hibernation of the arts in England, including the news that there were few good exhibitions, that the theatre had reached a new 'pitch of inanity', that the only opera house had closed, and that in literature J. C. Squire and his followers controlled what little so-called literature there was:

> **Literature, in the semblance of an old female, drowses in satiate sleep, after her Christmas fare, before the logs of the Squirarchy.**

English critics typically confused Art with Politics:

> **Having just discovered the existence of a Jewish problem, they roll it into a hard ball with Bolshevism, and aim it at the head of any young Artist or Writer, good or bad.**

Consequently, some of the younger artists were driven to panic:

> **This, then, leads the young man to imagine that he must be a Jew or a Bolshevik, spells confusion, and compels poor Mr. Rodker to write of vibro-massage, or to complain of the lack of English 'fauves' (et, tu Brute!) in the cosmopolitan pages of 'L'Esprit Nouveau'.**

Sacheverell Sitwell was referring here to John Rodker's 'La Littérature Anglaise d'aujourd'hui'[26] which had appeared in the French arts monthly *L'Esprit Nouveau*, No. 4, earlier in 1921. Rodker, whose main targets had been J. C. Squire and the Georgians, had failed to acknowledge the Sitwells as the true English 'fauves', which probably accounts for the disparaging tone in Sacheverell's reference to Rodker.

This passing reference to *L'Esprit Nouveau* is interesting, however, because that periodical published occasional contributions by Dadaists such as Paul Dermée, Louis Aragon, and Georges Ribemont-

Dessaignes, or by critics interested in Dadaism (Céline Arnauld, for example). More importantly, relevant to subsequent Sitwellian ventures, is the fact that the issue in which Rodker's article had appeared also contained notes by Albert Jeanneret on the ballets *Parade* and *Le Sacre du Printemps*.

Sacheverell Sitwell concluded his *De Stijl* article with the judgment that the older visitors to even the good exhibitions were Philistines; he commented with typical Sitwellian shrewd fancifulness on the exhibition of French and Flemish tapestries then on show in London;

A horde of old-women tartars, uglier and more ferocious than any led by Attila, armed to the hilt with parasols and pince nez, march into the South Kensington Museum, get in the way, trip up anyone younger than themselves with the end of their ragged umbrellas, and are loud in their praises of works of Art, whose very principle they would deride if they could but understand! They praise the Gothic Tapestries, which show in every stitch a complete disregard of realistic likeness and a sacrifice of everything for expressive form, a contempt for sentimentality, and an almost Cubist insistence on shape. But age has made these qualities respectable, and what the old ladies themselves call 'quaint' — besides 'Think' said one of them, 'of the time it must have taken to make'.[27]

The attitudes shown here – in 1921 – are fully consistent with the Sitwells' normal attitudes to the arts and to the English public. In a letter to me Mr Lindsay has pointed out that although Edith Sitwell knew, for example, the work of Picasso, Diaghilev and the Russian Ballet, Gertrude Stein and Apollinaire, to his knowledge she had not followed up closely the work of poets such as Tzara and Eluard. Mr Lindsay added that her line of revolt, 'from her family and its society, which during the '20s became a full sense of bourgeois society (*Gold Coast Customs* and *Black Sun*) was very much her own, and she had been driven to it on her own momentum.' This view of the nature of Edith Sitwell's contribution to the literary scandals provoked and led by the Sitwells at the end of World War I and through the 1920s is confirmed by a reading of the literary periodicals which were the main vehicle for the Sitwells' deliberately provocative activities. What such reading also confirms is that Sitwellism and Dadaism, for all their apparent similarities, were planes apart.

Reference has already been made to Edith Sitwell's own *Wheels*, and to *Coterie*, both of which journals were considered to be foolishly modern by the more conservative critics of the period. In *Wheels: A Third Cycle* (1918) some extracts from favourable reviews of earlier cycles were reprinted. These testify, by the obvious self-conscious daring of the reviewers, to the general conservatism of the time. The poetry critic of Orage's *New Age*, for example, thought that the verses of *Wheels* were produced by people with 'nerves':

On the whole, modern English poetry, in striking contrast to modern Slavonic poetry, for example, suffers from a lack of nerves, which gives

it what I am inclined to call a 'woolliness' of outline . . . Many of the poems in 'Wheels' are almost Slavonic in this respect.

While the even more enthusiastic critic of the *Morning Post* looked forward to today's recognition of the importance of these volumes for English poetry:

The whole book is the protest of eager and aspiring youth against the exhausted truths which are now no more than living lies . . . Fifty years hence, its appearance will be remembered as a literary event, as an omen of an intellectual awakening.[28]

In fact, neither *Wheels* nor *Coterie* exhibited much awareness of, or response to, contemporary European art. *Coterie* sometimes printed translations of French 'modernist' verse: the issue for September, 1919 (No. 2), for example, printed five poems from Rimbaud's *Les Illuminations* in a translation by Edith Sitwell's friend Helen Rootham. There were occasional drawings by modern artists – one by Henri Gaudier-Brzeska who had been a founder-Vorticist, in the same issue, for example, and another by Modigliani, in the issue of December 1919. But such instances are hard to find, and the magazine remained comparatively inward-looking.

A similar lack of genuine involvement with the European postwar scene is found even in the most self-consciously avant-garde journals. The quarterly *Art and Letters* appeared, somewhat irregularly, between July 1917 and 1920. On the whole, *Art and Letters* – whose editors included at various times Charles Ginner, Harold Gilman, Frank Rutter, and Osbert Sitwell – could fairly claim to be the most important and beautifully produced 'contemporary arts' journal of the postwar period in Britain. Each issue consisted of poetry, short stories and criticism, as well as some excellently reproduced drawings. Its writers included all three Sitwells, Wyndham Lewis, Herbert Read, Ezra Pound, T. S. Eliot, Ronald Firbank and Dorothy Richardson. Some of Wilfred Owen's poetry, and poems and drawings by Isaac Rosenberg were first published in *Art and Letters*.

T. S. Eliot's criticism in its pages was largely concerned with English literature (including studies of 'Marlowe's Blank Verse' and 'The Duchess of Malfi and Poetic Drama'), though his famous essay on Marivaux appeared in Vol. II, No. 2. Herbert Read, whose influence on the journal increased steadily during its fairly short existence, contributed 'An Approach to Jules Romain' (which article was followed in a subsequent issue by some rather feebly archaic translations of poems by Romain). The drawings reproduced in the journal, especially, represented the best of the contemporary English scene, including Walter Sickert, Paul and John Nash, Edward Wadsworth, Wyndham Lewis, Augustus John, and Harold Gilman. Drawings by several distinguished European artists also appeared in its pages; these included Lucien Pissarro, Matisse, Picasso, Modigliani, and the Italian Futurist, Severini.

And yet, despite this array of talent, there is something oddly stifling and narrow about the whole tone of the periodical. This feeling arises partly from the generally outmoded character of the work by foreign artists, but its main cause is undoubtedly the self-conscious and clumsy manner of the periodical's attempts to shock and ridicule the English middle-classes. Osbert Sitwell (who was to become poetry editor of *Art and Letters* with the issue of winter, 1920) was largely to blame for this. His 'Te Deum' of 1919 is a fair example of his schoolboy polemics, the wooden, heavy-handed nature of which becomes obvious when compared with anything produced in Zürich at the same time. The opening of the poem will illustrate my point sufficiently:[29]

Te Deum

We will not buy 'Art and Letters',
 It is affected!
 Our sons
And brothers
Went forth to fight
To kill
Certain things –
'All this poetry and rubbish' –
We said
We will not buy 'Art and Letters'.
We sent them quite willingly
To kill
Certain things –
Cubism, futurism, and so on.
There has been
Enough art
In the past;
If they would only turn
Their attention
To killing and maiming.
If they cannot kill men,
Why can't they
Kill animals?
There is still
Big game in Africa;
Or there might be trouble
Among the natives
We will not buy 'Art and Letters'.[29]

This inept and empty performance (and the poem gets worse as it progresses) directed against the stereotyped – though, as we have seen, not entirely imaginary – foe affects the whole tone of the magazine. The detestation which the Sitwells felt for the English upper middle classes, from which they themselves were struggling so hard to break free, suggests a not altogether groundless mistrust of their newly found cosmopolitanism.

Despite such lack of literary sensitivity as is to be found in Osbert's

satires, what really consitutes a major difference between the English postwar poetry of protest and Dadaist literature is that there is nowhere on the English scene any evidence of a loss of confidence in art itself. A satire by Edith, in the same issue of *Art and Letters*, illustrates this point:

The Lady with the Sewing Machine

Across the fields as green as spinach,
Cropped as close as Time to Greenwich,
Stands a high house: if at all,
Spring comes like a Paisley shawl –
Patternings meticulous
And youthfully ridiculous.
In each room the yellow sun
Shakes like a canary, – run
On run, roulade, and watery trill,
Yellow, meaningless and shrill.
Face as white as any clock's
Cased in parsley-dark curled locks,
All day long you sit and sew,
Stitch life down for fear it grow,
Stitch life down for fear we guess
At the hidden ugliness.
Dusty voice that throbs with heat,
Hoping with its steel-thin beat
To put stitches in my mind,
Make it tidy, make it kind –
You shall not! I'll keep it free
Though you turn earth, sky and sea
To a patchwork quilt, to keep
Your mind snug and warm in sleep.[30]

In comparison with Osbert's poems in *Art and Letters* 'The Lady with the Sewing Machine' has skill and charm, and there are clear indications of Edith Sitwell's genuine lyrical gifts, but at this stage of her career it is skill, charm, and lyricism used in an unconsciously self-revelatory way. The fanciful images woven by Edith Sitwell to suggest the stale ordering of life in the English middle-class household are indistinguishable from the way in which *she* experiences middle-class life. In his *Goodbye to All That* (1929) Robert Graves remembered his postwar friendship with Edith Sitwell: 'It was a surprise, after reading her poems, to find her gentle, domesticated, and even devout. When she came to stay with us she spent her time sitting on the sofa and hemming handkerchiefs.'[31] Graves was obviously thinking of the more exotic and consciously 'modernist' images of the *Façade* poems. In many of her earlier poems, as in this one, Edith Sitwell revealed a certain nostalgia for her origins. Though she was plainly aware of its imprisoning effects, she also enacted the attractions of the life in such poems. The reader feels a strong sense, especially in the resolve of the last four lines, of difficult struggle against the cosy and neat littleness

of the peaceful life-style of the 'high house'. Of course, it is possible that such an effect may have been deliberate. If such is the case, it reinforces the argument that the Sitwells – whether inept or skilful, consciously or unconsciously artistic – believed that they were defending or producing new art. The concept of 'anti-art' is nowhere apparent in anything they did. It is most important to realise that this cannot be simply explained by assuming that the Sitwells were, in reality, a completely provincial would-be-artistic family in an equally provincial postwar London.

FAÇADE AND PARADE

Perhaps the best instance of continuity and growth in the arts common to both Paris and London before and after World War I is to be seen in the ballet, particularly in the Russian Ballet, which, under the direction of Serge Diaghilev, gave many performances in London between 1911 and 1914. The brilliant dancers seen during this period included Vaslav Nijinsky, Thamar Karsavina, and Anna Pavlova. Long seasons at Covent Garden and Drury Lane were made up of magnificent new productions of classical ballet, especially ballet based on the music of nineteenth century Russian composers. But London audiences were also able to hear much new music and see much new stage design.

Stravinsky's *L'Oiseau de Feu* had its English première at Covent Garden on 18 June 1912, and *Le Sacre du Printemps*, which caused infamous near-riots at its first performance at the Théâtre des Champs Elysées on 29 May 1913, was to be seen at Drury Lane only six weeks after the Paris opening. *Petrouchka*, first seen at Covent Garden on 4 February 1913, was subsequently included in all the prewar visits of the Ballets Russes. During the last prewar season of ballet, in summer 1914, the productions included *Petrouchka*, *L'Oiseau de Feu*, and the first English performance of Stravinsky's opera-with-ballet *Le Rossignol*. Among other controversial productions of this time was the 'futuristic' *Jeux* (to music by Debussy) which was seen at Drury Lane on 25 June 1913, again only six weeks after its Paris première (15 May 1913).

The three Sitwells were ardent and vociferous supporters of this revitalised art form, especially, though not only, [32] the newer productions, some of which surprised and shocked English audiences and critics.

After the Armistice, the Russian Ballet returned, for even longer seasons and with some very controversial new productions. The most striking of these was undoubtedly the result of a collaboration between Jean Cocteau, Erik Satie, Léonide Massine, and Pablo Picasso, the ballet *Parade*. According to Cocteau, *Parade* was his successful answer to Diaghilev's directive 'Etonne moi!'. There have been many descriptions of *Parade*,[33] but the success of the work may be judged by the

claims and counter-claims to ownership of its spirit. *Parade* was not, of course, Dadaist (or Surrealist), but in spite of the hatred which many Paris Dadists felt for Jean Cocteau, it appears as a favourite recruit for the Dadaist pedigree, and most historians of Dadaism give it honourable mention.[34] At its first performance in Paris, on 18 May 1917, the combination of Cocteau's scenario, Picasso's costumes and curtain (in a mixture of his harlequin and Cubist styles), Satie's music (with futurist noises included apparently at the suggestion of Diaghilev), and some very strange 'dance', resulted in audience participation on a truly Dadaist scale.

For this first performance, Apollinaire had written a programme note which employed his newly coined word 'surréalisme' to describe the new spirit of the work:

> **a kind of super-realism (sur-réalisme). This I see as the starting-point of a succession of manifestions of the 'esprit nouveau': now that it has had an opportunity to reveal itself, it will not fail to seduce the elite, and it hopes to change arts and manners from top to bottom, to the joy of all.**[35]

The Times for Friday 14 November 1919 announced the first English performance which was to be given that evening, along with *Children's Tales* and *Scheherazade*.[36] The next day's review, by F. S. Flint, in *The Times* is interesting evidence of the tempered excitement of intelligent English critical response which, however, did not see *Parade* as a cultural landmark:

'PARADE' AT THE EMPIRE

What phrase can describe it? Cubo-futurist? Physical *vers-libre*? Plastic jazz? The decorative grotesque? There is no hitting it off.The programme is of very little service. It tells you that the period is eighteenth-century, and the subject the vain efforts of showmen to lure the public inside their booths. But you begin to wonder whether the programme's analysis of the newly presented ballet is not just another bit of M. Massine's fun, when you discover the 'American Manager' disguised as a skyscraper, and 'The Manager' as another architectural joke, and 'The Circus Managers' bumped together into the most comical pantomime horse that ever was seen. M. Massine as the Chinese Conjurer is recognizable: so is Mme Karsavina as a ridiculous American child, not of the eighteenth but of the twentieth century, wearing a sailor coat and a huge white bow in her hair: and there is no mistaking Mlle. Nemtchinova and M. Zverev as the acrobats in their skin-tight blue.

But while they are in view there is no possibility of bothering about what the programme says. The whole things is just a piece of entrancing silliness; the silliness of artists who can play the fool with point because of all their knowledge and their sense of form and their restless imaginations. It is all utterly incomprehensible and deliciously ridiculous with its stampings and scrapings, its passionately absurd postures, its owlishly serious folly. And M. Erik Satie, the composer, plays the fool with as noble an air as M. Jean Cocteau, the author, or M. Massine, the choreographer. He begins with a lovely little flowing

overture, into which he drops queer hints of squeaks and crashes; before the ballet is over he is rioting in rich and suggestive cacaphony. And M. Picasso lends a hand to the elaborate nonsense, not only by designing these 'managers' but by painting a huge drop scene in which Harlequin and Pierrot and lovely ladies and Spaniards, and a mare with wings on her quarters and a winged lady on her back and a foal at heel, are mixed up with a huge Roman ruin and a marble pillar and red velvet curtains with gold fringe. Thankfully one resigns oneself to a world of nonsense, where anything means everything and nothing, yet everything is exciting to the eye and ear and mind.[37]

Cyril Beaumont, who was also present at a performance of *Parade* at this time, gave a rather more critical view:

The production seemed rather obviously planned *pour épater les bourgeois* to which end Picasso had designed cubist costumes for the several managers, which produced a curious effect of false realism, so that the real dancers resembled puppets, while Satie's often interesting music was spoilt by such 'signature noises' as the clicking of typewriters for the American Girl and the humming of an aeroplane engine for the acrobats. The ballet was mildly amusing as a joke, but should never have been put forward as a serious choreographic work. It had a lukewarm reception.[38]

The Sitwells, however, were delighted and deeply moved by *Parade*. In his *Laughter in the Next Room* (1949) Osbert Sitwell recalled that *Parade* was 'in essence the most tragic and the most original of the newer spectacles',[39] while Sacheverell has suggested more recently that 'the Russian ballet *Parade* with music by Satie, and the wonderful fairground curtain by Picasso'[40] was one of the influences on *Façade*, the 'Entertainment', consisting of poems by Edith Sitwell set to music by William Walton, and presented by all three Sitwells.

Edith Sitwell herself was much moved by *Parade*. In her *Children's Tales: From the Russian Ballet* (1920) she wrote an account of its effect on her, which reveals, I believe, a quite profoundly sensitive response to the ballet's scenery, dancing, costume, and music:

In *Parade* again (whose tall lodging-houses with black windows hide from us, perhaps nothingness, perhaps half-human creatures, landladies scuttling like crabs) that white blankness of sea, as seen through the portals of the travelling theatre, that mechanism the showman — (all cubes of bones and no flesh) — and the lonely child-dancer playing upon the sand to the sound of the wheezing wind's harmonium — this gives us the eery loneliness of each identity. The wheezing wind's harmonium oozes out cold memories of ancient ragtime tunes: they are blown hither and thither, whirling quick and light and inhuman, looking for the dancing lovers whom we shall never see . . . but the salt water had got into these ragtimes, till they are dead out of tune, no longer human and warm; and we are tired and not a little frightened by these exteriors — always exteriors.[41]

The titles of the two works may be thought to confirm the influence of *Parade* on the making of *Façade*, though another explanation for the

title of the Walton–Sitwell piece is that a hostile artist (or a charlady) had remarked about Edith's poems (or the Sitwell trio), 'Very clever, no doubt – but what is she [are they] but a façade [façades]?'[42] Whatever the origin of the title, the first private performance of *Façade*, in January 1922, was the beginning of an enterprise which for the Sitwells was always the highlight of their artistic co-operations, and it certainly produced in them a provocative spirit and the kind of publicity and response which led Dr Leavis to make the rather spiteful and unfair judgement that the Sitwells 'belong to the history of publicity rather than of poetry'.[43]

Undoubtedly *Façade* had several of the deliberately provocative characteristics of the Cocteau–Satie–Picasso collaboration, including a striking curtain, designed by Frank Dobson, and the use of popular songs and jazz styles. It may even be claimed that the declamation of the poems through a Sengerphone (a kind of megaphone designed for Wagnerian opera) while the performers remained invisible behind the curtain was inspired by Cocteau's original plans for *Parade*. In his *Le Coq et L'Arlequin* (1918),[44] which appeared in Rollo Myers' translation for the Egoist Press, London, in 1921, Cocteau described his ideas for a never-completed ballet, *David*, in which 'a clown, who would then become a box, the theatrical equivalent of the fair phonograph, the modern version of the ancient mask, would sing through a megaphone of the prowess of David and entreat the public to enter and see the show inside'.

The Sitwells always claimed Parisian-style hullabaloo at the first public performance of *Façade* (12 June 1923), but none of the accounts of the 'riots' is really very convincing.[45] Nevertheless, the early performances of *Façade* were, perhaps, the nearest thing to Dadaist manifestations to appear in London during the early 1920s.[46] What made *Façade* totally unlike any Dada manifestation, however, was the artistic seriousness, or, rather, its refusal to be anti-art. Doubtless it was intended to be provocative and 'modernist' (like *Parade*), but the Sitwells were, as always, attacking with this work what they believed to be a self-satisfied and Philistine middle-class establishment, and they believed that they were helping to create an audience for new art as well as creating new art itself.

Whenever Edith Sitwell wrote of the poems of *Façade* it was in order to defend them or to explain them as serious artistic experiments. Even the use of the Sengerphone – an idea introduced by Sacheverell Sitwell – and the invisibility of the speaker she defended as artistic necessities, the megaphone employed so that the voice could be heard above the musicians and the non-appearance of the speaker producing more 'objectivity'.[47] The poems of *Façade* (several of which predate the London productions of *Parade*) consisted largely of 'enquiries into the effect on rhythm and on speed, of the use of rhymes, assonances and dissonances, placed outwardly and inwardly (at different places in the line) and in most elaborate patterns.'[48]

Some of Edith Sitwell's contemporaries – including Robert Graves, who, after earlier enthusiasm for it, considered that her work represented a concealed nihilism[49] – viewed her methods with great suspicion, but there is no doubt that the poems of *Façade* do not represent anything like the destructive principles which lay behind Dadaism in its first phase. Some of the poems written for *Façade* had appeared in earlier volumes, but poems written in collaboration with William Walton (between November 1921 and January 1922) are not noticeably different from several written up to three years earlier. 'Mariner Man', for example, had appeared in *Clowns' Houses* (1918)[50]:

Mariner Man

'What are you staring at, mariner man,
Wrinkled as sea-sand and old as the sea?'
'Those trains will run over their tails, if they can,
Snorting and sporting like porpoises! Flee
The burly, the whirligig wheels of the train,
As round as the world and as large again,
Running half the way over to Babylon, down
Through fields of clover to gay Troy town –
A-puffing their smoke as grey as the curl
On my forehead as wrinkled as sands of the sea! –
But what can that matter to you, my girl?
(And what can that matter to me?)'

The artistic intent of 'Long Steel Grass' (later renamed 'Trio for Two Cats and a Trombone') is neither more nor less 'radical', yet this was written in 1921:

Trio for Two Cats and a Trombone

Long steel grass –
The white soldiers pass –
The light is braying like an ass,
See
The tall Spanish jade
With hair black as nightshade
Worn as a cockade!
Flee
Her eyes' gasconade
And her gown's parade
(As stiff as a brigade).
Tee-hee!
The hard and braying light
Is zebra'd black and white
It will take away the slight
And free
Tinge of the mouth-organ sound,
(Oyster-stall notes) oozing round
Her flounces as they sweep the ground.
The
Trumpet and the drum

And martial cornet come
To make the people dumb.
But we
Won't wait for sly-foot night
(Moonlight, watered milk-white, bright)
To make clear the declaration
Of our Paphian vocation,
Beside the castanetted sea,
Where stalks Il Capitaneo
Swaggart braggadocio
Sword and moustachio —
He
Is green as a cassada
And his hair is an armada.
To the jade 'Come kiss me harder!
He called across the battlements as she
Heard our voices thin and shrill
As the steely grasses' thrill,
Or the sound of the onycha
When the phoca has the pica
In the palace of the Queen Chinee!

The difference between the two poems include the Spanish imagery of the later poem (one result of the Sitwells' postwar visits to Spain) and an increase in esoteric vocabulary, but these cannot justify Robert Graves's opinion in 1925, that because Edith Sitwell let 'caprice govern her creative intelligence', she was 'not merely artistically but metaphysically irresponsible'.[51] It is clear that Edith Sitwell made use of rhyme in a way which allowed rhymes to govern sense. However, it may be that the musical necessities of *Façade* led to an increase in such apparently arbitrary methods: *Façade* has to be judged as a complete work – like Schoenberg's *Pierrot Lunaire* (1912), a work which was certainly known by William Walton. To suggest that Edith Sitwell was working to any kind of metaphysical scheme is to over-estimate her poetic intelligence, as well as to misunderstand not only the way she worked but also, in my opinion, the basic difference between the work of any artist working within a metaphysical–artistic theory and one working inside the possibilities of an artistic medium. Graves's error is repeated in Paul C. Ray's *The Surrealist Movement in England* (1971) when he claims that Edith Sitwell, in spite of her emphatic denials, was using a 'process akin to that of the surrealists, with results akin to those of surrealist method'.[52] He also argued that some of the explanations which she supplied for images in *Façade* were rationalisations (which may or may not be true), and that conjunctions of images inspired by rhyme are analogous to surrealist attitudes. For example:

'Aubade', another poem from *Façade*, contained the lines,

Flames as staring, red and white,

**As carrots or as turnips, shining
Where the cold dawn light lies whining.**

Miss Sitwell's explanation of the last line is that to her 'the shimmering movement of a certain cold dawn light upon the floor suggests a kind of high animal whining or simpering, a half-frightened or subservient urge to something outside our consciousness'. One suspects, however, that the rationale is a result of the line and that 'whining' suggested itself, perhaps automatically, as a rhyme for 'shining'.[53]

What is most puzzling here is that Paul Ray seems to have assumed that 'automatic' rhyming precludes the possibility of other, additional and different reasons for a poet's choice of words; the suggestion throughout his discussion of Edith Sitwell that she was unthinkingly working according to the principles of a 'real' surrealist philosophy is as strange as Robert Graves's contemporary assumptions about the ways in which poets may work.

Despite her pleasure at the thought of having caused Dadaist-style uproar in the postwar years, Edith Sitwell (and her brothers) had little else in common with either Dadaists or Surrealists. She settled the point firmly and, I believe, rightly, in her 1937 Northcliffe Lecture:

It was about this time that my brothers and I began to write, and the Dadaist nonsense ... was seized upon, immediately, as a rod with which to belabour us. It was decided that we were doing the same thing as the Dadaists, and the fact that we were doing nothing of the kind makes no difference to the attackers. My poems especially, were singled out as Dadaist, and this was, I imagine, because I was writing exceedingly difficult technical exercises ... The fact that the surrealists for the most part have not even a rudimentary technique, ... indeed boast that they have no technique, made no difference to these critics.[54]

The talent for scandalising tactics which placed the Sitwells at the head of the younger generation for a time – and also kept their names almost permanently in the correspondence and gossip columns of the press – was not without a fair amount of shrewd, sensitive, and intelligent literary judgement. Their support of some of the best poets of their time (particularly Edith's energetic championing of Wilfred Owen) and their biting and often amusing attacks on the Georgians, go some way to support the view that the 1920s would not have been prepared even as inadequately as that decade was for the achievements of its best poets without the groundwork carried out by the Sitwells. In Edith Sitwell's single-minded determination never to see any merit whatsoever in the poetry of the Georgians, perhaps she came nearest to a Dadaist refusal to compromise with what might be regarded as the more attractive side of 'bourgeois' culture. In her review, 'Georgian Poetry, 1918–1919' for *Art and Letters*, for example, there was all the characteristic acidity of her dismissive manner:

Generally the veritable heavy dragoon from (I think) 'Patience' has to rattle out the highways and by-ways. Such morbid dwelling on a hopelessly inadequate tract of dull country would have bored the winter evenings of even tenth-century life. The inability of wire bunches, the medley from which unattached similes and forlorn facts fall on us, show the usual cornflowers, meadow hazel, lavender, and the uniform yaffle is almost a gold-frogged coat by now.[55]

Even here, however, it was an attack on dullness and lack of craftsmanship which Edith Sitwell led, not an attack on the foundations of art itself. The liveliest backbenchers of the literary Left were apparently almost as uninterested in and quite unmoved by the distant clamours of Dadaism as were the staidest frontbenchers of the literary establishment. There was, however, one notable exception to this general truth.

ALDOUS HUXLEY

Aldous Huxley was just twenty years old when World War I began, but seriously defective eyesight had prevented his being called up for military service. By the end of the war he had made a reputation as a brilliant young poet and essayist.[56] In 1917 he was literary reviewer for the *New Statesman*, and during that year several of his poems had appeared in *Wheels*. After the war he was a regular contributor to *Wheels* and also to *Coterie*. *Coterie* No. 1 had reprinted his poem 'Beauty' which first appeared in *Wheels: A Third Cycle* (1918), and *Coterie* No. 2 contained the whole of his long poem 'Leda'.[57] With the third issue of *Coterie* he appeared as a member of the Editorial Committee, alongside T. S. Eliot, Richard Aldington, Wyndham Lewis, and others, and he remained a member of that rapidly dwindling committee up to and including the sixth and final issue (winter, 1920–1921).

Huxley resisted most of the attractions of the literary scandals. He knew all the Sitwells, but he had few illusions about them. In a letter to his brother, Julian, dated 3 August 1917 (just about the time he began to contribute to *Wheels*) he described them thus:

The folk who run (*Wheels*) are a family called Sitwell, alias Shufflebottom, one sister and two brothers, Edith, Osbert and Sacheverell – isn't that superb – each of them larger and whiter than the other. I like Edith, but Ozzy and Sachy are rather too large to swallow. Their great object is to REBEL, which sounds quite charming, only one finds that the steps they are prepared to take, the lengths they will go are so small as to be hardly perceptible to the naked eye.[58]

With such a low opinion of the Sitwell's radicalism, it is not surprising that Huxley joined in their publicity stunts only half-heartedly. In July 1920, for example, Huxley wrote to his father, Leonard Huxley, about an article in the *Daily Express* which had attacked the poetry of

the *Wheels* contributors, especially that of the Sitwells, Iris Tree, and Huxley himself. The article, by Louis J. McQuilland, led to three weeks of spirited 'bourgeois-baiting' in the correspondence columns of the *Daily Express*. In his letter to Leonard Huxley, dated 23 July 1920, Aldous threatened retribution:

> **I am slightly irritated at the attentions of the *Daily Express* which has elected to make of me and several other youthful poets its Giant Gooseberry for this year's Silly Season. A most impertinent article about us all, headed 'The Asylum School', appeared 2 or 3 days ago and they are following it up. So I suppose we shall be in for a merry August. I am preparing counterblasts; the man who signs the article has written verse himself – and what verse! It is here that he gives himself into an enemy's hand. I hope to make him sit up before he has done.**[59]

Despite the apparent firm intent expressed here Huxley failed to produce any of the promised 'counterblasts'. Probably, as Grover-Smith suggested, Huxley was aware that the whole affair was an 'arranged demonstration', but, in any case, Huxley was becoming tired of the triviality and ineffectiveness of such methods, especially, perhaps, since he had been following with growing interest (and had even witnessed) some of the Dadaist activities in Paris. Indeed, at the very time of the *Daily Express* 'news-stunt' he was reflecting and speculating upon the significance of Dadaism.

For a short period at the end of 1919 Huxley had been a contributor to Squire's *London Mercury*, but his main loyalty was to the newly restored *Athenaeum*. *The Athenaeum* had suffered during the war from a shortage of both paper and good literary editorship. In April 1919 Arthur Rowntree purchased the journal which, under the editorship of John Middleton Murry, became once more a literary weekly. Under Murry *The Athenaeum* was never ultra-Modernist, but it did set about the Georgians with almost the same intensity of energetic antipathy as the Sitwells had shown, with the result that during the first year of Murry's editorship it had acquired the permanent displeasure and literary rivalry of the *London Mercury*. It would seem that even the tolerant and sympathetic Huxley was unable to keep one foot in both these camps, and so by the end of 1919 he had become *The Athenaeum*'s most frequent reviewer and columnist, and had severed all connections with the *Mercury*. Most of the 'Notes and Essays' which make up his collection *On the Margin*[60] first appeared in *The Athenaeum*, where Huxley, using the pseudonym Autolycus, wrote a weekly full-page of 'Marginalia', or reflections on any topic which took his interest. Those qualities which sometimes led Huxley in his novels, short stories, and essays into a maddenly dilettanteish stance – his wide-ranging curiosity, encyclopaedic knowledge, objectivity, and sensitive intelligence – were always evident in the short *belle-lettrist* pieces which were such a prominent and regular feature of *The Athenaeum* after the war.

Huxley was no stranger to continental Europe, which he had visited frequently before the war. In 1912 he had studied German and music at Marburg, and he visited France several times after the Armistice. During a visit to Paris in January 1920 he stayed with the young French poet, Pierre Drieu la Rochelle, who, though not a Dadaist, had written for *Littérature*. Huxley wrote to his father on 21 January that he had been seeing 'a certain number of amusing people'.[61] Six weeks later, in a letter to Edward Sackville-West, Huxley referred again to his visit to Paris:

Paris shd be amusing: I was there in January and had an entertaining time among the cubists of literature. But it's all very like London, with quite as little real work of real importance being done — except, of course, in painting.[62]

Huxley's only recommendation to Sackville-West was that he should visit the 'Cirque Médrano' ('the finest circus in the world') during his forthcoming trip to Paris, so it is not possible from these letters to say what Huxley saw in Paris or even which people he met. The designation 'cubist of literature' would generally be reserved[63] for the group of poets and painter-poets who formed 'la bande à Picasso' or 'l'Ecole de la rue Ravignan' during the years 1903–1912, when Picasso had had his studio in the Rue Ravignan. There he attracted a number of talented young artists who were to theorise about the principles of modern art, Cubism in particular, and who were to attempt to write in ways which they regarded as parallel to the methods of Cubist painting. The most famous of the group were Apollinaire, who had died in 1918, André Salmon, and Max Jacob (whose prose poems, *Le Cornet à dés*, had appeared as recently as 1917). It is possible that Huxley met some of the survivors of this group and their younger disciples. What is certain, however, is that he had come into contact with some of the activities of Paris Dadaism.

The clowns of the Cirque Médrano and the Dadaists were yoked together interestingly in an article which Huxley wrote for Harold Monro's *Chapbook* soon after his return from Paris. 'Three Critical Essays on Modern English Poetry' were the principal contents of the *Chapbook* for March 1920.[64] Huxley's essay (the others were by T. S. Eliot and F. S. Flint) was called 'The Subject-Matter of Poetry'.[65] In this short piece Huxley belaboured both the 'traditionalists' for their employment of conventionally false subject-matter in their poems, and also the sensationalism of Edith Sitwell's verse which, Huxley argued, made use of an equally false technique of 'dissociation' to make quite unimportant material seem 'somehow horribly significant'.

Huxley argued that the traditionalism of subject-matter in much contemporary verse was particularly deplorable in the treatment of 'two of the most pregnant of all poetical subjects, nature and love'. This is because of our self-deception about nature:

> Only in poetry do we pretend seriously to believe that nature is a person of like passions with ourselves. In our sober senses we know that nature is a machine and that our fate is wholly indifferent to it.

and about love:

> ... while in private life we are convinced disciples of Freud, we go on assuring ourselves in verse that sexual love partakes, somehow, of the divine.[66]

Huxley traced the existence of both Futurism and Dadaism to this prevalent poetic self-deception: 'And then we are astonished at the appearance of Marinetti and "Dada". We have brought them on ourselves.'[67] Dadaism, in its extreme manifestations, was, Huxley believed, thoroughly undesirable, but not much less desirable than the condition of poetry in contemporary London:

> And so everything goes, till there is nothing left but a few little jokes and a few sensations. This is surely a deplorable conclusion to what is in its beginnings a very healthful tendency; deplorable unless you desire, as some of the most implacably youthful Frenchmen avowedly do, to destroy literature completely.[68]

The staleness and unreality of much traditionally minded contemporary poetry had led to identifiable extreme reactions both in Britain and France, where the 'counter culture' had gone much further; from the following passage we learn that Huxley had been present at the famous 'Première Vendredi de Littérature', on 23 January 1920:

> Too clever and too sensitive, we are perpetually haunted by the fear of having our work called sentimental or chocolate-boxy. And so we are reduced to our clowns and our bright prismatic sensations. The process has not gone so far in England as it has in France, where M. Cocteau rewrites Shakespeare for performances by clowns from the Cirque Médrano[69] and M. Tristan Tzara recites his onomatepoeic poems to the accompaniment of an electric bell of eight-inch calibre (a performance which it was recently my pleasure and privilege to attend). But the same tendency, advanced to a less extreme stage, is also discernible here.[70]

For Aldous Huxley, as for Robert Graves, the nihilistic tendencies of Dadaism was to be found in the poetry of Edith Sitwell who employed a method of false dissociation of objects, that is by contemplating such objects out of their natural contexts:

> By thinking about it hard enough you can make the sunshine dance and sing, you can cause the whole landscape to crepitate and twitch galvanically as it does in the poetry of Edith Sitwell. Brilliantly accomplished and exquisite as the poetry of this talented writer often is, one is always painfully conscious of its limitations. It is difficult to see how it can advance.

Huxley proposed a reduction in the output of poetry. In view of the amount of poor verse still being produced after the war by 'moderns' and 'traditionalists' alike, Huxley could even see one virtue in Dadaism: 'Anyone who, labouring at the sweated trade of reviewing, has had to battle with the turgid inrush of contemporary verse will have agreed, in months of desperation, with M. Tzara, that literature ought to be destroyed.'[71]

There is evidence of wider reading and deeper thinking about the implications of Dadaist literature by Huxley. In a letter to Dr B. G. Brooks, written at the beginning of May 1920 (probably occasioned by Brooks's response to the *Chapbook* article of March) Huxley recommended several Dadaist publications and also gave brief comments on the contributors to these. He recommended *Littérature* as the most respectable of the periodicals, adding his choice of Aragon as the ablest of its editors. Huxley had read *Proverbe*[72], and even enclosed a copy of this for Brooks, and he had seen several publications of the Au Sans Pareil press which printed most of the early Dadaist and Surrealist works in Paris. Of these Huxley specifically mentioned Soupault's *Rose des Vents* (1920) and Picabia's *Unique Eunuque* (1920), with its preface by Tzara. Huxley also pointed out the main similarities of, and differences between, Futurism and Dadaism, and showed that he had some appreciation of the theory of 'automatism'. He ended his letter with some acknowledgement of Tzara's 'curious' talent and a greater respect for Aragon's, but apart from these specific exceptions, Huxley had no sympathy whatsoever for the Dadaists: 'Personally I don't much like their theories or their practice. Their satire is healthy, but I see no point in destroying literature; and for the most part I find their utterances rather boring.'[73]

There were several other references to Dadaism in *The Athenaeum* during this time. In July 1920 Edward J. Dent had written a quirky little piece on the music of Stravinsky (whose music was, in fact, played at some Dada manifestations, and who was one of the official Dada 'Présidents'). Dent had referred to Stravinsky's music as 'dadaist', apparently thinking that the term referred to a 'wholeheartedly aesthetic movement' devoted to childishness in art: 'It concerns itself simply with what the child considers to be beautiful, or rather, what the grown-up composer imagines that the child considers to be beautiful.'[74] A fortnight later (*The Athenaeum* No. 4711) a letter appeared from the music critic Rollo H. Myers (who was later to translate into English several of Jean Cocteau's pre-Dadaist and anti-Dadaist works, and who also made a study of Satie). Myers, who had also 'assisted' at Dadaist manifestations in Paris, pointed out that Dadaism was far from being any kind of aesthetic movement; on the contrary, it stood for 'all-round Negation'. Myers, whose letter was not at all sympathetic to Dadaism, gave two examples of Dadaist literature from an issue of *Cannibale*.[75]

Dada est un chien un compas l'argile abdominale ni nouveau ni

japonaise nue gazomètre des sentiments en boules Dada est brutal et ne fait pas de propagande Dada est une quantité de vie en transformation transparente orange et giratoire.

The second, a poem:[76]

SUICIDE

A b c d e f

g h i j k l

m n o p q r

s t u v w

x y z

The next issue of *The Athenaeum* carried a typical piece of 'Marginalia' by Huxley which, deliberately or otherwise, was able to benefit from Myers' clarificatory letter about Dadaism. This piece, called 'Water Music', is probably one of the earliest theoretical considerations of aleatory principles in art by an English critic, and Huxley had the Dadaists very much in mind. He started from the common experience that the sounds made by a dripping tap make a kind of 'music'. This music (Huxley's house was troubled by a tap which produced it) disturbed him with its disconcerting challenges:

Drip drop, drip drap drep drop. So it goes on, this water melody for ever without an end. Inconclusive, inconsequent, formless, it is always on the point of deviating into sense and form. Every now and again you will hear a complete phrase of rounded melody. And then – drip drop, di-drep, di-drap - the old inconsequence sets in once more. But suppose there were some significance in it! It is that which troubles my drowsy mind as I listen at night. Perhaps for those who have ears to hear, this endless dribbling is as pregnant with thought and emotion, as significant as a piece of Bach. Drip-drop, di-drap, di-drep. So little would suffice to turn the incoherence into meaning. The music of the drops is a symbol and type of the whole universe; it is for ever, as it were, asymptotic to sense, infinitely close to significance but never touching it. Never, unless the human mind comes and pulls it forcibly over the dividing space. If I could understand this wandering music, if I could detect iin it a sequence, if I could force it to some conclusion – the diapason closing full in God, in mind, I hardly care what, so long as it closes in something definite – then, I feel, I should understand the whole incomprehensible machine . . .

Dadaist literature puzzled Huxley in much the same way:

Suppose, after all, that this apparently accidental sequence of words should contain the secret of art and life and the universe. It may be, who knows? And here I am, left out in the cold of total uncomprehension.

He concluded with the interesting confession that he had once written an entirely 'automatic' poem which he had found disturbing at the time, but also, finally, disappointing:

> **This sounding of the underconsciousness revealed nothing of any particular interest. A number of drowned poetical memories floated to the surface, words and phrases from forgotten reading. One remarked, too, a few curious associations of ideas, and that was all. But the poem was odd, and, as I have said, rather disquieting. It was certainly the finest example of the leaky-tap school of literature I have ever seen. I begin to think that I ought to publish it.**[77]

Huxley's view of the products of the Dadaists was not very much more sympathetic, in the final analysis, than that of any of the more conservative and more radical writers and critics so far considered. Certainly he shared the usual 'moral' objection to aleatory art – that it is too easy, at least for the artist. But, as we have seen, Huxley was more understanding about the destructive elements in Dadaism, seeing them as caused by extreme disgust for an utterly moribund postwar literature. His critical analysis of the brilliant but comparatively superficial and 'sensationalist' modernism of Edith Sitwell shows distinctive astuteness on Huxley's part – and integrity too, when one thinks of the pressures towards uncritical loyalty created by the narrow 'coterie' groupings of literary London. Such dissatisfaction with the verse being produced by all the coteries was felt by other discriminating critics.

It must be conceded that Aldous Huxley's early interest in Dadaism, particularly in its *Athenaeum* context, was something of a literary curiosity. Unlike the Sitwells, for example, Huxley never professed much interest in, or sympathy for, the experimental techniques of literary modernism; nor would the readers of *The Athenaeum* have welcomed it had he done so in 1920. On the other hand, it may be argued that Huxley's involvement with Dadaism was not entirely accidental. He was essentially a writer who kept his mind open to possibilities in the metaphysics of literature. Nihilism was one such possibility, and Huxley's novel *Point Counter Point* (1928), beneath the surface brilliance and chatter, is as tragic and impassioned a journey through all the depths of nihilism as any other twentieth-century writer has made. The suicide of Spandrell after his failure to gain the confirmation that he needs of the existence of a Godhead has many autobiographical echoes.

But Huxley himself, for all the fashionable cynicism of his early novels, rejected a completely nihilistic world-view. After Huxley's death in 1963 André Maurois, who wrote the preface to the first French edition of *Point Counter Point*, said of him:

> **What was Huxley's philosophy of life? It is expressed by a character in *Point Counter Point*, whose ideal was that of a man who was complete and balanced, believing that though this was an ideal difficult to attain**

it was the only thing worth pursuing. 'A man, mind you. Not an angel or a devil. A man's a creature on a tight-rope, walking delicately, equilibrated, with mind and consciousness and spirit at one end of his balancing pole and body and instinct and all that's unconscious and earthy and mysterious at the other. Balanced. Which is damnedly difficult. And the only absolute he can ever really know is the absolute of perfect balance. The absolute of perfect relativity.' This philosophy of life delighted me because it was also mine.[78]

Such a philosophy could never countenance a claim of 'centrality' made on behalf of any kind of extremism, artistic or otherwise.

NOTES

1 C. K. Stead, *The New Poetic: Yeats to Eliot* (Hutchinson, London, 1964), p.53.

2 *Ibid.*, p. 84.

3 *Ibid.*, p. 49.

4 Robert H. Ross, *The Georgian Revolt: Rise and Fall of a Poetic Ideal, 1910–1922* (Faber, London, 1967), p. 202.

5 Edward Lucie-Smith, 'The Other Poets of the First World War', *Critical Survey* IV, 2 (summer 1969), pp. 101–6.

6 *Ibid.*, p. 105.

7 *Ibid.*, p. 106.

8 *Ibid.*, p. 104.

9 Robert H. Ross, *op. cit.*, p. 188.

10 See Letter from Rupert Brooke to Jacques Raverat from Berlin, April–May 1912: 'Berlin, you know, is *frightfully* out of date. What do you think is the thrillingly latest sensation here? A picture-exhibition just opened. By some young Italians. Who call themselves Futurists. Wirklich! Fancy being pursued by those old phantoms! And Signior Marinetti delivered his famous lecture on Monday' *The Letters of Rupert Brooke*, ed. Sir Geoffrey Keynes (Faber and Faber, London, 1968), p. 377.

11 cf. Ford Madox Ford, writing about the original intentions for the review, in 1908: 'I had announced the name of the periodical, *The English Review*, in the press. It was Conrad who chose the title. He felt a certain sardonic pleasure in the choosing so national a name for a periodical that promised to be singularly international in tone, that was started mainly in his not very English interest and conducted by myself who was growing every day more and more alien to the normal English trend of thought, at any rate in matters of literary technique' (Ford Madox Ford, 'Starting a Review' in 'Selected Memories', *The Bodley Head Ford Madox Ford*, Vol. I (Bodley Head, London, 1962), pp. 311–12).

12 'The Madness of the Arts' appeared in *The English Review* as follows: Part I in the issue for December 1920, pp. 481–6; part II in the issue for January 1921, pp. 1–5.

13 W. R. Titterton, 'The Madness of the Arts', *The English Review* (January 1921), p. 5.

14 W. R. Titterton, *The Madness of the Arts* (Erskine, Macdonald, London, 1921), p. 9.

15 Albert Thibaudet, 'A Letter from France: The Young Reviews', *London Mercury*, I, 5 (March 1920), pp. 622–4.

16 J. C. Squire, 'Editorial Notes', *London Mercury*, I, 4 (February 1920), p. 386.

17 *London Mercury*, III, 16 (February 1921), p. 359.

18 *London Mercury*, I, 3 (January 1920), p. 334.

19 J. C. Squire, *London Mercury*, III, 13 (November 1920), p. 7.
20 *Punch* (7 July 1920), p. 19.
21 E. V. Knox (of *Punch*), *Parodies Regained* (Methuen, London, 1921), p. 31.
22 *Ibid.*, p. 34.
23 Jack Lindsay, *Meetings with Poets* (Muller, London, 1968), p. 57.
24 *Ibid.*, pp. 57–8.
25 Martin Seymour-Smith, in his very funny and usually accurate *Bluff your way in Literature* (Wolfe, London, 1966), says that 'In England, the Sitwells, in their dilletante and unserious way, were slightly influenced by [Dadaism]' (p. 18). Paul C. Ray, in his *The Surrealist Movement in England*, claimed that Edith Sitwell produced her most striking images in *Façade* by a process which is 'akin to that of the surrealists, with results akin to those of surrealist method' (p. 271).
26 Rodker's only praise was for the prewar achievements of Ezra Pound who had recognised the talents of Joyce, Wyndham Lewis and Eliot, and was a poet of considerable stature. On the English scene only some of the contributors to the *Athenaeum* (Katherine Mansfield, Middleton Murry, Aldous Huxley, E.. M. Forster, and James and Lytton Strachey) together with D. H. Lawrence, W. B. Yeats, and F. M. Hueffer were treated with any respect. The young imitators of Pound and Eliot – including the Sitwells – were of no account: 'La plupart des jeunes poètes (et tous sont de la plus extrème respectabilité) s'efforcent de l'imiter, mais avec peu de succès. 'Art and Letters' et 'Coterie' qui sont leurs organes, ne seraient que des productions médiocres s'il n'y paraissait de temps à autre un dessin ou une nouvelle de Wyndham Lewis, une poème de T. S. Eliot' (p. 477).
27 Sacheverell Sitwell, 'Engeland – Our London Letter Door' (sic), in *De Stijl* (June 1921), pp. 76–9.
28 Quoted in *Wheels: A Third Cycle* (1918), pp. 99–100.
29 *Art and Letters*, II, 1 (1918–1919), pp. 1–2.
30 *Ibid.*, p. 8 (also in *The Wooden Pegasus* (Blackwell, Oxford, 1920).
31 Robert Graves, *Good-bye to All That* (Cape, London, 1929), P. 404.
32 The Sitwells' enthusiastic interest in the Ballet Russes prior to World War I is recorded in Osbert Sitwell's *Great Morning* (Macmillan, London, 1948), especially Book VI, ch. 3, 'Before the War'. See also, Edith Sitwell's *Children's Tales from the 1920 Russian Ballet* (Parsons, London, 1920).
33 Interesting and full accounts of *Parade* may be found in Roger Shattuck, *The Banquet Years* (Cape, London, revised edition, 1969), pp. 151–8; Douglas Cooper, *Picasso Theatre* (Wiedenfeld & Nicolson, London, 1968), pp. 16–28; Francis Steegmuller, *Cocteau* (Macmillan, London, 1970), pp. 160–97; Boris Kochno, *Diaghilev and the Ballets Russes* (Allen Lane, The Penguin Press, 1970), pp. 116–23. These accounts differ in focus, in that they concentrate upon the music, the costumes and sets, the scenario, or the dance.
34 E.g. *Parade* appears in Hans Bolliger and Willy Verkauf's 'DADA Chronology', in *Dada, Monograph of a Movement*, p. 100, and in several essays in the same book.
35 G. A. Apollinaire, 'Parade', in F. Steegmuller, *Cocteau* (Macmillan, London, 1970), Appendix VII, p. 513.
36 The ballet was also given at the Saturday matinee performances, sandwiched between *Les Sylphides* and *Cleopatra*.
37 *The Times* (London, 15 November 1919), p. 10.
38 Cyril W. Beaumont, *The Diaghilev Ballet in London* (Black, London, 3rd edition, 1951), p. 150.
39 Osbert Sitwell, *Laughter in the Next Room* (Macmillan, London, 1949), p. 14.
40 Sacheverell Sitwell, 'Façade', in *Façade, An Entertainment: The Poems by Edith Sitwell; The Music by William Walton* Oxford University Press,

London, 1972), pp. xiii–xiv.

41 Edith Sitwell, 'Introduction', *Children's Tales (from the Russian Ballet)* (Parsons, London, 1920; reissued by Duckworth, London, 1928), pp. 14–15.

42 See John Lehmann, *A Nest of Tigers* (Macmillan, London, 1968), p. 6.

43 F. R. Leavis, *New Bearings in English Poetry* (Chatto & Windus, 1932; Penguin Books, 1963), p. 64.

44 *Cock and Harlequin: Notes Concerning Music* by Jean Cocteau, translated by Rollo H. Myers. With a portrait by the author and two monograms by Pablo Picasso (The Egoist Press, London, winter 1920–1921).

45 See 'Façade' in Osbert Sitwell, *Laughter in the Next Room*, pp. 168–98, and 'The Audience is meant to Laugh' in Edith Sitwell, *Taken Care Of: An Autobiography* Hutchinson, London, 1965), pp. 122–5 ('Never, I should think, was a larger and more imposing shower of brickbats hurled at any new work' p. 122). A good account of the critical reception to *Façade* is given in John Lehmann's *A Nest of Tigers*, pp. 1–9.

46 Other productions in London at this time included, for example, Cocteau's *The Nothing-Doing Bar (Le Boeuf sur le Toit)* at the Coliseum in July, 1920, although according to *The Times* (Tuesday 13 July 1920, p. 10) 'a Coliseum audience could make nothing of it'. In his *Ox on the Roof* (Macdonald, London, 1972), p. 80, James Harding claimed a warm reception for this production – and certainly it ran for two weeks at the Coliseum and later went on tour – but it caused no reported significant disturbances.

47 See 'The Audience is meant to Laugh', in *Taken Care Of*, p. 123.

48 'A Note by Edith Sitwell', *Façade* (Oxford University Press, 1972), pp. xi–xii (from a Note written originally to accompany the record of *Façade* issued by Decca in 1954).

49 '... writers like Miss Sitwell who reject the orthodox opinions of philosophers and religious writers, express their dissatisfaction with all the means at their disposal in metre, texture, diction, and as for rhyme, not only employ false rhymes, French rhymes, Cockney rhymes, assonances, stressed with unstressed, and similar violences, but let the rhymes seem to guide the sense, thus definitely challenging the ethical system with which the orderly use of rhyme is associated, putting forward a view of life as being wedded in error and ugliness and ruled by caprice. As a matter of fact Miss Sitwell seldom comes out with as direct an arraignment of the philosophical and ethical structure as I have credited her with, but it is implied in all her work. She will even quite sincerely avow herself a traditionalist, but that is not more than bearing lightly home the handle of the family pitcher after it has gone to the well once too often' Robert Graves, *Contemporary Techniques of Poetry: A Political Analogy*, (Hogarth Press, London, 1925), p. 35 (The Hogarth Essays, No. VIII). The volume is dedicated, nevertheless, 'To Edith Sitwell, in all friendship' (p. 4). In his *Poetic Unreason* (1922) Graves had demonstrated the meaningfulness of two of the *Façade* poems, 'Jumbo's Lullaby' and 'When Sir Beelzebub' (*Poetic Unreason*, pp. 133–8).

50 The poems went through several mutations in various editions. See Richard Fifoot, *A Bibiliography of Edith, Osbert and Sacheverell Sitwell* (Hart-Davis, London, 1963), (The Soho Bibliographies). I have quoted the versions of the poems as they appear in Edith Sitwell, *Collected Poems* (Macmillan, London, 1957).

51 Robert Graves, *Contemporary Techniques of Poetry*, p. 37.

52 Paul C. Ray, *The Surrealist Movement in England* (Cornell University Press, Ithica, N.Y., 1971), p. 271.

53 *Ibid.*, p. 270.

54 'Three Eras of Modern Poetry', in *Trio: Disserations on Some Aspects of National Genius* (Macmillan, London, 1938), pp. 162–163.

55 Edith Sitwell, *Art and Letters*, III, 1 (winter 1920), p. 49.
56 Huxley's first novel, *Crome Yellow*, was written in Italy during Summer 1921, and published in November that year.
57 *Coterie* No. 2 (September 1919) pp. 46–62.
58 *Letters of Aldous Huxley* ed. Grover Smith (Chatto & Windus, London, 1969), p. 132.
59 *Ibid.*, p.. 188.
60 Aldous Huxley, *On the Margin* (Chatto & Windus, London, 1923).
61 *Letters of Aldous Huxley* p. 182
62 *Ibid.*.
63 See Glenn Hughes, *Imagism and the Imagists* (Stanford University Press, Stanford, Cal., 1931), p. 7, and Wallace Fowlie, *Climate of Violence: The French Literary Tradition from Baudelaire to the Present*, (Secker & Warburg, London, 1969), Part IV, pp. 155–202 for a fuller discussion of this term.
64 *The Chapbook*, III, 9 (March 1920).
65 *Ibid.*, pp. 11–16.
66 *Ibid.*, p. 13.
67 *Ibid.*, p. 13.
68 *Ibid.*, p. 14.
69 In his study of Cocteau, Francis Steegmuller described the proposed production of *A Midsummer Night's Dream* which Cocteau and Albert Gleizes 'hoped might be given in the famous Paris circus, the Cirque Médrano'. Cocteau wrote a version of the play suitable for performance in the circus, while Gleizes made designs for the costumes and sets. Originally planned just before the outbreak of war, this project almost took place in 1915: 'About the middle of 1915, Jean Cocteau, Gémier and I met at the Cirque Médrano to put on a production of *A Midsummer Night's Dream* for the benefit of the Theatre Manager's Fund for the Wounded . . . The music was taken from Erik Satie's *Gymnopédies*. It was Cocteau's brilliant idea to have the parts of Bottom, Flute and Starvling played by Paul, François and Albert Fratellini (the well-known circus clowns)' Gabriel Astruc, *Le Pavillon des Fantômes* (1929), quoted in *Cocteau*, p. 132. In fact, the work was never produced in full, though it is probable that excerpts were produced during the immediate postwar years, and that Huxley saw one of these performances.
70 *The Chapbook*, III, 9, p. 14.
71 *Ibid.*, p. 15.
72 Huxley also mentioned the second issue of *Proverbe* in his essay 'Great Thoughts', *On the Margin*, pp. 125–6.
73 *Letters of Aldous Huxley*, p. 185.
74 Edward J. Dent, 'The Cat and the Kettle', *The Athenaeum*, 4709, 30 July 1920, p. 153.
75 *Cannibale*, No. 1, 25 April 1920. The poem is by Louis Aragon.
76 In *The Athenaeum*, 4711 (13 August 1920), p. 221. There are interesting discussions about Dadaism in relation to music in Rollo Myers' *Modern Music: its Aims and Tendencies* (Kegan Paul, London, 1923) and, more recently, in his *Modern French Music* (Blackwell, London, 1971).
77 Aldous Huxley ('Autolycus'), 'Water Music', *The Athenaeum*, 4712, 20 August 1920, p. 243. Reprinted in *On the Margin*, pp. 39–44.
78 André Maurois, in *Aldous Huxley: A Memorial Volume*, ed. Julian Huxley ((Chatto & Windus, London, 1965), p. 63.

moderates and moderns

F. S. FLINT AND MODERN EUROPEAN LITERATURE

A short review which appeared in *The Athenaeum* towards the end of 1919 was the occasion for a relatively polite and mild exchange of opinions which, nevertheless, provides some indication of the comparative conservatism of the journal in the spectrum of English literary opinion. The review was of F. S. Flint's 'Some French Poets of Today' which had appeared in the *Monthly Chapbook* (Vol. I No. 4) in October:

> A useful but decidedly uncritical survey of modern French poetry since 1914. The title should have indicated that Mr. Flint is dealing only with the poetry of the war, and it would have been better if he had more clearly shown what he himself thinks of the poets whom he discusses. There is in England far too much puerile acceptance of inferior French work at its own estimations, and we conceive it to be the duty of the knowledgeable critic to take every opportunity of restoring the sense of proportion. Here Mr. Flint fails.[1]

This produced an immediate reply from Richard Aldington who wrote that the charges were 'unjust to a man who had done more pioneer work in the criticism of contemporary French poetry than anyone else in this country, and who, by the way, has received little credit for it'.[2] A letter from Flint himself appeared in the following issue:

> I am afraid that your reviewer and Mr. Aldington are using the word 'critical' in two different senses. My essay is critical in the sense Mr.

Aldington seems to have in mind. It does not pretend to be critical in your reviewer's sense.[3]

Flint developed this argument slightly the following week in what were to be the last words of this particular exchange. His object, he said, had been 'not so much to be critical as to present a few specimens of the kind of poetry produced by French writers since the outbreak of the war, and to indicate *des états d'âme*'.[4]

It is hard to understand what in Flint's article deserved *The Athenaeum's* rebuke. Perhaps something in the tone of Flint's opening paragraph, which seemed to promise a cool, detached survey, but then moved swiftly into an apparently sympathetic and receptive mood:

> **Nothing has happened; a slight displacement of matter, a few ether-waves which have been lost in space, a few sound-waves which have long since impinged on the silence that, at the limit of the atmosphere, opposes an infinite resistance to all our uproars and hullabaloos. Nothing in nature has changed; but a generation of men has been ham-strung, and the keystone of a civilisation perhaps shattered. What France has lost in youthful genius can never be computed. Of known writers, 275 had been killed and 28 were missing by March, 1917. It is impossible to say what effect the war has had on those who have survived. After the comparatively slight blood-letting and the defeat of 1870–71, came the strange dreaming, the breaking-away from traditions, the exoticism, the revolt of the *décadence* and of Symbolism. After the exhaustion and victory of 1914–18, what?**[5]

Very little else in Flint's main text should have given offence. Several pages were devoted to the work of Guillaume Apollinaire whose beautiful poem 'La jolie rousse' was printed in full. Flint did not quote from any of the 'eccentricities' which he had noted in Apollinaire's *Calligrammes* (1918) – 'words arranged in the form of pipes, trees, cravats and in complicated designs, and rain trickling down the page in single letters' – these he regarded as 'amusements' of an adventuring mind. Flint had seen some of Apolllinaire's 'ideogrammes' (later renamed 'calligrammes') before the war. They had first appeared in *Les Soirées de Paris* in June 1914. An article by Flint ('Imagistes') appeared in the July/August issue of *Les Soirées de Paris* (Nos. 26/27), which also contained an illustrated article by G. Arborin on 'Apollinaire's ideogrammes'. But 'La jolie rousse', a plea for, and a hymn to, the finer hopes of prewar modernism, rightly deserved and received Flint's complete respect:

La jolie rousse

Ma voici devant tous un homme plein de sens
Connaissant la vie et de la mort ce qu'un vivant peut connaître
Ayant éprouvé les douleurs et les joies de l'amour
Ayant su quelquefois imposer ses idées
Connaissant plusieurs langages

Ayant pas mal voyagé
Ayant vu la guerre dans l'Artillerie et l'Infanterie
Blessé à la tête trépané sous le chloroforme
Ayant perdu ses meilleurs amis dans l'effroyable lutte
Je sais d'ancien et de nouveau autant qu'un homme seul pourrait des
 deux savoir.
Et sans m'inquiéter aujourd'hui de cette guerre
Entre nous et pour nous mes amis
Je juge cette longue querelle de la tradition et de l'invention
De l'Ordre et de l'Aventure
Vous dont la bouche est faite à l'image de celle de Dieu
Bouche qui est l'ordre même
Soyez indulgents quand vous nous comparez
A ceux qui furent la perfection de l'ordre
Nous qui quêtons partout l'aventure
Nous ne sommes pas vos ennemis
Nous voulons vous donner de vastes et d'étranges domaines
Où le mystère en fleurs s'offre à qui veut le cueillir
Il y a là des feux nouveaux de couleurs jamais vues
Milles phantasmes impondérables
Auxquels il faut donner de la réalité

Nous voulons explorer la bonté contrée énorme où tout se tait
Il y a aussi le temps qu'on peut chasser ou faire revenir
Pitié pour nous qui combattons toujours aux frontières
De l'illimité et de l'avenir
Pitié pour nos erreurs pitié pour nos péchés

Voici que vient l'été la saison violente
Et ma jeunesse est morte ainsi que le printemps
O Soleil c'est le temps de la Raison ardente
 Et j'attends
Pour la suivre toujours la forme noble et douce
Qu'elle prend afin que je l'aime seulement
Elle vient et m'attire ainsi qu'un fer l'aimant
 Elle a l'aspect charmant
 D'une adorable rousse

Ses cheveux sont d'or on dirait
Un bel éclair qui durerait
Ou ces flammes qui se pavanent
Dans les roses-thé qui se fanent

Mais riez riez de moi
Hommes de partout surtout gens d'ici
Car il y a tant de choses que je n'ose vous dire
Tant de choses que vous ne me laisseriez pas dire
Ayez pitié de moi[6]

About Cocteau's 'Le Cap de Bonne Espérance' (a translation of which by Jean Hugo with the assistance of Ezra Pound was to appear in the autumn 1921 issue of the *Little Review*)[7] Flint was less sure:

> **The poem, in fact, is a collection of images placed one against the other, with few of the ordinary connecting links of speech, it being left to the reader to form the fusion in his mind. If the fusion takes place you have the sensation of poetry, if not, you are bewildered.**[8]

One section of Cocteau's poem was referred to as 'a very comprehensive American college yell', or, Flint suggested, more accurately, an example of Marinetti's influence on French poetry:[9]

éo ié iu ié
é é ié io ié
ui ui io ié
aéoé iaoé
a u i a ou a o é
io io io iu
aéiouiu
iuiaé ui ui io ué
o é o
a é o é
oé aé iéoa
iéiaoaoa iéua iéua
oa oa iéua
ié ié é é

 é coute

This passage was quoted out of its local and total contexts, and any differences in effect, possible or actual, resulting from this separation from the whole poem were apparently not appreciated by Flint. He was reminded of Pierre Albert Birot's 'L'Avion (Poème à crier et à danser)' which had appeared in *SIC* during November 1918.[10] This was a work which, as its subtitle says, also needed to be performed, just as Apollinaire's *Calligrammes* usually need to be seen. It is by no means certain that all Flint's readers could be assumed to appreciate this, even if Flint himself did so.

The remainder of the article was devoted to rather more traditional poems and poets – among them Jules Romain and Emile Verhaeren – Flint showing genuine concern about the mental condition of Paul Eluard, but little sympathy for the poems in Eluard's *Le Devoir et l'Inquiétude*, which 'seem to have been conceived in a state of mind bordering on hallucination, produced by the tensions of active service'.[11] Apart from the visual poems of Apollinaire and the phonic poems of Cocteau and Pierre Albert-Birot, none of which received any

praise from Flint, there was nothing very novel in Flint's essay, and there was no hint whatsoever of the changes in the artistic atmosphere of Paris which were the first rumblings of the fast-approaching Dada storm. Flint had published an unsigned review called 'French War Poetry'[12] in the *Times Literary Supplement* during the same month (October 1919), and there too he had expressed interest in Apollinaire's *Calligrammes*, Eluard's *Le Devoir et l'Inquiétude*, and both interest in and sympathy for Cocteau's *La Cap de Bon Espérance*. But, again, he had seen no significant connection between these works except as individual expressions of 'des états d'âme'.

In order to understand *The Athenaeum*'s conservative wariness about a review of foreign literature by F. S. Flint in a journal edited by Harold Monro it may be helpful to explain briefly the position which Flint and Monro had come to occupy on the English literary scene by this time. Some useful guidelines for such an explanation have been given in Joy Grant's *Harold Monro and the Poetry Bookshop* (1967).[13] This book is a carefully detailed assessment of Harold Monro's considerable achievements as founder of The Poetry Bookshop, publisher of the *Georgian Anthologies*, editor of several important poetry periodicals, as well as being the author of several books of highly accomplished verse. Dr Grant frequently cites the comradeship, encouragement and support which Harold Monro received from, and returned to, F. S. Flint, whose talents and enthusiasms perfectly matched and complemented Monro's own.

Frank Stewart Flint (1885–1960), who had undergone only an elementary formal education, published his first volume of poems in 1909.[14] This was followed by two further collections, both of which were published by The Poetry Bookshop: *Cadences* (1915) and *Otherworld: Cadences* (1920). In 1920 Flint's first wife died and, apparently partly in consequence of this personal tragedy, he published no more poetry.

Flint's 'Preface' to *Otherworld* presents familiar negative arguments for the liberation of poetry from inessential devices; these are two of three 'propositions':

> **In these preface I have kept three propositions before me; the first being that poetry is a quality of all artistic writing, independent of form; the second that rhyme and metre are artificial and external additions to poetry and that, as the various changes that could be rung upon them were worked out, they grew more and more insipid, until they have become contemptible and encumbering.[15]**

His third proposition was positive and, Flint believed, one in complete harmony with literary tradition:

> **. . . the artistic form of the future is prose, with cadence – a more strongly accented variety of prose in the oldest English tradition – for lyrical expression.**

The term 'cadence', which provided the sub-title of this volume and the title of the 1915 collection, was taken from Chaucer:

And nevertheless hast set thy wyt,
Although that in thy hede ful lyte is,
To makë bokës, songës, dytees
In ryme or ellës in cadence.

Flint's earlier 'cadence' or free-verse poems had appeared in *The English Review*, *Des Imagistes* (edited by Ezra Pound, 1914), *Some Imagist poets* (three volumes, edited by Amy Lowell, 1915, 1916, and 1917), and Pound's *Catholic Anthology* (1915). It has been suggested by at least one critic[16] that Flint, rather than Pound, may be regarded as the founder of English Imagism. Certainly Flint's theory and, to a lesser degree, his practice did much to keep Imagism alive in Britain, especially after Pound's early departure from the movement.

Flint's enthusiasm for other poets' work, and his willingness to keep his mind open for new poetry of all kinds – qualities which, again, he shared with Monro – were important influences in the education of the English poetry-reading public before and after World War I. His remarkable linquistic gift (according to Joy Grant he was 'finally able to read thirteen languages and to speak and write nine')[17] is evident throughout his reviewing of contemporary literature in most of the major, and several of the minor, European languages. Something of the scale of Flint's talent and reputation may be gathered from the fact that for many years he was a reviewer for T. S. Eliot's *The Criterion*, especially responsible for surveys of Danish, Spanish and Italian periodical literature; from No. VIII of *The Criterion* he replaced Richard Aldington as reviewer of French periodicals. It is no exaggeration to claim, therefore, that Flint was one of the most important bridges between England and the European literary scene during the entire period of experimental modernism.

His first reviews had been for A. R. Orage's *New Age*, then for the *Poetry Review* which Monro edited for The Poetry Society during 1912. Flint's seventy-page survey of the contemporary French scene in the August issue of the *Poetry Review* was a famous 'tour de force'.[18] After Monro's break with The Poetry Society at the end of 1912, Flint was made responsible for the 'French Chronicles' which appeared in all eight issues of *Poetry and Drama*,[19] the quarterly edited by Monro from March 1913 to December 1914. These 'Chronicles' are long, thorough, and 'uncritical'; as Joy Grant suggests: 'Flint's talent was always to exhibit poetry persuasively rather than to criticise it'.[20] Most of the pages of *Poetry and Drama* for September 1913 (Vol. I, No. 3) were devoted to translations of Futurist manifestoes and other material, including translations by Monro himself of poems by the Italian Futurists Marinetti, Paolo Buzzi, and Aldo Palazzeschi.[21] In the 'French Chronicle' for this 'Futurist Issue' Flint revealed both

sympathetic openness and perhaps more honest uncertainty than most other critics would ever confess to:

> **People may laugh at M. Marinetti; but if they will take the trouble to consider his theories without prejudice – it is very stupid to have literary prejudices – they might profit; and the beginning of the new art that is to fit in with the future mind, modified by machinery, might be made. Without going so far as M. Marinetti, we may ask ourselves what is the use, for instance, of logical syntax in poetry? Why we should have so absolute a respect for the integrity of words? Whether poetry will not finally develop into a series of emotional ejaculations, cunningly modulated, and coloured by a swift play of subtle and far-reaching analogies? Are we not really spellbound by the past, and is the *Georgian Anthology* really an expression of this age? I doubt it. I doubt whether English poets are really alive to what is around them. And to betray myself completely, whether, perhaps, it is worth while being so alive. It is a question to consider and thresh out. There are so many old emotions to which we cling that it is legitimate to pause before we set out to transform ourselves into the fiends that M. Marinetti would have us be, although it may be admirable to be a fiend.**[22]

In the following issue of *Poetry and Drama* (December 1913) Monro made it clear that Marinetti's visit to London in mid-November had had only limited success. Apparently Marinetti had lectured and declaimed his poems at the Poetry Bookshop, the Cabaret, the Poet's Club, Clifford's Inn Hall, and the Doré Gallery, and a private dinner had been given in his honour by the English painters. Monro, like many others who knew Marinetti, admired the force of his personality and the power of his reading, but was far from enthusiastic about the achievements of Futurist poetry:

> **During his visit Signor Marinetti declaimed a number of his own poems in this new medium. We admire his extraordinary inventiveness; we were enthralled by his declamation; but we do not believe that his present compositions achieve anything more than an advanced form of verbal photography.**[23]

Monro's considered judgment was that the English had nothing to learn (and little to fear) from Futurism: '. . . it is essential for us to be allowed to solve our own problems in our own manner. The Latin temperament is not ours, and its present violent materialism will fail to find permanent footing here.'[24] In spite of this firm rejection by Monro, it was not forgotten in some literary quarters that Marinetti had appeared at the Poetry Bookshop, that the Futurists with their 'poetic' and artefacts had taken over *Poetry and Drama* for one issue, and that Flint himself had never made an unequivocal public denunciation of the latest European 'stunt'.

Despite – or perhaps because of – the admirable qualities of openness and tolerance which Monro encouraged in *The Chapbook*

towards most new work, and because of the freedom which he allowed to his contributors, it must be admitted that there was often some disparity between the reviewing manners of those assessing work by well-known contemporary English writers and Flint's discussion of contemporary foreign work. Flint was seldom anything but polite and sympathetic. His reviewing would appear to be 'uncritical' or even enthusiastic when set alongside, for example, the incisive comments which Monro's second wife, Alida, made about both some of the Victorian 'traditionalists' and some of her more wayward contemporaries.

The Chapbook for June 1920 contained a closely printed forty-four page 'Bibliography of Modern Poetry' in which 'Recorder' (Alida Monro) set out to give a list, with occasional comment, of no fewer than 1,029 contemporary poets and their books published between 1912 and 1920. Some writers received almost unstinted praise (Rupert Brooke and Walter de la Mare, for example) but most writers were carefully and spiritedly placed by Alida Monro in a way which her husband would never have followed and which Flint would reserve for very rare occasions only when he had to deal with someone both powerful and past all redemption (J. C. Squire, for example).[25]

Some of Mrs. Monro's dismissals of established writers would have done credit to Ezra Pound or Wyndham Lewis at their most scathing:

WATSON, William: Pompous poet left over from the last century. He received a knighthood during the European War.[26]

The entry for the Sitwells is worth quoting in full too. They were treated with a curious mixture of amused enjoyment (amounting in the case of Edith almost to empathy) and contemptuous dismissal. Edith was cleverly tricksy and Osbert transparently so, while, though Sacheverell had more about him, he too shared the family's ungoverned eccentricity:

SITWELL, Edith: While reading this lady's works one feels as if in a gigantic conservatory lined with mirrors, electric lights blazing from every corner, tom-toms beating ceaselessly, while thousands of parrots scream in unison and enormous cats slink after rats, festooning themselves among exotic plants. Jewelled snakes twine in and out, writhing their way up balustrades. Meanwhile, one or two bishops discuss the weather with drunken clowns and the entire aristocracy looks on approvingly from a far corner.

After reading one feels like a circus rider who has jumped through a paper hoop and is now drinking cold tea.

SITWELL, Osbert: Various metaphors may be applied: a bag of conjuring tricks. A rattle without a handle. A beautiful set of toy teeth in a secondhand shop. Fireworks by daylight. A pin pricking a parachute.

SITWELL, Sacheverell: The most promising member of his family. There is depth and insight in his writing, but his mind has the riotous instincts of his brother and sister.[27]

Flint's earliest discussion of the Dadaists, in a long review of Tzara's *Vingt-Cinq Poèmes* (January 1920) in the *Times Literary Supplement*, showed a brief lapse from his usual tolerance and good manners. In his unsigned 'The Dada Movement' Flint detected just a glimmer of sense in the Dadaist manifestoes which he had read, but none at all in the poems and drawings of Tzara's book. He quoted one poem by Tzara ('pélamide') and, from *Dada 3* (December 1918), 'Flamme' by Philippe Soupault. There was no arguing with the Dadaists, however. Even the traditionally suspect and Philistine middle classes seemed preferable:

It is useless to refute these men [i.e. the Dadaists]. 'Non ragioniam di lor . . .' Their principle being to have no principles and their art to have no art, their works can be safely left to the general common sense, which will destroy them. (We read in the 'Anthologie Dada' [i.e. *Dada 4/5*, Zürich, May 1919] a protest against the action of the director of the Pestalozzi school of Zürich in effacing 'les 2 grandes peintures murales de Van Rees et Arp, premières oeuvres moderns, abstraites, sur les murs d'un grade efifice . . .Cet acte de barbarie ne fut que très vaguement condamné par la presse.') For once, the much decried bourgeois was probably in the right.[28]

But, like Aldous Huxley's, Flint's first reaction was to be followed by a much more considered one, almost certainly the most important discussion of the subject printed in England at the time.

'THE YOUNGER FRENCH POETS'

Tristan Tzara's survey of dadaist activity in Europe – 'Memoirs of Dadaism' (1922) – contained only three lines about England: 'Dada has no adepts in England, but it is very well known there. M. A. Binnyon has given a lecture on Dadaism, and F. S. Flint has written a brochure about us.'[29] The 'brochure' to which Tzara refers was *The Chapbook* for November 1920. The entire issue[30], some thirty pages in length, was devoted to Flint's study, 'The Younger French Poets'. Both the title and Tzara's description of it were apt. Apart from two paragraphs on Paul Morand (whose work, though not Dadaist, was published by Au Sans Pareil), Flint's study was concerned exclusively with Dadaism, and almost exclusively with its appearance in Paris. The essay was in three sections: a general survey of Dadaism; short critiques, illustrated by original translations, of selected Dada poets, Tzara, Picabia, Eluard, Breton, Soupault, and Aragon (and, in addition, as already mentioned, Paul Morand); and the original French texts of the poems chosen to illustrate these short critiques. Two drawings by Picabia ('Portrait de Tristan Tzara' and 'La Sainte-Vierge') and one of Arp's woodcut illustrations for Tzara's *Vingt-cinq Poèmes* were also reproduced.

It is not possible to assess exactly the extent of Flint's reading of Dadaist literature; a good deal of Dadaist work could be seen in the contemporary French surveys which Flint had read. But from the evidence of the quality of Flint's previous work as a reviewer, from the

perceptive grasp of the essential nature of Dadaism which is demonstrated throughout the essay, and from other internal evidence in the commentary, there can be no doubt that Flint had examined a large amount of Dadaist literature with his usual patience, fairness, and sensitivity.

The first section ('The Dada Movement') began by asserting that most of the younger French poets had become involved with Dadaism, and that nobody in Paris was able to ignore it. In England, however, 'One or two of the literary weeklies have given a hint or a slighting account of it. One newspaper, at least, has reproduced a 'Dada poem', with an appropriate yell of derision.'[31] The poem referred to, and quoted by Flint, was Louis Aragon's 'Suicide' (see p. 60). From these opening remarks it is clear that Flint had come to believe that more than 'hints' and 'slighting remarks' were now necessary, and that English readers should also have been taking Dadaism seriously, as several well-known French artists had done:

> **Effectively, Dada has assaulted Paris with gibe and insult and lunacy; and Paris has been taken. M. André Gide contributes to the Dada review 'Littérature', and his own review 'La Nouvelle Revue Française' has published a defence of Dada by the Dadaist, M. André Breton, and a 'Reconnaissance à Dada', by its editor, M. Jacques Rivière, in addition to a benevolent article on the same subject by M. André Gide himself.[32]**

Flint offered little on the subject of the history of Dadaism; he accepted the general view of the time that it had been 'fathered' in Zürich by Tzara. He was more interested in what Dadaism had to say than in its pedigree. His first substantial quotations, however, were from Tzara's *1918 Manifesto*, which had first appeared in *Dada 3* in Zürich, though the text was frequently reproduced in Paris during 1920. Flint referred to Huxley's mention in the March issue of the *Chapbook* of Tzara's 'onomatopoeic poems', and pointed out – what we have seen Huxley himself already realised – that Dadaism was in no sense an aesthetic movement:

> **Onomatopoeic is perhaps too kind a description. It does at least imply an attempt to convey something. M. Tzara does not wish to convey. His verse, good or bad, never says anything. It merely makes a noise. 'Je hais le bon-sens . . .'[33]**

Then followed a long quotation from the Manifesto:

> **Dada means nothing . . .**
> **If I shout**
>
> **Ideal, ideal, ideal,**
> **Knowledge, knowledge, knowledge,**
> **Boomboom, boomboom, boomboom.**
>
> **I have set down exactly enough progress, law, morality and all the other fine qualities which so many very intelligent people have discussed in so many books, to come finally to this that, after all, each**

one has danced according to his own personal boomboom, and that so far as he is concerned his boomboom is right: satisfaction of a sickly curiosity; private bell for inexplicable needs; bath; pecuniary difficulties; stomach with repercussion on life . . . If everybody is right, and if all pills are not Pink, let us try for once not to be right. People think they can explain rationally, by thought, what they write. But it is very relative. Thought is a fine thing for philosophy, but it is relative. Psychology is a dangerous sickness; it puts to sleep the anti-real leanings of man and systematizes the bourgeoisie. There is no last truth. Dialectic is an amusing machine that leads us (in a commonplace way) to opinions we should have held in any case. Do you think that by a minute refinement of logic you have proved the truth and established the exactness of these opinions? . . . Measured by the scale of eternity, every action is vain . . . [34]

Flint was not impressed by Tzara's clear reasoning. It was not very original; the ideas could be found in Carlyle and Nietzsche, and the style in Marinetti. Moreover, even if the epistemological premises were correct, the nihilistic ethical conclusion was invalid:

... everybody, at some time or another, has made the reflection that the ratio of the works of man to eternity is equal to zero; but that does not drive us out with intent to tomahawk the decoration of our nullity. [35]

Flint also quoted at length from the final section of Tzara's *1918 Manifesto* in which 'Dadaist disgust' was proclaimed. Flint's comment was again directed against the nihilistic logic, or rather, in this instance, Tzara's lack of it. Tzara's nihilism was not thoroughgoing, but meandered at times into the acceptance of contradictions:

Its author's liberty is as illusory as the ideals he attacks; and merely to pour out pell-mell and incoherently every oddment and figment of the brain, is at least as vain as to find some connecting thread for them and to make a decoration of life with them. If M. Tzara really held the opinions he professes, he would, like the M. Th . . . Remy de Gourmont speaks of in 'Le Deuxième Livre des Masques', never write at all. But M. Tzara does not hold any opinions. 'I write this manifesto', he says, 'to show that you can perform two opposing acts together, in one sole fresh respiration; I am against action; for continual contradictions for affirmation also, I am neither for nor against and I do not explain, for I hate good sense.' [36]

Flint had noticed that several of the younger French writers, notably Paul Dermée in his periodical *Z*, had adopted this spirit of contradiction, and from it they had already formulated a 'perfectly definite doctrine', though, because of Tzara's anti-doctrine attitude, they had 'a doctrine that leaves its devotees free to talk nonsense or to temper his nonsense with flashes of meaning, as he pleases'. It is interesting that the passage from *Z* which Flint used to illustrate this 'doctrine' presaged some of the ideas and attitudes of orthodox Surrealism:

Dada, ruining the authority of constraints, tends to set free the natural play of our activities. Dada therefore leads to amoralism and to the most spontaneous and consequently the least logical lyricism. This lyricism is expressed in a thousand ways of life.

Dada scrapes from us the thick layer of filth deposited on us by the last few centuries.

Dada destroys and stops at that. Let Dada help us to make a complete clearance, then each of us rebuild a modern house with central heating and everything to the drain, dadas of 1920.[37]

In spite of his general disapproval, and despite his recognition that the Dadaists had apparently no aesthetic goal, Flint did record an occasional flash of genuine 'poetry' . . . 'if *ces Messieurs* will permit me to say so'.[38]

Flint then gave several pages of examples of Dadaist products 'from a mass of reviews'. Represented among these reviews were *Dada 2, Dadaphone No. 7*, both issues of *Cannibale, 391* and *Proverbe*. Flint did not share the dismissive view of several contemporary critics, that the Dadaists were mad, and therefore to be given psychiatric help, or better still, to be ignored completely:

their authors know perfectly well what they are doing. They are amusing themselves at our expense, without, however, letting us share the joke, and with the ultimate object of discrediting all the works of the mind. As M. Gide said in his article on 'Dada': 'What! While our fields, our villages, our cathedrals have suffered so much, our language is to remain untouched! It is important that the mind should not lag behind matter; it has a right, it too, to some ruins. Dada will see to it.'[39]

Flint's examples included poems and other pieces by Picabia, Georges Ribemont-Dessaignes, Pierre Albert-Birot and Paul Eluard, as well as Breton's carefully constructed 'Pièce Fausse':[40]

Du vase en cristal de Bohème
Du vase en cris
Du vase en cris
Du vase en
En cristal
Du vase en cristal de Bohème
Bohème
Bohème
En cristal de Bohème
Bohème
Bohème
Bohème
Hème hème oui Bohème
Du vase en cristal de Bo Bo
Du vase en cristal de Bohème
Aux bulles qu'enfant tu soufflais
Tu soufflais
Tu soufflais
Flais
Flais
Tu soufflais

Qu'enfant tu soufflais
Du vase en cristal de Bohème
Aux bulles qu'enfant tu soufflais
Tu soufflais
Tu soufflais
Oui qu'enfant tu soufflais
C'est là, c'est là tout le poème
Aube éphé
Aube éphé
Aube éphémère des reflets
Aube éphé
Aube éphé
Aube éphémère de reflets

Breton's prose – though scarcely Dadaist – introduced Flint's considerations of arguments in defence of the 'arbitrary', and against conventions, reasoned discourse and book-knowledge, which Breton had brought to 'Pour Dada'. Flint paraphrased part of them as follows:

It is saddening to read these unilluminated phrases, to receive these objectless confidences, to experience each moment, through the fault of a chatterer, this impression of the already known. The poets who have recognised this fly hopeless from the intelligible. They know that their work has nothing to lose thereby. You can love a mad woman more than any other.[41]

In this way Flint attempted to give the 'feel' as well as the flow of Breton's own words, but, Flint suggested, it was odd to find reason used in this way to argue against the primacy of reason.

Flint also summarised Jacques Rivière's 'Reconnaissance à Dada', for which he had obviously a good deal of respect, though he thought that Rivière had made the error of thinking that the Dadaists were disinterested in their motives and fully conscious in their aims:

It makes no allowance for the common, human, vulgar desire just simply to show off. Although the Dada movement may be a logical development, it does not follow that its adherents were conscious that that was so when they began cutting their strange capers. The motives of the young when they start to revolutionise the world are rarely unmixed.[42]

Rivière had traced 'the implicit dream of several generations of writers' through Rimbaud, Apollinaire and Max Jacob in particular, but also through Flaubert and Mallarmé, to Dada. His analysis of the way in which during the nineteenth century the path to Romanticism has led to a 'gradual weakening of the objective instinct', and to the reduction of art to 'nothing but a sort of deputy for their [i.e. the artists'] personality' was one which Flint found sound. He was less sure about Rivière's conclusion that Dadaism had deliberately taken such a trend to its logical conclusion; Rivière's interpretation of the Dada message was too flattering:

We must renounce subjectivism, effusion, pure creation, the transmigration of the ego, and that preterition of the object which has

precipitated us into the void. The writer must make a new effort to understand; he must ally himself once more with the scientist, if fertility is to return to him.[43]

For Flint there could be no special pleading or sympathy for a movement which produced bad art to a formula or from a philosophy of any kind:

It is useless to tell an artist that he must renounce this or that; but it is legitimate to ask of him, if he wishes to communicate with his fellow-men, that he accept the conventions by which he will make himself intelligible. This the Dadaists – and they are not alone - refuse to do. To a philosophy of nihilism they add a psychology that is at least as false as any other. 'Nothing' one of them has said, 'can compromise the integrity of the mind'. And that may be true. But you are not doing any homage to the integrity of the mind by putting into words every idea that passes through your head, and offering that as a true image of your mind. It is like skimming the scum off the refining cauldron and offering it as a sample of purity and sweetness.[44]

In his critiques of individual Dada poets Flint attempted what may seem to be an impossible task, to examine them all for signs of genuine 'poetry'. Like Monro, Flint believed that true poetry is a quality which will always manifest itself, and, like J. C. Squire, that true talent will win through any 'stunt'. Therefore he found Tzara, though incomprehensible, an 'artist' because he possessed 'personality, sincerity, and style' – three qualities which Flint had argued in an earlier issue of the *Chapbook* were present in true poetry. Picabia, on the other hand, apparently possessed none of these qualities and, consequently, remained unread by Flint. Eluard was praised for a genuine attempt to communicate, and for a certain honesty and simplicity, but Breton was 'very incomprehensible' while Soupault was suffering from bad 'growing pains and melancholy'. Like Aldous Huxley, Flint had some admiration for the talent of Louis Aragon, though he thought that Aragon had been badly served by Dadaism. Flint's inclusion of Paul Morand in his short critiques was explained finally:

M. Morand's poetry presents both a picture and a criticism of the life of to-day – the swirl and fever of its anarchy, its flaunting baseness, its crawliness, its stupidity. His view of life is probably no different from that of the Dadas; but while he expresses it, and thereby sharpens our sense of wrong, they fling a new confusion into the general anarchy, and merely add to our hopelessness. In one of his poems, M. Morand, after analysing the present state of humanity, describes the task of the poet:

A free and serious limning of one's thought,
a simple effusion of oneself
with more kindness and an entire good faith.
This is not a revolt
but a method
to enable us to endure and finally conquer
the anarchy that is coming,
and, whence, thanks to us, if we are strong,

will spring a better state,
a just law of right and wrong,
as infallibly as the disorder
of the present hour
which has only the appearance of order
being but hatred and confusion.

It is a pity that the Dadas, who certainly have men of talent among them, have not so far shown as much generosity.[45]

Flint gave as his reason for not discussing the works of other Dada poets (including Ribemont-Dessaignes, Dermée, Paulhan, Albert-Birot, and Reverdy) that he did not possess copies of their work. There is evidence that he did possess and had read most of the Dadaist works issued by Au Sans Pareil up to that time, as well as some of the books published in Switzerland before the end of the war.[46]

It could be argued against Flint that he showed a similar lack of awareness of the possibilities of new literary techniques as he exhibited in his earlier treatment of Apollinaire's *Calligrammes* and the phonic poems of Albert-Birot. The genuine expressive achievement of Breton's 'Pièce fausse' for example, was disregarded. Quite rightly, however – as the Dadaists themselves would have wished – Flint concentrated his main attention on the destructive nihilism of Paris Dada. Even his search for 'poetry' in the work of individual poets was in quest of the positive values which Dadaism forbade. The attitude expressed in the extract from Paul Morand's 'Une lampe indicatrice'[47] was completely in accord with the ideals expressed in Apollinaire's 'La Jolie Rousse', particularly in Morand's rejection of 'hatred and confusion' and the insistence upon 'more kindness and entire good faith'. That freedom and spontaneity ('a simple effusion of oneself') need not exclude good sense, decency and hope is implicit throughout Flint's analysis.

Most important of all, and also implicit throughout, is an unshakeable faith in artistic tradition. That such faith in art was not simply an unthinking reaction is shown in Flint's rejection of the ethical conclusions of Tzara's *1918 Manifesto*. For Flint, a rejection of art – even if all art is mere decoration of life in an absurd universe – was unacceptable. It is a position which Flint (probably more conscious than most of the power of the counter-arguments to that position) shared with all other major English artists and critics of this decisive period, and it is one that marked a genuine and fundamental difference between English art and that of almost every other western country at the end of World War I.

The USA, for example, where Dadaism had some sympathetic reception for a period in the early 1920s[48] (particularly as we have seen, in *The Little Review*), provides some interesting comparisons. For example, in an article 'Why Dada?' by the well-known art and theatre critic Sheldon Cheney, published in *The Century Magazine* in May 1922[49], Cheney, who more than half-seriously claimed to be a Dadaist,

expressed admiration for Flint's article. He described it as 'perhaps the most temperate expression in English on the subject', and he admired Flint himself ('a poet and critic of marked progressive tendencies [who] had a better right than most of us to be heard') but Cheney's sympathies and conclusions were quite different from Flint's. Cheney argued that though, according to those critics who said Dadaism would never be taken seriously in the United States, Americans had no 'traditions worth destroying', yet, 'who will say that we have not an officialdom quite as powerful in its smaller sphere, and none the less vicious for having less art to deal with?' This may sound like Huxley's use of Dadaism to attack the dead art of his day; but the next step in Cheney's thinking went further than anything in Huxley's considera-tion of anti-art: 'Who will say that the sacred regard for "old masters", so astutely kept aflame by the art-dealers and antiquarians, is not fair target for a little bomb-throwing?'[50] Cheney's conclusion shows the same wildness of aim in its failure to discriminate sufficiently between art and contemporary American society: '. . . we need a Dada to destroy our whole mechanized system, which has blindly clamped the acquisitive supply-and-demand principles of business down over the realms of art and spiritual life.'[51] I am not trying to suggest that American critics and artists gave general credence to Dadaist views. As Cheney's article suggests, the reaction generally had been hostile.[52] Several American artists and critics, like Cheney, were much more sympathetic towards Dadaism than any English artist or critic (with the single doubtful exception of John Rodker), and this, it seems to me, is an important difference.

It may be worth reminding ourselves here that several serious English writers who had shown interest in and sympathy for Italian Futurism (as an essential stage in that country's growing up into an industrial age) had shown no sympathy whatsoever for the Futurist call for a total rejection of the art of the past. In a letter written from Italy by D. H. Lawrence to A. W. McLeod in June 1914, Lawrence declared an interest in Futurism and revealed that he had seen much of its theory and artefacts. His enthusiasm carried him only so far:

> It interests me very much. I like it because it is the applying to emotions of the purging of the old forms and sentimentalities. I like it for its saying – enough of this sickly cant, let us be honest and stick by what is in us. Only when folk say, 'Let us be honest and stick by what is in us! – they always mean, stick by those things that have been thought horrid, and by those alone. They want us to deny every scrap of tradition and experience, which is silly. They are very young, college-student and medical student at his most blatant. But I like them. I agree with them about the weary sickness of pedantry and tradition and inertness, but I don't agree with them as to the cure and the escape.

Lawrence's words about the Futurists match almost exactly those of Aldous Huxley about the Dadaists, except that Lawrence could regard the Futurists as very young Italians whose instincts were right but who were still immature and open to correction:

Italy has to go through the most mechanical and dead stage of all – everything is appraised according to its mechanic value – everything is subject to the laws of physics. This is the revolt against beastly sentiment and slavish tradition and the dead mind. For that I love it. I love them when they say to the child, 'All right, if you want to drag nests and torment kittens, do it lustily'. But I reserve the right to answer, 'All right, try it on. But if I catch you at it you get a hiding'.[53]

Lawrence was in fact rather kinder to the Futurists than the English Vorticists who, in 'Manifesto II' in the first issue of *Blast* (1914), had asserted that 'It is only the second-rate people in France or Italy who are thorough revolutionaries'.

In his rejection of literary Futurism on behalf of English poetry (*Poetry and Drama*, December 1913), Harold Monro had taken the argument a most important stage further. As we have seen, in regarding Futurism as a particular manifestation of Latin temperament during a period of 'violent materialism' Monro had not been far away from the basic judgement given by Lawrence in his letter to McLeod. But Monro's critique of Futurism included a modest yet firm expression of belief in the general health of the English tradition-root:

Against Signior Marinetti we claim only what none will deny, that English poetry has not stood still since the days of the Elizabethans, and what some at least will admit, that its development continues, however humbly, to-day as ever.[54]

Such faith in the capacity of English poetry to change and develop according to its own basic nature proved to be just as effective a prophylactic against Dadaism in literature as it had been against Futurism. However, this belief in the necessity for English poetry to maintain and develop vital connections with its own past found strongest and most articulate support among those writers who, in the years before World War I, had fought with most determination for a truly modern and original poetic.[55] Like F. S. Flint, other survivors of the prewar Imagist and Vorticist groups continued to stress the necessity, in the process of continual renewal that art demands, for awareness of whatever can be profitably absorbed from other cultural traditions. Which other cultures – past or present, exotic or indigenous – would most successfully graft on to the root-stock had often been the cause of both strange poetic enterprises and fierce controversy in the prewar period: but nobody had doubted then (and few wavered in this belief after 1918) that the Anglo-European past constituted the only sound basic root-stock for English poetry even when that poetry had to cope with the demands of twentieth-century life.

EZRA POUND AND DADAISM

Among those who wavered in the belief that the Anglo-European past could be sustained by the writers of the literary establishment in

England was Ezra Pound (1885–1972). Before, and even during the war, Pound, whose best-known catch-phrase was 'Make it new!', was insistent on an intelligent regard for tradition as the *sine qua non* of literature. For example, in *The Egoist* for September, 1917, Pound proclaimed: '. . . only the mediocrity of a given time can drive the more intelligent men of that time to "break with tradition".' and later, in the same essay:

I take it that the phrase 'break with tradition' is currently used to mean 'desert the more obvious imbecilities of one's immediate elders'; at least, it has had that meaning in the periodical mouth for some years. Only the careful and critical mind will seek to know how much tradition inhered in the immediate elders.[56]

This distinction is understandable when we consider that Pound felt the greatest possible contempt for most of his literary elders in London. Early in 1918 he was experiencing the bitterest feelings about the lot of the creative artist in London - feelings that were to grow to such a pitch that by April 1920, he would sever most of his ties with London and turn temporarily to postwar Paris as a more congenial city for a serious artist to live.[57] In *The Egoist* for January 1918, writing about the attractive possibility of reprinting Gawine Douglas's works, Pound commented:

This will probably be done by some dull dog who will thereby receive cash and great scholastic distinction. I, however, shall die in the gutter because I have not observed that commandment which says 'Thou shalt respect the imbecilities of thine elders in order that thy belly shall be made fat from the jobs which lie in their charge.[58]

But Pound, unlike some of his American contemporaries, never contemplated the abandonment of all past art: on the contrary, in his unceasing quest for new and vital art he was driven more deeply and widely, if sometimes esoterically, into the art of the European past as well as that of non-Western cultures. Paradoxically it was this constructive impulse which led Pound into a flirtation with Dada activities in Paris and the USA.

Pound's keen ear for signs of anything new in the arts was demonstrated in January 1919, when he wrote to William Carlos Williams: 'All sorts of projects artoliteresque in the peaceconferential-bolshevikair. Switzerland bursting into Dadaique Manifestoes re the Nothingness of the All.'[59] At the time, however, he showed little active sympathy towards the Dadaists or detailed interest in their projects. As far as Zürich was concerned, his main artistic passion had been in furiously (and selflessly) proselytising on behalf of the work of one of its distinguished wartime inhabitants, James Joyce, especially in encouraging the completion, and furthering the publication of *Ulysses*. It is significant too that Joyce, who lived in Zürich from June 1915

until November 1919 – that is, exactly coincident with the period of Zürich Dadaism – showed almost no interest whatsoever in the Dadaists' activities.

During the war Pound had never relaxed those standards of rigorous, but energetically, even aggressively, prosecuted criticism which he believed to be necessary for the revitalisation of all the arts. Nor was adverse criticism directed solely against the shortcomings of the older generation of poets and critics. A letter to John Quinn dated 10 March 1916 about the painting of Percy Wyndham Lewis, makes plain Pound's criteria for artistic excellence, and also contains his views on the comparative worthlessness of the work of Francis Picabia, and the magazine *291* with which Picabia was then connected in New York:

> **This is the first day for I dont know how long that I have envied any man his spending money. It seems to me that Picasso alone, certainly among the living artists whom I know of, is in anything like the same class. It is not merely knowledge of technique, or skill, it is intelligence and knowledge of life, of the whole of it, beauty, heaven, hell, sarcasm, every kind of whirlwind of force and emotion. Vortex. That is the right word, if I did find it myself – – –**
>
> **In all this modern froth – that's what it is, froth, 291, Picabia, etc. etc. etc., Derain even, and the French – there isn't, as far as I have had the opportunity of knowing, ONE trace of this man's profundity.**[60]

After his gradual withdrawal from the London scene during 1920 and 1921, Pound's estimation of Picabia's work as artist was to rise. Pound wrote to Wyndham Lewis during 1921 about his new plans for the *Little Review:*

> **I should take you, Brancusi, Picasso, and surprising as it will seem to you, Picabia, not exactly as a painter, but as a writer. He commences in *Pensées sans paroles* [sic] and lands in his last book *J. C. Rastaquouère* and there is also more in his design stuff than comes up in repro.**[61]

Though by 1921 Picabia had broken away completely from the central Dada movement in Paris, the works mentioned by Pound are generally regarded as products of Picabia's most Dadaist period: in his *Dada, Art and Anti-Art* Hans Richter claimed *Jésus Christ Rastaquouère* as one of the 'classics' of French Dadaism, constituting 'the high-water-mark of literary production in 1920'.

Although he was never directly involved in any of the zanier doings of the French Dadaists, Pound's work appeared in several of their publications, including Dada No. 7 (*Dadaphone*) in March 1920, in *Littérature* No. 16 (October 1920), and in Picabia's *391* No. 16 (*Le Pilhaou Thibaou*) in June 1921; he also contributed to the Dutch Dadaist periodical *Mécano*. Furthermore, he was responsible for publication of some of the Dadaist work which appeared in the *Little Review* after 1920, culminating in the special issue, most of which was

devoted to the work of Picabia, in spring 1922.

Pound's visit to Paris in 1920, and his subsequent 'exile' there in 1921, were marked by a series of articles for the long-established and very conservative American literary journal *The Dial*, which he was hoping to modernise.[62] In these articles Pound showed that he regarded the spontaneous vitality of the young French avant-garde artists – to whom he frequently referred – as a corrective to both the entrenched conservatism of most English literary activity and the brash and wilful fashionableness of much American work – 'a poetic serum to save English letters from post-mature and American letters from premature suicide and decomposition'.[63]

It was on such grounds that Pound supported the 'indiscipline' and the attacks on literary over-seriousness by writers such as Breton and Aragon who 'have expressed a desire to live and die, preferring death to a sort of moribund permanence'.[64] At the same time it is important to remember, again, that Pound's call for rejection was never as total as that of the young Dadaists. His sympathy was with their attack on 'the more obvious imbecilities of one's immediate elders', not with any call for a complete break with the past.

In my view, it is a mistake to claim as Dadaist Pound's various contributions to the magazines of Paris Dada, or to the Dada numbers of the *Little Review*. In *Dadaphone* (March 1920), for example, there is a translation by the Dadaist Georges Herbiet of Pound's 'Moeurs contemporaines' – eight poems published originally in *Quia Pauper Amavi* (1919). In the margin of another page of the issue the following appears: 'Paris quoi? Paris centre du monde? Quoi? Et je suis ici depuis trois moin sans trouver une maitresse convenable.' Andrew Clearfield has pointed out[65] that this comment is taken from a letter written by Pound to Picabia. Pound's most Dadaist contribution is the full-page prose-poem entitled 'Kongo Roux', which Clearfield described as:

a pastiche of historical references, contemporary events, Pound's own bizarre theorizing about the Jews and international finance, and typical Dada *jeux d'esprit*. The irregular typography appears to be Pound's own attempt to imitate Picabia's eccentricities. [66]

A more convincing explanation, it appears to me, is that 'Kongo Roux, is Picabia's more eccentric arrangement – with or without Pound's connivance, of some of Pound's eccentric views expressed in letters to Picabia.

In the *Little Review* and elsewhere Pound's 'Dadaist' contributions exhibit, to say the least, ironic ambiguity in relation to some of the Dada movement's American sympathisers, as in the two 'Poems of Abel Sanders' which were published in the *Little Review* (No. VIII, p. 111) in Autumn 1921. These poems were mockingly dedicated to Bill Williams and to 'Else von Johann Wolfgang Loringhoven y Fulano':

CODSWAY bugwash
Bill's way backwash
FreytagElse ¾arf an'arf
Billy Sunday one harf Kaiser Bill one harf
Elseharf Suntag, Billsharf Freitag
Brot wit thranen, con plaisir ou con patate pomodoro

Bill dago resisting U.SAgo, Else ditto on the verb
basis yunker, plus Kaiser Bill reading to goddarnd stupid wife anbrats works
of simple
domestic piety in Bleibtreu coner of Hockhoff'sbesitzendeecke
before the bottom fell out. Plus a little boiled Neitzsch
on the sabath. Potsdam, potsdorf potz gek und keine ende.
Bad case, bad as fake southern gentlemen tells you
everymorn that he is gentleman, and that he is not black.
Chinesemandarinorlaundryman takes forgranted youwillsee he is
not BookerTWashington.

: : : : : :

Poem No. 2.

Able Abel
Mounts dernier bateau :
@¼%&:¼/?½ @¾) (&?;¼%@&%&&&&&
¼¼¼¼@¼% ;34%3

It must be explained that this issue of *Little Review* contained Bill Williams' 'écriture automatique, Kora in Hell: Improvisations (1920)' and an incomprehensible review of Williams' work by Baroness Else von Loringhoven. An additional comment printed (sideways) on the same page

dada
deada
what is deader
than dada

holds a similar ambiguity of attitude.

These not-too-serious manifestations of Pound's attitude towards Dada art demonstrate that he was able to regard Dadaism much as he later came to regard Surrealism as a symptom of a recurrent and perhaps necessary disturbance in art and society. As always he could look with unaffected enthusiasm at such new and youthful art for signs of genuine creativity without too much critical interest in underlying philosophical principles. The wavering in Pound's mind at this time was reflected, as we should expect, in his poetry as well as in his criticism – in the mind that could begin the 'Ode pour l'Election de Son Sepulchre' in *Hugh Selwyn Mauberley* with lines which emphasised his commitment to poetic tradition:

For three years, out of key with his time,
He strove to resuscitate the dead art
Of poetry; to maintain 'the sublime'
In the old sense . . .

and could end with the deeply felt anguish and anger of:

There died a myriad,
And of the best, among them,
For an old bitch gone in the teeth,
For a botched civilisation,

Charm, smiling at the good mouth,
Quick eyes gone under earth's lid,

For two gross of broken statues,
For a few thousand battered books.[67]

The last lines are in no sense a contradiction of the opening ones; they are complementary. This is close to the precarious 'balance' of which Aldous Huxley and André Maurois approved, keener and more disturbed perhaps; but the balance here is sufficient to keep in check any impulse towards a mindless destruction.

JOHN RODKER AND THE *LITTLE REVIEW*

Something of Pound's desperate hunger for the new, and of his energetic determination to publish and defend recently completed work or substantial 'work in progress', had been shared by the editorial staff of the *Little Review*, which included after 1918 the English poet, novelist, translator[68] and publisher John Rodker. Rodker, who became 'foreign editor' of the *Little Review* during the immediate postwar period, had been a contributor to *The Egoist*, and four of his poems had appeared in Pound's *Catholic Anthology* (1915). Rodker was a pacifist and had served some time in prison during the war years for his beliefs. After the end of the war he was very active in publishing. His most important literary work was in connection with the Egoist Press, for whom he undertook the first publication in book form of James Joyce's *Ulysses* (Paris, October 1922).[69] Rodker's own Ovid Press produced limited first editions of some of Pound's major poems, including *The Fourth Canto* (1919) and *Hugh Selwyn Mauberley* (1920). Rodker's novel *Adolphe* (1920) attracted qualified praise from Pound.

As foreign editor of the *Little Review* (a position which he held from the end of World War I until Autumn, 1921, when Picabia took over this title with Pound as a collaborating editor) Rodker was a regular contributor of poems and literary comment to the periodical and he appears to have shared most of the notoriously indiscriminate postwar enthusiasms of its American editors, Margaret Anderson and Jane Heap (jh). Perhaps the most remarkable contributions to the magazine at this time were the Dada-style 'phonic' and 'experimental' poems of the remarkable Baronness Else von Freytag-Loringhoven.[70] In the issue for March, 1920, for example, the poem printed overleaf appeared.[71]

Klink—Hratzvenga
(Deathwail)

Narin—Tzarissamanili
(He is dead!)

Ildrich mitzdonja—astatootch
Ninj—iffe kniek—
Ninj—iffe kniek!
Arr—karr—
Arrkarr—barr
Karrarr—barr—
Arr—
Arrkarr—
Mardar
Mar—dóórde—dar—

Mardoodaar! ! !

Mardoodd—va—hist—kniek— —
Hist—kniek?
Goorde mee—niss— — —
Goorde mee! ! !
Narin—tzarissamanilj—
Narin—tzarissamanilj! ! !
Hee—hassee?
O—voorrr!

Kardirdesporvorde—hadoorde—klossnux
Kalsinjevasnije—alquille—masré
Alquille masréje paquille—paquille
Ojombe—ojoombe—ojé— — — —

Narin—tzarissamanilj—
Narin—tzarissamanilj ! ! !
Vé—O—voorrr—!
Vévoorrr—
Vrmbbbjjj—sh—
Sh—sh— —
Ooh ! ! !
Vrmbbbjjj—sh—sh—
Sh—sh—
Vrmm.

It is perhaps not surprising that the *Little Review* laid claim to having encouraged a Dadaist spirit in New York, though strange to say there were no signs in the magazine of any awareness of the earlier contributions of Picabia's *291* and *391* in New York. Commenting briefly on the activities of French Dadaism in the *Little Review* for June–August 1920 (Vol. VII, No. 2), Rodker quoted verses by Evola (the Italian Dadaist), Ribemont-Dessaignes, Dermée, and Tzara, and though he found them not very original, he did understand that Dadaism and earlier avant-garde movements had different principles: 'We seem to remember Marinetti at this game. *Dada* is different. It says it won't take seriously (beyond coin, I mean) its lack of seriousness.'[72] He recorded Pound's excitement at the news of the arrival of the Zürich Dadaists in Paris, but Rodker seemed to be more concerned to suggest that the *Little Review* had pre-empted Paris: 'It is possible that Else von Freytag-Loringhoven is the first Dadaiste in New York and that the *Little Review* has discovered her.' During 1920 this New York 'Dadaiste' was a frequent and prominent contributor to the *Little Review*, though when Pound reappeared with Picabia in 1921 she was overshadowed first by the French Dadaists, to be followed by the Surrealists, and indeed by many of the most avant-garde European writers. In the autumn 1924–winter 1925 issue the review quoted with pride the adverse comment of H. L. Mencken: 'What one observes in the Little Review and other such advanced sheets is simply a sort of organised imbecility.'[73] Whether or not one shares such a view of the *Little Review* after World War I, it must be conceded that both Pound and Rodker had also encouraged some of the magazine's most provocative 'experimental' activities and, therefore, had helped to set a definite style for the Anglo-American avant-garde review of the nineteen-twenties – one which was to reappear in *This Quarter* (founded 1925) and *transition* (founded 1927), for example.

It must be added that when the *Little Review* ceased publication in 1929 the editors received much praise for their work between 1914 and the end of the war. T. S. Eliot wrote:

> I have, I believe, a complete file of *The Little Review* of the days in which Pound was foreign editor and both he and Lewis and I were occasionally contributors, and the serial parts of 'Ulysses' were eagerly awaited. In those days *The Little Review* was the only periodical in America which would accept my work, and indeed the only periodical there in which I cared to appear.[74]

Ford Madox Ford also praised[75] the achievements of the magazine during the war years when its contributors had included Flint, Aldington, Yeats, as well as Ford himself and, of course, Joyce, Eliot, and Pound.

WYNDHAM LEWIS AND ANTI-ART

A curious contrast to Ezra Pound's immediate postwar dissatisfactions

is to be found in the activities of Percy Wyndham Lewis (1882–1957). Lewis, a founder-member with Pound of English Vorticism, had spent most of the war years in the Royal Artillery. As well as being a novelist, short-story writer, and poet of distinction, he was a graphic artist and painter of dynamic originality; but many critics would claim that his distinctive claim to fame as a modern artist lies in his ideas and his criticism. After demobilisation Lewis returned to London with, if anything, increased optimism about the possibilities open to the artist of genuine talent. Several of his closest friends and colleagues – notably T. E. Hulme and Henri Gaudier-Brzeska – had been killed during the war, but Lewis was apparently prepared to resume with unquenchable zest the struggle for 'new art' (particularly, though not only, painting) which he had led before his enlistment in 1915. In his most optimistic moods he was inclined to believe that the main struggle was over and the battle already won. Writing in the *English Review* for April 1919,[76] Lewis proposed the real postwar task as one of consolidation of the gains of prewar modernism:

> **The general question as to what art we are going to have for the next decade, or, rather, if it will be different from what we had before the war, can be answered quite directly and certainly and for all the arts. The war has not changed our industrial society or the appearance of our world; nor has it made men desire different things, only possibly the same things harder still. Therefore, as you find the appearance of the world and the volition of men, so you will find art. An extreme political readjustment of our society in the near future even would not disturb these fundamentals of what art today must be, I should imagine.**
>
> **The innovations in painting, pressed everywhere before the war, have by their violence and completeness exhausted the scope of progress on that point. That America may be considered as not only discovered, but crossed and cross-hatched from side to side, with the surveys and trekkings of its invaders. Expressionism, Cubism, Vorticism, all these movements now have to set about construction and development, and evolve a new world of art out of the continent their enterprise has acquired.[77]**

Nowhere in Lewis's writings, however, is it possible to find any attempt to defend 'new art' by rejecting the achievements of the past. The essay just quoted included a typically forceful expression of his attitude towards fashionable and stupidly destructive 'innovation':

> **Artists do not experiment to give old Breughel one in the eye, or to go one better than Monsieur Tel et Tel, or to *improve* on this creation or on that. The particular attitude of mind and of speech we have just dealt with is confined to the unproductive cafe-haunting microbe, many of whose attitudes and imbecilities are attributed to artists.[78]**

Lewis's period of optimism lasted just long enough to enable him to edit *The Tyro* (1921–1922), both issues of which, though announced as 'A review of the arts of painting, sculpture and design', included

literary contributions (criticism, poetry, and short stories) from Lewis himself, and also from T. S. Eliot (sometimes alias Gus Krutzsch), John Rodker, and Herbert Read. In *The Tyro* Lewis continued to argue the success of the prewar modern movements, and he confidently believed that the work reproduced in the magazine represented the continuity of that success.

Long before the end of the decade, however, Lewis's hopes – particularly for British painting – had been dashed, and his criticism was to become increasingly pessimistic. He came to regard the war as the direct or indirect cause of the abandonment of the positions won by modernism. Sometimes, at his most passively resigned, he regarded the loss of the experimental impulse itself – art as 'game' – to have occurred as the direct result of the general destructiveness and turmoil of the war and its aftermath. In his autobiography, *Blasting and Bombardiering* (1937), Lewis gave eloquent expression to both his hopes and their defeat:

> **A few arts were born in the happy lull before the world-storm. In 1914 a ferment of the artistic intelligence occurred in the west of Europe. And it looked to many people as if a great historic 'school' was in process of formation. Expressionism, Post-impressionism, Vorticism, Cubism, Futurism were some of the characteristic nicknames bestowed upon these manifestations, where they found their intensest expression in the pictorial field. In every case the structural and philosophic rudiments of life were sought out. On all hands a return to first principles was witnessed. . . .**
>
> **These arts were not entirely misnamed 'new' arts. They were art especially intended to be the delight of this *particular* world. Indeed, they were the heralds of great social changes. Then down came the lid – the day was lost, for art, at Sarajevo. World-politics stepped in, and a war was started which has not ended yet: 'a war to end war'. But it merely ended art. It did not end war.**
>
> **Before the 'great War' of 1914–18 was over it altered the face of our civilisation. It left the European nations impoverished, shell-shocked, discouraged and unsettled. By the time President Wilson had drawn up his famous Fourteen Points the *will to play* had been extinguished to all intents and purposes forever in our cowed and bankrupt democracies.**[79]

At other times Lewis was to trace the human failure of these artistic hopes to the wrong paths taken by Dadaism and Surrealism during the nineteen-twenties. In this more active, and responsible, mood he was to use every argument and insult in his inventive mind to pursue the betrayers. In his review *The Enemy* (three issues, Nos. 1 and 2, 1927, and No. 3, 1929), and indeed in nearly all his critical writings during the late twenties and throughout the thirties, Lewis harangued the Dadaists, Surrealists, and the 'quasi-surrealists' of the '*transition-welt*' for failing in their responsibilities to modern art and to the public who needed such art:

A dozen people, Paris 'intellectuals', who earned a comfortable living as civil servants in ministries, or in advertising offices (which is what the 'Dadaists' were) spent their spare time in concocting politico-aesthetic manifestoes and promoting exhibitions of 'more-than-real-objects'.

For twenty years or more before this the patience of the public had been sorely tried. It did not know that a new age had made its appearance – it thought, as it always does, that it was still living in the age of the French Impressionists. Van Gogh had been more than it could stomach; and Picasso strained its credulity to the breaking-point.

Then had come the War; a gigantic pause, when it got something it really *did* understand – shrapnel and poison gas. And, as I have indicated at the beginning of this essay, that wrote *finis* to any hopes – for I daresay a century – of attending to the art-needs of the new-born epoch. Such dreams had definitely to be laid aside.

It was *then* that Dada got busy. The raree-shows labelled 'super-real' (in which the public were solemnly shown a lot of uproariously assorted junk) the final effort of Dada, was like an answer to their prayer to be quit of all this 'modern' nonsense. As if the public had not enough to worry about as it was!

They had at last become convinced that all along – and by *everybody*, who had ever 'cubed' or 'vorticised' – they were having their legs pulled. Here was the proof at last. The result was that people stopped buying pictures altogether, or bothering about 'art' at all.[80]

And for Lewis the failure of the whole modern movement in painting could be traced directly back to the wartime and postwar influence of Dadism:

What had been really deadly for painting has been what was first 'Dada' and then all that irresponsible journalism of the 'super-real' that came out of Dada. As painting slumped, that fungus waxed and flourished.[81]

T. S. ELIOT AND ENGLISH MODERNISM

To turn to the critical views of T. S. Eliot during and just after World War I is to discover a style of criticism recognisably closer in several important ways to that of English critics such as F. S. Flint and Harold Monro. At least this is so when Eliot's essays are compared with those of either his fellow-American, Pound, or Lewis (whose father was American). For all his close collaboration with Pound and Lewis, Eliot possessed qualities of sympathy and tact which they either lacked or eschewed, and these qualities contributed to his slow but finally complete adoption by English critics, writers, and readers. In his autobiography *Life for Life's Sake* (1941), Richard Aldington compared the relative fortunes of Pound and Eliot and London:

Ezra started out in a time of peace and prosperity with everything in his favour, and muffed his chances of becoming literary dictator of London – to which he undoubtedly aspired – by his own conceit, folly and bad manners. Eliot started in the enormous confusion of war and post-war England, handicapped in every way. Yet by merit, tact, prudence, and

Aldington fails to point out that Pound's refusal to take root here was as great a loss for English letters as it was a personal tragedy for Pound himself, but his analysis of the situation from an English viewpoint is convincing.

Between the final issue of *The Egoist* (December 1919) and the beginning of *The Criterion* (October 1922), Eliot had no literary journal of his own, but there are no very marked changes of attitude between these two important periodicals. In one of the talks broadcast just after the end of World War II, on the subject of 'The Unity of European Culture',[83] Eliot described to his German listeners his aims in founding *The Criterion*, the first issue of which contained 'The Waste Land'. He suggested that *The Criterion* shared a 'common basis' with such European literary periodicals as *La Nouvelle Revue Française*, the *Neue Rundschau*, the *Neue Schweizer Rundschau*, the *Revista de Occidente* (Spain), and *Il Covegno* and other Italian periodicals. This basis was:

> **a common concern for the highest standards both of thought and expression, [and] . . . a common curiosity and openness of mind to new ideas. The ideas with which you did not agree, the opinions which you could not accept, were as important to you as those which you found immediately acceptable. You examined them without hostility, and with the assurance that you could learn from them. In other words, we could take for granted an interest, a delight, in ideas for their own sake, in the free play of intellect.**[84]

The characteristic quiet authority of Eliot's views, founded on just such principles for public debate, is discernible as much in his earliest literary essays, which appeared in the *New Statesman*, *The Egoist*, and *Art and Letters*, as in such postwar periodicals as the resurrected *Athenaeum*, *The Tyro*, and *The Criterion*. Every student of modern literature is aware that Eliot's constant theme throughout this period was the importance of a sense of the literature of the past. He immersed himself particularly in studies of English literature (especially the poetry and drama of the Elizabethans and Jacobeans), and these studies were to be a revelation to many English readers of the richness and the relevance of their own literary heritage. On the other hand, Eliot's criticism, like his poetry, never allows any scope for mere indulgence of narrow-minded complacency and parochial self-congratulation. He could be as severe as any other critic, especially when he contrasted bad contemporary writing in English, or past literature which had an adverse influence on contemporary writing, with good literature from any other time of place. For all his 'tact' and 'prudence' he did not spare Swinburne and other popular English romantics, for example, or the Georgians, or the contributors to

Wheels, for what he considered to be their bad example and influence.

A keystone of Eliot's theoretical writing at this time is the famous postwar essay 'Tradition and the Individual Talent' which originally appeared in *The Egoist* during September and October 1919, shortly before the demise of that periodical. Eliot's insistence on the importance, for the creative artist, of an awareness of the literature of the entire European past, on the continual living presence of that past, and, above all, on the need for intelligence and standards of high excellence in the writing of poetry, were all balanced by his view of the poet's task as the exploration of the 'medium' of language, and the final mysteriousness of the creative process which is suggested in the following extract:

> **It is a concentration, and a new thing resulting from a concentration, of a very great number of experiences which to the practical and active person would not seem to be experiences at all; it is a concentration which does not happen consciously or of deliberation.**[85]

Any suggestion that 'The Waste Land' itself was a poem expressive of despair, disillusionment, or pessimistic melancholy was always strongly resented by Eliot. Probably an important reason for Eliot's reluctance to be characterised as a pessimistic writer was his fear of being misunderstood to be a more pessimistic writer than he really was. That is, Eliot distinguished carefully between a philosophy or attitude of despair and disillusionment and the poetic manifold which, for the too-simple critic, might be taken to express such a philosophy or attitude. At the time he was writing 'The Waste Land' Eliot referred in *The Tyro (1921)* to *'a deliberate school of mythopaeic nihilism'*[86] in contemporary French literature. It is tempting to see here indirect reference to Dadaism and to its French precursors, particularly perhaps to the Ubu character of Alfred Jarry whose first appearance on the Paris stage had so horrified not only the Frenchmen who were supposed to recognise themselves but also W. B. Yeats, who saw the underlying savagery enacted and presaged in Jarry's play.[87]

Whatever 'The Waste Land' was therefore, it is clear that, as far as its author was concerned, it was not the expression of any doctrine, and especially not nihilism. Sometimes this distinction between the poem and the doctrine can create a sense of disorientation for the reader who is erroneously looking for some kind of 'formulation'. Nowhere is this sense of disorientation more likely to occur than in reading through the first volume of *The Criterion* where Eliot continually, solemnly and even primly, warns against the dangers of chaos and disorder to readers who have just gone through the experience of reading 'The Waste Land' for the first time. It must have been difficult to reconcile Eliot the artist, who produced the final lines of 'What the Thunder Said', for example, with Eliot the critic, who wrote in a 'Note' in the July 1923, issue of *The Criterion*:

> ... in our time the pursuit of literary perfection and the preoccupation
> with literature and art for their own sake, are objects of attack, no
> longer in the name of 'morals', but in the name of a much more
> insidious catchword 'life'. I say 'more dangerous' because the term
> 'morals', at worst, stands for some order and system, even if a bad one;
> whereas 'life' with much vaguer meaning, and therefore much greater
> possibilities of unctiousness, may be more a symbol of chaos.[88]

To refer back to Mr. Lucie-Smith's article (pages 36–7, Chapter 2), it
has to be said, in answer to his labelling of Eliot's 'The Hollow Men' as
one of the 'mild echoes' of the Zürich, Berlin, and Paris explosions, that
if 'The Hollow Men' is a mild echo of anything it is of 'The Waste Land',
and comes within the tradition of that poem rather than that of
rationalist nihilism or destructive extremism, both of which Eliot
deliberately and responsibily rejected.

Another of the difficulties which Eliot bequeathed to his critics was
that of reconciling his full commitment to Europe (and his struggle
after 1922 and until 1939 in *The Criterion* to achieve the greatest
possible communication between all the countries of Europe) with the
priority of his concern for English literature. In an otherwise
extremely astute assessment of the relationship between Eliot's
'Europeanism' and his Englishness – as represented in *The Criterion* –
Herbert Howarth, in his *Notes on Some Figures Behind T. S. Eliot*
(1965),[89] argued that one of the 'disappointments' of the first issue of
The Criterion was Hermann Hesse's 'Recent German Poetry'.[90] The
flatness of this contribution from Hesse, Howarth suggested, led to
Eliot's not publishing him again. It is true that Hesse's commentary on
the contemporary poetic scene in Germany was rather more depressing
even than that of Eliot's reviewers of French verse at that time,
Richard Aldington and F. S. Flint, both of whom found little of any
value whatsoever in the work of the younger French poets. Apart from
Sternheim, Herman Hesse (1877–1962) named none of the writers to
whom his generalisation referred, but those generalisations, I believe,
represented a point-of-view entirely consistent with that of *The
Criterion*'s other commentators (including Eliot himself) on the
postwar European literary scene.

The genuine reason for the failure of Hesse to appear again as
German poetry reviewer in *The Criterion* – at least, during the years
after World War I – is to be found in his opening statement that he had
read 'a large number of books by the latest German poets' and that 'My
labour, although instructive, has been no pleasure to me, and I do not
intend to go on with it any longer'. Hesse identified two major groups of
younger poets, one slavishly orthodox and dogmatic in its modernity
(and already outmoded), the other moving 'lingeringly, but more or
less consciously and determinedly towards chaos'. To some of these
poets, form mattered so little that they employed old forms with casual
indifference; to others, the urge towards breakdown was more
purposive:

[They] drive impatiently forward, and seek consciously to hasten the disintegration of the German literary language – some with the sullen grief of the man who breaks up his own house, others with reckless humour and in the somewhat shallow mood of complete indifference to the ruin of the world. The latter, since art offers no further satisfactions, want at least to have a little fun at the expense of the philistines and to laugh a while and make merry before the ground collapses beneath them. The whole of literary 'Dadaism' belongs hereto.[91]

Hesse did not feel particularly pessimistic about this from a long-term view. The recognition by the young of the bankruptcy of prewar culture and their discovery of the significance of Freudian psychology were welcomed by him as good 'foundations'. He approved also of the revolt by the young against the prewar and wartime, blind obedience of their elders to authoritarian figures:

Europe is seen by the youth of today as a very sick neurotic, who can be helped only by shattering the self-created complexes in which he is suffocating. And the otherwise tottering authority of the father, the teacher, the priest, the party, and of science finds a new and terrible antagonist in psycho-analysis, which projects so merciless a light into all the old modesties, apprehensions, and prudences.[92]

Nevertheless, he refused to take any further interest in the 'art' being produced acccording to these revolutionary principles. The Dadaists were 'more concerned with making a noise and the assertion of self-importance than with progress and the future', and the good foundations themselves – the experiences of the war and psychoanalysis – 'have hitherto produced no other effect than a kind of half-crapulous, half-frenzied outburst of puberty'.

Hesse's final paragraph would certainly have struck sympathetic chords in Eliot who, in the Notes to 'The Waste Land' (lines 366–70), had already referred to Hesse's *Blick ins Chaos* (1920): 'Schon ist halb Europa, schon ist zumindest der halbe Osten Europas auf dem Wege zum Chaos, fährt betrunken im heiligem Wahn am Abgrund entlang und singt dazu, singt betrunken und hymnisch wie Dmitri Karamasoff sang . . .':

And the new psychology, whose harbingers were Dostoievski and Nietzsche, and whose first architect is Freud, will teach these young men that the emancipation of the personality, the canonisation of the natural instincts, are only the first steps on the way, and that this personal freedom is a poor thing and of no account in comparison with that highest of all freedoms of the individual: the freedom to regard oneself consciously and joyously as a part of humanity, and to serve it with liberated powers.[93]

As we might have expected from the subtly ordered complexity of his general position, as much as from his belief in the essentiality of a sense of tradition, Eliot himself gave Dadaism little more than a

passing glance, regarding it as a foreign irrelevance. In doing so, however, he managed to use it as a stick with which to beat many of his literary foes. In the first issue of *The Tyro* (1921), Eliot wrote a short piece called 'The Lesson of Baudelaire'.[94] His first point was that Dadaism was essentially a symptom of a French sickness, and was mainly irrelevant for an English readership:

> With regard to certain intellectual activities across the Channel which at the moment appear to take the place of poetry in the life of Paris, some effort ought to be made to arrive at an intelligent point of view, on this side. It is probable that this French performance is of value almost exclusively for the local audience; I do not here assert that it has any value at all, only that its pertinence, if it has any, is to a small public formidably well instructed in its own literary history, erudite and stuffed with tradition to the point of bursting. Undoubtedly the French man of letters is much better read in French literature than the English man of letters is in any literature and the educated English poet of our day must be too conscious, by his singularity in that respect, of what he knows, to form a parallel to the Frenchman. If French culture is too uniform, monotonous, English culture, when it is found, is too freakish and odd. Dadaism is a diagnosis of a disease of the French mind; whatever lesson we extract from it will not be directly applicable in London.

The value of Dadaism, then, depended upon how far 'it is a moral criticism of French literature and French life'. The lesson of Baudelaire, on the other hand, was that 'all first-rate poetry is concerned with morality'. From the lessons of Baudelaire and of Dadaism Eliot was able to lead a number of spirited attacks against romantic writing and writers, particularly Rousseau ('not only was the foundation of Rousseau rotten, his structure was chaotic and inconsistent'), though even romantic writers who attempted to be 'moral' (including Byron, Goethe, and Poe) were 'incoherent'.

English poetry was criticised for its failure to be serious; Milton, Tennyson, and Browning were 'trifling'. The contemporary scene stood accused of the worst trifling of all:

> As for the verse of the present time, the lack of curiosity in technical matters, of the academic poets of to-day (Georgian *et cetera*)is only an indication of their lack of curiosity in moral matters. On the other hand, the poets who consider themselves much opposed to Georgianism, and who know a little French, are mostly such as could imagine the Last Judgement only as a lavish display of Bengal lights, Roman candles, catherine wheels, and inflammable fire-balloons, *Vous, hypocrite lecteur* . . .

One can only imagine that Eliot assumed that his readers – especially Edith Sitwell and other contributors to *Wheels* – would know the full context of Baudelaire's words. But even with the implied judgment against himself it is hardly a good example of 'tact' of a mealy-mouthed variety.

Moving confirmation of the steadying influence by Eliot on the minds of the younger generation of writers who returned from the war, quite often totally shattered in spirit, was given by Richard Aldington (1892–1962). Before the war Aldington had been actively involved in the English avant-garde, particularly the Imagist and Vorticist groups. He had received early recognition as a member of the Imagist group, and in 1913 he had married one of its leading American contributors, Hilda Doolittle ('H.D.'). He contributed poems and critical articles to many of the leading literary periodicals, including *The New Freewoman*; when this became *The Egoist*, Aldington was appointed literary editor, though Harriet Weaver was nominal editor. T. S. Eliot took over this position from Aldington in 1917. Aldington had supported the aims of Vorticism (including its rejection of Futurism), and he was one of the signatories to the declarations of *Blast*.

Like so many of his contemporaries (including, for example, Robert Graves and Herbert Read), Aldington returned to postwar literary life in an attitude of profound disgust and bewilderment. This attitude was strengthened by his having suffered severe shell-shock. Some of the poems which he produced at this time demonstrate his feelings of confused horror at his war experiences. A powerful example is his free-verse poem 'Bodies'[95] which appeared in *The Anglo-French Review* for March 1920:

Your slight delicate body lies on the coloured cushions before the fire; red light blooms in its glossy shadows and the higher curved flesh glows white and gold. Your eyes are half shut, your clear red lips just parted: under the small left breast I see the beating of your heart. I sit and watch you as you drowse there: you are life.

But the horror will not leave me yet; suddenly my senses are gripped by ghastly memories. I struggle against them. Useless. The beauty of your body goes, the room, the silence, the glow of perfume.

I stand with a calm old Frenchman by a ruined outhouse in a by-street of the village.

'Behind that door, Monsieur,' he says, 'you will find another of them.'

The filthy stench of rotten flesh assaults my throat and nostrils, terrifies the animal in me. I bend – as I now bend over you – and note the shattered bloody skull, the grinning fixed face desecrated with dust, blue-grey like the uniform. It is a young officer. Someone has stolen his boots. He was handsome once. How would his mistresses like him now? Pouf! What a stink!

The old man is unmoved.

'There is another down the street, Monsieur.'

'Show me, I will have them buried.'

Let me not shriek – let me hide my face in your pale odorous breasts and shudder a little and try to forget.

In his autobiography, *Life for Life's Sake*, Aldington recalled vividly the feelings of disgust and disillusionment which haunted him in the period after the Armistice:

> Every night as I read or lay sleepless I heard the raucous shouts and whoops of drunken revellers, a strange disorderliness in the decorous West End. I am no enemy to rejoicings, but this debauchery over ten million graves seemed to me indecent. I saw nothing to rejoice about, having too many vivid recollections of endless desolation and rows upon rows of wooden crosses.[96]

Just such nightmare was recorded in the long poem 'The Blood of the Young Men' which first appeared in *Images of War* (1919). The following extracts demonstrate the universal horror and sense of isolation experienced by many of the returning soldiers among normal civilian activities:

II
Day has become an agony, night alone now,
That leisurely shadow, hides the blood-stains,
The horrible stains and clots of day-time.

III
All the garments of all the people,
All the wheels of all the traffic,
All the cold indifferent faces,
All the fronts of the houses,
All the stones of the street —
Ghastly! Horribly smeared with blood-stains.

IV
The horror of it!
When a woman holds out a white hand
Suddenly to know it drips black putrid blood;
When an old man sits, serene and healthy,
In clean white linen, with clean white hair,
Suddenly to know the linen foully spotted,
To see the white hair streaked with dripping blood.[97]

VII
We, any few that are left, a remnant
Sit alone together in cold and darkness,
Dare not face the light for fear we discover
The dread woe, the agony in our faces,
Sit alone without sound in bitter dreaming
Of our friends, our dear brothers, the young men
Who were mangled and abolished, squeezed dry of blood
Emptied and cast aside that the lakes might widen,
That the lips of the women might be sweet to the old men.

The fact that these lines – and indeed the whole poem, and many others in *Images of War* – show signs of hysterical over-writing by

Aldington may say little for Aldington's stature as a war-poet, but they do indicate the dramatically altered state of mind of a man who had been one of the leading figures in the Imagist school in 1914. It is in the context of lines and poems such as this that we have to assess Aldington's testimony that Eliot's example (rather than any exhortation) had been crucial in supporting his saner instincts. The passage (again from *Life for Life's Sake*) is worth quoting in full:

I believe personally that Eliot's greatest service to English literature at that time was his insistence that writers could not afford to throw over the European tradition. Just after the war, in the confusion and reaction against everything prewar and war, there was an almost unanimous belief among artists of the vanguard that all the art of the past was so much dead stuff to be scrapped. They were wilfully trying to make themselves barbarians. I felt unhappy about this, for my instinct was to do just the opposite. After the long hiatus of the war I thought we should for a time at least steep ourselves in the work of the masters; but nobody would agree with me. I was delighted, therefore, when I came across a sensitive and well-written article on Marivaux in one of the small arty periodicals which sprang up in 1919. Evidently here was somebody who did not believe that illiteracy was a symbol of originality.[99]

More importantly, Aldington followed Eliot's example, at least as reviewer. He too embarked on an exploration of what he regarded as the relevant and living past, and in his turn Aldington helped to encourage an intelligent and responsible reconstructive attitude.

As reviewer of French literature for *The Anglo-French Review*, *The Times Literary Supplement*, and *The Criterion*, Aldington, who throughout his life showed little sympathy for the more extremist modes of experimental modernism, refused to take the explosive productions of some of his French contemporaries seriously.

His total impatience with the products of the Dadaists[100] was not simply the unthinking and ignorant conservatism of the literary establishment; nor did it stem from facile optimism, escapism, or ignorance about Dadaism. *The Times Literary Supplement*, for which Aldington and Flint were prominent reviewers of French literature, took some notice of the work of the younger French writers for a year or two after the Armistice. All the reviews of 1919 and 1920 followed the line taken by F. S. Flint in his *Chapbook* articles (probably for the simple reason that most of them were written by Flint himself). After 1920, however, the journal took very little interest in the Dadaists or in their successors, the Surrealists. Between 1920 and 1925, there were brief references to odd productions by members of the groups, including a short notice in praise of Soupault's edition of the *Poésies* of Isidor Ducasse,[101] and to Aragon's *Anicet*,[102] but after 1921 the journal turned its back for several years on both Dadaism and the young French Surrealists who had belonged to that movement. In this

respect, the *Times Literary Supplement* typified most intelligent literary response in this country.

The Anglo-French Review, one of the periodicals to which Aldington was a regular contributor, had also been early in its attention to Dadaist activities. In the issue of June 1920 Jean Lefranc had attacked the movement in an essay in French 'La crise Dada',[103] and the editors of the magazine, Henry D. Davray and J. Lewis May, were to remain unimpressed by anything the Dadaists did or were to do. Like Eliot, Aldington concentrated his efforts on studies of those writers, past and present, who were thought to have made works of art worth making and to have said things worth saying and resaying, both for their own time and for a Europe in postwar ruins.

Aldington's major reviews and studies[104] during this period followed the example of Eliot, and were not to be troubled by the Dadaists any more than they were by the dead hand of the literary establishment. In his essay 'The Poet and his Age', which appeared in *Literary Studies and Reviews* (1924), Aldington showed that he accepted fully the rightness of Eliot's position; the enemies of English poetry were the extreme and the entrenched, both Left and Right:

> **A little of the poetry written in English, a good deal of French poetry and (if I am not misinformed) still more of German poetry, are now distinctly incoherent. On the other hand, a large proportion of recent poetry, particularly English, is stagnant, a repetition in a degraded form of something that has been done better before. The reader is in both cases disappointed; he feels that there is plenty of energy and intelligence and talent in the poetry I have called 'incoherent' but it fails to become art because it lacks *ordonnance*, while he feels that the order of the poetry I have called stagnant is arbitrary, artificial, and unintelligent. The poetry which this hypothetical reader is seeking, which, he is convinced can be written and will be written, has not yet emerged.**[105]

I believe that the examination of the immediate English response to Dadaism has exposed the fallaciousness of the view that the English, in their approach to that movement, were merely prejudiced, ignorant, and provincial. It is true that much entrenched and uninformed opinion did exist in postwar English literary life, but though it continued to exert influence – mostly in popular literary journalism – its power was waning and a whole new generation of younger writers and readers regarded such opinion with complete contempt. Much heat and energy were expended in the battles between the 'establishment' and some of the writers who emerged during the second decade of this century, but there is little evidence of any squandering of genuine talent in the furious paper war between the coteries of the extremes.

The period in English literature which produced James Joyce's *Portrait of the Artist as a Young Man* (1916) and *Ulysses* (1922); Ezra Pound's *Lustra* (1916) and *Hugh Selwyn Mauberley* (1920); T. S. Eliot's

Prufrock and Other Observations (1917) and 'The Waste Land' (1922); Ford Madox Ford's *The Good Soldier* (1915) and *Parade's End* 1924–1926); W. B. Yeats's *Responsibilities* (1914–1916) and *Michael Robartes and the Dancer* (1920); D. H. Lawrence's *The Rainbow* (1915) and *Women in Love* (1916–1920), as well as Percy Wyndham Lewis's *Tarr* (1918), Lytton Strachey's *Eminent Victorians* (1918), the posthumous poems of Wilfred Owen, Edward Thomas, and Isaac Rosenberg, Katherine Mansfield's *The Garden Party* (1922), and Virginia Woolf's *Mrs Dalloway* (1925) – to mention only some of its acknowledged finest achievements – such a period can hardly be regarded as provincial or insular. None of these writers, or their younger contemporaries, had very much patience for the destructive, wilder excesses of twentieth-century modernism. The achievement of their art is in itself almost sufficient reason for this. In the major literary reviews of the nineteen-twenties, which laid down new standards of intelligent, informed, and balanced response which were to revolutionise literary criticism in England – particularly *The Criterion* (1922–1939), *The Adelphi* (1923–1930, under the editorship of John Middleton Murry), and *The Calendar of Modern Letters* (1925–1927) – a similar refusal to abandon hard-won positions is to be found. There too the fight against both destructive negation and small-minded dullness was fiercely continued.

The myth that English literary life was cut off during the postwar period and through the nineteen-twenties from the most valuable literary activity of modernist Europe is one which will simply not stand up to scrutiny. The more interesting truth is that there was also much well-informed and responsible English opinion in the postwar period, and that writers and critics such as Aldous Huxley, Harold Monro, F. S. Flint, Wyndham Lewis, T. S. Eliot, and Richard Aldington – all of whom had central and influential roles in the literary journalism of the time – continued to demonstrate a sensitive, intelligent, and fairly balanced awareness of new developments in foreign literature while often expressing a strong distrust of these developments. I have tried to show how such men decisively and responsibly rejected extremist nihilist and destructive attitudes from whatever source without any relaxation of their constant attack on what they considered to be moribund English literary attitudes and inadequate critical standards.

NOTES

1 *The Athenaeum*, (31 October 1919), p. 1137.
2 *Ibid.*, (7 November 1919), p. 1163.
3 *Ibid.*, (14 November 1919), p. 1200.
4 *Ibid.*, (21 November 1919), p. 1237.
5 F. S. Flint, 'Some French Poets of Today', *The Chapbook*, I, 4, (October 1919), p. 1.
6 *Ibid.*, pp. 9–10.
7 *The Little Review* (Autumn 1921), pp. 43–96.

8 *The Chapbook*, I, 4, p. 10.

9 *Ibid.*, p. 11.

10 Flint made a slight error here; the poem actually appeared in *SIC*, No. 23 (November 1917).

11 *The Chapbook*, I, 4, p. 13.

12 'French War Poetry' (unsigned but by F. S. Flint), *The Times Literary Supplement* (2 October 1919), pp. 521–2.

13 Joy Grant, *Harold Monro and the Poetry Bookshop* (Routledge & Kegan Paul, London, 1967).

14 F. S. Flint, *In the Net of the Stars* Elkin Matthews, London, 1909).

15 F. S. Flint, 'Preface', *Otherword: Cadences* (Poetry Bookshop, London, 1920), p. xii.

16 G. S. Fraser, *Ezra Pound* (Oliver & Boyd, Edinburgh and London, 1960), p. 13.

17 Joy Grant, *op. cit.*, p. 118.

18 Joy Grant reminds us that Ezra Pound wrote to Harriet Monroe, the editor of *Poetry: (Chicago)*, on 28 March 1914 that this issue was 'something which everybody had to get'. Over eight years later May Sinclair, writing in the *English Review* a not over-enthusiastic article on 'The Poems of F. S. Flint', could state: 'If you want to know about the origin, development, worth, and significance of *vers libre*, you cannot do better for a beginning than read his "Contemporary French Poetry", published in The Poetry Review for August, 1912' (*The English Review*, January 1921, p. 17).

19 Flint's 'French Chronicles' were published as follows: *Poetry and Drama* I, No. 1, pp. 76–84; No. 2, pp. 217–31; No. 3, pp. 357–62; No. 4, pp. 473–84. *Poetry and Drama* II, No. 5, pp. 97–106; No. 6, pp. 211–20; No. 7, pp. 302–4; No. 8, pp. 393–403.

20 Joy Grant, *op. cit.*, p. 48.

21 *Poetry and Drama* I, pp. 291–305.

22 *Ibid.*, pp. 359–60.

23 *Poetry and Drama* IV (December 1913), p. 389.

24 *Ibid.*, p. 391.

25 See comment on Squire's work by Flint in *The Chapbook* (March 1920): 'Lack of artistic cohesion, lack of poetic rhythm, clumsiness: they can be found in all J. C. Squire's work' ('Notes on the Art of Writing; on the Artfulness of Some Writers; and on the Artlessness of Others', *The Chapbook*, II, 9 (March 1920), p. 22).

26 'Recorder' [Alida Monro] 'A Bibiliography of Modern Poetry', *The Chapbook*, II, 12 (June 1920), p. 46.

27 *Ibid.*, pp. 39–40.

28 'The Dada Movement' (unsigned but by F. S. Flint), *The Times Literary Supplement* (29 January 1920), p. 66.

29 In Edmund Wilson, *Axel's Castle*, p. 311.

30 F. S. Flint, 'The Younger French Poets', *The Chapbook*, II, 17 (November 1920).

31 *Ibid.*, p. 3.

32 *Ibid.*, p.4.

33 *Ibid.*, p. 4.

34 *Ibid.*, pp. 4–5.

35 *Ibid.*, p. 5.

36 *Ibid.*, p. 6.

37 *Ibid.*, pp. 6–7.

38 *Ibid.*, pp. 7–8.

39 *Ibid.*, p. 12.

40 *Ibid.*, p. 10.

41 *Ibid.*, p. 13.

42 *Ibid.*, p. 14.
43 *Ibid.*, pp. 14–15. (A full translation of Rivière's 'Reconnaissance à Dada' is given in *The Ideal Reader: Selected Essays by Jacques Rivière*, edited and translated by Blanche A. Price (Harvill Press, London, 1960), pp. 200–17).
44 *Ibid.*, p. 15.
45 *Ibid.*, pp. 25–6. The original text of the extract from 'Une plaque indicatrice' is as follows:

> Un libre et sérieux dessin de sa pensée,
> une simple effusion de soi-même,
> avec plus de bonté et une entière bonne foi.
> Ceci n'est pas une mutinerie,
> mais une méthode
> pour pouvoir durer et vaincre enfin
> l'anarchie qui va venir,
> et, d'où, grace à nous, si nous sommes forts,
> renaîtra un état meilleur,
> un statut juste de la conscience,
> aussi immaquablement que le désordre
> de l'heure que voici
> qui n'a de l'ordre que l'apparence,
> n'étant que haine et confusion . . .

46 Among the publications to which Flint refers (and to which I have added fuller bibliographical details) are: Tristan Tzara, *La Première Aventure Céleste de Monsieur Antipyrine* (Zürich, Collection Dada, 1916) with coloured woodcuts by Marcel Janco; *Vingt-cinq Poèmes*, (Zürich, Collection Dada, 1916) with ten woodcuts by Hans Arp; Francis Picabia, *Râteliers Platoniques* (Lausanne, 1918); *Unique Eunuque* (Au Sans Pareil, Paris, 1920, Collection Dada); Paul Eluard, *Le Devoir et l'Inquiétude* (pre-Dadaist poems); *Les Animaux et leurs Hommes: les Hommes et leurs Animaux* (Au Sans Pareil, Paris, 1920) five drawings by André Lhote; André Breton, *Mont de Piété* (Au Sans Pareil, Paris, 1919) two drawings by André Dérain; (with Philippe Soupault) *Les champs magnétiques* (Au Sans Pareil, Paris, 1920); Philippe Soupault *Aquarium*, 1917 (pre-dadaist poems); *Rose des Vents* (Au Sans Pareil, Paris, 1920) four drawings by Marc Chagall; Louis Aragon, *Feu de Joie* (Au Sans Pareil, Paris, 1920) one drawing by Picasso.
47 Paul Morand, *Lampes à Arc* (Au Sans Pareil, Paris, 1920).
48 A full account of Dadaism in the USA is given in Dickran Tashjian, *Skyscraper Primitives: Dada and the American Avant-garde, 1910–1925* (Wesleyan University Press, Middletown, Conn.., 1975); *New York Dada*, the periodical edited by Marcel Duchamp and Man Ray (New York, April, 1921), is reproduced in fascimile in Motherwell, *op. cit.*, pp. 214–18.
49 Sheldon Cheney, 'Why Dada?', *The Century Magazine* (New York, May 1922), pp. 22–9.
50 *Ibid.*, p. 28.
51 *Ibid.*, p. 29.
52 See, for example, Alfred Schinz's attack on Dadaism in 'Dadaism', *The Bookman*, LV, 2 (New York, April 1922).
53 *The Letters of D. H. Lawrence*, ed. Aldous Huxley (Heinemann, London, 1932), pp. 195–7.
54 Harold Monro, *Poetry and Drama* (December 1913), p. 390.
55 Even the Sitwells thought in terms of an unbroken English tradition. In a noisy aphoristic pamphlet of 1921, Osbert proclaimed: 'The great tradition of English poetry has always made use of everything new that came to it. It has swallowed up local and foreign traditions impartially'

Who killed Cock Robin? (C. W. Daniel Ltd, London, 1921), p. 13)

56 Ezra Pound, 'Elizabethan Classicists', *The Egoist*, IV, 8 (September 1917), p. 120.

57 Pound's quarrel with literary London at this time is recorded in Charles Norman, *Ezra Pound* Funk & Wagnalls, New York, 1960 (revised edition, 1969) – particularly Ch. XII ('Farewell to London'). See also Donald Davie, 'Ezra Pound Abandons the English', *Poetry Nation* No. 4 (Manchester, 1975), pp. 75–84.

58 Ezra Pound, *The Egoist*, V. 1 (January 1918), p.9. (Revised for *Literary Essays of Ezra Pound*, ed. T. S. Eliot (Faber, London, 1954), pp. 247–8).

59 Quoted in *Pound/Joyce: The Letters of Ezra Pound to James Joyce*, ed. Forrest Read (Faber, London, 1968), p. 150.

60 Ezra Pound, letter to John Quinn, *The Letters of Ezra Pound* (1907–1941). Ed. D. D. Paige (Faber, London, 1951), p. 122.

61 Ezra Pound, letter to Wyndham Lewis, *Ibid.*, p. 230. The works of Picabia to which Pound referred were: *Pensées sans langage* (Eugène Figuiere, Paris, 1919), and *Jésus Christ Rastaquouère* (Collection Dada, Paris, 1920), drawings by Ribemont-Dessaignes; introduction by Gabrielle Buffet.

62 See letter from Ezra Pound to T. E. Lawrence, 20 April 1920: '*The Dial* is an aged and stolid publication which I hope, rather rashly, to ginger up to something approaching the frenetic wildness of *The Athenaeum.*' *Letters of Ezra Pound (1907–1941)*, p. 215.

63 Ezra Pound, 'The Island of Paris: A Letter' *The Dial*, LXIX (October 1920), p. 406. See also 'Paris Letter', *The Dial, LXXI (October 1921), pp. 456–63.*

64 *The Dial*, LXIX, p. 408.

65 Andrew Clearfield, 'Pound, Paris, and Dada', *Paideuma*, VI, 2 (Fall 1977), p. 120 (footnote 29).

66 *Ibid.*, pp. 119–20.

67 Ezra Pound, 'E.P. Ode pour l'Election de Son Sepulchre', *Ezra Pound: Selected Poems* (Faber, London, 1959), p. 173 and p. 176.

68 Among Rodker's translations was an edition of Lautréamont's *The Lay of Maldoror*, a key-work in the surrealist canon (The Casanova Society, London, 1924). This translation had appeared in the magazine *Broom* during 1922, and parts of a revised version of it were printed in *transition* (1927). An earlier translation of Canto I of *The Lay of Maldoror*, by Richard Aldington, appeared in *The Egoist*, (October 1914–January 1915).

69 Jane Lidderdale and Mary Nicholson, *Dear Miss Weaver: Harriet Shaw Weaver 1876–1961* (Faber, London, 1970). This book gives some account of Rodker's work with the Egoist Press.

70 Baroness Else von Freytag von Loringhoven (1874–1927): see Margaret Anderson, *My Thirty Years' War* (Knopf, London, 1930), where among other records of the Baroness's activities in relation to *The Little Magazine* is the following characteristic account of her arrival at the magazine's office: 'One day while Jane was alone in the office this extraordinary person walked in. She walked slowly but impressively, with authority and a clanking of bracelets. She saluted Jane with a detached How do you do, but spoke no further and began strolling about the room, examining the contents of the bookshelves. She wore a red Scotch plaid suit with a kilt hanging just below the knees, a bolero jacket with sleeves to the elbows and arms covered with a quantity of ten-cent store bracelets – silver, gilt, bronze, green and yellow. She wore high white spats with a band of decorative furniture braid around the top. Hanging from her bust were two tea-balls from which the nickel had worn away. On her head was a black velvet tam o'shanter with a feather and

several spoons – long ice-cream soda spoons. She had enormous earrings of tarnished silver and on her hands were many rings, on the little finger high pleasant buttons filled with shot. Her hair was the colour of a bay horse.

Finally she bestowed her attention upon Jane.

I have sent you a poem, she trumpeted.

Yes, said Jane, pulling out a manuscript signed Tara Ostik.

How do you know I write that poem?

I am not entirely without imagination, said Jane.'

71 Else von Freytag von Loringhoven, *The Little Review* VI, 10 (March 1920), pp. 11–12.
72 John Rodker, '"Dada" and Else von Freytag von Loringhoven', *The Little Review*, VII, 2 (July–August 1920), pp. 33–6.
73 H. L. Mencken, *The Little Review* (autumn 1924–winter 1925), p. 61.
74 Letter from T. S. Eliot, *The Little Review Anthology*, ed. Margaret Anderson (Hermitage House, New York, 1953), p. 380.
75 *Ibid.*, pp. 381–3.
76 Wyndham Lewis, 'What Art Now?', *The English Review* (April, 1919), pp. 334–8.
77 *Ibid.*, p. 334. (Such was the task which Lewis saw as the main aim of the 'X-group', ten painters, including some former Vorticists, who met for the first time shortly after the appearance of this article. The group's aims are given fully in their catalogue for an exhibition in March, 1920. See *Wyndham Lewis on Art*, ed. Michel & Fox (Thames & Hudson, London, 1969), pp. 184–6.)
78 *Ibid.*, p. 337.
79 Wyndham Lewis, *Blasting and Bombardiering, An Autobiography, (1914–1926)* (Eyre & Spottiswoode, London, 1937; New edition by Calder & Boyars, London, 1967), p. 257 and p. 259.
80 *Wyndham Lewis the Artist (from 'Blast' to Burlington House)*, (Laidlaw & Laidlaw, London, 1939), pp. 47–8.
81 *Ibid.*, p. 46.
82 Richard Aldington, *Life for Life's Sake* (The Viking Press, New York, 1941; Cassell, London, 1968), p. 199.
83 Later reprinted as an 'Appendix' in *Notes towards the Definition of Culture* (Faber, 1948), pp. 110–24.
84 *Ibid.*, pp. 117–18.
85 T. S. Eliot, 'Tradition and the Individual Talent', *The Egoist*, VI, 5 (October 1919), p. 72.
86 T. S. Eliot, 'The Romantic Englishman, the Comic Spirit, and the Function of Criticism', *The Tyro*, No. 1 (1921), p. 4.
87 An account of this first performance, with Yeats's comments, appears in Martin Esslin, *The Theatre of the Absurd*, Ch 6, 'The Tradition of the Absurd' (revised edition Pelican Books, 1968), pp. 346ff. Yeats's comments appear in his *Autobiographies* (Macmillan, London, 1955), pp. 348ff.
88 *The Criterion* (July 1923), p. 421.
89 Herbert Howarth, *Notes on Some Figures Behind T. S. Eliot* (Chatto & Windus, London, 1965), pp. 250–64.
90 *The Criterion*, I, 1, (October 1922), pp. 89–93.
91 *Ibid.*, p. 90.
92 *Ibid.*, pp. 90–1.
93 *Ibid.*, p. 93.
94 T. S. Eliot, 'Notes on Current Letters: The Lesson of Baudelaire', *The Tyro*, No. 1 (1921), p. 4.
95 Richard Aldington, 'Bodies', *The Anglo-French Review*, III, 2 (March 1920), p. 137.

96 *Life for Life's Sake* pp. 196–7.

97 Richard Aldington, *Images of War* Allen & Unwin, London, 1919), pp. 60–1.

98 *Ibid.*, p. 62.

99 *Life for Life's Sake*, p. 199 (Eliot's essay on Marivaux appeared in *Art and Letters*, II, 2).

100 In *Life for Life's Sake* (p. 154), Aldington recalled that *The Times* refused to print his review of the volume of poems which contained Aragon's 'Suicide' (the poem which consisted of the alphabet arranged in five lines). Aldington's review ('the most snappy review I ever wrote') was the numbers one to ten.

101 Unsigned review, *The Times Literary Supplement* (16 June, 1921), p. 389.

102 Unsigned review (S. de Madariaga?), *The Times Literary Supplement* (28 July, 1921), p. 478.

103 Jean Lefranc, 'La crise "Dada"', *The Anglo-French Review*, III, 5 (June 1920), pp. 443–6.

104 See Richard Aldington, *Literary Studies and Reviews* (Allen & Unwin, London, 1924), and *French Studies and Reviews* (Allen & Unwin, 1926).

105 Richard Aldington, 'The Poet and his Age', *Literary Studies and Reviews* (Allen & Unwin, London, 1924), pp. 209–10.

after dada

PART III

what is surrealism?

The simplest surrealist act consists of going out into the street revolver in hand and firing at random into the crowd as often as possible.

André Breton

The history and theory of the Surrealist movement is far more complex than that of Dadaism, not least because there is an unbroken if gradually weakening line of Surrealist group-activity from 1924 up to the present day,[1] though Surrealism's most vital period belonged to the nineteen-twenties and the early nineteen-thirties. Both the history and the theory of Surrealism have been repeatedly described and discussed, and there are many well-known major studies in English and English translation.[2] I shall not, therefore, attempt to give any fully comprehensive account of over half a century of Surrealist activity, though I will discuss incidentally whatever is necessary for an understanding of the English response to any such activity during the period from 1924 up to the end of World War II when English, serious interest in Surrealism had become almost negligible.

Also, as is the case with any study of Dadaism, it is impossible to confine discussion of Surrealism to questions of literary theory; why this should be so ought to become evident in this chapter. Nevertheless, as with any study of the English response to Dadaism in previous chapters, it is important to stress that I do not intend to assess the effects of Surrealism on aspects of English art other than literature.

Obviously, Surrealist ideas and activities have made considerable impact on English art, particularly on the visual arts, including film, and they continue to do so; as far as possible, however, this study will be centred on the response to Surrealism of English writers, in particular poets and literary critics.[3]

It is necessary, however, to have some brief initial sketch of Surrealism. To provide this is much more difficult even than the summary of Dadaism which was attempted in Chapter 1. Surrealism's theories have been modified continually since the early nineteen twenties, sometimes because of changes in the movement's membership, sometimes in response to changing political circumstances, but always because the orthodox Surrealist has insisted from the movement's earliest years that all the thinking of the movement must be founded on scientific principles, on the dialectical metaphysic found in the theories of Hegel, Marx, and Freud. Thus change and modification, at least in theory, have been welcomed and encouraged in Surrealist thought. Any account of Surrealist theory must represent, therefore, a stage in its development rather than a final, achieved position.

This leads me to suggest that the most appropriate introduction in relation to a study of the English response to Surrealism is a critical summary of André Breton's *Qu'est-ce que le Surréalisme*, a short book which was first published in 1934 (Henriques, Brussels) and which was translated in a modified version into English by David Gascoyne in 1936.[4] *What is Surrealism?*, which appeared as *Criterion Miscellany* No. 43 ('specially prepared' by Breton himself 'for the occasion of the first international Surrealist Exhibition to be held in London'), though in no sense a simplified introduction to Surrealism, has the virtues of relative directness and conciseness consequent upon its having been compiled with the intention of reaching foreign (i.e. non-French) readers. Perhaps more importantly for the purposes of this book, it represents the stage in the development of Surrealism when English interest in the movement was at its greatest.

At first view *What is Surrealism?* is a characteristically rhapsodic collage in six disconnected episodes of statements by André Breton. Only the last and longest of these episodes, occupying over half the length of the pamphlet (pages 44–90), is directly concerned with a systematic account of the history and justification of the Surrealist movement. However, the five introductory sections, though apparently snatched at random from previous Surrealist tracts by Breton, are important in establishing the revolutionary militancy of the whole pamphlet. *What is Surrealism?* expressed emphatically the continuity of that militancy – what Breton called 'a truly insolent grace' – which Surrealism believed it shared with both its recent precursors in French literature (Lautréamont, Rimbaud, and Mallarmé), and such contemporary painters as Picasso and Salvador Dali: one principal aim of Breton's argument was to deny any primary importance to considera-

tion of differences between the media explored by writers and painters.

The first part of the work then, consisted of five sections, all of which were given titles: 'Surrealism and Painting' (pages 9–24); 'Exhibition X . . . Y . . .' (pages 25–6); 'the First Dali Exhibition' (pages 27–30); 'The Communicating Vessels: The Phantom Object' (pages 31–6); 'Beauty will be Convulsive' (pages 37–43).

The title of the first section, 'Surrealism and Painting', had also been that of an essay by Breton (1928)[5] in which he had attempted to demonstrate that Surrealist methods could be as successful in the plastic arts as they had already proved to be in literature. In this section's relatively brief restatement of the Surrealist position Breton argued that identifiable degrees of visual sensation (objective or subjective) corresponded with definite 'spiritual realisations'. The relative clarity of such correspondences proved the superiority of the visual arts to music as expressive media:

> **Auditive images, in fact, are inferior to visual images not only in clearness but also in strictness, and with all due respect to a few melomaniacs, they hardly seem intended to strengthen in any way the idea of human greatness. (p. 10)**

Breton's obsession with (or limitation to) the concept of the image (the application of which to the theory of musical language seems to be both quaint and extremely naive here) led him to link the language of the plastic arts to that of poetry – both poetry and painting being capable of super-reality:

> **The need of fixing visual images, whether those images exist before their fixation or not, stands out from all time and has led to the creation of a veritable language, which does not seem to me more artificial than any other, over the origins of which I do not feel it necessary to linger here. The most I can do is to consider the present state of this language from the same angle as that from which I should consider the present state of poetic language. It seems to me that I can demand a great deal from a faculty which, above almost all others, gives me advantage over the real, over what is vulgarly understood by *the real*. (p. 10)**

Dismissal of the visual art of the past was, for Breton, in part the rejection of a dead-end of academic realism. But it was also the proclamation of the primary role for art – the questioning of reality, the discovery of super-reality by the living imagination. Imitative art, the work of 'embroiderers', was created only by those who, by an action of 'inexcusable abdication', had given up this primary task. Breton proclaimed the necessity for a figurative art which was neither imitative nor purely abstract, one which would perform the essential task of art at a time when 'the exterior world appears more and more suspect': 'The plastic work of art, in order to respond to the undisputed necessity of thoroughly revising all real values, will either refer to a *purely interior model* or cease to exist' (pp. 13–14). What this meant,

Breton argued, could be best understood in relation to the example of the poets, Lautréamont, Rimbaud, and Mallarmé; their attitude had given not only art but also the human mind new scope: 'a truly *insolent* grace which has enabled the mind, in finding itself withdrawn from all ideals, to begin to occupy itself with its own life.' (p. 14) Breton added that the insolence was to be directed not only against artistic realism but also against the values of the world which was represented by such realism; here Breton was very close to the mood, the style, and even the content of Dadaist invective: '. . . the idea of what is forbidden and what is allowed adopted its present elasticity, to such a point that the words family, fatherland, society, for instance, seem to us now to be so many macabre jests.' The painter who had most achieved this same 'insolent grace' was Pablo Picasso, and Breton, during the course of a long apostrophe to Picasso, cited several of Picasso's works, most of them from the period before World I, which demonstrated the possibility of *Surrealist* painting. That Picasso had not been, nor was ever to be, an official member of the Surrealist group was immaterial. His work had all those magical qualities which Surrealism saw as its ideal; indeed, any formulation of Surrealist critical principles had itself to stand the test of Picasso's creations. The section concluded with a savage attack on those artists who, after early promise, had failed to live up to the new standards created by Picasso, and, to a lesser extent, by the earlier work of George Braque.

The two short episodes, 'Exhibition X . . . Y . . .' and 'The first Dali Exhibition', though occasioned by particular exhibitions of paintings, were also important in defining general Surrealist attitudes. In the first Breton, who always fairly acknowledged Surrealism's great debts to earlier stages of romanticism, stressed the all-important difference between Surrealism and all previous theory. This amounted to a radically new way of seeing, one in which the distinctions between dream and waking reality no longer counted. For poetry, the consequences included a new attitude towards language, one in which differences between figurative usages, including the concept of the simile, were to disappear:

Oneiric values have once and for all succeeded the others, and I demand that he who still refuses, for instance, to *see* a horse galloping on a tomato should be looked upon as a cretin. A tomato is also a child's balloon — surrealism, I repeat, having suppressed the word 'like'. (p. 25)

This section of the pamphlet ended with a declaration of revolution, the amalgam of 'death' and 'barricades' with 'flowers' and 'love', suggesting for me the confused and conflicting idealisms of the period between the two wars as well as the contraries inherent in anarchism at all times (including our own):

Today it is up to man unhesitatingly to deny everything that can enslave him, and, if necessary, to die on a barricade of flowers, if only to give body to a chimera; to woman, and perhaps to her alone, to rescue both that which she brings with her and that which lifts her up — silence! There is no solution outside love. (p. 26)

A similar anarchistic attitude underlies 'The First Dali Exhibition'. Salvador Dali (b. 1904) had joined the Surrealists in 1929, the year in which his Paris Exhibiition had taken place at the Galerie Goemans, and though his work after 1936 was to be denounced by Breton and most other surviving adherents of Surrealism, at the time of *Qu'est-ce-que le Surréalisme* he was still in favour. Dali's grotesque bad taste and extremism avoided any possible charge against him of producing art which pleased the conventional middle-class gallery visitor, but Breton's suspicions were already aroused by Dali's large circle of admirers ('ticks who try to cling to his garments') which included many non-Surrealists, and even several representatives of the despised 'establishment'. Breton regarded Dali's great notoriety, even as early as 1929, as a possible threat to the continuing radicalism and subversiveness of Surrealism. Among the 'ticks' Breton seemed to include academic critics as well as other rival self-proclaimed artistic revolutionaries of the late twenties:

At last, surrealism quite dead, the professional mouthpieces, such as we are, crushed beneath the heel, 'documentation' triumphant, the police re-established as *very fine chaps* at least — you surely don't hope to change the world? we shall perhaps be able quietly to assimilate quite a good number of tough joints (say the ticks, after which they retire into old fashion papers, into what remains of abstract painting — ? — into criticism in which they aspire to bring about 'the revolution of the word',[6] into left-wing anti-communist politics, and into that really deliciously sugary stuff, the talking cinema). (pp. 27–8)

Breton found in Dali's work itself, however, the genuine Surrealist subversive article; Dali's anarchism was total, its irrationalism complete. The world of 'Cimmeria', newly discovered by Surrealism, apparently replaced anti-art (ruin?) as definitely as it condemned patriotism and the art of the past:

We have every hope of winning the case that we have brought against reality, and that is why, from this point on, we intend to produce, laying particular emphasis upon it, the pathetic witness of a man who seems more than anyone else to have nothing to save: *nothing, not even his head.* While we are still alive, come what may, never will the ignoble flag of homeland, art or even of ruin be set up on Cimmeria, the only place that we have discovered on new account, and that we intend to reserve to ourselves. (p. 28)

A prospect of Cimmeria (presumably Homer's fabled land of perpetual darkness mentioned by Milton too in his 'L'Allegro'?) was to be revealed by recourse to the power of '*voluntary hallucination*' which

promised a 'methodological assault on life'. Dali's methods and their results provided the clearest evidence of the destructive possibilities of this power:

The art of Dali, the most hallucinatory known until now, constitutes a real menace. Absolutely new and visibly mal-intentioned beings hereupon enter into play. It is with a sinister joy that we watch them pass by unhindered, and realize, from the way in which they multiply and *swoop down*, that they are beings of prey. (p. 30)

In the fourth section, 'The Communicating Vessels: The Phantom Object', Breton rejected any theory which postulated the existence of mystical or religious elements in Surrealism. In *Les Vases Communicants* (1932)[7] Breton had acknowledged again the debt owed by Surrealism to Freud's discoveries in the analysis of dreams, and had argued that human existence could be regarded as two vessels, dream and the waking state, between which there was constant interaction. The manifestations of such interaction were open to analysis and interpretation in exactly the same way that, as Freud had revealed, dreams were. Breton gave several examples of Surrealist 'objects' which could be approached in this way. His examples included '*monsters*' produced by Picasso, Chirico, Duchamp, Ernst, and Dali; one of Giacommetti's 'personages', and a 'phantom-object' produced by Breton himself while playing the 'Exquisite Corpse' game.[8] Much of Breton's illustration was devoted to an ingenious analysis of his own strange drawing, involving verbal puns as well as childhood memories of toilet-training and a French-style chamberpot. His most interesting example from literature was Lautréamont's 'Beautiful as the chance meeting of a sewing-machine and an umbrella on a dissecting-table'. Part of the secret of the mysterious hold of this famous image, often regarded as *the* perfect frisson-producing surrealist image, was interpreted by Breton:

. . . it should not take one long to realize that this hold owes its strength to the fact that the umbrella represents the man, the sewing-machine the woman (just as all other machines do, with the sole aggravation that this one, as is well known, is frequently used by women for onanistic purposes) and the dissecting-table the bed. The contrast between the immediate sexual act and the extremely broken-up picture that Lautréamont makes of it, is alone the cause here of the reader's thrill. (p.34)

'Beauty Will be Convulsive', the fifth and final section of the first part, takes its title from Breton's novel *Nadja* (1928) which ends: 'La beauté sera CONVULSIVE ou ne sera'. This section had not appeared in the French edition, *Qu'est-ce-que le Surréalisme*. It began with a passionately lyrical declaration that the search for new beauty ('beauty envisaged exclusively for passionate ends') would be one carried out 'right at the very bottom of the human crucible':

in that paradoxical region where the fusion of two human beings who
have really chosen one another restores to all things the lost colours of
the time of ancient suns, yet where the solitude also runs amok with
one of those fantasies of nature which, around the craters of Alaska,
prefer the snow to remain covered with ashes . . . (p. 37)

Breton confessed interest only in works of art or natural objects which
could produce in him a particular kind of physical disturbance
'characterized by the sensation of a wind brushing across my forehead
and capable of causing me to really shiver'. Such experience, which
Breton believed to be sexual in origin (mystical and religious sources
having been discounted), had been occasioned by certain lines and
passages of poetry, especially those of Lautréamont, none of which had
lost for him any of their original power to work the convulsing
magic. All the objects capable of causing the frisson of convulsive
beauty conformed to three conditions. First:

the affirmation of the reciprocal relationship that joins an object in
movement to the same object in repose.

(One of Breton's examples was of a 'very handsome locomotive after
having been abandoned for many years to the fever of a virgin forest'.)
Second:

The work of art, considered as being as seriously significant as such
and such a fragment of human life, seems to me to be lacking in all
value if it does not present the same hardness, rigidity, regularity and
lustre on all its surfaces, both inside and out, as the crystal.

(Breton immediately tried to make it clear that he was not advocating
any kind of voluntary formalist view of creativity, but that the crystal
was the perfect expression of 'convulsive' beauty, such beauty to be
produced by sponaneity.) Third:

Such a kind of beauty will only be able to arise from the poignant
emotion caused by the thing revealed, from the integral certainty
brought about by the arrival of a solution which could not, on account
of its very nature, have reached us by the normal logical channels.

The images produced by automatic writing were, for Breton, the
perfect example of such solutions. The recognition of those magical
objects which the mind desires and needs – matching 'our extraordin-
ary capacity for receiving stolen goods' – though apparently gra-
tuitous, suggested for Breton that 'all one's most involuntary percep-
tions, such, for instance, as that of the words spoken by the prompter in
the wings, carry within them the solution, symbolic or otherwise, of
some difficulty within oneself.' (p. 43) From such a viewpoint, all
experience was a *forest of signposts*, where man lost his way only
when, because ill-prepared, he took fright.

The preamble to the final part of *What is Surrealism?* showed that

Breton felt that he could not overstress the radical and subversive character of Surrealism. Before attempting to discuss the history of the movement between 1919 and 1936 he insisted on the strong parallels and links between the atmosphere of defeatism which the Franco-Prussian War of 1870 had created and the defeatism of World War I and its aftermath. The first of these cataclysms had produced social disorder which had ended with the 'atrocious crushing of the Paris Commune'. The years between 1868 and 1875 had also been the period of Lautréamont and Rimbaud, a period unparalleled in its poetic richness – 'so victorious, so revolutionary and so charged with distant meaning', World War I, in its turn, had brought about the Bolshevik Revolution and the Dadaist-Surrealist revolution. Breton conceded that during and immediately after World War I he and his fellow-artists had not understood fully the significance of the Russian Revolution; this was because of their petit-bourgeois upbringing and would-be-artistic aspirations. Nevertheless, he claimed, they had been true revolutionaries, ruthlessly destructive ones:

Above all, we were exclusively preoccupied with a campaign of systematic refusal, exasperated by the conditions under which, in such an age, we were forced to live. But our refusal did not stop there; it was insatiable and knew no bounds. (p. 45)

The 'refusal' had been directed against

the whole series of intellectual, moral and social obligations that continually and from all sides weigh down upon man and crush him. Intellectually, it was vulgar rationalism and chop logic that more than anything else formed the causes of our horror and our destructive impulse; morally, it was all duties: religious, civic and of the family; socially it was work . . . (pp. 45–6)

The only thing they had believed to be worth saving was *'l'amour la poésie'* (the title of a book by Eluard published in 1929). The excesses of the Dadaist–Surrealists were understandable only in the light of that revolutionary attitude and its historical antecedents of fifty years before. The defeatism of the intellectual atmosphere of 1868–1875, repeated at the time of World War I, had not passed away. On the contrary, the rise of fascism, with its threat to all the freedoms sought by Surrealists required Surrealist identification with the proletarian struggle for the fundamental condition of all freedom:

today, more than ever before, *the liberation of the mind*, the express aim of surrealism, demands as primary condition, in the opinion of the surrealists, *the liberation of man*, which implies that we must struggle with our fetters with all the energy of despair; that today more than ever before the surrealists entirely rely for the bringing about of the liberation of man upon the proletarian Revolution. (pp. 48–9)

Such identification with the proletarian Revolution without any

surrender to any of the dogmas of orthodox Marxism, was to be suspiciously regarded by most Marxists, as it was also to attract the sympathies of 'anarchists' and would-be-anarchists all over Europe (including Herbert Read in England, for example). I do not suggest that the Surrealists did not share any of the Marxist metaphysics. Much of the social and historical analysis presented by the Surrealists relied on attitudes and assumptions found also in the thinking of orthodox Marxists. The final aim of Surrealism, according to Breton, was the unification of interior and exterior reality, which because of the contradictions inherent 'in the present form of society' was far from being achieved. But Breton did not give any priority to the need for change in 'exterior reality' which, presumably, would be the solution offered by the Marxist materialist. For the Surrealist 'interior reality' was as important and as worthy of attention as 'exterior reality'. The real task was a systematic examination of both realities with the purpose of uniting the two in action.

Breton's attempt to 'retrace . . . the whole evolution of Surrealism, from its origins until the present day' did not commence, therefore, until page 50 of the pamphlet. He began this task by distinguishing between two phases of Surrealism. The first, a 'purely *intuitive* epoch', occurred between 1919 and 1925. The second, 'a *reasoning* epoch', referred to the period between 1925 and the publication of *Qu'est-ce que le Surréalisme*.

The first phase had been characterised by a philosophical idealism which had deceived Breton into what he now considered to be a false definition of Surrealism. This had appeared in the *First Surrealist Manifesto* of 1924[9]:

SURREALISM n. Pure psychic automatism, by which it is intended to express, verbally, in writing, or by other means, the real process of thought. Thought's dictation, in the absence of all control exercised by the reason and outside all aesthetic or moral preoccupations.

He now rejected the last phrase of that often-quoted definition: 'It should at least have been said *conscious* aesthetic or moral preoccupations.' (p. 51) Surrealism had entered a new phase at the time of the outbreak of the Moroccan war in 1925, a phase in which the need for a coherent political and social attitude had become evident. The earlier phase, which had led up to the *First Manifesto*, had had no such attitude, unless total non-conformity could be called a coherent social attitude. In 1925 the Surrealists had been forced to consider their attitude to colonial warfare, and this had brought about an important philosophical development::

Surrealist activity at this moment entered into its *reasoning* phase. It suddenly experienced the necessity of crossing over the gap that separates absolute idealism from dialectical materialism. (p. 51)

Breton argued that the Surrealist movement had passed through the

whole development of modern thought within a few years, from the Empiricism of Berkeley and Hume, to Hegel, and thus to Marx. Though the intuitive stage had led to the production of a large amount of Surrealist *material*, it has also been forced to recognise its 'relative insufficiency':

how surrealist activity had to cease being content with the results (automatic texts, the recital of dreams, improvised speeches, spontaneous poems, drawings and actions) which it had originally planned, and how it came to consider these first results as being simply so much *material*, starting from which the problem of knowledge inevitably arose again under quite a new form. (p. 52)

The genuine Surrealist would accept the necessity of change since Surrealism must be viewed as a living movement, 'a movement undergoing a constant process of becoming'. Changing panoramas, and even a changing membership, along with always changing, sometimes contradictory, points of view were inevitable. Where differences had occurred between genuine Surrealists they had done so 'essentially within the rhythmic scope of the integral whole, in itself a least disputable element of objective value'. Before beginning his account of the theory and practice of Surrealism proper, Breton acknowledged again the decisive effect of the French Surrealists' association with Dadaism, and he paid special tribute to the influence of Duchamp, Picabia, Vaché, and Tzara.

The history of Surrealism began with a reminder that the movement was initially a literary one, little more than 'a new method of poetic writing'. A long extract from the 1924 *Manifesto*, part of an article 'Enter the Mediums' which had originally appeared in *Littérature* during 1922, described the circumstances of Breton's first Surrealist literary experience when one sentence suddenly caught his attention:

. . . it ran approximately like this: 'a man is cut in half by the window'. What made it plainer was the fact that it was accompanied by a feeble visual representation of a man in the process of walking, but cloven, at half his height, by a window perpendicular to the axis of his body. Definitely, there was the form, re-erected against space, of a man leaning out of a window. But the window following the man's locomotion, I understood that I was dealing with an image of great rarity. Instantly the idea came to me to use it as material for poetic construction. I had no sooner invested it with that quality, than it had given place to a succession of all but intermittent sentences which left me no less astonished, but in a state, I would say, of extreme detachment. (pp. 57–8)

Breton went on to describe how this experience and his wartime study of Freud's methods had suggested to him the development of 'automatic' technique, one in which 'the speed of thought is not greater than that of words, and hence does not exceed the flow of either tongue or

pen' (compare Tristan Tzara's 'Thought is made in the mouth'). Breton and Philippe Soupault had produced a good deal of writing employing these automatic methods, Soupault being important for having insisted on opposing any inclination by Breton to 'correct' any passage produced in this way. Their results, though not identical in manner, had much in common:

> **. . . similar faults of construction, the same hesitant manner, and also, in both cases, an illusion of extraordinary verve, much emotion, a considerable assortment of images of a quality such as we should never have been able to obtain in the normal way of writing, a very special sense of the picturesque, and, here and there, a few pieces of out and out buffoonery. (p. 58)**

One important characteristic of such writing was the strangeness ('as strange as to anyone else') of the writer's own work to himself. The results also had a 'very high degree of *immediate absurdity*'.

Having appropriated and defined the word 'Surrealism' the *Manifesto* gave a list of absolute Surrealists (the French Surrealists themselves, by definition) as well as a large number of writers and painters of the past who had possessed some Surrealist quality – though, because they had all had some 'preconceived notions' and had acted according to such notions, none of them could be regarded as genuine Surrealists. In this Limbo, for example, were Heraclitus ('surrealist in dialectic'), Swift ('surrealist in malice'), 'Monk' Lewis ('surrealist in the beauty of evil'), Carroll ('surrealist in nonsense'), and Picasso ('surrealist in cubism'). The true Surrealist was only a medium; Breton's group had been content to be 'modest *registering machines* that are not hypnotized by the pattern that they trace'. An example from the recipes for producing genuine Surrealist works offered in the 1924 *Manifesto* gave the conditions for producing automatic writing. These included tips for breaking free from any 'prompting whisper' or from too great 'lucidity':

> **If through a fault ever so trifling there is a forewarning of silence to come, a fault, let us say, of inattention, break off unhesitatingly the line that has become too lucid. After the word whose origin seems suspect you should place a letter, any letter, *l* for example, always the letter *l*, and restore the arbitrary flux by making that letter the initial of the word to follow. (p. 62)**

Breton's objections to logic and reason involved his belief that they could be obstacles to valid kinds of experience, to imagination itself which was now on the point of 'reclaiming its rights'. Surrealism, Breton claimed, had restored to reality the marvellous which was always beautiful; indeed, nothing else could be beautiful. The *Manifesto* looked forward to the time when all men (not just poets) would see life transformed by the unity of dream and 'reality':

> **I believe in the future transmutation of those two seemingly contradic-**

tory states, dream and reality, into a sort of absolute reality, or surreality, so to speak. I am looking forward to its consummation, certain that I shall never share in it, but death would matter little to me could I but taste the joy it will yield ultimately. (p. 66)

The *First Manifesto* of 1924 summed up, for Breton, the conclusions to which the Surrealists had come during what he called the '*heroic period*' of Surrealism. The period between the appearance of the first and second manifestoes (1925–1929) had been marked by all kinds of wrangling which had led to many wrong-headed deviations from the Surrealist ideal. Some had seen it as a movement essentially on the artistic plane, thus failing to understand its essentially subversive nature on all levels. Artaud, Desnos, Ribemont-Dessaignes, and Vitrac were among those responsible for this major theory. Others had challenged the autonomy of Surrealism by trying to fit it to a political creed. Aragon and Naville (at one time co-editor of *La Revolution Surréaliste*) had demonstrated this tendency, one which Breton had attempted to counter in his pamphlet *Légitime Défense* (1926).[10] There he had argued that there was no contradiction between, on the one hand, the Surrealist attempt to resolve the problems set by the discovery of the relations between the conscious mind and the unconscious and, on the other, the problem of the right social action. Again Breton stressed Surrealist belief in the proletarian revolution (the liberation of man) and the liberation of mind, seeing these as quite separate and equally desirable questions and objectives.

The *Second Manifesto*[11] had set out to purge the movement of some of its more heretical and warring individuals as well as to 'tidy up surrealist ideas'. There is no doubt too, that the 1930 *Manifesto* represented an attempt to meet the criticisms of Marxist materialism. Breton's quotations from the *Second Manifesto* concerned the drift by Surrealism towards a 'crisis in consciousness', the success or failure of which would match the life or demise of Surrealism itself. Breton recognised the common origins of 'Historical Materialism' and Surrealism in the dialectical method which had grown out of the 'colossal abortion' of the Hegelian philosophy, but he rejected any claim by materialists to set the limits of application for this method. Again, while renouncing idealism, Breton revealed an even greater antipathy for a 'low conservative' materialism.

It was in 'language', however, that Surrealism's greatest strides had been made and where it now felt most at home. In poetry, especially, Surrealism had shaken the foundations, and through books, pictures, and films a revolution in ways of feeling was already well under way. The 'unhealthiness' found in the poetry of Baudelaire, Rimbaud, Huysmans, and Lautréamont had spread into other modern works, and was continuing the romantics' work of undermining 'that foolish illusion of happiness and *good understanding*'. The 'authorities' were

celebrating the centenary of Romanticism, but Surrealism claimed that the spirit of Romanticism was still alive in Surrealism, its 'prehensile tail'. Surrealism had realised the truly subversive *essence* of Romanticism which was 'the negation of these authorities and this celebration':

we say that for Romanticism to be a hundred years old is for it to be young, and what has wrongly been called its heroic period can no longer pass for anything but the pulings of a being who is now only beginning to make known its wants through us. (p. 77)

Breton continued to defend automatic writing, though he conceded that too many 'surrealist' works suffered from the failure of their authors to pay enough attention to 'what was at the time going on inside themselves' (that is as revelatory texts conveying new knowledge to those who paid proper attention). Surrealism's methods – and this was perhaps the main message of the *Second Manifesto* – had to be followed in complete good faith:

Provided the products of psychic activity which dreaming and automatic writing are, are as much as possible distracted from the will to express, as much as possible lightened of ideas of responsibility ever ready to act as brakes, and as much as possible kept independent of all that is not the *passive life of the intelligence*, these products have the following advantages: that they alone furnish the material for appreciating the grand style to the body of critics who in the artistic domain are strangely disabled; that they allow of a general reclassification of lyrical values; and that they offer a key to go on opening indefinitely that box of never-ending drawers which is called man . . . (p. 80)

Reviewing the period from 1930 to 1936 Breton saw it as a time during which Surrealism had been successfully combatting attempts to reduce the movement to politics ('political opportunism') or to art ('artistic opportunism'). He felt able to point to the continuity of this task from *La Révolution Surréaliste* (twelve issues, 1924–1929) to *Le Surréalisme au Service de la Révolution* (six issues, 1930–1933). In the 'paranoiac-critical' method of Salvador Dali, especially, the development of the Surrealist experiment had regained momentum and 'order'. Dali and other artists had proved that automatism was indeed the 'crossroads' of all successful Surrealist paths. During recent years a new development in such experiment had been the production of 'a fundamental crisis of the "object"' ('the oneiric object, the object functioning symbolically, the real and virtual object, the moving but silent object, the phantom object, the discovered object, etc.').

The concept of Surrealism as an experimental laboratory was central in Breton's conclusion in which he attempted to bring together the various strands of his argument, in particular the view that Surrealism was both artistic revolution and on the side of the proletarian revolution without losing any of its essential anarchistic autonomy; he quoted with complete agreement from the Communist

writer Claude Cahun's pamphlet, *Les Paris Sont Ouverts* (1934):

The most revolutionary experiment in poetry under the capitalist regime having been incontestably, for France and perhaps for Europe, the Dadaist—surrealist experiment, in that it has tended to destroy all the myths about art that for centuries have permitted the ideological as well as economic exploitation of painting, sculpture, literature, etc. (e.g. the *frottages* of Max Ernst, which, among other things, have been able to upset the scale of values of art-critics and experts, values based chiefly on technical perfection, personal touch and the lastingness of the materials employed), this experiment can and should serve the cause of the liberation of the proletariat. (p. 89)

At the same time, however, Breton made it plain that he believed that Surrealist activity 'cannot be pursued within the limits of any one of the existing revolutionary organisations'.

As an introduction to the Surrealist movement, *What is Surrealism?* did have some obvious limitations. That it was primarily the work of only one Surrealist is not the most important of these. Breton was, until his death in 1966, the undisputed[12] leader of Surrealism and its major theorist. To pursue disagreement with Breton ('the Pope of Surrealism') at any time was tantamount to breaking with the movement itself, as many artists, poets, and critics of the late twenties and early thirties discovered. Perhaps the most glaring deficiency of *What is Surrealism?* was its lack of reference to or illustration from contemporary Surrealist creative literature. Breton's stress on the links between Surrealism and the literature of nineteenth-century Romanticism, particularly the work of Lautréamont and Rimbaud, gave Surrealism longer historical roots at the expense of an underplaying of the achievements of Surrealist poets themselves. No doubt Breton had good reasons, apart from lack of space, for such emphases. In the mid-thirties, as the pamphlet itself demonstrated, he was most anxious to prove the genuine social and revolutionary commitment, as well as the reasoning seriousness, of the movement. The centre of his argument, therefore, was the autonomous subversion of Surrealism – in other words, its revolutionary and anarchistic nature. The insistence on the relative unimportance of questions concerning artistic media; the avoidance of detailed discussion of Freud's role in the development of Surrealist methods during the early stages; the renewed insistence on the links with the political and literary turmoils of 1870 and with Dadaism, as well as the suppression of quotation from contemporary Surrealist literature – all these were not simply the result of Breton's need and capacity for expediency, diplomacy, and compromise. On the contrary, in my view, Breton was merely drawing attention to what had always made Surrealism most distinct from other general and particular trends in modernism, namely the movement's unchanging attitude of destructive subversion. Surrealism's anarchism, though not explicitly nihilistic as Dadaism had been, could be, in effect, at least as uncompromisingly radical in terms of

social and artistic consequences.

In examining English reaction to Surrealism, I propose to divide the period between 1922 and 1936 into two, corresponding roughly to Breton's distinction between two phases or epochs: the 'intuitive' or 'heroic' early years (which are also the years of a largely *literary* Surrealism) and the later 'reasoning' phase (when painting and other artistic media had become much more prominent in the Surrealist canon). In fact, I will attempt to deal first with English critical reaction to Surrealism between 1922, when T. S. Eliot's *The Criterion* appeared, and 1927, a year that marked significant changes in the character of the literary magazine, and in English. Wyndham Lewis's *The Enemy* was first published in January 1927, but the year also saw the demise of the *Calendar of Modern Letters*. In the same year, Eugene Jolas founded the Paris-based Franco-American review *transition*, and *This Quarter*, which had published much of the avant-garde work in English since 1925, became a much more conservative publication.[13] The two issues of *Ray*, edited by Sidney Hunt, also appeared in 1927.

The most important consequences of Breton's analysis of Surrealism follow from his insistence that the actual rise and development of French Surrealism required, as historical necessity, that mood of wartime and postwar defeatism found in Dadaism. If Breton's analysis is correct, then it must follow that the form of Surrealism which eventually appeared during the thirties (albeit during a period of intense crisis) must have had both different historical causes and different theoretical principles from those of the early ('intuitive') stage. It also follows, therefore, that the modes of French Surrealism most likely to influence the English at that particular time would belong to the later ('reasoning') stage – the stage represented by *What is Surrealism?*

The total rejection of Dadaism by the English in the twenties and, in consequence, a long delay in sympathetic interest in Surrealism, must have worked to produce a necessarily modified and weakened English verion of the movement. The longer that influential English critics and writers continued in their attitude of deep hostility towards Dadaism– Surrealism (and continued to encourage a new hope in the opportunities offered within either the tradition itself or in that tradition combined with less radical modernism) the stronger such modifying and weakening effects on 'English' Surrealism would tend to be. Indeed, the question then becomes concerned not with the *delay* between the formation of French Surrealism and its 'arrival' in England, but with the *arrival* itself. That is, we become concerned with the character of the English cultural scene in the thirties when Surrealism appeared. Debates about the causes of an assumed, reprehensible weakness and delay in the English response to Surrealism are possible only if it is assumed that Surrealism is a self-evidently, universally desirable and inevitable manifestation of modern Western art.

1 Many critics have suggested that André Breton's death in 1966 marked the end of Surrealism proper.

2 Among the most important (in alphabetical order by author) are: Dawn Ades, *Dada and Surrealism Reviewed*. With an introduction by David Sylvester and a supplementary essay by Elizabeth Cowling, (Arts Council of Great Britain, London, 1978); Ferdinand Alquié, *Philosophy of Surrealism*, translated by Bernard Waldrop, University of Michigan, Ann Arbor, (Mich., 1965) (*Philosophie du surréalisme* (Flammarion, Paris, 1955)); Sarane Alexandrian, *Surrealist Art*, translated Graham Clough (Thames & Hudson, London, 1970) (*L'Art surréaliste* (Fernand Hazan, Paris, 1969)); Anna Balakian, *Surrealism: The Road to the Absolute*, rev. edn. (Unwin Books, London, 1972). Originally published by Noonday Press, New York, 1959; Mary Ann Caws, *The Poetry of Dada and Surrealism* (Princeton University Press, Princeton, N.J., 1970); Mary Ann Caws, *Surrealism and the Literary Imagination* (Mouton, The Hague and Paris, 1966); Wallace Fowlie, *Age of Surrealism*, new edition (Indiana University Press, Bloomington, Ind., 1960); Herbert S. Gershman, *The Surrealist Revolution in France* with *A Bibliography of the Surrealist Revolution in France* (University of Michigan Press, Ann Arbor, Mich., 1969); Marcel Jean and Arpad Mezei, *The History of Surrealist Painting*, translated Simon Watson-Taylor, Wiedenfeld & Nicolson, London, 1967) (*Histoire de la peinture surréaliste* (Editions du Seuil, Paris, 1959)); Georges Lemaitre, *From Cubism to Surrealism in French Literature* (Pennsylvania University Press, University Park, P, 1965); Maurice Nadeau, *The History of Surrealism*, translated Richard Howard (Cape, London, 1968) (*Histoire du surréalisme* (Editions due Seuil, Paris, 1954)); Marcel Raymond, *From Baudelaire to Surrealism*, translated by G. M. (Wittenborn & Schultz, 1945) (*Du Baudelaire au Surréalisme*, R. A. Corréa, Paris, 1933). University Paperback, with Bibliography by S. I. Lockerbie (Methuen, London, 1970); Ed. Herbert Read, *Surrealism* (Faber, London, 1936); William S. Rubin, *Dada and Surrealist Art* (Abrams Inc., New York, 1970); Patrick Waldberg, *Surrealism* (Thames & Hudson, London, 1965) (*Le Surréalisme* (Skira, Geneva, 1962)).

3 Even such a distinction may be thought to be somewhat arbitrary. For example, Herbert Read was a poet and literary critic as well as an art-critic of world-renown. Humphrey Jennings was both a poet and an extremely talented film-maker; six of Jenning's paintings, collages, and 'image-objects' were shown at the International Surrealist Exhibition in London (1936).

4 André Breton, *What is Surrealism?*, translated by David Gascoyne, Faber, London, 1936)(Criterion Miscellany No. 43).

5 André Breton, *Le Surréalisme et la peinture* Gallimard, Paris, 1928). The book appeared between 1925 and 1927 in various issues of *La Révolution Surréaliste* (Nos. 4, 6, 7, 9 and 10), André Breton having taken over the editorship with the first of these issues (May 1925).

6 i.e. Eugene Jolas, who proclaimed 'the revolution of the word' as the task of his magazine *transition*.

7 André Breton, *Les Vases Communicants* (Editions des Cahiers Libres, Paris, 1932).

8 'EXQUISITE CORPSE: Game of folded paper played by several people, who compose a sentence or drawing without anyone seeing the preceding collaboration or collaborations. The now classic example, which gave the game its name, was drawn from the first sentence obtained this way: The—exquisite—corpse—will—drink—new—wine' (André Breton, from the catalogue of an exhibition at La Dragonne, Galerie Nina Dausset, Paris, 7–30 October 1948, entitled *Le Cadavre Exquis: Son*

Exaltation).

9 *Le Manifeste du Surréalisme* (Paris, 1924), published with André Breton's *Poisson soluble* KRA, Paris, 1924).
10 André Breton, *Légitime Défense* (Editions Surréalistes, Paris, 1926).
11 *Second Manifeste du Surréalisme* (KRA, Paris, 1930).
12 See, for example, David Gascoyne, *Short Survey of Surrealism*, p. 58: 'one thing is certain: that except for André Breton the surrealist movement could never have existed, for it is as difficult to imagine it without him as it is to imagine psycho-analysis without Freud'.
13 *This Quarter* was founded in Paris in 1925 by Ernest Walsh and Ethel Moorhead. Walsh died the following year after producing two issues of the magazine and having planned a third. Issue No. 4 (edited by Ethel Moorhead in Monaco, Spring, 1929) announced that Edward W. Titus would assume editorship in Paris. From 1929 Titus was responsible for the publishing policy of the magazine.

english critics and french surrealism

1922-1927

The general lack of foreign sympathy for, or even curiosity about, the earliest activities of the French Surrealists has surprised some of the movement's most enthusiastic admirers. For example, in his *The Surrealist Movement in England* 1971) Paul Ray expressed disappointment in the inadequacy of theoretical discussion of Dadaism and Surrealism by even the most avant-garde English-language reviews, including the *Little Review*. He complained also that the *Transatlantic Review* (founded by Ford Madox Ford in Paris in January 1924) was extremely slow to report Surrealist activities and, like the *Little Review*, failed to explain them. Ray was still more surprised that the *Transatlantic Review*'s French correspondent, the Surrealist, Philippe Soupault, omitted a mention of Surrealism in his series 'Letter from Paris' (*Transatlantic Review*, January, February and May 1924). Ray came to the conclusion that the only possible explanation for such curious neglect was that '. . . even for a collaborator in the inception of the new movement, it was at the time an event of interest only to a small coterie'.[1] It is true that at this time André Breton showed nothing like the same fierce energy in trying to spread his movement's message throughout the Western world as was shown by Marinetti on behalf of Futurism or Tzara for Dadaism – though small Surrealist groups did develop in the mid-twenties in other European countries (Yugoslavia in 1924 and Belgium in 1926, for example), and a 'Bureau of Surrealist Enquiries' was set up in Paris in 1924. Moreover, Breton was completely involved in a series of desperate struggles in Paris to

achieve separate identity for his group, and these struggles, in spite of their public violence, were internal and esoteric. But the relative inwardness of Breton and his group does not sufficiently account for the almost complete English indifference to Surrealism during its first years.

As early as 1922 the *Littérature* group had been using the label 'surréaliste' to refer to themselves and their work; very soon most of the activities of group members appeared under that label. Between 1922 and 1927 the output of books and pamphlets by the Surrealists was enormous. Apart from the *Manifeste du surréalisme* of 1924 and ten issues of the periodical *La Révolution Surréaliste* (also founded in 1924) most of the members of the group published individual or joint volumes of poems or prose. Any short-list of Surrealist literature during these five years or so would include Aragon's *Une Vague de Rêves* (1924) and *Le Mouvement Perpétual* (1926); Breton's *Poisson soluble* and *Clair de Terre* (1925); Desnos' *Deuil pour Deuil* (1924), *C'est les Bottes de Sept Lieues, Cette Phrase 'Je me vois'* (1926), and *La Liberté ou l'Amour* (1927); Eluard's *Répétitions (1922), Les Malheurs des Immortels* (1922), *Mourir de ne pas Mourir* (1924), and *Les Dessous d'une Vie ou la Pyramide humaine* (1927); Péret's *Au 125 du Boulevard Saint-Germain* (1923), *Immortelle Maladie* (1924), and *Dormir Dormir dans les Pierres* (1927); and Soupault's *Georgia* (1926) and *Chansons des Buts et des Rois* (1925). *152 Proverbes mis au Goût du Jour* by Eluard and Péret (1925) and *Au Grand Jour* by Aragon, Breton, Eluard, Péret and Unik (1927) are just two instances of several group productions of the period. The sheer quantity of Surrealist works published during the first five years of the movement's existence makes questionable any suggestion that Surrealism could ever have been simply unnoticed in England as the activity of a small coterie.

I believe that a more acceptable explanation of critical neglect is that English critics perceived distinctly the strong subversive and anti-traditional roots of Surrealism and either refused or failed to distinguish these from the nihilistic and destructive principles of Dadaism. In addition, in so far as most major English writers of the twenties were consciously and actively concerned with new critical and creative explorations of their own living traditions there would tend to be a proportionate lack of interest in anything that seemed to be produced as a result of already outmoded foreign extremism, or that offended against the basic principles of serious craftsmanship.

Unsympathetic reaction to Surrealism was not characteristic only of conservative or English critics. Even in the most avant-garde European circles Surrealism was sometimes seen as both unoriginal and lacking in interest. Paul Ray noted[2] that for one issue of the Franco-American *This Quarter* (Vol. V, No. 1, September 1932) the editor Edward W. Titus handed over his magazine to Breton and his group, thus illustrating a comparatively early recognition of and sympathy towards Surrealism. Ray did not record, however, that

during 1925 and 1926 when, under the editorship of Ernest Walsh, *This Quarter* was probably the most adventurous experimental English language publication of its time in Europe, the works of the Surrealists were almost entirely ignored or treated with scornful disdain. Ernest Walsh's destructive, anti-traditional editorial attitudes were to earn for him some of Wyndham Lewis's most blistering broadsides (in *The Enemy*, Vol. 1, January 1927). Apparently, however, Walsh's attitudes towards the past, diametrically opposite as they were to the views of most English writers in the mid-twenties, did not allow free rein to the Surrealist style of innovation. In the first issue of *This Quarter*, Lewis Galantière reviewed recent French books, including Breton's *Poisson soluble* which was published with the first Surrealist *Manifesto* in 1924. Galantière's response to Breton's practice and theory was to dismiss both as provincial and naive:

> **In other words, Breton has discovered Freud, whose name has been a household word in America these past fifteen years. As for the 'magical art' of super-realism, it is more easily learned and practised than the art of leger-demain or knitting. Take writing materials, make yourself comfortable, put yourself in a state of perfect receptivity (i.e. mental blankness), dismiss any genius or talent you may know yourself to possess, and write. Write swiftly without preconceived ideas and without re-reading what you write. The result will be a *poème surréaliste*.[4]**

Galantière's comments on Breton's *Poisson soluble* were equally sharp, and in agreement, as will become obvious,, with the general contemporary English view that both Surrealist theory and its poetry were boring effusions of an unacceptable anti-literary anarchism:

> **The fact – it is a fact – that all the great images of poetry are written out of the unconscious cannot be taken to prove that all unconscious writing will necessarily turn out to be poetry. All of Breton's *Poisson soluble* may have been written in a state of ecstasy; much of it can be read only in a state of boredom. Despite an overwhelming conceit, he is more convincing as polemist and debater than poet. He is more passionate in the service of anarchy than of poetry. Anarchy is an important factor in the social fabric, but for my part, I am interested in poetry.[5]**

Galantière's gibe that Breton and the Surrealists had been late in discovering Freud is not entirely unfair. Breton himself had certainly become acquainted with some of Freud's work before World War I, and he had used Freud's methods during his period as an intern at the neurological centre in Nantes in 1916, but it is also true that Freud disliked the French for their failure to show an early interest in his work. In her *Surrealism: the Road to the Absolute*, Anna Balakian pointed out that France 'had remained the only country indifferent to [Freud's] work' and that the first French translation of *Der Witz und seine Beziehung zum Unbewussten* (1905) did not appear until 1930,

though the first English translation had appeared in 1917.[6] It is also important to remember that, like Breton, several English writers of the twenties, notably Robert Graves and Herbert Read,[7] had first embarked upon studies of Freud and his relevance to literature as a direct result of their wartime experiences. Moreover, some English writers, especially those connected with the 'Bloomsbury' group, had discovered and had shown an understanding of Freud's general theses, with some of their literary and artistic implications, even before 1914. In James Strachey, Lytton Strachey's brother, they had produced a translator of Freud who was so good that, as Michael Holroyd tells us,

> **This twenty-four volume edition, with its maze of additional footnotes and introductions, was said to be so fine both as a work of art and of meticulous scholarship that a distinguished German publishing house was endeavouring to have it re-translated back into German as their own Standard Edition.[8]**

All of this tends to discredit the view that the failure of Surrealism in England may be explained simply in terms of a cultural 'time-lag' between Europe and England. If there had been general recognition by English artists of the importance of Surrealist ideas there would have been no shortage of people able to understand and to develop the relationship between those ideas and Freudian theory. That the English did not apply Freud's ideas and methods to art during the twenties as the French Surrealists did proves only that the English were not Surrealists!

THE ADELPHI, THE CRITERION, THE CALENDAR

It must be admitted that most English critics and writers of the twenties simply ignored not only Surrealism but also all the activities of the avant-garde in Europe. This is not surprising perhaps, except when we are considering those publications whose editors and contributors had been sympathetically interested in new foreign art at other times. The failure of the *Times Literary Supplement* to pay any attention to more than one or two of the books published by the Surrealists between 1922 and 1927 has already been noted. Similar omissions in more conservative periodicals (*The London Mercury*, or even *The Chapbook*, for example) are more predictable. Some of the editors of the twenties who might have been expected to take some interest in new developments in foreign art deliberately turned back to the English tradition and, in doing so, turned their backs on anything outside that tradition.

In mid-1923 John Middleton Murry's new monthly *The Adelphi* appeared for the first time. From the start Murry expressed a clear allegiance both to the English tradition and to Romanticism. In an editorial note to an early issue he declared that 'Romanticism . . . is itself the English tradition' and that *The Adelphi*'s Romanticism

would have nothing to do with any contemporary French fashions, with writers who were 'but false and incomplete Romantics, people who for the sake of a little prestige in a little coterie try to wear their rue with a difference imported from Paris.'[9] Such contemptuous dismissal of foreign fashion was to characterise *The Adelphi* throughout the nineteen-twenties, and though *The Adelphi* published some fine original creative work and criticism (particularly its 'Shakespeare Notes') it printed little contemporary foreign work, even in translation, and rarely reviewed anything remotely avant-garde. This kind of 'inwardness' is too easily assumed to be typical of English literary activity after World War I. It is also often assumed to be an automatic English cultural reaction, and to have affected the postwar younger generation as much as their literary elders.

Discussions about radicalism in literature during the early twenties in England were concerned with English-speaking artists. The most interesting poetic 'revolutionaries' or dangerous 'extremists' were those contemporaries who, like Gertrude Stein, Laura Riding, and e. e. cummings, were exploring the medium of the English language in new ways.[10] The greatest scandals of the time were created around the writings of Gertrude Stein, with Wyndham Lewis and Edith Sitwell, predictably perhaps, taking opposite sides as adversary and champion. Even this debate failed to disturb *The Adelphi*. There were, however, some journals which took wider and larger views of the literary scene in Europe.

By far the most important English periodical of the period between the two wars was *The Criterion* which, unlike most other publications of that period, set out to keep England in contact with the best of European culture. Eliot's insistence on an English and a literary focus for *The Criterion* made it quite unlike any of the international multi-media reviews of the same period, just as his active belief in the possibility of European cross-cultural fertilisation made it quite different from other native English reviews. According to Eliot, speaking in 1946, *The Criterion* had been 'an ordinary English periodical, only of international scope'.[11] This meant, he explained, that since *The Criterion* was designed primarily for readers of English in England, all foreign contributions had to appear in translation. Nevertheless, there is no doubt that a primary objective for Eliot throughout the period 1922 to 1939 had been to publish in *The Criterion* the best new work from, and critical reviews concerning, as many European literatures as possible. He declared that it had been his wish to represent writers from different generations according to two main aims:

to present to English readers, by essays and short stories, the work of important new foreign writers, and to offer longer and more deliberate reviews than was possible in magazines of more frequent appearance.[12]

These aims, or rather, limiting principles, were to be crucial. Eliot's belief that foreign poetry could not be accurately or adequately rendered into English, taken in conjunction with his principle of aiming for a fair-sized English readership, meant that direct quotation from a foreign language would appear, if at all, only in very brief extracts in the review—essays or in the notices given to foreign periodicals. These principles were always strictly and impartially followed by Eliot, with the consequence that unlike, for example, *The Little Review*, *The Criterion* never devoted most of a single issue to an illustrated study of one foreign author or 'school'. Though the amount of space allocated to creative and critical work, both English and foreign, was evenly balanced, *The Criterion* could never have acted as agent in England for any of the European avant-garde poets or movements in poetry.

As far as Dadaism and Surrealism were concerned, however, Eliot's restrictive publishing principles were practically irrelevant. During the nineteen-twenties, neither the theory nor the practice of either movement was regarded at all favourably by *The Criterion*'s reviewers of foreign literature, amongst whom were Richard Aldington, F. S. Flint, Herbert Read, and Bonamy Dobrée. This does not mean that Eliot and his reviewers had ceased to be concerned about postwar European literature; on the contrary, throughout the twenties there was a constant and anxious look-out for some signs of recovery from the wartime damage caused to the art of letters in Europe, especially France. The growing exasperation shown by Eliot's reviewers against their young French contemporaries during this period passed through several stages.

F. S. Flint was not only Eliot's chief foreign reviewer during this time; he was also responsible for translations of several important critical articles, including, for example, Jacques Rivière's 'Notes on a possible generalisation of the theories of Freud' (July 1923)[13] and Jacques Maritain's 'Poetry and Religion' (January and May 1927).[14] Flint inherited Aldington's position as main reviewer of contemporary French literature – usually as it appeared in foreign periodicals – commencing with the issue for July 1924 (Vol. II, No. 8), and must therefore be regarded as the critic mostly responsible for the expressed attitudes of *The Criterion* to new French writing. Aldington had made occasional brief notes, during 1923, about Dadaist periodicals which were by that date rightly regarded as no longer shocking or very entertaining. For example, in July 1923 he referred to the March and April issues of *Les Feuilles Libres* as '"Dada" repentant or at least toned down', and he supplied merely a list of contributors. But it was Flint who consistently refused to concede any significant differences between the attitudes and achievements of the Dadaists and the Surrealists in literature.

Flint's hostility to the Surrealists earned him a brief but strongly expressed rebuke from Paul C. Ray:

In England proper, F. S. Flint, reviewing French periodicals for T. S. Eliot's *Criterion*, took occasional though consistently hostile notice of surrealist activity across the Channel. In the July and December [*sic*, see note 15 to this chapter], 1925, numbers, he dismissed surrealism in harsh, contemptuous, and essentially ignorant terms. This, from the man who had always been extremely sympathetic to modern French literature, and who had done so much a decade earlier to familiarise the British public with the newest French poetry, represents a curious hostility, or at least an unwillingness to find out what the new movement was about.[16]

It seems from this that Ray had not seen any of Flint's postwar criticism of Dadaism, and had failed to understand how easily the activities of Surrealism may be connected with those of Dadaism. It is true that Flint failed to mention the early Surrealist group publications, including *La Révolution Surréaliste*, but it is not certain that even such direct awareness of the Surrealists' ideas would have modified Flint's attitudes, or those of any of his colleagues.

Flint always noted the presence of strong Dadaist elements in all Surrealist activities. In *The Criterion* for October 1924 he reviewed an issue of *Les Feuilles Libres*, one which Eluard had produced, and which contained poems and drawings by lunatics:

M. Paul Eluard, Dadaist, or ex-Dadaist, whose competence in the matter no one will wish to deny, introduces them: *Le privilège le plus enviable des fous est de poétiser les plus ingrates besognes*, he says. One could name some French writers of the last two years who have coveted and usurped that privilege. It is gratifying to note that the lunatics at least who are quoted and reproduced here are trying to be sane.[17]

This comment was uncharacteristically terse and dismissive, but it indicates that during the two years to which he refers (1922–1924) Flint's exasperation with the French avant-garde had brought him to the end of his patience. This impatience was not merely temporary, as was demonstrated in *The Criterion* for July 1925[18] where Flint reviewed two issues of *Le Disque Vert*, one devoted to the theme of suicide and the other to dreams. He found a poem by Reverdy incomprehensible, and gave an example of a Surrealist 'recipe' for writing a poem:

Procédé: Prenez une large superficie de papier, demeurez assis plutôt que debout, plutôt couché qu'assis, plutôt encore ensommeillé, indifférent à tout, à tout sujet, à tout but, sauf à mettre en mots immédiatement le contenu apparent de votre imagination.

Flint's comment this time was even terser – 'Suicide: or self-deception'.

That *The Criterion*'s strictures against extremist modernism in literature did not apply indiscriminately to all other modern art forms is shown by the appearance of surveys and studies of, for example, contemporary French music, cinema and ballet, such as the report on

'Cinema and Ballet in Paris' which appeared in *The Criterion* in January 1926.[19] Walter Hanks Shaw reported with sympathetic interest on the experimental cinema in Paris, especially recent attempts to produce abstract films. Most of his discussion concerned Picabia's film *Entracte* which was the middle section of the ballet *Relâche*, to music by Erik Satie whose death was sadly announced at the close of Shaw's report. Such reports of successful work in other media had no ameliorative influence on the literary reviewers of *The Criterion*. Flint never ceased to berate the Surrealists or other French writers who had betrayed literature, in his view, and had sold out to nihilism. In April 1926 he protested against Valéry's pronouncement that, for him, art was merely a game. The elevation of this attitude to a major aesthetic principle, Flint argued, meant the end of the central role of art in the communication of fully human values. This was a triumph of Dadaist nihilism:

if art is only a game, it is a game which may be played by four, three, two or even only one player; it ceases to be a communication, and becomes, in fact, a form of nihilism; and what is this but Dadaism, and what is M. Valéry's art but a refined form of Dadaism? And even this statement contains an element of contradiction, for it implies that form has been given to that which admits of no form. But perhaps M. Valéry's practice is better than his principles? If so, it is open to those who believe in him to convince me and to persuade me that some of the few hours of my life may be profitably spent on his work.[20]

The Criterion's policy of questioning principles without attempting a practical criticism of work created in accordance with those principles shows at its weakest on such occasions. But there is no doubting Flint's serious concern with the central problems of modernist literary theory and his view that literature was a humanising activity which the Dadaists and Surrealists had betrayed.

The Criterion's rather solemn belief in the concept of reason was not merely a part of the major domestic 'classical-romantic' debate of the nineteenth-twenties (in contention with Middleton Murry's avowedly Romantic *Adelphi*, for example). It represented also a much more serious awareness of the dangers of general European and Western cultural anarchy, which, far from being liberating, would tend towards a destructive, completely demoralising nihilism. Flint's refusal to see any important differences between Dadaism and Surrealism on this count meant that neither he nor his fellow reviewers paid detailed attention to any early Surrealist publications. During the period which Breton called the 'intuitive' stage of Surrealism it was not easy to separate the subversive elements of Dadaism–Surrealism from the creative ones.

The only other English literary periodical of the nineteen-twenties which could make any kind of claim to rival *The Criterion*'s standards in criticism and creative-writing, as well as its involvement in new

foreign art, was *The Calendar of Modern Letters*. The four volumes of *The Calendar* appeared between March 1925 and July 1927. This review, edited by Edgell Rickword and Douglas Garman, was founded by a small group including the editors, Bertram Higgins (an Australian who had been at Oxford with Rickword just after the war) and Ernest Wishart who initially organised *The Calendar*'s finances. According to Malcolm Bradbury in his essay-introduction[1] to the reprint of *The Calendar* in 1966, the members of this group had come to feel increasing dissatisfaction with the failure of Eliot's *The Criterion* fully to achieve those high standards in literary criticism which Eliot's own critical contributions to early issues of his review had seemed to promise. *The Calendar* was essentially, though not only, a great critical review, forging the principles which led eventually to the founding of *Scrutiny*. Certainly Dr Leavis took the title for his review from *The Calendar*'s vigorous 'Scrutinies' or re-appraisals of the work and reputations of such established modern authors as Barrie, de la Mare, Masefield, and Shaw. *The Calendar*'s attempt to secure more definite and yet more flexible critical principles and methods than *The Criterion* had managed to achieve was not undertaken at the cost of any loss in intelligent and sensitive awareness of contemporary literature either in English or by European writers, both new and relatively well-known. Distinguished writers in English who contributed creative work or criticism to *The Calendar* included D. H. Lawrence, A. E. Coppard, Edwin Muir, and the Americans John Crowe Ransom, Hart Crane and Allen Tate. The contributions from foreign writers and about foreign literature – including, especially, Russian and French literature – were substantial. Among the writers whose works appeared in new translations in *The Calendar* were Dostoevsky, Chekhov, Baudelaire, and two contemporary Russians, Rosanov and Niervierov. Critical essays on Rimbaud, de Sade, Valéry, and Anatole France, as well as reviews on work by such authors as Villiers de l'Isle Adam, Drieu la Rochelle, Raymond Radiguet, Baudelaire, Gide, Proust, de Sade, and Rimbaud, demonstrate that the editors were well aware of many of the writers who influenced their European contemporaries.

Edgell Rickword himself, a regular contributor to the *New Statesman* and *The Times Literary Supplement* between 1921 and 1925 of reviews and comment on French, English, and American literature, was responsible for several of the translations and reviews of French literature, as well as the 'Notes for a Study of Sade'[22] an essay in which Rickword argued the importance – particularly after the experiences of World War I – of an honest confrontation of man's sadistic and masochistic tendencies. The essay also demonstrated that Rickword was familiar not only with much of Sade's writings but also with many of those writers considered important by the French Surrealists, including Baudelaire, Lautréamont and Rimbaud.[23]

The Calendar was especially concerned with the question of the role of the artist in the society of their own time. For example, Edwin Muir's important discussions of contemporary literature stressed the dual role of the important artist as an individual fully exposed to the characteristics of his time ('the Zeit Geist') and most probably in opposition to it. Such opposition, however, profoundly expressed in the most serious artists such as James Joyce, D. H. Lawrence, and T. S. Eliot, had to be distinguished from the fashionable unquestioned disillusionment which, Muir thought, was to be encountered typically in the novels of Aldous Huxley. In all important contemporary writers both the individual who suffered and the individual who struggled with his age were working together. In some writers, such co-operation was dramatically divided: in his poetry T. S. Eliot 'sets side by side the response of the poet who desires to escape from his environment, and that of the critic of life who wishes to come to terms with it.'[24]

Moreover, Muir stressed in a later essay, the modern poet's double response was not traditional (and reasonable) pessimism but rather 'a bewilderment and distress of mind' which resulted from a total loss of orientation:

> **Everything is conditional, everything is potential. Modern thought and modern life present the poet with a number of possible worlds, but not with the one he needs if he is to feel, as well as to speculate upon reality.**[25]

Muir's essays illustrate *The Calendar*'s general anxiety to discover literature and criticism which was truly contemporary and which met the real needs of the modern world. Such literature had to meet the highest editorial standards.

Foreign literature of the day had to be included in this search for relevant modern writing. As might be expected, however, from the standards of criticism and creation imposed by the editors, most extremist avant-garde groups and periodicals were given short shrift.

The second issue of Ernest Walsh and Ethel Moorhead's *This Quarter* was attacked for its shrill editorial style, though the contributors, including Hemingway, who were 'heard above the editorial drum' were thought to be interesting and to give some pleasure. The Antheil musical supplement to the same issue, however, provided an opportunity to berate the whole Parisian avant-garde which had been for some years on the verge of inescapable bankruptcy. George Antheil (who had received the support of Ezra Pound for several years) was the musical representative of the last surviving group:

> **Only one little group remains, shouting the old war-cries, writing the same long manifestoes and the same short works, still convinced, seemingly, that it represents the advance guard of artistic progress, whereas it is actually quite out of date and behind the times.**[26]

The litte group referred to is, presumably, the Surrealist group; in view of the interest shown in such writers as Baudelaire, Rimbaud, Sade, and Lautréamont, it would have been surprising if *The Calendar* had failed to discern the beginning of something as new as Surrealism. But obviously its reviewers were not impressed.

The main reasons for *The Calendar*'s low estimate of the new movement had been succinctly expressed in a review of Breton's *Poisson soluble* and the first *Manifeste du surréalisme* the previous year. The review (by Edgell Rickword) found Breton's (and the Surrealists') ideas to be following the fashionable theory of the unconscious and the free association of images, but these ideas were dogmatically expressed by the Surrealists, and decadent and wasteful of talent. Poems which were produced as a result of the theory were generally tedious:

[Breton's] ideas are based on the theory of the unconscious and the association of images which holds the field at present; he is dogmatic where he should be tentative.. His effort is in the direction of what M. Benda has described as the hatred of general ideas, the feminisation of art, the sole enjoyment of the concrete and the particular; the emotionalisation of literature. It ignores altogether the constructive effort in poetry, the organisation of the *whole* into something significant. It is this lack of organisation which makes so tedious the reading of M. Breton's prose poems *Poisson soluble*. The concantenation of imagery is sometimes stimulating, but it leads nowhere. The poem and the day-dream are not identical, though they may make use of the same mental processes. Perhaps M. Breton will agree when he has carried his analysis a little deeper.[27]

The wariness about the application to literary theory of contemporary psychological theory cannot be dismissed as mere English prejudice against foreign ideas. By a coincidence Robert Graves's attempt to link psychology and literature, *Poetic Unreason*, was reviewed in the same issue of *The Calendar*. J. F. Holms, the reviewer of Graves's book, was much in agreement with Graves's own later considered judgement that the book fell into those dangers awaiting anybody who tried to correlate literary theory with modern psychology, though Holms conceded that the book had 'considerable value as the psychological confession of an interesting poet'.[28]

The only other direct reference in *The Calendar* is to be found in the comments on the issue of *Le Disque Vert* which was devoted to one of the Surrealist super-heroes, Isidore Ducasse, the self-styled Comte de Lautréamont. 'The Lautréamont Affair' which appeared in *The Calendar* in 1926, began by noting the quasi-religious atmosphere surrounding much contemporary theory in general, but especially Surrealism, for which Lautréamont had been elevated to the status of a major prophet: 'A parallelism with the early stages of a new cult is apparent in recent poetic propaganda in France; the fulfilment of a prophecy – the theory of the psychology of the unconscious.'[9] The

reviewer (again Edgell Rickword) conceded that some of Lautréamont's work was impressive, but thought that it was neither abnormal nor very remarkable, and certainly required no 'new dispensation'. What Surrealist work he had read, written according to what the Surrealists regarded as Lautréamont's revolutionary principles – especially automatic writing methods – had none of his qualities: 'We have read some work admittedly produced on this plan, and it was neither more or less tedious than, say, a translation from Tagore. But it bore no resemblance to Lautréamont's work'.[30] Surrealist attempts to link Lautréamont with Rimbaud and Baudelaire in their theory were merely irresponsible: 'Much of [Lautréamont's] originality is only superficial, a reminiscence of romantic reading . . . including the shoddiest works of the English school of terror.'[31] Lautréamont's method of replacing all the abstractions in the earlier (1868) edition of *Le Chant de Maldoror* with 'the names of objects or with the names of animals which had no logical connexion with the poem' was a simple device which thrilled the 'modern' because 'his psychology is not very distinct from that of the 1830-romantic'. Only 'literary snobism' separated the world of the 1830 romantics (Maturin, Lewis, Ossian, Young, Borel, and Bertrand) from that of the Surrealists. Lautréamont was being used as the foundation for a merely fashionable literary cult.

WYNDHAM LEWIS AND POST-DADA

Edwin Muir's conception of the true artist as a man likely to be running counter to the 'Zeit Geist' of his contemporary culture while still deeply aware of its nature was materialised fully for the second half of the twenties and later in the work and personality of Percy Wyndham Lewis whose review *The Enemy* first appeared in January 1927.

The previous year Lewis had emerged explosively from relative postwar reticence to publish a tract in political theory, *The Art of Being Ruled*,[32] in which he had examined the prevalent fashionable 'revolutionary' attitudes in politics and art, and had denounced them as anti-human in the fullest meaning of that word. During 1927 he published (in addition to two issues of *The Enemy*) an astonishing number of large-scale works, and demonstrated that his mind had been far from dormant during those years of the 'Post-War'. The books included a study of the role of the hero in Shakespeare, *The Lion and the Fox*, a collection of stories, *The Wild Body*, and a philosophical study, *Time and Western Man*.[33] In *Time and Western Man* Wyndham Lewis re-emphasised his conviction that a healthy civilised society flourished only where free and responsible individuals recognised the basic necessity for a creative, value-seeking, and truth-telling intellect. Under such conditions artist and intellectual were not separated from each other or from the community at large. Modern European society, Lewis complained, had failed to maintain an integrated vision

of man, and its artists and intellectuals had become increasingly isolated from each other. Art was tolerated in modern society only because it had become feebly eccentric and sensationalistic, and, in direct consequence, intellectuals themselves had become increasingly abstract, compartmentalised and remote. The modern European artist's surrender to man's traditional enemy, the 'time-flux', was the most typical symptom of the general abandonment of a deeper spritual view of the human intellect.

In the *Editorial* to the first issue of *The Enemy* Wyndham Lewis cited the view of the contemporary French classicist Julien Benda (1867–1956), whose *La Trahison des Clercs* was published in 1927 (and translated into English by Richard Aldington in 1928, with the title *The Great Betrayal*):

> **Our documents for determining the aesthetic tendencies of present-day society are . . . above all, the works of those authors that must give, we can assume, seeing their success, the greatest satisfaction to the public taste, and must most accurately represent it. One is sorry to have to remark that those authors are not only of second rank, and that the law enunciated in other times by a critic (Faguet) according to which *good writers, far from incarnating the prejudices of a time, are, on the contrary, opposed to them*, no longer holds in our day.**[34]

Lewis agreed with Benda's analysis, and declared that a 'Time' was, in any case, 'always a congeries of the most insignificant people within it'. These leaders of artistic fashion were always ready to take credit for work which they themselves could never have created or conceived. Under their influence, contemporary culture became one stale, conformist, and violent pattern. Lewis declared himself the Enemy of all such mediocre fashion-mongering and pseudo-radicalism.

The first number of *The Enemy*, most of which was written and illustrated by Lewis himself, was devoted primarily to his long study 'The Revolutionary Simpleton',[35] a book-length essay in which he attacked without polite restraint the 'High Bohemia' of the Russian Ballet and the slavishness to the time-flux and the 'Child-Cult' of Dadaism, Gertrude Stein, Anita Loos and Charlie Chaplin. Ezra Pound, one of the 'revolutionary simpletons' of the title, in spite of his acknowledged passion for artistic modes of the past, was scourged for his uncritical enthusiasm for everything new. Joyce's *Ulysses* received more respectful analysis, though he too was seen primarily as a craftsman or technician of literature: 'not so much an inventive intelligence as an executant' ('what stimulates him is *ways of doing things*, and technical processes, and not *things to be done*' (p. 109). This first issue of *The Enemy* received widespread critical acclaim in Britain, much of it in agreement with the assessment of the reviewer of the *Times Literary Supplement* (17 March 1927) who wrote:

> **'The Revolutionary Simpleton' is the finest and most searching piece of literary criticism we have had for a long while. If there should never**

appear a second number of *The Enemy* the first will keep its memory green.

Much encouraged by the reception given to the first number, Lewis went on to issue a second at the end of September 1927. Apart from Henry John's 'The Reintegration of Experience' – the third section of a long essay which attempted to relate the argument of Lewis's *The Art of Being Ruled* to Catholic thought – *The Enemy*, No. 2 was entirely Lewis's own work. Most of it (pp. 3–110) was devoted to 'Paleface', his critique of the 'radical' Romantic fashion for the savage and the primitive which, he argued, was being foisted (particularly by D. H. Lawrence) on an apathetic European civilisation which had lost faith in itself and in its ability to foster its own genuine revolutionary change:

> **When he is abused or bullied, the European or American has nothing to reply: he has nothing much, very recently, to be proud of, he is compelled to confess. The War is there just behind him to prevent him from claiming to be anything much better than a brute, and a helpless, shifting brute at that. And he has to admit that, for the moment, he has not the inclination or energy to undertake a *radical* reform. So under the pressure of the real misery and fomented discontent of the working masses of his own kind, he is bound to accept an alien programme of 'radical' change or revolution.**[36]

The introductory 'Editorial Notes' to *The Enemy*, No. 2 included an attack on the Parisian 'post-Dada' literary scene. The principal targets of Lewis's 'The Paris Address' were to be more fully and vigorously persecuted in 'The Diabolical Principle', the essay which formed the main section of the third and final issue of *The Enemy* in January 1929, but the main lines of attack were already established in 'The Paris Address'.

According to Lewis, Paris, the home of many brilliant contemporary European artists, had been infiltrated by a large group of 'anglo-saxon' and other upstarts ('a mixture of the lively highbrow dregs of Roumania and Chicago, Moscow and Birmingham'). The main vehicle for this group was the magazine *transition*, edited by Elliot Paul and Eugene Jolas, which had been founded that year (1927), and which was based on the radical nihilism of the Dada movement: 'The real foundation for *Transition* is *Dada*, which group has become the Super-realist group now; the Super-realists are the former Dadas.'[37] 'Super-realism' was a political movement – Lewis having noted that they were 'declared adherents of Russian communism' – and were 'the intellectual wing, more or less, of the communist party in Paris'. Other contributors to *transition* were linked with the Dada or post-Dada milieu of artistic mediocrity. Gertrude Stein, though no orthodox Communist, was '*artistically* identical with Dada, or post-Dada', while other more important artists had been forced into association with the *transition* group because other Western countries had failed to offer to

their artists anything to rival either the pseudo-radicalism of post
Dada art or Russian Communism:

> ... in fact the Paris *Super-realist* is luckily a professing *radical* as well,
> as much as the personnel of the *New Masses*. Joyce, or Picasso, or
> Chirico, are called in to advertise something that is not primarily *art*,
> just in the same way as the Soviet leaders very sensibly employ
> 'advanced' artists to advertise their regime, and make it look very
> new.[38]

'Super-realism', like Marinetti's Futurism before it, had all the
characteristics of a 'youth movement' devoted to political instability
(despite the fact that most of the members of both movements were
now middle-aged), and Lewis noted that other youth movements
(Royalist, Catholic, and militantly anti-Communistic) had begun to
emerge in Paris and elsewhere in Europe. The student Paris group
centred on the *Action Française* was 'the truest spontaneous express-
ion of the mind of Young France'. Lewis recognised that such
arguments and enthusiasms were likely to be viewed (rightly) as very
reactionary, but he was unrepentant. The defence of Western values
required a more positive belief in the West by its artists and
intellectuals.

Lewis ended by stating his intention to continue the fight in
subsequent issues of *The Enemy* against the 'convulsive, politico-
artistic forms of radical propaganda' of the '*transition*-welt', especially
Gertrude Stein and post-Dada. As in *Time and Western Man*, for Lewis
the challenge of pseudo-radicalism had to be met by more creativity
and intellect, by a more dynamic artistic conservatism: 'Surely it is not
with dullness, or with less intelligence, but rather more, that this
prodigiously industrious, super-clever, if not super-real, adversary can
be met?'[39]

Although Lewis in his role as 'The Enemy' was certainly guilty of
failures in sympathy with large numbers of the under-privileged and
exploited in and beyond Europe, and though he expressed strong
opinions with too much vigour, harshness and verbose repetition, there
is no indication that during the twenties his views were regarded as
either eccentric or illiberal by other English critics of his generation.

Like the reviewers of *The Criterion* and *The Calendar* – though
more aggressively and articulately than they – Lewis was primarily
concerned with the expressed or supposed general principles of
post-Dadaist art. Individual works or particular aspects of methodolo-
gy, where they were discussed, were found to be unoriginal, tedious,
and unrewarding as examples for English writers. Whenever the
concepts of a civilised Anglo-European tradition in art were set by an
English critic against what was seen as those of an alien nihilism or
revolutionary anarchy and anti-art, there was no real contest. Herbert
Read's view of *Time and Western Man* (*Nation and Athenaeum*,
November 1927) was typical of the notices of Lewis's work:

In *Time and Western Man* he has done some heroic cleansing – he has simply swept away those silly types of romanticism which pass currently for revolutionary modernism in Literature and Art. That in itself is a great accomplishment ... in all these fatal encounters, Mr Lewis has engaged himself with an originality and a lusty vigour without parallel in contemporary criticism. [40]

English attitudes which underpinned the deliberate refusal to take Surrealism seriously during the nineteen-twenties were identical with those of the generation which had rejected the extremisms of prewar Futurism and postwar Dadaism. Some of the major critics of the twenties (several of whom had been acknowledged leaders of English modernism) had been actively involved in the assessment and rejection of all these late-modern extremisms, and they continued to demonstrate, as has been seen in this chapter, a strong and influential hostility towards much postwar European art and literature because of such extremism. Any successful spread of literary Surrealism to England (as Read's review above indicates) would require a new generation's very different view of the nature of the Surrealist movement and its contemporary relevance for English art.

NOTES

1 *The Surrealist Movement in England*, p. 68.
2 *Ibid.*, pp. 80–2. Ray argued that Titus was 'concerned with the inaccessibility of the work of the surrealists to English and American readers', but Titus's introductory *Editorial* to that issue of *This Quarter* (p. 6) suggests that he was more concerned about the Surrealist challenge to ordinary literary and critical standards.
3 See for example, Walsh's Editorial to the second issue of *This Quarter*: 'There are several kinds of so-called artist and writer and poet. There is the kind that in the main has become the standard on which a tradition of culture or art has been laid. Perhaps all the accepted conceptions of civilisation and culture have been got from the traditional contemplation. That is from believing that tradition was the strongest force. And therefore what was *not* built on tradition was not strong enough to survive its opposition. It is the aim of the present writer to imagine that life has begun only today as far as culture and civilisation are mixed up with it. And to give importance only to work which is important now.'
4 Lewis Galantière, 'Recent French Books', *This Quarter* I, i (1925), p. 202.
5 *Ibid.*
6 Anna Balakian, *Surrealism: The Road to the Absolute*, revised and enlarged edition (Unwin Books, London, 1972), pp. 125–6.
7 See Robert Graves, *On English Poetry* (1922) and *Poetic Unreason* (1925). *Poetic Unreason*, Graves explained in his 'Author's Note', was one of the results of his desperate attempts to develop his 'wayward notes on poetic psychology' published in *On English Poetry*, and to complete a B.Litt. thesis at Oxford University on 'The Illogical Element in English Poetry'. In *Goodbye to All That* (1929), Graves' final judgement on *Poetic Unreason* was that 'The weakness of the book lay in its not clearly distinguishing between the supra-logical thought processes of poetry and pathology.
8 Michael Holroyd, *Lytton Strachey: A Biography* (Penguin Books, 1971), pp. 11–12.

9 John Middleton Murry, 'On Fear: And On Romanticism', *The Adelphi*, I, 4 (September, 1923), p. 275.
10 See Robert Graves, *Contemporary Techniques of Poetry: A Political Analogy*, The Hogarth Essays No. VIII (Hogarth Press, London, 1925).
11 T. S. Eliot, 'Appendix', *Notes Towards the Definition of Culture* (Faber, London, 1948), p. 115.
12 T. S. Eliot, 'Preface', *The Criterion* Collected Edition), (Faber, London, 1967), p.v.
13 *The Criterion*, I, 4 (July 1923) pp. 329–47.
14 *The Criterion*, V, 1 (January 1927); V, 2 (May 1927).
15 Ray obviously intended to refer to the April 1926 issue of *The Criterion* here. There was no issue for December 1925 and Ray's biliography refers only to Flint's reviews of 'French Periodicals' for July 1925 and April 1926.
16 *The Surrealist Movement in England*, p. 70.
17 *The Criterion*, III 9 (October 1924), p. 157.
18 *Ibid.*, 12 (July 1925), pp. 601–2.
19 Walter Hanks Shaw, *The Criterion*, IV, 1 (January 1926), pp. 178–84. See also for example: Ezra Pound, 'George Antheil', *The Criterion*, II 7 (April 1924), pp. 321–31, and 'The Contemporary French Theatre: a Short Survey', *The Criterion*, VI, 3 (September 1927); Walter Hanks Shaw had reported (*The Criterion*, III, 9 (October 1924), p. 123) the disappointment caused to both Dadaists and Surrealist/anti-Dadaists by Tzara's fifteen-act tragedy *Mouchoir de Nuage* because neither party had been able to repeat the intensity of the demonstrations caused by his first play *Le Coeur à Gaz*.
20 'French Periodicals', *The Criterion* IV, 2 (April 1926), p. 407.
21 'A Review in Retrospect', *The Calendar of Modern Letters* (Cass, London, 1966), pp. vii–xix. Bradbury's essay had appeared originally in *The London Magazine* (October 1961).
22 *The Calendar of Modern Letters*, II 12 (February 1926), pp. 421–31.
23 In 1924 Rickword had produced his much-admired study of Rimbaud (*Rimbaud: The Boy and The Poet* (Heinemann, London, 1924)) in which translations of letters and poems by Rimbaud (by T. Sturge Moore and Edgell Rickword) had appeared in an appendix. Rickword had refused then to regard Rimbaud as the founder of anti-art in the Dadaist sense: 'He has had the most profound influence of any poet since Baudelaire. Even if we burden him with the parentage of the Dada movement (which looking at his work as a whole we cannot justly do), he still remains as the poet whose scepticism broke down what faith could not pierce, the barriers of positivism' (p. 190).
24 *The Calendar of Modern Letters*, II, 8 (October 1925), p. 118.
25 Edwin Muir, 'The Present State of Poetry', *The Calendar of Modern Letters*, II, 11 (January 1926), p. 327.
26 [Cecil Gray], 'Notes', *The Calendar of Modern Letters*, II, 12 (February 1926), p. 433 (unsigned).
27 [Edgell Rickword], 'Among New Books', *The Calendar of Modern Letters*, I, 4 (June, 1925), p. 336 (unsigned).
28 *Ibid.*, pp. 333–4.
29 [Edgell Rickword], 'The Lautréamont Affair', *The Calendar of Modern Letters*, III, 2 (July 1926), p. 154 (unsigned).
30 *Ibid.*, p. 155.
31 *Ibid.*
32 Percy Wyndham Lewis, *The Art of Being Ruled* (Chatto & Windus, London, 1926).
33 Percy Wyndham Lewis, *The Lion and the Fox: The Role of Hero in the Plays of Shakespeare* (Grant Richards, London, 1927); *The Wild Body* (Chatto & Windus, London, 1927); *Time and Western Man* (Chatto & Windus, London, 1927).

34 Wyndham Lewis, 'Editorial', *The Enemy*, No. 1 (January 1927), pp. x–xi.
35 *Ibid.*, pp. 27–192.
36 Wyndham Lewis, *The Enemy* No. 2, p. xxxvii.
37 *Ibid.*, p. xxiv.
38 *Ibid.*, p.xxvi.
39 *Ibid.*, p. xxx.
40 Herbert Read, quoted in *The Enemy* No. 3 (first quarter, 1929) (advertising pages).

english critics and post-dada
1927–1936

GERMAN AND DUTCH DADAISM

It is regrettable, though understandable, that very little was heard in England of German experimental art during the early twenties. For some time after the Armistice there was a lingering popular hatred of everything German, a hatred which sometimes extended even to long-dead and previously revered writers and composers. Contemporary German experimental art was rarely reported in detail in English literary periodicals. This was partly because Dadaism in Germany, as we have seen, tended to be completely identified inside the political turmoils of the postwar years. Paradoxically, this more politically involved role for Dadaism in Germany was accompanied by an effort by some of its artists (including some of those who were directly involved in Zürich Dadaism) to develop a much purer formalist theory and practice. Several of the abstract and mixed-media techniques which had been force-grown by the Zürich Dadaists were developed in the major German cities where Dadaist groups were formed at the end of the war.

In Berlin, for example, Raoul Hausmann, the editor of the periodical *Der Dada* (3 issues, 1919), wrote a phonic poem 'fmsbw' which, he claimed, inspired his friend Kurt Schwitters (1887–1948), a leading member of the Hanover group, to experiment with 'sound poetry'. The most famous result of Schwitters's experiments was his *Ur-sonate* (c. 1924/5, published in 1932). Of Schwitters Hausmann wrote in his *Courrier Dada* (1958):

Schwitters was absolutely, unreservedly, 24-hours-a-day PRO-art. His genius had no time for transforming the world, or values, or present, or the future, or the past; no time in fact for any of the things that were heralded by blasts of Berlin's Trump of Doom. There was no talk of the 'death of art' or 'non-art' or 'anti-art' with him.[1]

In Cologne, during 1919, Hans Arp, Max Ernst, and Johannes Baargeld founded a Dada group. Arp's influence, like Schwitters's, was always towards the creative possibilities which Dadaism had helped to develop, especially in free form and 'abstract' composition.

In Holland Theo van Doesburg (1883–1931), painter, architect, and poet, was a co-founder of the De Stijl group in 1917, and editor of the periodical *De Stijl*. He met many of the French Dadaists, including Tristan Tzara, in the early twenties, but he found much more in common with the 'aesthetic' German Dadaists. Under the pseudonym I. K. Bonset, he produced four issues of a Dadaist periodical *Mécano* (1922–1923) which stressed creative principles and new art alongside some of the more familiar Dadaist rejection of the past. In *Mécano* there was a permanent confusion of the nihilistic rage and deep cynicism of the postwar mood with what was more like the clearly less earnest destructiveness of prewar modernist bravado and shock tactics.

Van Doesburg's arguments were rarely negative, though he could make radical Dadaist gestures. In his Manifesto 'Tot een Constructieve Dichtkunst' ('Towards a Constructive Poetry') in *Mécano* No. 4 (white issue), 1923, he came close to the principles which were to characterise early Surrealism, but he revealed most pointedly his complete sympathy with the ideas and work of Schwitters. Van Doesburg's stress on 'the reconstruction of poetry' on an aesthetic basis as the long-term aim makes *Mécano*, in spite of its Dadaist sympathies, quite unlike French Dada periodicals. Further confirmation of the important differences in emphasis which linked Van Doesburg more positively with prewar experimental modernism may be found in the second issue of *Mécano* (blue issue, 1922) which included an extract from Wyndham Lewis's 'Essay on the Objective of Plastic Art in Our Time' which had appeared in *The Tyro*, No. 2, 1922, p. 25:

ART AND GAMES

The game of cricket or billiards is an ingenious test of our relative, but indeed quite clumsy and laughable prowess. These games depend for their motive on the physical difficulties that our circumscribed extention and capacities entail. It is out of the discrepancy between *absolute* equilibrium, power, and so on, of which our mind is conscious, and the pitiable reality, that the stuff of these games is made. Art is cut out of a similar substance.

It was the European abandonment of just such a view of art as analogous to game-playing which Lewis was to regret, placing the

blame on the 'Post-War', and particularly on Dadaism–Surrealism.

The major English literary periodicals (with few exceptions, all of them significantly undetailed)[2] showed no interest in the literary aspects of formalist Dadaism, but although English response to the German and Dutch activity was delayed, and until recent years,[3] very minor, it was a little more positive than it had been to French Dadaism.

SIDNEY HUNT AND *RAY*, 1927

In 1927 two issues of *Ray*, an art-miscellany edited by the English painter and poet, Sidney Hunt, appeared in London. As far as I know this was the first publication in England[4] to include phonic poems by Dutch and German writers. Phonic poems by Schwitters and Theo van Doesburg, as well as articles on architecture, painting, and the theatre; several reproductions of paintings and drawings by English artists, including Ben Nicholson, P. Capeli, Claud Flight, and Sidney Hunt himself; and also by such modern artists as Moholy-Nagy, di Chirico, Malevich, and Kandinsky, were presented in an attractive format.

Ray was clearly intended to have a European image, though the second issue contained work by expatriate Americans, a poem by Matthew Josephson, and Gertrude Stein's 'Lipchitz'. The range of influence on *Ray* was very wide, from prewar Suprematism and the paintings of di Chirico, to De Stijl, early Dadaism, and some quite up-to-date work in experimental art. The label 'art-miscellany' was appropriate.

The tone of *Ray* was established in the first issue by Malevich's infamous black square. This, Hunt declared, was because 'The black square, perilously near the zero point of art, is therefore a signal and stimulus for new departures', and he quoted Malevich's own view: 'Midnight of art is ringing. Fine art is banished. The artist–idol is a prejudice of the past. Suprematism presses the whole of painting into a black square on a white canvas.'[5] Among foreign publications recommended by Hunt were *De Stijl* and *La Revolution Surréaliste*. A little of Surrealist influence may have been present in Hunt's inclusion in *Ray* of a 'sensitive drawing by Betty Edwards (uninstructed–age eleven)' – though this may have been a part of his attempt to disparage 'academism' rather than to capture the naive and primitive; in any event, these were the only possible indications of a response to the French movement. Most of the magazine's theory and practice derived from German–Dutch postwar experimental activity, and the aggression of its Modernism was relatively tame.

Hunt included one 'found poem' (an advertisement for Ajax tyres extracted from *The Saturday Evening Post* and entitled 'COMMERCIAL POEM (anonymous)'), and at the end of the second number he presented a page of aphorisms in defence of the 'new art'. These ideas

were only weakly provocative – indeed they linked, rather quaintly, epigrams by Oscar Wilde with utterances by Tristan Tzara, Pontius Pilate and Voltaire's Dr Pangloss. Hunt proclaimed the irrelevance of standards of good or bad in art, the relativism of beauty, and the moral neutrality of art:[6]

$$\overline{36}\ \mathbf{37}$$

VARIATIONS, REPETITIONS, ETC.

Beauty is everywhere—RODIN. **Beauty is everywhere**—FERNAND LEGER. **Beauty is everywhere**—SIDNEY HUNT. **Next please ! Any preoccupation with ideas of what is right and wrong in conduct shows an arrested intellectual development**—OSCAR WILDE **(1894).**

GREAT THOUGHT→ For TO-DAY

ANY PREOCCUPATION WITH IDEAS OF WHAT IS GOOD OR BAD IN ART SHOWS AN ARRESTED ARTISTIC DEVELOPMENT—S.H. **(1927).**

not transferable

One thing is as good as another. " The ephemeral is the eternal."

Nothing that actually occurs is of the smallest importance—OSCAR WILDE **(1894).**
My manifestoes will tell you that nothing is of any importance—TRISTAN TZARA **(1923).**
What is truth ?—PONTIUS PILATE.
Truth does not exist—TRISTAN TZARA **(1923).**
" All is for the best in the best of all possible worlds " (for the artist—S.H., 1927). No artist desires to improve anything.

Hunt produced none of his own poems in these issues of *Ray*, though two of them appeared in the second issue of *transition* (May 1927):[7]

```
w h i t e  limp droop UP
        h
        r
        o
        u
          g
          h
       p   i   n   k
       t
       o
       R
   R    E   Drooping
   ───────
   E    D
   D      droopink
       kto ww
       w h i t e
```

design V

**BRONZE PLATES WITH
EXTRA
DEEP CHISELLED
V-CUT**

LETTERS

> **SOLID
> BEAUTIFUL
> LEGIBLE
> PERMANENT**

Neither of these poems is evidence of any remarkable talent in a formalist experimental mode, though they may be the first 'concrete' poems by an English writer. They provide, however, a minor but interesting contrast with the poem by Hunt which appeared in *transition* three years later:

two seen and one dreamed

stare for air her
EYE
in back of black hat
UNMOVING

on yellow two flat black ovals round swell to seated
buttocks elongate in rising inking back to whisky ads
insolent eyes in saloon window rounding smalling to
ballsto balloons tight blown
eyes right to

EYE
TERROR RISING

shaded face
sadeyed feet
I cannot follow you home
to inaccessibles cabinets

This work in itself is enough for us to be able to judge that the mode in
which Hunt had been working in 1927[9] had been thoroughly absorbed
three years later into the characteristic features of the *transition* ethos
– a hotch-potch of Dadaism (destructive *and* aesthetic or ex-
perimental), Surrealism, James Joyce, Gertrude Stein, Jungian
theory, and contemporary Franco-American 'experimentalism', all
processed through the personality of *transition*'s main editor Eugene
Jolas.

THE '*TRANSITION*-WELT'

During its first year, *transition*, edited by Eugene Jolas, with Elliott
Paul and Robert Sage, was issued monthly and, as in the case of the
Little Review, its main attraction to English readers was its serialisa-
tion of James Joyce with, to a lesser extent, its regular inclusion of
contributions from American expatriates such as Gertrude Stein and
Hemingway. From the first issue (April 1927) Surrealist and Dadaist
writers were given prominence. The first issue contained translations
by Jolas himself of poems by Desnos and Soupault, and a painting by
Max Ernst, as well as the inevitable article on the music of George
Antheil. Five poems by Eluard (from *Capitale de la Douleur* and *Les
Dessous d'une Vie ou La Pyramide Humaine*), paintings by di Chirico,
Ernst, and Tanguy, the two poems by Sidney Hunt, a review of
Aragon's *Le Paysan de Paris*, and Elliot Paul's 'The New Nihilism'
appeared in the following month's issue. Between June and September
1927 *transition* printed works by Ribemont-Dessaignes, Breton, Mas-
son, Man Ray, Hans Arp, Kurt Schwitters, and a 'Manifesto' signed by
all the members of the Surrealist group ('Hands Off Love', *transition* 6,

September 1927) in support of Charlie Chaplin, who was defending himself at that time against his wife's lawsuit; this Manifesto was also signed by the magazine's editors. The seventh issue of *transition* (October 1927) printed an extract (Canto 1) from a revised version of Rodker's translation of Lautréamont's *Lay of Maldoror*. In spite of all this, there was some justification for the editors' indignant and long response to Wyndham Lewis's first attack on *transition*, especially his accusation in *The Enemy*, No. 2 that the magazine's ethos was entirely Dada—Surrealist:

> . . . it would be well to start out with the direct statistical statement that out of 309 contributions appearing in the first eight numbers of *transition* exactly 31 were by men in any way connected with the Surrealist movement.[10]

The editors declared for a 'new romanticism' rather than Surrealism.

On the other hand, several of the frequent editorial comments and notes – a dominant feature of *transition* throughout its history – were much in harmony with Dadaist—Surrealist principles. The third issue (June 1927) had contained 'Suggestions for a New Magic' which had echoed the destructive anarchism of anti-art:

> . . . We believe in the ideology of revolt against all diluted and synthetic poetry, against all artistic efforts that fail to subert the existing concepts of beauty. Once and for all let it be stated that if there is any real choice to be made, we prefer to skyscraper spirituality, the immense lyricism and madness of illogic. (p. 178)

The editors claimed that *transition*'s aim was to re-establish the 'simplicity of the word', and enlisted as guides in this quest Rimbaud, Gertrude Stein, Hart Crane, Léon-Paul Fargue and August Stramm, as well as André Breton and Louis Aragon. The main purpose, apparently, was to be looking for a purpose:

> Perhaps we are seeking God. Perhaps not. It matters little one way or the other. What really matters is that we are on the quest. Piety or savagery have both the same bases. Without unrest we have stagnation and impotence.[11]

Wyndham Lewis's refusal to recognise *transition*'s 'purely experimental' approach (a standard defence employed also by the Surrealists who posited the existence of a 'surrealist laboratory') was, the editors declared in a short note in *transition 8* (November 1927), typical of small-minded Anglo-Saxon attitudes:

> The Enemy's blunder stems from a characteristic Anglo-Saxon prejudice that no venture in the arts can be taken for its own sake, for the pleasure it may give a few readers, for the charm which the element of research has. In the meantime we shall leave Mr. Lewis to the pleasures he craves of receiving the plaudits of that most despicable of vermin: the American and English literary hack.[12]

Some years later (in *Transition*, No. 22, February 1933) Jolas was to deny totally the influence or importance of Surrealism for his 'Revolution of the Word'[13], but Surrealist writers and painters continued to appear in *transition* until the magazine was suspended for two years after the double number (19–20) of June 1930. An earlier issue (16–17, June 1929) had already proclaimed the *transition* doctrine of the 'Revolution of the Word', and several English writers, including Samuel Beckett, had appeared in that issue. In November 1929 (*transition* 18) there was a long section on dreams ('Dreams and the Chthonian mind', pp. 15–84), and a 'Little Anthology' which followed this section included poems by two English writers who were co-editors of the Cambridge periodical *Experiment*, Jacob Bronowski ('Prayer', p. 86) and Hugh Sykes (later Hugh Sykes Davies).

In June 1930 *transition* included a long opening section called 'Dream and Mythos' (pp. 23–60) which included Jung's essay 'Psychology and Poetry'. In an article called 'The Dream' – a reply to an attack on *transition* by Yvor Winters in the American periodical *The Gyroscope* – Jolas again rejected the 'surrealist' label for *transition* and its contributors, and restated his allegiance to a wider form of romanticism:

> **As a matter of fact, I translated and published certain surréaliste poets because their interest in the subconscious functions of the human spirit – derived from Freud and Dadaism – coincided with my own interest in this phenomenon. This application by the surréalistes of their experiments seemed to me an error.**[14]

A study of the dream, Jolas declared, was not the exclusive province of Surrealism. It was a 'poetic–esthetic liberation': 'It solidifies our artistic perceptions and gives the poetic creation a universal significance that leads to the metaphysical and the mythological in all its fabulous possibilities.'[15] In the same issue, however, Jolas conceded that the Surrealists had been the first to recognise the full importance of the exploration of the subconscious world, thus developing the possibilities suggested by Rimbaud, Lautréamont, Freud, and the Dadaists.

transition AND *EXPERIMENT*

The June 1930 issue of *transition* also contained a long section entitled 'Cambridge Experiment: A Manifesto of Young England' (pp. 106–38). Jolas informed his readers that he had asked Jacob Bronowski, one of the editors of the Cambridge magazine *Experiment* (seven issues, 1928–1931), to prepare the manifesto 'in order to give a documentary idea of the new currents in Young England'.[16] The first statement (presumably by Bronowski) admitted that the principles of the 'Cambridge Experiment' were 'uncertain and not at all startling'. This description was an understatement; the uncertainty of the principles of the manifesto was the most startling thing about it:

A sense that literature is in need of some new *formal* notation: an attempt to show how such a notation can be built out of *academic* notations, where academic means perhaps no more than non-moral and is after all best explained in our poetry: a belief in the compact, *local* unit: and in the *impersonal unit: a belief, finally, and a disbelief — for it is about this mainly that we are at odds — in literature* as a singular and different experience, something more than an *ordering* of life. You see how haphazard it all is. And its criterion ultimately is only again *Experiment*.[17]

The main body of the 'manifesto' itself included articles and comments by Bronowski, Hugh Sykes Davies, and Julian Trevelyan, all of which managed to match these admittedly 'haphazard' principles. The article by Bronowski and the collection of statements by Hugh Sykes ('Localism') suggested some attempt to discern principles for an experimental aesthetic, and there were signs of a strong shared reaction against the positivistic and behaviouristic psychological theories which had begun to have such influence in Cambridge thinking in many academic areas, including literary criticism, during the nineteen-twenties.[18] Julian Trevelyan's 'Dreams', which frequently reiterated the statement 'To dream is to create', made it obvious that the contributors to *Experiment* regarded Surrealism as only one of the possible creative responses to modern discoveries about dream-experience, and already an outmoded response: 'Today artists have identified the aesthetic faculty, still chiefly by analogy, with the subconscious (where Surrealism flounders, prematurely corpulent, through treasure trove).'[19] None of the creative contributions, including work by William Empsom, Richard Eberhart, and John Davenport, in addition to Bronowski and Hugh Sykes Davies, showed any certain signs of direct Surrealist influence.

Hugh Sykes Davies's poems, which made relatively mild use of typographical and syntactical dislocation, came nearest, perhaps, to capturing Surrealistic dreamlike effects. But these effects were probably derived directly from visual sources, including film, rather than from Surrealist poetry. 'Music in an Empty House', the poem which had appeared in *transition* 18 (November 1929) and, one year earlier, in the first issue of *Experiment* (I, 1, November 1928),[20] is an example of Davies's writing at its most effective:[21]

Music in an Empty House

**The house was empty and
 the people of the house
 gone many months**

**Months for the weevil
 for the patient worm
 timber-mole softly tunnelling
 for the parliament
 of rats**

Footsteps slink past
 damp walls
 down
 long
 corridors

Slow feet
 warily scuff
 bare boards
The much-bitten
 tapestry
 holds
 many
 moths

In a certain curtain'd room
 the halting steps evade
 chairs white shrouded

To twitch the winding-sheet
 around a grand piano
 thin phalanx of sound
 sharp rat's teeth edge yellow
 with decay

The much-bitten
 tapestry
 holds
 many
 moths

On rat's teeth-edge
 fingers preparate
 hestitate

Then falling send
 as tenantry
 damp-muffled chords
 rusting strings
a still-born song

Their fortissimo	**The tattered**
scarce	**tapestry**
stirs	**holds**
near	**many**
cobwebs	**moths**

The unusual typographical arrangement of this poem is much in line with the work of some of the younger American writers appearing at that time in *transition*, as well as in such American journals as *Blues* which was edited by Charles Henri Ford and Kathleen Tankersley Young (eight issues, 1929–1930). In a 'London Letter' published in *Blues*, No. 7 (Fall, 1929), Sidney Hunt complained that the then current London literary scene exhibited a 'sniffy earnestness and superciliousness towards the new thing', and having turned away from radical modernism, had found safer attitudes under which to shelter:

> **Who wants a rock of ages? there is a good variety — Eliot's anglocatholic royalist classicism, Wyndham Lewis's less ladylike alignment with Aquinas in torrents of words, Middleton Murry's hopeful it'll-all-come-right-in-the-end-somewhere-somewhen gropings in the infinite, expressed respectively in the CRITERION, THE ENEMY, NEW ADELPHI.**[22]

Hunt referred indirectly to Jolas's *transition* in his rejection of contemporary English periodicals and his declaration of loyalty to *Blues*: 'of the revolution of the word & the dream let loose there is little here. For that we come to you, blues and others.'[23] *Blues*, as a purveyor of 'the dream let loose' was even less in debt to Surrealism than *transition* was. Among the contributors were some who were also published in *transition*, including Gottfried Benn, Gertrude Stein, Harry Crosby, Kay Boyle, Parker Tyler and Jolas himself. None of the Surrealists ever appeared, even in translation. One interesting simultaneous sonnet by Parker Tyler typifies the experimental work encouraged in *Blues*:[24]

```
I smell an oriental luxury
from him
        his suit is brown
                    I smell an or-
iental lux
    I love his nose
                ury
from him
        's slender hook
                I smell an or-
ien
        and he is strong as rope
                tal lux-
ury from
        excellently built
                him
                    I
I dream of
        smell an oriental lux
ur
        him at night that
                    y from him
                        he
                        I
makes love to me yes
                smell an orien-
tal luxury from
        strenuous love
                him
sweet marvellous
                I smell an orien-
tal
        he's in busi-
                luxury from him
ness
```

```
I
    a Jew and O his sex ap
            smell
 an
    peal
       rien
           him
              from
                 ury
                    lux
                       smell
```

The young contributors to *Experiment* demonstrated an attitude similar to Hunt's in some respects – a movement away from the more earnest attitudes of all their literary elders and a wide-ranging, if inevitably callow, curiosity which was quite able to distinguish, for example, the differences between the French Surrealist group and the less politically orientated artistic subversion of such journals as *Blues* and *transition*. That such distinctions could be and were made by young undergraduates in the late twenties should not be too surprising. Isaiah Berlin (b. 1909), who was at St Paul's School and then at Oxford in the twenties, has recalled the sort of intellectual experiences which many of his generation must have shared:

> ... the masters ... were (with one exception – an obscure eccentric, devoted contemporary and follower of Lytton Strachey) solid, sentimental and unimaginative. While the most civilized among them recommended Shaw, Wells, Chesterton, Gilbert Murray, Flecker, Edward Thomas, Sassoon and the *London Mercury*, we read Joyce, Firbank, Edward Carpenter, Wyndham Lewis, Schiller's Logic, Havelock Ellis, Eliot, *The Criterion* and, under the impulsion of Arthur Calder-Marshall whose elder brother was then in America and favoured them, the works of H. L. Mencken, Carl Sandburg, Sherwood Anderson; we also took an interest in Cocteau, *transition*, the early surrealists. We looked down on *Life and Letters*, edited by Desmond MacCarthy, as tame and conventional. Among our major intellectual emancipators were J. B. S. Haldane, Ezra Pound, Aldous Huxley.[25]

A general reaction against the moderns – Eliot, Pound, and Wyndham Lewis – had obviously not yet begun when Berlin was at school in the mid-twenties, but the distinction which he makes between *transition* and the early Surrealists is significant. Many undergraduates of the late twenties and early thirties were just as well-informed about current literary trends as was Isaiah Berlin, as the seven issues of *Experiment* confirm.

Experiment was unashamedly an undergraduate magazine which tried to create new attitudes among its contributors who were to see themselves, according to the editors, as 'the only literary group which is positively post-war, which honestly seeks to transcend the spirit of academism and stoicism of the older generation'. Younger contributors

to *Experiment* included Richard Eberhart, Kathleen Raine, Malcolm Lowry, and William Empson, as well as writers who were later to become associated with Surrealist activity in England: Jacob Bronowski, Hugh Sykes Davies, and Humphrey Jennings.

The magazine's 'experimental' attitudes were obviously nearer to those of *transition* than to Surrealism, though original creative work published in *Experiment* was far from radical by any standards. There were occasional articles on arts other than poetry, including, for example, Hugh Sykes Davies's 'The Primitive in Modern Art' (1929),[26] and 'Rock Painting and La Jeune Peinture' by Humphrey Jennings and G. F. Noxon (1931).[27] The French Surrealists were never referred to directly, however, whereas *transition* was stoutly defended—in *Experiment*, No. 3 (1929)[28]—against 'The Enemy', Wyndham Lewis. The few instances of 'experimental' work by established writers printed in later issues of *Experiment* echoed *transition*'s early preoccupations. The issue for October 1930, for example, contained notes by George Reavey on phonic poetry,[29] and the final issue (spring 1931) reprinted a section from Joyce's 'Work in Progress' which had appeared in the first issue of *transition* four years previously.

It is hard to know why the magazine itself was ever linked with Surrealism, though some of its leading English contributors were thought of at the time as 'Surrealists' by their Cambridge contemporaries. In his *New Writing in Europe* (1940) John Lehmann, a self-confessed adversary of the *Experiment* group during his Cambridge years, described the period during which *Experiment* appeared (1929–1931) as precisely that time when 'a series of events took place that cracked the world of the twenties beyond repair'.[30] Those events included the greatest economic crisis of modern times in the Western world and a contrasting economic health and rise to industrial power of Soviet Russia. The period also marked the emergence of new groups of English writers who firmly rejected what they believed to have been the trivially private and false principles of twenties-style Modernism in literature. In the introduction to his *New Signatures* (1932) – the anthology which introduced the work of such writers as W. H. Auden, C. Day Lewis, William Empson, and Stephen Spender to a wider poetry-reading public – Michael Roberts analysed the causes of the isolation of the poets of the past decade:

The poet, contemptuous of the society around him and yet having no firm belief, no basis for satire, became aloof from ordinary affairs and produced esoteric work which was frivolously decorative or elaborately erudite.[31]

The poems in *New Signatures*, Roberts claimed, represented 'a clear reaction against esoteric poetry in which it is necessary for the reader to catch each recondite allusion . . .'

In *The Whispering Gallery* (1955), the first volume of his autobiography, John Lehmann said that Roberts had deliberately omitted

contributors to *Experiment* from *New Signatures*:

Three Cambridge poets, leading lights of *Experiment*, he excluded because he thought them too close to T. S. Eliot and to the French surrealists, Eluard and Tzara. In his view, however estimable their aims might be, we were on a different tack that he was convinced would in the long run prove more important.[32]

Lehmann's autobiography showed too that other Oxbridge writers agreed with Roberts in thinking the *Experiment* group too much in sympathy with the French Surrealists. The contributors to the Cambridge magazine *The Venture* (six issues, 1928–1930), who included John Lehmann, Jean Stewart, Anthony Blunt, and Michael Redgrave, set themselves up as deliberate rivals to the *Experiment* group who were sometimes disparagingly described as 'surrealists'. As we have seen, none of the contributions to *Experiment* could have been so described with any accuracy, though some of the contributors' activities by 1932 were certainly indicative of rather stronger affinities with Surrealism than could have been inferred from their creative work and literary reviews published at the time of *Experiment*. Most of the translations from French into English in the 'Surrealist Number' of *This Quarter* (September 1932) were made by English writers, including Samuel Beckett, David Gascoyne, and one of *Experiment*'s editors, Jacob Bronowski. Bronowski was responsible for the translations of Salvador Dali's 'The Stinking Ass'[33] and Marcel Duchamp's notes for his 'The Bride Stripped Bare by Her Bachelors, Even',[34] as well as poems by Benjemin Péret. This issue also contained the scenario of the remarkable Buñuel–Dali film *Un Chien Andalou (An Andalusian Dog)*,[35] the short Surrealist film, first shown in 1928, which was obviously quite well known in England even in the late nineteen-twenties.

THE LAST *ENEMY*

At the beginning of 1929 Wyndham Lewis published the third and final issue of *The Enemy*. This issue, entirely by Lewis himself (apart from two poems, one by Roy Campbell and the other by Laura Riding), was devoted to a renewed attack on *transition* and the Surrealists, and on the new-romantic-nihilism which both represented. Many of the arguments and much of the abuse used by Lewis had been employed in earlier attacks, but he had given *transition* closer scrutiny this time.

According to Lewis the 'diabolism' advocated by *transition* – particularly in Elliot Paul's essay 'The New Nihilism' which had appeared in *transition* 2 (May 1927) - was only a development by journalist–nihilists without a scrap of real talent of the anti-human vindictiveness present in much late-nineteenth-century art:

it is a return to the feverish 'diabolism' that flourished in the middle of the last century in France, and which reached England in the 'nineties',

with Oscar Wilde and Beardsley as its principal exponents. Huysmans's exploitation of the mediaval nightmare and his *Messe Noire* interests; Nietzsche's turgid satanism and the diabolism of Baudelaire and Byron: the 'Drunken Boat' of Rimbaud, and the rhetoric of Lautréamont, are its basis.[36]

Much of Lewis's attack was directed against *transition*'s enthusiasm for the Surrealist cult-figure Lautréamont, and against the editors' claims to detachment and their right to pursue merely 'amusing' art. Lautréamont's *Lay of Maldoror* was, Lewis proclaimed, 'a very tiresome and monotonous bellow' (p. 34), and its author 'a kind of happy mixture of the Marquis de Sade and Frederick Nietzsche but without remarkable talent', yet his work was filled with 'a spirit of demented hatred of other men, and an obsessional attachment to apocalyptic images of horror and destruction' (p. 39).

About Surrealism itself Lewis was just as direct and forceful, identifying the movement with the 'infantilism' and nihilism of *transition*:

> Super-reality, in short, is not so much a doctrine for art as for life. It is a sort of cheap and unnecessary, popularised, *artistic-ness* of outlook that is involved. The creative faculty, released into popular life, and possessed by everybody, that is really what 'Super-reality' means — it is merely a picturesque phase of the democratisation of the artistic intelligence and the creative faculty. It would result in practice, and in everyday life, in a radical shifting of the normal real towards the unconscious pole. If thoroughly effective it would result, even, in a submergence of the normal, conscious, real in the Unconscious.[37]

Not that Lewis rejected the role of the unconscious in art; on the contrary, all art depended upon it. Surrealism, however, was not a specifically *art* doctrine, but a pernicious and unintelligently radical general life-attitude:

> for all art worth the name is already *super-real*. To say that it should be more so — or very much more so as is implied in superreality — is to pass over into the living material of all art, its ground and what it contemplates, and tamper directly with the cezannesque apples, for instance, before the painter has started his picture, or modify the social life which the artist interprets or reflects.[38]

The text of Elliot Paul's 'The New Nihilism' was given in full (pp. 59–61), and was followed by Lewis's 'gloss'. To Paul's claim that the postwar world needed the new nihilism, Lewis retorted that such nihilism was neither new nor, in practice, particularly humanising in its effects:

> Ever since Darwin men have doubted the christian premises and tended to regard themselves as animals rather than 'humanists', and ever since the French Revolution they have dreamed spasmodically of universal armed proletarian revolt to put back a bit of the jungle where

it was badly needed in the centre of the artifices of very imperfectly humane life.[39]

In the final sections of the essay, Lewis vigorously reiterated his belief that *transition*, in spite of the professed liberal detachment of its editors, represented a threat to genuine intelligence and art in contemporary Europe.

Ironically, it was just at this time, during the late-twenties, that the authority of Wyndham Lewis began to lose its influence, not least on account of the emergence of the ultra-right-wing political attitudes already apparent in *The Enemy*. Lewis's long isolation from the influential centre of English literary life was about to begin, and this was to be both a personal tragedy for Lewis himself and a serious loss of an incisive critical intelligence in English culture.

THE CRITERION AND *LEFT REVIEW*

By the early nineteen-thirties mere political *analogies* for the attitudes of literary periodicals or critics or movements were no longer appropriate. In the process of moving or being moved into real political camps several of the writers who had been seen as the extreme revolutionary Left by their elders in 1920 were to be regarded as the reactionary Right by the younger generation. It is to Eliot's credit that *The Criterion*, at least, could not be so easily categorised politically, and that it remained a forum throughout the thirties for intelligent minds from many shades of opinion and from different generations. Even more radical and extremist outlooks were allowed expression so long as they observed the general conventions of intelligent and rational communication.

At the turn of the decade some of the contributors to *The Criterion* began to take a little more detailed, though not much more sympathetic, notice of Surrealism. In an essay entitled 'Meaning in Art'[40] in January 1930, Montgomery Belgion discussed Surrealism as one of the current theories of art as self-expression. His arguments were based on a new edition (1929) of Breton's first *Manifeste du Surréalisme*. For Belgion, art without the control of reason was not only unacceptable as an aim, but also probably impossible in practice. He rejected the whole concept of a superior 'reality'.

Ezra Pound responded to Belgion's essay in the next issue of *The Criterion*. Though not wildly enthusiastic about Surrealism itself (Pound felt that the whole thing had happened several times before), the movement demonstrated some awareness of the increased scope and freedom for poetic language which had been offered in the twentieth-century, especially (though not only) for French literature:

As far as writing goes we are laggards, I mean in relation to scientists; we still cling to modes of expression and verbal arrangements sprung from, and limited by, scholastic logic. French suffers from a worse

paralysis than English. The verbal stirrings of Apollinaire and Cocteau is not yet comprehended . . .[41]

and

> **. . . we no longer think or need to think in terms of monolinear logic, the sentence structure, subject, predicate, object, etc.**
> **We are as capable or almost as capable as the biologist of thinking thoughts to join like spokes in a wheel-hub and that fuse in hyper-geometric amalgams.**

Perhaps the only writer of the time who was still developing the poetic modes of Apollinaire and Cocteau was Ezra Pound himself. Certainly none of the Surrealists were held up as examples to follow.

During this period there were occasional reviews of works by Surrealist or post-Dada authors. Tzara's *De Nos Oiseaux* was reviewed in January 1930, for example, and Hugh Sykes Davies reviewed, without much enthusiasm for its literary quality, the newly revived *Transition* (July 1932). Most of the reviewers of Surrealist work showed no diminution of their feelings of hostility towards the movement, though some of the English work produced 'under the influence' of Surrealism in the mid-thirties had a sympathetic reception. Hugh Sykes Davies's *Petron*, for example, was reviewed warmly by Rayner Heppenstall in January 1936. Heppenstall believed Surrealism's influence to be evident only in the weakest passages of *Petron*.[42]

Janet Adam Smith's review of Gascoyne's poems *Man's Life is This Meat*[43] displayed the usual *Criterion* distrust of psychological theory. A main difference between Gascoyne and such English writers as Lear and Carroll, she argued, was that whereas the latter tended towards verbal fantasy ('expressed in play of rhyme and metre, puns and invented words'), Gascoyne's poetry was that of a visualiser, producing startling collisons of images, rather than words:

> **Often his nouns and adjectives pair off as comfortably as in the most conservative verse — fevered breath, strident cries, cruel claws, oblivious dream, divided terrain, knotted hair, carnal lusts, pointing finger, chosen victim, sudden spasm, are examples from one poem.**[44]

Michael Roberts's review of Herbert Read's *Surrealism* in *The Criterion* for April 1937 made very much the same points. Roberts saw Surrealism as making an impact during a period when Marxist materialism had developed ('Christian art does not need Surrealism because it already includes superrealism'), but the Surrealist division between the conscious (reasoning) and the unconscious (irrational) aspects of the human mind was a false one. Surrealist visual art – and here Roberts cited the work of Dali and Ernst as well as the strictly non-Surrealists, di Chirico and Picasso – was much more impressive than any Surrealist poetry.

The poems are less satisfactory: they are nearly always verbal descriptions of visual images . . . The Surrealists, it seems, incline to the popular theory that the subconbscious presents itself in dreams in the form of visual images, and therefore in trying to present simulacra of these dreams, they turn to visual images. [45]

If Michael Roberts saw Surrealism as a necessary complementary activity for Marxist materialism, it must be said at once that the Marxists of the thirties did not see or feel such necessity themselves. *The Left Review*, which had first appeared as a literary monthly in October 1934, frequently quoted Louis Aragon, who had become a member of the Communist Party and had broken with the Surrealists in 1932; there was general agreement with his analysis that the true 'dialectical' path for any young poetic talent 'in the maze of the expiring bourgeois culture' should have led inevitably 'from Dada to Surrealism and Surrealism to Realism'.[46] In an interview with Derek Kahn for *Left Review* in May 1936 (a month before the International Surrealist Exhibition in London), Aragon accused the Surrealists of having lost the impulse towards objectivity and of having lost their early anti-mystical and scientific purpose (which had been 'to analyse the mechanism of inspiration'):

> **They began to worship themselves. The poetic impulse was now no longer something to be analysed, it was something sacred, which could not be questioned. I, who had been a communist for four years before I left the group, said that it was necessary to discover the conditions under which the machine of the imagination worked – they wanted to worship it as an autonomous holy power.** [47]

Jolas's *Transition*, at one time accused by Wyndham Lewis of extremist Bolshevist sympathies, was dismissed as a journal with near-Fascist tendencies.[48] Indeed, Surrealism's anti-bourgeois and revolutionary image – one which they tried to share with Communism – was a mask. In his review of David Gascoyne's *A Short Survey of Surrealism* for the *Left Review* in January 1936 Lord Hastings claimed that Surrealist art 'in spite of undoubted talent and genius, remains the complete expression of bourgeois decadence, appreciated and patronised chiefly by a very limited and sophisticated group of bourgeois intellectuals.[49] David Gascoyne's *Man's Life is This Meat*, which was reviewed by J. Brian Harvey in *Left Review*, July 1936, was seen as destructive in the true Surrealist tradition:

> **He certainly kicks the old impedimenta downstairs with gusto and accuracy with an extra boot for anything labelled sex –**
>
> **'little girls stick photographs of genitals**
> **to the windows of their homes,**
> **prayer-books in churches open them-**
> **selves at the death service**
> **and virgins cover their parents' beds**
> **with tea leaves . . .'**

It would seem, then, that he is full of good, clean, honest hatred: it is the hatred for what André Breton has called the 'old and mortal shivers' which 'are trying to substitute themselves for those which are the very shivers of knowledge and life'.[50]

Such destructiveness, however, had no alternative society to offer. It had nothing at all to offer; its revolutionary claim was false:

But it seems obvious that they cannot find anything very practical or compelling to say while they continue to express the need for mental liberation in terms other than those of the need for immediate social liberation. Which is why Gascoyne fails to fulfil the first necessity of modern poetry: the basic realism which is the true meat of man's life is missing.[51]

Herbert Read was allowed the opportunity to hit back at the Marxists in July 1936, one month after the International Surrealist Exhibition, when *Left Review* included a nine-page 'Surrealism Supplement'. This contained poor-quality reproductions of paintings by Miro (*sic*) and Maguitte (*sic*), and short articles by Read, Anthony Blunt, and Alick West. Read argued[52] that Surrealism was the 'only all-embracing aesthetic which opposes the aesthetic conventions of the capitalist epoch'. He insisted that the Surrealists offered the only true application of the principles of dialectical materialism, and he rejected the narrow realism of orthodox Soviet art. Both Anthony Blunt and Alick West repeated the charges that Surrealism was both bourgeois and pseudo-revolutionary.

Herbert Read's *Surrealism* provided the occasion for another onslaught on the movement by A. L. Lloyd in *Left Review* for January 1937.[53] This time the Surrealists were not only dismissed as fake revolutionaries, they were also in the same camp as the Fascists 'whose object it is to perpetuate our more and more irrational capitalist system, to assail in every conceivable way the supremacy of human reason'. The Surrealists betrayed the proletarian revolution:

The frivolous games of automatism and newspaper-clipping-creation, of goosy ghost-hunting and a hazardous preoccupation with chance, though in many cases of undoubted scientific interest and value, can play no serious part in making the proletariat conscious of its social and revolutionary responsibilities.

It is clear from all this, that *Left Review*'s distrust of Surrealism at the time of the movement's greatest activity in England was typical of left-wing thinking at the time and, as in France, the rejection of Surrealism – in its 'reasoning phase' – by the more orthodox Marxists must have helped to weaken the effects of the movement in England.

NEW VERSE

In his *The Rise and Fall of the Man of Letters* (1969),[54] John Gross

suggested that a 'fair-minded' tradition of English criticism and literary editorship was not entirely superseded 'even in the baton-swinging 1930s'. This tradition was one of 'breadth, enlightenment, rational sociability, civilised forbearance'. As we have seen, it was certainly present in *The Criterion*. But John Gross also reminded his readers that Geoffrey Grigson, the editor of *New Verse* throughout its existence (1933–1939), was later to become apologetic about his 'triviality' at that time in going for 'the Desmond MacCarthy streak in English letters', by which, presumably, Grigson meant the *too* open-minded and tolerant receptiveness to contemporary writing shown by *New Verse* especially during its early years.

Between 1933 and 1936 *New Verse* printed more Surrealist work – both that of self-styled English 'Surrealists' and translations of French Surrealists – than any other English periodical of the period except, perhaps, *Contemporary Poetry and Prose*. It is not surprising, therefore, that Grigson, a vigorously polemical writer at times, and an admirer of the literary principles advocated by Wyndham Lewis, should have come eventually to regret his earlier catholicity of taste. On the other hand, under Grigson's editorship *New Verse* provided a creative outlet for many writers of quite different outlooks during a decade which was one of the most disturbed and uncertain in Western history. Grigson's openness (or even indulgence) in *New Verse* was also a welcome breakaway from the inhibiting, over-critical attitudes of other literary periodicals, especially *Scrutiny* which had begun life in 1932.[55]

New Verse's policy allowed for the inclusion of poems, sometimes clumsy, sometimes well-made, by nearly all the genuine creative talent then at work in England. Surrealist-style poems were inevitably produced in its pages. The December 1933 issue of *New Verse* showed several signs of a growing English response to the exhibition of Surrealist paintings which had been included in the Post-Cubist Exhibition at the Mayor Gallery in April that year, and which had prompted a good deal of English critical interest already.[56] Poems by Ribemont-Dessaignes ('Sliding Trombone'), Giacometti ('Poem in Seven Spaces'), Pierre Unik ('The Manless Society') in translations by David Gascoyne, in addition to poems by Gascoyne himself, were a striking feature of this issue of *New Verse* which also contained Charles Madge's essay 'Surrealism for the English' – one of the first sympathetic responses in any English journal to literary Surrealism. Madge's essay was not the start of an attempt to bring the French movement to England but, he argued, Surrealism did have implications for English literature which included an evaluation of the principles of the French movement:

Close study of the philosophical position of the French surrealists is needed to extract the essential purpose from the formal appearance of their work. But English writers will need something more: namely, a knowledge of their own language and literature.[57]

Madge found much in English writing and even in English philosophy to harmonise with Surrealism. The message of Surrealism for the English was one of re-discovery of the vital imagination in its tradition. Surrealism produced in its poets (Eluard, for example) something which, though 'new to the French language', was familiar to the English, and he instanced Shakespeare and other English writers, including Edward Young. Madge quoted Young's defence of creative daring which was appropriate to the period which had produced the Paris Surrealist group. Here was a challenge for the English too:

It holds true in this province of writing, as in war, 'The more danger, the more honour'. It must be very enterprising; it must, in Shakespeare's style, have hair-breadth escapes; and often tread the very brink of error; nor can it ever deserve the applause of the *real* judge, unless it renders itself obnoxious to the misapprehensions of the *contrary*.

Not all the poems translated by Gascoyne in the same issue were strictly Surrealist. The ex-Dadaist and, after 1929, ex-Surrealist, Ribemont-Dessaignes was strongly critical of Breton and the Surrealists during the thirties. As early as 1931 he had expressed the view that the defeat of Dadaism was a 'return to servitude, as the dog of the Scriptures to his vomit'.[58] If his 'Sliding Trombone' was full of Dadaist rather than Surrealist mockery, the poem by Giacometti, who in any case was associated with the Surrealists only between 1929 and 1935, and who was to renounce his Surrealist works as 'nothing but masturbation',[59] was obviously more in the *transition* style.[60]

During the period 1934 to 1936 many translations and original poems by David Gascoyne, as well as original reviews, essays, and notes by English sympathisers with Surrealism were to appear in *New Verse*, which also paid occasional attention to other Surrealist publications. During 1936, however, some of the contributors to *New Verse* began to be more critical of Surrealist methods and principles. Perhaps the most important single contribution to the debate about Surrealism to appear in *New Verse* was the set of questions posed by (J)ohn (B)ull (i.e. W. H. Auden) in the June–July 1936 issue.[61] Auden began by admitting that his knowledge of Surrealism had been derived from the books of David Gascoyne, from writers such as Aragon and Breton, painters such as Dali and Ernst, and from the magazine *Minotaure*.[62] Auden's questions about Surrealism, under the heading 'Honest Doubt', were divided into those with aesthetic and those with political implications. Under the first of these headings Auden wanted to know the point at which writing which had been consciously 'worked over' ceased to be Surrealist. He pointed out the impossibility of deciding how much artistic activity was conscious and how much unconscious. Next, he wished to know how the Surrealists distinguished more from less valuable artistic activity. He suggested that the best Surrealist writing came from 'highly repressed individuals in a society with very strong taboos', and instanced Lewis Carroll, Edward

POEM IN SEVEN SPACES

2 golden
claws

a drop
of blood

the yellow
field of
folly

white spiral
of wind upon
two great
 breasts

3 galloping black horses

the legs of
chairs break
with a dry
 crack

all objects have gone
far away and the sound
of a woman's steps and
the echo of her laugh
fade out of hearing

Lear, and Rimbaud. In a relatively self-aware and liberated society, Auden suggested, 'the lack of pressure' would 'leave you material without form'. Finally, he quoted a passage from Jacobsen's novel *Niels Lyhne* in which the author warned against the monotony, uniformity, and final emptiness of fantasy and dream-states.

Under 'political' questions for Surrealism, Auden began with the Surrealist view that 'The unconscious mind, its reason and its judgement, are so conditioned to-day by the Bourgeois world, that to the revolutionary writer it is artistically valueless'. First, if this were accepted as true why, Auden asked, did it not also apply to all individuals, including proletarians? And why did it not also apply to the 'repressed unconscious' itself?[63] Second, what was the 'revolutionary value in the automatic presentation' of represssed material? Was it a socially moral one, and therefore only available to the *bourgeois* artist, or was it a personally moral one, and therefore the preliminary,

that is not the essential, task of the would-be creator of revolutionary art? Third, if the Surrealists rejected the use of reason and the conscious faculties through all the stages of creativity, how was this to be reconciled with the position of importance accorded to these by Communism and by psychoanalysis 'both of which are profoundly rational, believing, certainly, in unconscious forces, economic or instinctive, as the driving forces in life, but also in the necessity for their conscious recognition and rational understanding and guidance?'

New Verse promised 'authoritative answers' to Auden's obviously serious and shrewd questions in the next issue, but in the event these questions were almost the last sign of critical interest in official Surrealism in *New Verse*. The Christmas 1936 issued carried only a pointedly brief notice by Grigson himself of Read's *Surrealism*:

A good picture book, a good contribution – 'Poetic evidence' – by Eluard, queerly contrasting with the English academic footnoted pedantry of Herbert Read and Hugh Sykes Davies (which yet does contain suggestions, statements, ideas of positive as well as negative interest).[64]

The influence of Surrealist fashion continued to be seen in the work of one or two contributors to *New Verse*, particularly Kenneth Allott and Philip O'Connor. O'Connor's 'Blue Bugs in Liquid Silk' (*New Verse* No. 25, May 1937, p. 12) is a typical example of poetry written, as O'Connor confessed later,[65] under the influence of such fashion. Its totally synthetic nature ought to have been obvious to Geoffrey Grigson, generally an astute spotter of fake literature:

**blue bugs in liquid silk
talk with correlation like
two women in white bandages**

**A birdcage swings from the spleen of ceiling framing her soul in large wastes
and a purple sound purrs in basket-house
putting rubies on with red arms**

**enter the coalman in a store of sacks
holding a queenly egg-cup
the window stares and thinks separately her hair
impartially embankment
to the flood of her thought in motionless torrent
roundly looking the ladies**

**there is no formula for disruption of pink plaster
nor emotions to bandage the dead.**

NOTES

1 Raoul Hausmann, quoted in Hans Richter, *Dada, Art and Anti-art*, p. 138. Richter's 'Schwitters the man; Schwitters the poet' (*Ibid.*, pp. 137–149) supports Hausmann's view.

2 See for example, Herman Hesse, *The Criterion*, I, 1, pp. 89–93 and Richard Aldington, *Literary Studies and Reviews* (1924).

3 The short-lived little magazine *Form* (Cambridge, ten issues, 1966–1969) edited by Philip Steadman, Mike Weaver, and Stephen Bann, must take much credit for its revival of interest in the formalist principles of the experimental art of this period, especially in Germany, Holland, and the USA. *Form* may also take much of the credit for tracing the formalist pedigree of concrete and phonic poetry.

4 *The Little Review* for spring 1925 had contained articles on Dutch Modernist literature, including some of Theo Van Doesburg's phonic poems. Hunt may have seen these.

5 Kasimir Malevich, quoted in *Ray* No. 1 (1927?), p. 1.

6 Sidney Hunt, *Ray*, No. 2 (1927), p. 37.

7 Sidney Hunt, *transition*, No. 2 (May, 1927), pp. 134–5.

8 Sidney Hunt, *transition*, Nos. 19–20 (June, 1930), p. 217.

9 In fact, by the early nineteen-thirties the death of Van Doesburg (7 March 1931) combined with the insecurity for German art which accompanied the collapse of the Weimar Republic and Hitler's ascendancy meant the end of any possibility of a significant Dutch–German formalist influence on literature.

10 Jolas, Paul, and Sage, 'First Aid to the Enemy', *transition* 9 (December 1927), p. 173.

11 Editorial Note, *transition* 3 (June, 1927), p. 179.

12 Editorial Note, *transition* 8 (November, 1927), p. 184.

13 E. Jolas, 'What is the Revolution of Language', *Transition*, No. 22 (February, 1933), p. 125: 'The impulse for the revolution of the word owes its genesis to such precursors as Arthur Rimbaud, James Joyce, the Futurists, the early Zürich Dadaists, certain experiments of Gertrude Stein's, and Léon-Paul Fargue. It owes nothing to Surrealism.'

14 E. Jolas, 'The Dream', *transition*, Nos. 19–20 (June, 1930), pp. 46–47.

15 *Ibid.*, p. 47.

16 *Ibid.*, p. 393.

17 *Ibid.*, p. 106.

18 J. Bronowski, 'Experiment', *ibid.*, pp. 107–112; Hugh Sykes Davies, 'Localism', *ibid.*, pp. 114–16.

19 Julian Trevelyan, 'Dreams' (*ibid.*, pp. 120–3), p. 121.

20 Hugh Sykes Davies, 'Music in an Empty House', *Experiment* I, 1, November 1928, pp. 31–2.

21 Hugh Sykes Davies, *transition*, No. 18, November 1929, pp. 121–2.

22 Sidney Hunt 'London Letter', *Blues*, ed. Charles Henri Ford and Kathleen Tankersley Young (numbers 8 and 9 were edited by Ford and Parker Tyler), No. 7 (Fall 1929) (pp. 39–40), p. 40.

24 *Blues*, No. 2 (March 1929), pp. 50–1.

25 *Aldous Huxley 1894–1963: A Memorial Volume*, ed. Julian Huxley (Chatto & Windus, London, 1965), p. 144.

26 *Experiment* I, 3 (May 1929), pp. 29–32.

27 'Rock Painting and La Jeune Peinture', *Experiment* I, 7 (Spring 1931), pp. 37–40.

28 *Experiment* I, 3 (May 1929), pp. 2–5 (unsigned).

29 *Experiment* I, 6 (October 1930), pp. 16–17.

30 John Lehmann, *New Writing in Europe* (Penguin Books, Harmondsworth, 1940), p. 19.

31 Michael Roberts, *New Signatures* (Hogarth Press, London, 1932; 3rd (revised) edition, 1934), p. 11.

32 John Lehmann, *The Whispering Gallery: Autobiography I* (Longmans, Green, London, 1955), p. 174.

33 *This Quarter* (September 1932) ('Surrealist Number'), pp. 49–54.

34 *Ibid.*, pp. 189–92.
35 *Ibid.*, pp. 166–73. See Cyril Connolly's account of his early experience of this surrealist film: 'With the impression of having witnessed some infinitely ancient horror, Saturn swallowing his sons, we made our way out into the cold of Febrruary, 1929, that unique and dazzling cold …' 'Palinurus' Cyril Connolly,, *The Unquiet Grave* (Hamish Hamilton, London, 1944) p. 89.
36 *The Enemy*, (First Quarter 1929), p. 30.
37 *Ibid.*, pp. 41–2.
38 *Ibid.*, p. 42.
39 *Ibid.*, p. 63.
40 *The Criterion*, IX, 35, (January 1930), pp. 201–16.
41 Ezra Pound, 'Epstein, Belgion and Meaning', *The Criterion* IX, 36 (April 1930), p. 474.
42 An extract from *Petron* ('Banditti: From the Biography of Petron') had been published in *The Criterion* in July 1934 (XIII, 53, pp. 577–80).
43 Janet Adam Smith, 'Books of the Quarter', *The Criterion* XV, 61 (July 1936), pp. 730–4.
44 *Ibid.*, p. 734.
45 Michael Roberts, 'Books of the Quarter', *The Criterion*, XVI, 64 (April 1937) (pp. 551–3), p. 553.
46 Louis Aragon (report of Paris Congress speech), *Left Review*, I, 11 (August 1935), p. 473.
47 Louis Aragon, 'French Writers and the People's Front', *Left Review*, II, 8 (May 1936), p. 380.
48 G. A. Hutt, 'Jolas' Julep', *Left Review*, I, 12 (September 1935), p. 528.
49 Lord Hastings, 'The Surrealists', *Left Review*, II, 4 (January 1936), p. 187.
50 J. Brian Harvey, 'Four Poets', *Left Review*, II, 10 (July 1936), p. 530.
51 *Ibid.*, pp. 530–1.
52 Herbert Read, 'Surrealism – the Dialectic of Art', *Left Review*, II, 10 (July 1936), 'Surrealism Supplement', pp. ii–iii.
53 A. L. Lloyd, 'Surrealism and Revolutions', *Left Review* II, 16 (January 1937), pp. 895–8.
54 John Gross, *The Rise and Fall of the Man of Letters: English Literary Life Since 1800* (Weidenfeld & Nicolson, London, 1969).
55 Geoffrey Grigson has never changed his view that *New Verse* represented an Oxford outlook during the thirties, one which took risks and found a champion in the poetry of W. H. Auden, whereas the 'Cambridge Thirties tried to reduce risks to the meanness of a restrictive, costive, academic certainty – a certainty of not being wrong' (Geoffrey Grigson,'A Man of the Thirties', *Poems and Poets*, (Macmillan, London, 1969) (pp. 202–9), p. 206). In 'The Danger of Taste', an editorial in *New Verse* No. 4 (July 1933), Grigson predicted: 'If *Scrutiny* is not to be the perfect body-builder for prigs it must change its formula' (p.2). On the other hand, it should be remembered that *Scrutiny* printed one of the earliest and fullest accounts of Surrealism in 1932; this was 'Surréalisme' by Henri Fluchère, a most sympathetic supporter of the movement.
56 See for example Anthony Blunt, 'Post-Cubism', *The Spectator*, CL, 5,470 (28 April 1933), pp. 603–4; Peter Quennell, 'Surrealism and Revolution', *New Statesman and Nation* VI, 131 (new series) (August 1933), pp. 237–8.
57 Charles Madge, 'Surrealism for the English', *New Verse*, No. 16 (December 1933), (pp. 14–18), p. 14.
58 See 'History of Dada', in *La Nouvelle Revue Française*, No. 36, (June 1931); No. 37 (July 1931) in Motherwell, *The Dada Painters and Poets: An Anthology*, p. 120.
59 See *Surrealists on Art*, ed. Lucy R. Lippard (Prentice–Hall, Englewood Cliffs, N.J. 1970), p. 141.

60 Alberto Giacometti, 'Poem in Seven Spaces', translated by David Gascoyne, *New Verse*, No. 6 (December 1933), p. 8.

61 (J)ohn (B)ull (i.e. W. H. Auden), 'Honest Doubt', *New Verse*, No. 21, (June–July, 1936), pp. 14–16.

62 *Minotaure* was founded in Paris in 1933 by Albert Skira and E. Tériade. The first issue, with a famous front cover by Picasso, appeared in May 1933. In December 1933 (No. 3–4) it became a predominantly Surrealist periodical, particularly remembered for its striking covers (on the theme of the half-man, half-monster figure of the Minotaure and the Maze) by such surrealist artists as Miró, Masson, Magritte, and Dali. *Minotaure* No. 8, which contained work by Breton, Dominguez, Hugnet, Marcel Jean, and Tanguy, was published in June 1936, and was advertised as being 'en partie consacré à l'Exposition Surréaliste de Londres, 1936'.

63 Jean-Paul Sartre: 'Psychoanalysis has not gained anything for us since in order to overcome self-deception, it has established between the unconscious and consciousness an autonomous consciousness in self-deception' ('Self-Deception', (from *L'être et le néant),* in Walter Kaufmann, *Existentialism from Dostoevsky to Sartre* (Meridian Books, New York, 1956), p. 248).

64 Geoffrey Grigson, 'Books Lately Published', *New Verse*, No. 23 (Christmas 1936), p. 26.

65 Philip O'Connor, *Memoirs of a Public Baby* (British Book Center, New York, 1958), pp. 170–1.

surrealism and english literature
1935–1950

Herbert Read's 'Introduction' to the *Surrealism* manifesto which was prepared to coincide with the International Surrealist Exhibition in London in the midsummer of 1936 is typical English-style radicalism in its dramatic, defiant, but mere gesturing rhetoric:

June, 1936. After a winter long drawn out into bitterness and petulance, a month of torrid heat, of sudden efflorescence, of clarifying storms. In this same month the International Surrealist Exhibition broke over London, electrifying the dry intellectual atmosphere, stirring our sluggish minds to wonder, enchantment and derision. The press, unable to appreciate the significance of a movement of such unfamiliar features, prepared an armoury of mockery, sneers and insults. The duller dessicated weeklies, no less impelled to anticipate the event, commissioned their polyglot gossips, their blasé globe-trotters, their old-boy-scouts, to adopt their usual pose of I know all, don't be taken in, there's nothing new under the sun – a pose which merely reflects the general lack of intellectual curiosity in this country. But in the event they were all deceived; their taunts fell on deaf ears, and though for a time there was no lack of the laughing jackass – an animal extinct in most parts of the world and even in this country generally emerging only from beyond the pale of the ineffectual Cheviots – in the outcome people, and mostly young people, came in their hundreds and their thousands not to sneer, but to learn, to find enlightenment, to live.[1]

The exhibition, which was held at the New Burlington Galleries from

11 June to 4 July 1936, was certainly a target for the popular press, whose near-hysterical outrage doubtless increased the high attendance figures. Thousands flocked to view the first major international exhibition of Surrealist art to be put on in England. The *International Surrealist Bulletin* (*Bulletin International du Surréalisme*, No. 4) for September 1936, which was issued by the newly-formed Surrealist Group in England, reported that:

The number of the exhibits, paintings, sculpture, objects and drawings was in the neighbourhood of 390, and there were 68 exhibitors, of whom 23 were English. In all, 14 nationalities were represented.[2]

During the course of the exhibition, lectures were given by André Breton, Herbert Read, Paul Eluard, Hugh Sykes Davies and Salvador Dali, and there was a debate on Surrealism organised by the Artists' International at which Herbert Read introduced the session by reading a paper on the political position of Surrealism. Read's paper was reprinted in part of the *Bulletin*; he asked why, when surrealist groups existed already in France, Belgium, Czechoslovakia, Yugoslavia, Spain, Scandinavia,, Japan and elsewhere, it was only in 1936 that a group had been formed in England. The proposed answer shows how anxious the English Group was to prove that the Surrealist mixture of Anarcho-Nihilism and psychoanalytic theory could produce as penetrating a contemporary critique of bourgeois capitalism as could the prevailing Marxism. English individualism was one reason for the delay in the arrival of Surrealism:

After three centuries of sectarianism in religion, and a continual confusion of politics by their fusion with the innumerable sects, tolerance and individual liberty have been carried to such a point that they defeat their own ends, by making all social and co-operative life impossible.[3]

A second reason was that the English failed consistently to recognise the existence of a crisis in artistic and political life because of the 'equivocations and disguises' of the insidious brand of English capitalism:

In all probability English capitalism will not need to make use of official and open Fascism, because it can so easily transform the existing forms of government to suit its purposes. It is already doing so, and the process can be completed in a few years, so gently that few of us will ever know how or when it happened. At the same time, our ever-elastic sectarians are rooted in every rank of the political scale. We have left-wing priests, pacifist priests, communists priests, scientific priests. It is not surprising that so few people are clearly conscious of the existence of a crisis.[4]

Furthermore, English capitalism had been able to maintain a relatively benign face at home because of its exploitation of the Empire:

> **If the capitalists were to starve large numbers of British workmen, and then shoot them down, the situation would become too clear. But they can starve and shoot Indian workmen, using their labour to pay off the majority of English workmen, to maintain high wages here for the majority, while they starve a minority, the unemployed, in comparative security.**[5]

Finally, English art and intellectual life had a tradition of irresponsible individualism:

> **There is an idea that this is the proper way to work; that cranky ideas, confused ideas, lonely ideas, form the best background for artistic creation. Communal activity, group activity, would limit this crankiness, and so it is assumed it would cramp creative work. Moral, ideological, and political irresponsibility is assumed to be the proper basis of English art.**[6]

Of course, unless Surrealism was the only possible alternative to a capitalist society, the only way out of the crisis – and the Marxists in the Artists' International disagreed furiously with Read's attempt to steal what they considered to be *their* natural and exclusive role – then it is obvious that this explanation explained nothing.

To the unanswered question why there was such a long delay between the creation of Surrealism in France during the early twenties and its arrival in England over a decade later, more recent critics and historians of the movement[7] have been forced to add a second: why was there so little Surrealist work of any consequence created in England after the French movement had gained something of a foothold here in the mid-thirties?

I have already argued that the concept of a 'delay' is ambiguous, concealing the assumption that Surrealism, like Dadaism, was an inevitable manifestation of artistic modernism after World War I. We have seen how the deliberate refusal by the English to share the widespread postwar mood of destructive nihilistic pessimism, and their general re-affirmation of faith in both art and the Western artistic tradition – particularly the English literary tradition – entailed strong hostility against both Dadaism and early stages of Surrealism. This positive mood also encouraged a vigorous creative and critical activity in England during the best part of a decade after the Armistice. Some reaction against the inhibiting effects on creative writing of the high standards developed in modern criticism, together with increasing interest in psychological theory and its possible creative uses, helped to create a more sympathetic atmosphere for Surrealism at the end of that decade. The violent political extremisms of the thirties provided ideal opportunity for the growth of radical intellectual and artistic positions, but the refusal of official Surrealism to give unconditional allegiance to the most popular form of political radicalism, namely Marxism, during that time meant that even as an alternative political, intellectual, and artistic position Surrealism was doomed to failure.

Even more important was the refusal of most English writers and critics to see a need for any kind of dogmatic radical stance, including Surrealist-style anarchism. Above all the belief that Surrealism, like Dadaism, was essentially a foreign concern, not applicable in an English political or artistic context, or superfluous here, was decisive in producing the weak English response. In the present chapter I will attempt to test this assessment by examining some of the more important publications of 'official' Surrealists and Surrealist sympathisers in England.

A SHORT SURVEY OF SURREALISM (1935)

In his introduction to his *A Short Survey of Surrealism*, David Gascoyne acknowledged the assistance of Breton, Eluard and Hugnet in providing him with 'much information and many documents and publications with regard to the surrealist movement'.[8] Gascoyne's book, the first full-length study of Surrealism to appear in England and in English, appears, therefore, to have had the encouragement and the blessing of the leaders of French Surrealism. The book was a precocious achievement (Gascoyne was only nineteen years old) and it gave a remarkably well-informed account of both Dadaist and Surrealist activities since the earliest days. Some of his contemporaries (for example, Lord Hastings in *Left Review*) tried to suggest that Gascoyne's style gave the impression of a translation from a foreign language, but there is little doubt that the book's structure was entirely Gascoyne's, and it remains one of the most valuable introductions to Surrealism.

In his opening chapter Gascoyne traced the movement back to its French literary ancestors including, in particular, de Sade, Baudelaire, Rimbaud, and Lautréamont, but also such writers as Mallarmé, Huysmans, and Jarry (whose humour in the *Ubu* plays reminded Gascoyne of 'that demonstrated by Wyndham Lewis in *The Wild Body* —a cold cerebral humour at the expense of the stupid and clumsy human machine.[9]). The second chapter ('Dada: The Dadaist Attitude') gave a delighted short account (even Hastings found this the 'most amusing chapter') of Dadaist activities between 1915 and 1921 in Zürich, New York, Germany, and Paris. Gascoyne's emphasis on anecdotes about Dadaist (and indeed Surrealist) humour, and his failure to give a 'coherent presentation of surrealist doctrine' has led to the book itself being dismissed fairly briefly as a 'disappointment' by Paul C. Ray:

The chief impression that the *Short Survey* leaves is that Surrealism is mainly a wild romp, a new way of having fun, and that adherence to its tenets provides a writer with sanction to do away with the need for work or for any kind of discipline.[10]

There is some justice in Ray's assessment. Certainly Gascoyne's book contains many samples of Dadaist and Surrealist 'romps' (all of which,

however, did take place) and 'recipes' for producing Dadaist and Surrealist writing (all of which again had at some time been advocated and employed). Gascoyne's history of the Surrealist movement was, however, well-documented, providing much first-hand evidence from many Surrealist publications. These included the literary periodicals *Littérature, La Révolution Surréaliste, Le Surréalisme au Service de la Révolution,* and *Minotaure,* the Surrealist manifestos and nearly all the important individual theoretical and creative productions of the movement published between 1919 and 1935. An appendix of translations of Surrealist work was, in effect, a short anthology of creative work by Breton, René Char, Dali, Eluard, Hugnet, and Péret, in versions by Gascoyne himself and Ruthven Todd. The book also contained reproductions of paintings, photographs, and a still from the Dali–Buñuel film, *Un Chien Andalou.* One of the poems by Péret (translated by Ruthven Todd from *From Behind the Faggots* (1934)) was to become a familiar target for hostile English critics of Surrealism, possibly because it also became a model for the worst kinds of imitations of the 'surrealist style' in England:[11]

Honest Folk

The quarrel between the boiled chicken and the ventriloquist
had for us the meaning of a cloud of dust
which passed above the city
like the blowing of a trumpet
It blew so loudly that its bowler-hat was trembling
and its beard stood up on end
to bite off its nose
It blew so loudly
that its nose cracked open like a nut
and the nut spat out
into the far distance
a little cow-shed
wherein the youngest calf
was selling its mother's milk
in sausage-skin flasks
that its father had vulcanised.

Gascoyne's final chapter ('Surrealism to-day and tomorrow') proclaimed the current, more international aspirations of the Surrealists, and instanced the Surrealist contributions to *Minotaure* and the good response to that magazine in England as evidence of both the new, less isolationist, Surrealist attitude and possible common areas of interest between the French and English. Gascoyne noted too that the Surrealists had begun to be involved in political action outside France, and that groups had already been formed in Brussels, Belgrade, Prague, the Canary Islands and Copenhagen. He suggested that a Surrealist grroup was about to be formed in London, and he announced a forthcoming visit to England by Breton and Eluard which might coincide with 'a large surrealist exhibition'.

Gascoyne tried to develop an argument (already to be found in his earlier, unpublished Surrealist manifesto of 1935)[12] that there was a necessity for an international solution for art, which would save art from its reduction to either left-wing propaganda or mere 'self-expression'. He contended that only Surrealism offered a solution, by removing the false distinction between 'rational' and 'irrational', 'objective' and 'subjective', 'reality' and 'dream'. He attempted to counter the expected objection that Surrealism was only a French affair and would not thrive in England because it was foreign to the national temperament and had no roots in English tradition, by claiming that the movement was both close to the tradition of English literature, and international:

> **As a matter of fact, there is a very strong Surrealist element in English literature; one need quote only Shakespeare, Marlowe, Swift, Young, Coleridge, Blake, Beddoes, Lear and Carroll to prove this contention . . .**
>
> **Surrealism itself, as it is to-day, is by no means wholly the product of previous French culture; there is a very strong element both of German and of Spanish thought in it . . . For Surrealism transcends all nationalism and springs from a plane on which all men are equal.**[13]

The view that Surrealism had something new and of great value to offer to English literature was one which was certainly not accepted by most English writers and was hardly helped by such references by the Surrealists themselves to Romantic literature and especially to the English contribution. There was always a kind of love–hate relationship between the Surrealists and England, caused to some extent by the uneasy realisation by the movement's sympathisers that the fuller (and more English) the list of acknowledged Surrealist precurors the less plausible the claim to newness and originality would be. As we have seen, a common critical argument used by English critics and writers was that our own poets had been and were capable of beating the Surrealists at whatever was worthwhile in their own game. Surrealist attitudes towards English art are especially curious since, apparently, England was at once the least significant and also one of the most important countries.

In a Surrealist map of the world published in the Belgian periodical *Variétés* in June 1929, England, Scotland, and Wales were represented as a diminutive dot in a Europe in which Paris was all that remained of France. Italy and Greece were almost invisible. All Europe, in fact, was tiny in comparison with Alaska, Greenland, parts of South America, the Pacific islands and Russia. Patrick Walberg summed up the map's significance in his *Surrealism*:

> **. . . it corresponds to the permanent orientation of the surrealist ideal. That ideal tends to challenge Western Christian civilisation, born of the fusion of the Greek spirit and Hebrew monotheism. The surrealists would gladly have sacrificed all Romanesque art, the cathedrals, the**

chateaux of the Loire and Versailles in favour of the statues of Easter Island. I am speaking now of the orthodox surrealists, fanatically faithful to André Breton and his tastes elevated into doctrine.[14]

England was regarded as so unimportant in this context, presumably, because of her share in this same Western tradition, and also because, by definition, English artists were neither primitive nor Surrealists.

Apart from the point, made by many anthropologists, that primitive societies and art-forms are extremely rational and also restrictive in their unique and taboo-ridden contexts,[15] again there is the fundamental Surrealist dogmatism and conceit. The reason for the cosignment of all art of the past either to oblivion or to a kind of Surrealist Limbo seems to be that only after 1924, post-Breton, did the full truth become available. This also explains the element of hesitation which accompanied the admission of any earlier artists or thinkers into the ranks of Surrealist precursors. Thus, in the first Manifesto we were informed that 'bon nombre de poètes pourraient passer pour surréalistes, à commencer par Dante et, dans ses meilleurs jours, Shakespeare'. Other writers in English cited in the 1924 Manifesto included Swift and Poe, but it was Edward Young who received the most enthusiastic praise, tempered with the usual reservations about those traditional Surrealist objects of hatred and derision, priests: 'Les NUITS d'Young sont surréalistes d'un bout à l'autre; c'est malheureusement un prêtre qui parle, un mauvais prêtre, sans doute, mais un prêtre.'[16] Subsequently more writers in English were added to the canon. In Breton's introductory essay to the special Surrealist issue of *This Quarter* (1932), he named as outstanding antecedents of Surrealism, Swift, Walpole, Mrs Radcliffe, 'Monk' Lewis, Charles Maturin, Synge and, of course, Young ('unquestionably the most authentic forerunner of the surrealist style'). Even the Empiricists, Berkeley and Hume were given honourable mention as philosophers who had helped to lead Surrealism to Hegel and to dialectical materialism.[17]

A French bookseller's catalogue of Surrealist books,[18] dated 1931–1932, gave a list of recommended authors which included Swift, Berkeley, Young, Lewis, Maturin and Synge, among such important names as Rousseau, Kant, Marx, Engels, Baudelaire, Lautréamont, Jarry, Freud, Lenin, Cravan, Picabia, and Vaché. What is even more significant is that the list of writers who were *not to be read* (fifty-nine in all) included only one English writer, Rudyard Kipling; this probably proves little else but the point that the list was prepared for a French readership, though this is important in countering the view that English authors began to appear only when the French were trying to woo the Surrealist group in England and their supporters. In Breton's *De l'Humour Noir* (1937)[19] there were quotations from Lewis Carroll and De Quincey, both of whom had been translated into French. Notably Lewis Carroll's 'The Hunting of the Snark' was translated by Aragon in 1929.[20]

In one paragraph of his short study *Dada and Surrealism* (1972), C. W. E. Bigsby, discussing Surrealism and the English, found the English to have been 'curiously unaffected by Surrealism'. For Dr Bigsby the delay between the formation of Surrealism in France and its arrival here (which I have suggested was an effect rather than a cause) and the 'absence of André Breton from England' were both decisive. Some other characteristically English causes of the delay were suggested:

> **Partly because of a natural insularity, reinforced by a traditional and unashamed ignorance of foreign languages and suspicion of foreign ideas, the exuberant early years of a movement which rapidly spread throughout the world left English writers and artists largely unmoved.**

I hope that the preceding chapters of this book have demonstrated how wrong such a view is. It stems, I believe, from taking the Surrealists and their supporters at their own valuations and again from an assumption that their work was a natural development of Modernism instead of a betrayal of it. Dr Bigsby also fails to see the strength of the English literary tradition in terms other than those used by propagandists for Surrealism:

> **Despite a native tradition which included the fantastic absurdities of Lewis's *The Monk*, or, in another mood, the creations of Lewis Carroll and Edward Lear, as well as the visionary creations of Blake, there was little enthusiasm for a group which purported to despise literature and bourgeois society alike.**

If the first word of the above passage had been replaced by the words 'Because of', I believe that Dr Bigsby's analysis would have been closer to a balanced assessment. That he half – but only half – discerned this himself is demonstrated in his argument that

> **The freedom of the surrealist poets seemed less radical from the perspective of English romanticism and modernism, while the anti-clericism, which so shocked the French public, failed to provoke much more than wry amusement in a society so lacking in Catholic fervour and so inherently distrustful of passion. (pp. 54–5)**

An even more decisive contribution to Surrealist failure here was the general English refusal to see Surrealism as much more than a not-too-serious method of writing. The idea of Surrealism as a revolutionary way of life was given lip-service by the young Gascoyne but, as his examples and translations demonstrate, his radicalism was more a case of boyish high spirits rather than a genuine call to anarchist-style revolt and, like other English writers, he was more interested in the increased spontaneity which Surrealism appeared to offer to the would-be writer.

In his introduction Gascoyne suggested that the Surrealists conceived poetry as

. . . on the one hand, a perpetual functioning of the *psyche*, a perpetual flow of irrational thought *in the form of images* taking place in every human mind and needing only a certain predisposition and discipline in order to be brought to light in the form of written words (or plastic images), and, on the other hand, a universally valid attitude to experience, a possible mode of living.[21]

It must be conceded, however, that Gascoyne, like most other English writers, thought in terms only of the new poetic possibilities of the method, and largely disregarded the attitude to experience. (Herbert Read may be said to have done the opposite; that is, he never produced, as far as I am aware, a word of Surrealist poetry, but sympathised with the anarchistic attitudes of Surrealism as a possible revolutionary alternative to Fascist or Marxist extremisms.) At the end of his book (p. 136) it is true, Gascoyne declared that Surrealism was 'not simply a way of writing' and earlier (p. 80) he had been careful to say that 'surrealism is by no means simply a recipe', but in fact a good deal of *A Short Survey of Surrealism* was occupied with giving amusing and obviously amused descriptions of techniques employed by both Dadaist and Surrealist artists.

Gascoyne's book set the tone for the direction followed during the brief period of English Surrealist-style activity. I do not wish to suggest that Gascoyne was wholly or even mainly responsible for the relative flippancy of most English attempts at Surrealist writing; the young and enthusiastic Gascoyne's view that Surrealism's contribution to poetic method was at least equal in importance to its generally subversive nature is only further confirmation of the hopelessness for any aspiration at that time towards a serious English Surrealism. It is probably true, however, that Surrealism was the clumsy catalyst for several writers (including Gascoyne, Dylan Thomas, and George Barker) to explore more deeply their own tradition, though the jolt given by Surrealism made them realise the truth of what T. S. Eliot had been telling them since before World War I.

CONTEMPORARY POETRY AND PROSE (1936–1937)

All the available accounts of the International Surrealist Exhibition tend to suggest that though the exhibits were fairly serious, the behaviour of the visitors and even some of the participants, made this too little more than a romp. The curious mixture of Dadaist humour and claptrap which, for example, made Salvador Dali give an inaudible lecture inside a diving suit (which almost suffocated him), was seized upon by the English press as the essence of the exhibition. This meant that the English critics who tried to take it all seriously (Herbert Read, for example) were massively outnumbered by the many who saw it as a

distraction during a period of the nineteen thirties when distractions were probably both necessary and inevitable.

The exhibition did provide the opportunity for special articles about Surrealism, and special numbers of little magazines, the most serious and sympathetic of which was *Contemporary Poetry and Prose* (ten issues, 1936–1937), a magazine which began its existence one month before the exhibition opened. David Gascoyne provided most of the translations of work by French Surrealists which appeared in the 'Double Surrealist Number' of *Contemporary Poetry and Prose* in June 1936. This issue of the magazine edited by the nineteen-year-old Roger Roughton (who was a member of the Communist Party) coincided with the exhibition itself.

Although *Contemporary Poetry and Prose* was the nearest the English ever came to a Surrealist literary periodical, in my opinion whatever genuine character and quality it possessed appeared in the work of established writers (including William Empson, e. e. cummings, and Wallace Stevens), in some of the early poems and stories of Dylan Thomas, and in folk-ballads, traditional tales, and poetry collected by A. L. Lloyd. 'The Double Surrealist Number' contained translations of work by Eluard, Breton, Mesens, Dali, Buñuel, and several other Surrealists; stories by two children (one aged five, the other seven), and poems and prose by the English writers, David Gascoyne, Kenneth Allott, Roger Roughton and Humphrey Jennings. A comparison of the translations from the French with the English work is enough to reveal the relative paucity of the latter, although in fact there is not always a great deal to choose between them. This may be so because the poems (or poets) selected for publication exhibit those qualities favoured by the editor and his English friends. Certainly there is a complete absence of the frisson-producing quality of Surrealist painting. Benjamin Péret, whose selected poems, *Remove Your Hat* (published by Contemporary Poetry and Prose Editions),[22] went quickly into a second edition, provided four poems. One of these (translated by David Gascoyne) is 'That's No Good', and it is typical of the poems in *Remove Your Hat*:[23]

That's No Good

O little dogs little dogs
Swim in the ink
in the ink that is extracted from the hair of big dogs
with stamping clogs
with chucked oranges
like an enraged cow
slowly petrifying under the eyes
of a tobacconist
It will suit you to wear neck-ties
which will perhaps be out of the running
the slip-shod slippers will drag along at the corners of streets
leading to wastelands

as a legion of honour leads to the drain
The wind will have an attack of apoplexy
and the stones will throw themselves of their own accord
at skulls ravaged by winter and its floods
to murmur afterwards The Tower beware
of the spiced bread that goes rotten by degrees
Beware of what
of the little flowers of the fields
or of the toes that shake with a great laugh
the laugh of a melon that opens
to let a dozen butterflies fly out.

The second of Gascoyne's own two poems in this issue is the well-known 'The Very Image', a poem dedicated to and inspired by the paintings of the Belgian Surrealist, Magritte:[24]

The Very Image
to René Magritte

An image of my grandmother
her head appearing upside-down upon a cloud
the cloud transfixed on the steeple
of a deserted railway-station
far away

An image of an aqueduct
with a dead crow hanging from the first arch
a modern-style chair from the second
a fir-tree lodged in the third
and the whole scene sprinkled with snow

An image of the piano-tuner
with a basket of prawns on his shoulder
and a firescreen under his arm
his moustache made of clay-clotted twigs
and his cheeks daubed with wine

An image of an aeroplane
the propeller is rashers of bacon
the wings are of reinforced lard
the tail is made of paper-clips
the pilot is a wasp

An image of the painter
with his left hand in a bucket
and his right hand stroking a cat
as he lies in bed
with a stone beneath his head

And all these images
And many others
Are arranged like waxworks
In model bird-cages
about six inches high.

Magritte's paintings, which were shown at most of the Surrealist exhibitions of this period (fourteen of his works were on view at the London International Surrealist Exhibition of 1936, for example), were immensely popular with the English 'Surrealists', many of whom, including Gascoyne, Herbert Read, Humphrey Jennings and Roland Penrose, owned some of his work. A perceptive attempt to account for the strange, evocative power of Magritte's juxtapositions of objects and images was made by Humphrey Jennings at the time of a Magritte exhibition at the London Gallery in 1938:

> . . . the elements in a picture by Magritte are not *forced* together. Their 'bringing together' *occurs* in a passive sense in the painter' imagination. Hence their simultaneous irrationality – since nothing is chosen 'on purpose' – and their evident truth – since 'bringing together' is in fact an 'event' beyond choice.[25]

On the same occasion Paul Nougé, a Belgian Surrealist poet and theorist, referred to the 'poor beginner' who

> under the pretext of Surrealism devotes his attention solely to dreamwords, the appearance of automatism, and who proposes to reduce every Surrealist undertaking to certain elementary formulas about dreams, delirium, and the mechanisms of the unconscious.[26]

Whatever the truth about young, would-be-Surrealist English painters, Nougé's complaints were certainly justified in relation to poetic practice. Gascoyne's 'The Very Image', like so many of the English poems written under the influence of Surrealist art, was a misguidedly weak attempt to achieve in simple words the deceptively simple effects of Magritte's complex visual imagination. 'The Very Image' and most of the other English Surrealist poems which appeared in *Contemporary Poetry and Prose* demonstrated what should have been obvious, that a mere listing of 'images', no matter how unusual singly or in combination, could not constitute a worthwhile poem. Similar attempts to produce the effects of paintings by, for example, Salvador Dali, Max Ernst, and Hans Arp, showed the same naive disregard for essential differences between artistic media.

Not all the contributions to *Contemporary Poetry and Prose* were quite so banal and trivial as those by Péret and Gascoyne. Later issues of the magazine, which ceased publication with its tenth number in August 1937, contained translations of work in the Surrealist tradition by writers such as Picasso, Lautréamont, Jarry, Rimbaud and, in the last issue, ten poems by Tristan Tzara were translated by Francis Scarfe.

The general weakness of the Surrealist contributions to *Contemporary Poetry and Prose* cannot all be blamed on the editor's choice of material, the influence of David Gascoyne, or the lack of talent involved (especially among the English contributions), though all these had their effect. The most obvious feature of the periodical was

that its Surrealism, both English and French, was the least radical thing about it. Even Tzara's poems, in this context, failed to be more than mildly amusing. The contributions by other, non-Surrealist, writers were not invariably indicative of greater creative talent, but some of these contributions (notably some of Dylan Thomas's early prose-poems)[27] showed such original imaginative power that the 'Surrealist' work, by comparison, seems even more contrived and dull. By any critical standards, *Contemporary Poetry and Prose* demonstrates not only the bankruptcy of Surrealist method and talent in England during the mid-nineteen-thirties, but also the comparative creative health of more traditional methods and the writers who employed them.

SURREALISM (1936)

In the December 1936 issue of *Contemporary Poetry and Prose* there appeared a review by Humphrey Jennings who expressed all the customary exasperation of more orthodox Surrealist sympathisers then and since with the English lack of that genuine passion which the movement at its most radical was thought to possess:

> **How can one open this book, so expensive, so *well* produced, so conformistly printed, with so many and such mixed illustrations, so assorted a set of articles, containing so *protesting* a number of English statements and so stiffly pathetic a presentation of French ones, and compare it even for a moment with the passion, terror and excitement, dictated by absolute integrity and produced with all the poetry of bare necessity, which emanated from *La Révolution Surréaliste* and *Le Surréalisme au Service de la Révolution*, without facing a great wave of nostalgia, and bringing up a nauseating memory of the mixed atmosphere of cultural hysteria and amateur-theatricality which combined to make the Surrealist Exhibition of June so peculiar a 'success'.**[28]

The book to which Jennings referred was the most ambitious document published at the time of the International Surrealist Exhibition *Surrealism*, edited by Herbert Read. This book, and some of the controversy which it aroused at the time, provides complete confirmation of the all-important differences between French Surrealism and the ideas of those English writers who came nearest in sympathy with Breton and his followers. *Surrealism*[29] contained a long introduction by Read and also essays by Breton, Hugh Sykes Davies, Paul Eluard and Georges Hugnet.

In his '1870–1936', Hugnet attempted to give a survey–anthology of French poetry since 1870, including both work by acknowledged Surrealist forbears and by Surrealists themselves. His declared aim was:

> **to lay before English readers the chief weapons which Surrealism has used in its attack upon reality, and to emphasise its concern for human**

> dignity, a concern which permits us to believe that we alone in this age
> have the right to speak in the name of poetry. By denouncing poetry,
> Surrealism has restored its function.[30]

Hugnet's French pre-surrealist heroes – who included de Nerval,
Baudelaire, Lautréamont, Rimbaud, Jarry, Apollinaire, Reverdy, and
Vaché, as well as the entire Dada movement – were chosen for their
preparatory destructive role. Thus Rimbaud, for example, 'razes to the
ground the stores of poetic devices, he breaks the traditional mould'.[31]
Such negative emphases were balanced throughout the essay by an
equal stress on the dialectical necessity, originality, and scientific
objectivity of Surrealism, which, Hugnet argued, must not be confused
with any other ephemeral, merely literary, movement:

> ... whilst romanticism, symbolism, so-called cubist poetry and even
> dadaism itself (since it proved mortal) were all schools of poetry of
> greater or lesser scope – that is to say, *states* of poetry – Surrealism on
> the other hand is first and foremost a method of investigation and
> contains in itself a force which has always existed, a faculty as
> permanent as dreaming.[32]

Hugnet's most enthusiastic praise was reserved for Lautréamont. It is
praise which, in an English context which includes, for example, *King
Lear* or the poems of William Blake, to give only two instances, seems
ridiculously excessive:

> In his powerful romantic language, with its wild apostrophes, full of the
> most astounding images, he tried to deliver man from his illusory
> obsessions; throwing all notions of good and evil into the scales, he
> marked on the dial the hollowness of human justice. Lautréamont's
> contribution is thus more intellectual and moral than formal. I wish I
> could insist more on the disquieting aspect of Lautréamont, for
> everyone avoids speaking about it. He terrifies, stupefies, strikes
> dumb. Lautréamont is, par excellence, the Surrealist.[33]

The Surrealist brew required more than 'Disquiet'. It required too,
such total cynicism as Jarry's: 'He attacked everything, subjected
everything to ridicule, dragged it into the mud, from bourgeois
imbecility in all its aspects to the 'drapaud' whose spelling he so
happily modified.'[34] And, finally, the brew had to be taken entirely.
The artist could not be separated from his total allegiance to the
Surrealist doctrine, or from his living the Surrealist life:

> It is impossible, for example, to enjoy surrealist poetry without being
> led to share the aims of the writer. For Surrealism, the man and his
> work are inseparable. Socially, Surrealism desires the liberation of
> men, and devotes itself to this end by all the means in its power:
> unremitting defeatism, demoralisation, and aggression.[35]

Given such a mixture, Surrealist art had no claim to the role or the
status of art in any traditional sense:

> A surrealist text is to poetry what the surrealist object is in art. There can be no possible excuse for regarding them in an aesthetic light. Nothing in them could justify it; they are pure and simple expressions of a desire, fulfilments of a dream.[36]

And, consequently, Surrealist poetry was of necessity based on automatism: 'The essential basis of all its manifestations, the "open sesame", is automatism. Writing should be desire lifted to the plane of exaltation.'[37] Hugnet's article could easily justify the commonly held English belief that Surrealism was primarily a French movement making sense only within a French culture which had in the second half of the nineteenth-century belatedly started its struggle to break free from generations of atrophy.

Breton's essay, 'Limits not Frontiers of Surrealism', on the other hand, was much less related to any specific culture, but had the curious result of saying very little of real consequence about the movement itself. Breton attacked 'realism' and defended freedom and spontaneity in a relatively unsubversive way. He arged for the independence of the work of art (especially poetry) from the restrictive demands of current political events, and he advocated both spontaneity and poetry in a way which demonstrated his tactfulness in an English situation where many of his readers would identify with neither the 'committed' verse of the Auden group nor the more orthodox Communism of *Left Review:*

> A work of art worthy of the name is one which gives us back the freedom of the emotions of childhood. This can only happen on the express condition that it does not depend directly on the history of current events whose profound echoes to the heart of man can only make themselves felt by the systematic return to fiction.[38]

In his new approach to the English Breton included a long discussion of the 'romans noirs' and, finally, an astonishing eulogy to the English tradition generally as the truest source of a European consciousness, with some additional warm encouragement to his English sympathisers who were making possible the reception of Surrealism into their tradition. Indeed, Breton seemed to imply that Surrealism was already within this tradition.

In contrast, Paul Eluard's contribution was both intemperate and rhetorical, probably because it was originally given as a lecture at the New Burlington Galleries on 24 June 1936. Eluard's 'Poetic Evidence' was an attack on the capitalist system, bourgeois values, and apparently anything which, or anybody who, opposed or criticised Surrealism. To be against Surrealism was, for Eluard, to be identified indiscriminately with all the most repressive and Philistine forces in the history of modern man. Like Hugnet, Eluard seemed to suggest that Surrealism was a French necessity though he also took the view that it was the only method of combatting global Evil through a sort of Super-poetry.

The English contributors to *Surrealism* adopted a relatively more reasonable, even (as Jennings suggested in his review of the book in *Contemporary Poetry and Prose*) a scholarly approach. Both Hugh Sykes Davies and Herbert Read argued the normality and Englishness of Surrealism. In his 'Surrealism at this Time and Place' Davies tried to show that Surrealism was not something modishly new but rather a dialectical development from the past. It was possible to become a Surrealist 'without any act of conversion' (p. 120). His essay from the start assumed the importance of past literature. Though he rejected T. S. Eliot's interpretation of the concepts of 'history' and 'tradition' it was nevertheless impossible to reject 'Shakespeare and all the others' (p. 121). Instead of the 'orgy of eclecticism' which had given so much importance to 'Elizabethans, major and minor, Jacobeans, metaphysicals', Davies proposed the nineteenth century and romanticism as the correct starting-point for a study of the present age. A study of the English Romantic revaluation of the poetic imagination traced in particular the paths followed by Coleridge, who was responding to the 'spirits poetically great ... Blake, Byron, Wordsworth, Coleridge himself, Keats and Shelley'. Davies found Coleridge's rediscovery of a close connection between imagination and mania to be in close accord with the Surrealist insistence upon the similarities between poetry and paranoia. Wordsworth's best poetry, according to Davies, was paranoiac. Only Coleridge's developing enthrallment by German Idealism, replacing his healthy English materialism, prevented him from reaching conclusions in true accord with Surrealist theory. Davies ended his article by citing the evidence for the presence in English Romantic literature of the nineteenth-century of a strong 'algolagnic' sensibility; Mario Praz's *The Romantic Agony* (1933) had provided this evidence, though naturally Davies dissociated himself from Praz's 'premises, categories, terms, methods, and attitudes' (p. 159). To this evidence Davies added the 'astonishing development of the horror novel in the pre-romantic and romantic periods' and 'a case individually more important than any of these' (that is in Praz) 'that of Blake' who 'gives to the algolagnic sensibility its purest, and perhaps its most beautiful expression' (p. 162). For Davies, English Romantic writers were invariably political revolutionaries and, like the Surrealists, they understood 'that bourgeois culture, the culture of pure money, was inhuman and dehumanising; and they made war on it both by their poetry and by more direct political action' (p. 166).

Again the effect of Davies's arguments was to suggest that Surrealism was *within* the English literary tradition, though at the very end of his essay, Davies claimed that Surrealism had made important advances and that 'where romanticism was notoriously inchoate, disorderly, intuitive, Surrealism is organised, orderly and conscious.'[39] So much of the English literary past had been cited in support of Surrealism that the new movement was almost comically revealed as a very small and unoriginal aspect of Romanticism, from

which the English poet, fully aware of the literature of his past, could have very little to learn.

What he could learn apparently, according to Herbert Read in his 'Introduction' to *Surrealism*, was to revalue that past. Read's well-known essay, which appeared later in his *The Philosophy of Modern Art* with the title 'Surrealism and the Romantic Principle', was concerned with the visual arts as well as poetry, but his main points – that 'superrealism' was a permanent feature of all living art, and that English Romantic art in particular, had this superrealism in abundance – applied to literature especially. The importance and function of Surrealism in 1936, Read argued, was to make English writers, artists, and critics fully aware of this. Rather than pointing the way to French Surrealism, Read's contribution re-affirmed yet again the vigour and richness of English literature. Among the examples given by Read of necessary revaluations in English literature which Surrealism suggested were: 'a fuller acknowledgement of the supreme poetic quality of our ballads and anonymous literature' and 'driving home the inescapable significance of Shakespeare'. Read must have known that both these aspects of the tradition had been given particular attention by scholars and critics throughout the past two centuries, and that T. S. Eliot and John Middleton Murry had been both busy 'driving home the inescapable significance of Shakespeare' ever since World War I. Read also proposed that there should be more debate about the relations between metaphysics and poetry, and that the 'moral ban' which had worked against poets such as Shelley, Byron ('a superrealist personality'), and Swinburne, should be lifted. Among other writers to be revalued were Edward Lear, Lewis Carroll, and the Gothic horror writers so admired by the French Surrealists, Lewis, Maturin, and Mrs Radcliffe –though Read confessed that he did not find these latter easy to read.

In effect Read's essay, like all the English and some of the French contributions to *Surrealism*, must have given early warning to the French Surrealists, many of whom were to leave France via England for exile in the United States of America during the early stages of World War II, that they would find England an unsuitable climate for their theories and practice. For the English what was extremist in Surrealism was quite unpalatable: what was palatable was not particularly original.

SURREALISM AND NEW ROMANTICISM

Surrealist personalities and activities, including publications, in England after brief *succès de scandale* of the 1936 Exhibition confirm the feebleness of the official movement here. Most of the events consisted of exhibitions (none of which came anywhere near recapturing public response on any scale), and the only Surrealist publication to go beyond a single issue, *London Bulletin* (twenty numbers,

1938–1940), was published by an art gallery and contained no original Surrealist literary contributions of any merit whatsoever. E. L. T. Mesens, the Belgian Surrealist, was welcomed as Director of the London Gallery in the first issue (called *London Gallery Bulletin*) in April 1938. He and Toni del Renzio (also editor of *Arson: An Ardent Review*, one issue, March 1942), with some assistance from Roland Penrose and Jacques Brunius, kept up intermittent Surrealist-style agitation during the war-years, but none of it had any serious artistic response. A 'surrealist section' by del Renzio,[40] printed in *New Road 1943* (edited by Alex Comfort and John Bayliss) was dismissed savagely by some English critics, and theatrically by Brunius, Mesens and Penrose.[41] On the whole, however, it was simply ignored. As an organised movement in England, Surrealism failed to take root, and had withered away almost completely by the end of World War II. Its possible influence on the revitalisation of English writing did continue to exercise the minds of several English writers and critics for several years.

It is beyond the aim of this book to examine in detail the extreme confusions in English poetry, both theory and practice, during the period from 1936 to well beyond the end of World War II. English critics since the early fifties have been noticeably unsympathetic towards the literature which emerged during that period of turmoil. The spate of little magazines – including *Wales* (1937–1940), *Seven* (1938–1940), *Kingdom Come* (1939–1943), and *Poetry London* (1939–1951), to mention only a few of the better-known ones – most of them lacking real creative talent, and sometimes with a hotch-potch of poorly argued theory and policy, has been consistently represented until quite recently[42] as English literary life at its lowest ebb. However, in spite of a lack of coherence in much of their work, I believe that there is something to justify the claim that the loosely-formed groups of writers of the forties who wrote for these magazines were making a timely and responsive effort to re-assess the state of English writing within a situation in which both social and personal life had been cruelly disturbed. The nightmare world which had been created after Franco's victory in Spain, Stalin's 'show trials' and purges, and the nerve-wracking slow movement towards war with Nazi Germany, was intensified for young writers by the vacuum created by the collapse of that politico-literary activity which had attended such alien extremisms as Marxist-Communism, Anarchism, and Surrealism. Through many of the little magazines and their anthology-publications during this period there is one consistent if unsteady note, that of a search for meaningful order, an uncertain struggle to understand and to come to terms with a situation in which the leading theories, and the writers who were considered to be the chief exponents of such theories, had suddenly disappeared.

I believe that it would be possible to show that this apparently fallow period in English writing, far from being a 'dead-end', was one

in which English writers and critics were fumbling towards the rediscovery and re-affirmation of traditional poetic principles which had come under great pressure during the previous decade or so. The continuing influence of idealist Communism was still evident in the emphasis placed upon the artist's social role in the theory of both the 'New Apocalypse' and the 'New Romanticism', while Surrealism (modified by the theories of Carl Jung) continued to exert its influence too, particularly in the emphasis placed by both English 'movements' upon the power and importance of the personal and collective unconscious. But the key concept of many of the theoretical excursions of this period, one which renounced both Communism and Surrealism, was that of 'integration' or 'completeness'. In his *Auden and After* (1942), Francis Scarfe gave the 'Manifesto' of the New Apocalypse:

1. That man is in need of greater freedom, economic no less than aesthetic, from machines and mechanistic thinking.
2. That no existent political system, Left or Right; no artistic ideology, Surrealism or the political school of Auden, was able to provide this freedom.
3. That the Machine Age had exerted too strong an influence on art, and had prevented the individual development of Man.
4. That Myth, as a personal means of reintegrating the personality, has been neglected and despised.[43]

Perhaps it should be stated at this point that 'integration' hardly characterised the New Apocalypse group itself. Its members, who included Dorian Cooke, John Goodland, Nicholas Moore, Henry Treece, J. F. Hendry and G. S. Fraser, never met as a group. Indeed, some of its members did not meet each other at all; military service and other wartime difficulties made personal contact between members very irregular at the best.

Doubtless Geoffrey H. Moore, who had been an enthusiastic supporter of the New Romanticism at one time, was correct about both movements when he wrote in 1946:

What is lacking during a period of experiment (or *malaise*) cannot be forced into flower either by a theory or by a mode of writing. The 'integrated personality' is most commonly found in the integrated society, and the conditions which bring that about are so numerous, obscure and interrelated as to defy a laboratory-designed synthesis.[44]

Nevertheless, although some of the writers for the New Apocalypse thought that they were concocting a new theory for which bits of Marxism and Surrealist theory could be used as ingredients, and though much of their theory is completely muddled and unhelpful, the more intelligent and approachable examples show conscious respect for what I have argued are established traditional principles.

One such example is G. S. Fraser's essay 'Apocalypse in Poetry' which appeared as the introduction to the anthology *The White*

Horseman (1941)[45] which was the second of the New Apocalypse anthologies,[46] and the best-known. *The White Horseman* bore some resemblance in format to Herbert Read's *Surrealism*. Well-produced and with good illustrations it offered, in addition to Fraser's introduction, poems and prose by Apocalyptic writers, Henry Treece, J. F. Hendry, Norman MacCaig, Tom Scott, Vernon Watkins and G. S. Fraser himself; there were two essays by Robert Melville ('Apocalypse in Painting') and J. F. Hendry ('Myth and Social Integration'), as well as reproductions of paintings and drawings by di Chirico, Esteban Francés, Matta and Leonardo da Vinci.

Even Fraser's 'Apocalypse in Poetry', by far the most coherent and interesting of the contributions to the anthology, had some strange and puzzling moments in its theory, and some wild ones in its literary judgements. But he demonstrated his recognition of the plight of contemporary writing, both in the relationship of the writer to the community and in the unsatisfactory nature of the poetry then being produced:

> **The obscurity of our poetry, its air of something desperately snatched from dream or woven round a chime of words, are the result of disintegration, not in ourselves, but in society; we have not *asked* to be thrown back on our own imaginations for comfort and consolation, or to exercise our function in quite this isolated way.[47]**

Fraser identified himself at this time with the New Apocalypse 'group' which, like Surrealism, was not regarded by its members as simply a literary or even an artistic movement, though myth-making through poetry appeared to be its poets' most important and useful function:

> **To-day, we feel that we can best serve the general human interest by exercising our specific human function, which is to write poetry: to mount guard over the integrity of the imagination and the completeness of man.[48]**

Unlike Surrealism, which had had a stormy affair with Communism from the mid-twenties, the New Apocalypse had no sympathies with political orthodoxies.[49] Fraser thought that the group's politics 'tend towards the human', and he gave them a vaguely liberal flavour:

> **I suppose most of the group have a certain sympathy with ideas like those expressed by Lewis Mumford in *The Culture of Cities*: that culture should be less congested and centralized in great unwieldy cities like London, New York, or Paris, and that human units of control, generally, should be smaller and more adapted to natural regions.[50]**

Fraser renounced consistently the Auden group which, he believed, had represented a superficial kind of social awareness during the nineteen thirties. The writers of the New Apocalypse sidetracked the influence of such writers as Auden, Spender, and MacNeice, but

considered themselves to have derived from Pound and Eliot (in spite of their being 'reactionary' – a word which for Fraser did not necessarily carry pejorative connotations), from Freud and the Surrealists, and from Dylan Thomas.[51]

The greatest anti-climax comes from the examples of New Apocalyptic poetry which Fraser offered with much enthusiasm, those of Hendry, Treece and Nicholas Moore. The section of the essay in which he introduced these writers contained his most implausible judgements – including the view that Nicholas Moore's mind was 'more interesting than Blake's'. Most of the poems and stories in *The White Horseman* reveal immature talent, often clumsily imitative of Dylan Thomas, and with occasional signs of the continued influence of English sham-Surrealism, as for example in J. F. Hendry's 'golgotha':

> Crow, wooden lightning, from a sky of thorn –
> O cross-ribbed Adam, tumbled hill of blood.
> While blinded shell and body's thunder churn
> Ear to worm-ball, tongue to lipless stone.
>
> Our wound is night, bridged in the frigid hours;
> God's manna strung upon a nail spins dawn
> In skull-tolled bell behind straw eyes, and hoods
> A set dog barking at the rat of heart.
>
> One small wind in this ash blows up world fire.
> A struck prince launches legend at the dead,
> His healing voice the speech and severed core
> Of guttering earth and the stilled tides.
>
> Where forests are the history of man
> An eye of time is blinded by this bone.[52]

The form, theme, images, and rhythmic cadences in this are all derived from Thomas, particularly from his sonnet-sequence 'Altarwise by Owl-light'. Norman MacCaig's poems also reveal much dependence upon Thomas, but, as in the following example, some of those too were written under the influence of English 'Surrealism' at its worst:

> He walked in, the buccaneer with the lace collar,
> and all the wind-coloured dresses clenched in salute
> to the strings of his calves and his boomerang shoulders.
> The violins that had been filling the air with doves
> were sawn short, and the quivering music, mute
> and loveless, laid its curved neck along black water,
> slain by two heel tips and a grimace new lifted
> out of a ledger, fitted up at an untrue mirror
> and launched in a stream of ink. Men laid the hafted
> axes of arms along the walls and were shrugged
> into shadows, while the addled eggs of war
> crowed in its shell, where its shadows crowed and strutted.[53]

Despite the disappointing quality of the creative work which he introduced in *The White Horseman*, Fraser's essay contained a lively attempt to assess the ways in which the New Apocalypse differed from Surrealism, and in this aspect of the essay I believe Fraser's analysis was at its best. Throughout his essay, much of which had already appeared in an earlier review of *The New Apocalypse* in the magazine *Seven*, Fraser conceded a debt to Surrealism. Freud and the Surrealists had shown poets that 'a private perspective on the world' could become 'generally accessible human property'. This attitude had helped the poets of the New Apocalypse to become 'much more definitely interested (than was the Auden generation) in being poets rather than persons' (p. 29). The size of the debt to Surrealism was such, he argued, that the New Apocalypse could be regarded as 'A dialectical development of it: the next stage forward'. It embodied what was positive in Surrealism: '"the effort", in Herbert Read' phrase, "to realize some of the dimensions and characteristics of man's submerged being".' But it rejected what was negative: 'Surrealism's own denial of man's right to exercise conscious control, either of his political and social destinies, or of the material offered to him, as an artist, by his subconscious mind.' Surrealism's freedom was only apparent. It offered freedom 'for man's automatic verbal mechanisms, but not for man himself.' Human completeness required the freedom of the mind to select and reject from the material offered by the subconscious mind (which is a 'rubbish heap as well as a treasure-island'). Fraser suggested that Surrealist theory was close to Hume's phenomenalism:

> **the notion that the habitual association of cause and effect (or any other habitual association, for instance that of yellowness, roundness, sweetness, juiciness, and so on, to form what we call an 'orange') is, in fact, *just habitual*, depending on no inherent structure, or logic, in nature or the mind.**

Both Hume and the Surrealists were mistaken:

> **When we explore the mind or nature more thoroughly than Hume we find logic and structure; and artists more responsible than the Surrealists find that art is not merely the juxtaposition of images not commonly juxtaposed, but the recognition, the communication of organic experience; experience with personal shape, experience which (however wild and startling in content) is a formal whole . . .[54]**

In his criticism of Hume, Fraser demonstrated a healthy empiricist scepticism about empiricist principles taken too rigidly (by a fellow Scotsman). His rejection of Hume and Surrealism owed something to the influence of Kant or Coleridge:

> **Apocalypticism, then, unlike Surrealism, insists on the reality of the conscious mind, as an independent formative principle; and recognizing a certain continuance in the mind, it is also constrained to recognize a certain continuance in nature.**

Thus Fraser introduced another of the key concepts of the New Apocalypse, that of 'organic experience', with the task of the artist to create the art appropriate to the exploration and communication of such experience. It must be conceded that this concept of 'organic experience' was responsible for much of the muddled theory of the New Apocalypse, but in this essay, Fraser's position is relatively clear. Through art – that is, for the writer, through the making of 'myth' – the artist makes new meaning at that point where the world and the artist's feelings about the world fuse together. This is different from but just as valid as the scientist's search for regularity in nature.

Fraser was anxious to stress that the New Apocalypse was not trying to set up yet another dogma. He insisted that it had a flexible philosophy:

> **All it says is, 'Be honest, allow for complexity, and be yourself; *you* matter more than wars and politics, more than creeds, systems, and ideas: these things, so far as they are anything, are just your sprawlings and gropings, where you are still blind to your real needs'.** [55]

Fraser saw a need to find a balance between the too-selective order (classical and too rationalistic) of T. S. Eliot and other 'traditionalists' on the one hand, and the too-defeatist (absurdist, therefore arbitrary) ordering of writers such as Lawrence Durrell.

In his discussion of the poetic image (which appeared still to be the most important element in the poet's equipment, though Fraser suggested that the single word was too simple, and that the 'phrase' might be a more appropriate poetic unit), there was further criticism of the Surrealists' influence on modern poetry. Freud's most important discovery (as the Surrealists believed) had been that 'it is impossible really to talk nonsense'. Fraser argued that this attitude extended to art had resulted in the trivialisation of literature. He asked for a return to a more responsible and meaningful poetry than Surrealism offered. Finally, he summed up the differences between the worlds of Surrealism and the group which he supported, which were:

> **the difference between the madman, who sits back and contemplates all sorts of strange and trivial relationships, freed from the necessity of action; and the sane man, who accepts dream and fantasy and obscure and terrible desires and energies, as part of his completeness.**

No doubt the claim of the New Apocalypse to possess this kind of 'completeness' was, on the evidence of its writing, extravagant. Nevertheless, it appears to me that in the re-affirmation of poetry, the rejection of a simplified view of life, the idea of the complete man,[57] and the total mistrust of dogma of all kinds, Fraser's essay, which is representative of the New Apocalypse at its best, shows that one principal theorist of the movement at least had already moved strongly away from the 'great systems of theoretical constructs' and 'agglomera-

tions of unconscious commands' which Robert Conquest in his famous Introduction to *New Lines* (1956)[58] claimed to characterise the poetic atmosphere of the forties. At times, it is true, Apocalyptic enthusiasm for poetry led to the expression of sentiments which justify Conquest's claims. For example, 'Letter V' from Henry Treece's *How I See Apocalypse* (1946):

Poetry is the drum of that sophisticated medicine-man, the poet. He is the dream-maker, the spell-binder, who is master over the most potent weapon man knows – the word.

And because the word is so powerful, for good or evil, the poet's trade is almost a sacred one. He *is* the unacknowledged legislator of the world, but not at the council table; his magic works at the subterranean level from which dreams spring. He moves men by sly words and phrases that creep quietly and effectively through the barricades of sense, camouflaged by their colours and rhythms . . .(pp. 46–7)

Many of the basic ideas expressed in *The White Horseman* were to re-appear time after time in later anthologies of the New Apocalypse and its developing variants. Again the language in which the basic ideas were expressed was over-inflated, and the idea lost in verbiage. In his 'Preface' to *The Crown and the Sickle* (1945) for example, Henry Treece explained that the anthology's title was about completeness: 'The crown is glory, victory, the imagination; the sickle is the surgical reason. The two together are symbols of man's completeness, and it is totality of experience which this collection attempts to portray.'[59]

I have concentrated so much here upon *The White Horseman* and G. S. Fraser's essay, not only because the book was the best-known of the group's anthologies and the essay relatively concise and coherent, but also because they both demonstrate how some English writers of the forties attempted to cope with what they believed to be the very real challenge of Surrealism to traditional principles of English writing. It may seem that in using neo-Romantic theory bolstered with psychological and sociological speculation the advocates of New Apocalypse and later variations on much the same themes (including Personalism and New Romanticism) fell into many self-laid traps. There is no doubt, however, that throughout the forties English literary theory, as far as many young writers were concerned, continued to see some need for a counterweight to Surrealism (and even Dadaism). Myth-making, 'personalism', poetic completeness or integrity, and all the rest of the critical jargon of the period often appear to have been essential defensive barriers during a time of unprecedented cultural confusion (even if the odds were never quite so seriously against the defenders as they believed).

Even after the end of World War II several of the contributors to the later stages of Apocalyptic and New Romantic theory continued to see

a need to define their differences with Surrealism, whose last official exhibition in London was in October 1945 at the Arcade Gallery. In his essay 'Poetry and Mechanistic Ideology' in *How I See Apocalypse* (1946),[60] Treece suggested that some Surrealists, including Charles Cros and Hugh Sykes Davies, had produced work which met the requirements of Apocalyptic art:

> **for those Surrealists who still have the use of their faculties and the ability to employ a craftsman restraint, who can organise the import-ance and possibilities of the personal *organic* myth – that form of myth which is the result of man's reaction to living in a world occupied by other organisms – have produced some remarkable work.[61]**

But he disclaimed any French, and re-affirmed the British, origins of the Apocalypse itself (though it is not clear how Revelations are more British than French):

> **Basil de Selincourt assumed that it is the hangover of a French fashion, by Surrealism out of *Fleurs du Mal* which (thank God!) has no roots in This Country ... the Apocalyptic tradition is British and not French, since it has its roots in Blake, in Webster, even in Revelations.[62]**

And once again the 'Dada madhouse' was rejected as a viable alternative to 'bourgeois dullness':

> **Dada shook its supporters out of a world of bourgeois platitudes into the madhouse, the greenhouse of paranoia. Later the Surrealist who made his eggs twang like a banjo was paranoic, for he insisted on remaking the world in an arbitrary, casual and erratic image of himself as lunatic.[63]**

By 1946, however, the efforts of Treece and others were old hat. Defence against Dadaism and Surrealism in such magazines as *How I See Apocalypse* and *A New Romantic Anthology*, edited by Treece and Schimanski in 1949, was an excuse for printing poems and essays of little point and less talent. At that particular time after World War II, no English writer of any reputation was strongly influenced by Surrealism. As a systematic movement in England it was a completely spent force.

NOTES

1 Herbert Read, 'Introduction', *Surrealism*, ed. Herbert Read, (Faber, London, 1936; reissued 1971), pp. 19–20.
2 *International Surrealist Bulletin (Bulletin International du Surréalisme)*, No. 4, issued by the Surrealist Group in England, (September, 1936), p. 1. This issue of the *Bulletin* was 'read and approved' by: Eileen Agar, André Breton, Edward Burra, Hugh Sykes Davies, Paul Éluard, Mervyn Evans, David Gascoyne, Charles Howard, Humphrey Jennings, Rupert Lee, Sheila Legge, Len Lye, E. L. T. Mesens, Henry Moore, Paul Nash, Roland Penrose, Man Ray, Herbert Read, George Reavey, Roger Roughton, Ruthven Todd, Julian Trevelyan.

3 *Ibid.*, p. 4.

4 *Ibid.*

5 *Ibid.*, p. 6.

6 *Ibid.*

7 See, particularly: J. H. Matthews, 'Surrealism and England', *Comparative Literature Studies*, I, 1 (University of Maryland, 1964), pp. 55–72; Paul C. Ray, *The Surrealist Movement in England*; Dawn Ades, *Dada and Surrealism Reviewed* (Arts Council of Great Britain, London, 1978), pp. 346–57.

8 David Gascoyne, *A Short Survey of Surrealism* (Cobden Sanderson, London, 1935; reprinted Cass, London, 1970), p. xiv. Gascoyne's 'Introduction' is dated July–September, 1935.

9 *Ibid.*, p. 17.

10 *The Surrealist Movement in England*, pp. 94–5. Ray conceded that *A Short Survey of Surrealism* provided a useful introductory history of Surrealism, and suggested that Gascoyne's book together with his translation of Breton's *Qu'est-ce que le surréalisme* made excellent companion volumes; together they 'present a well-rounded account of both the history and the doctrine' (*ibid.*, p. 96).

11 Benjamin Péret, 'Honest Folk', quoted in David Gascoyne, *A Short Survey of Surrealism*, p. 155.

12 'Premier manifeste anglaise du surréalisme', *Cahiers d'Art* X, 1935, p. 106, is a shortened version of this manifesto. A summary of the unpublished manifesto appears in Ray, *op. cit.*, pp. 86–7.

13 David Gascoyne, *op. cit.*, pp. 132–3.

14 Patrick Waldberg, *op. cit.*, p. 24.

15 See for example L. Adams, *Primitive Art* (Penguin Books, Harmondsworth, 1940): 'The artist of to-day, however, even when he captures that original naivete, will never produce really primitive works. Art is the expression of the artist's mentality, and inseparably bound up with his whole life, surroundings and history' (p. 117).

16 André Breton, *Manifeste du Surréalisme* (1924), quoted in *A Short Survey of Surrealism*, p. 38.

17 André Breton, 'Surrealism, Yesterday, To-day and Tomorrow', *This Quarter* (1932), pp. 9–10.

18 'Les livres Surréalistes ainsi que les publications surréalistes' (Librarie José Corti, Paris, 1931–1932).

19 André Breton, *De l'Humour Noir* (G.L.M., Paris, 1937).

20 Lewis Carroll, *La Chasse au Snark*, traduit par L. Aragon, (Chapelle-Réanville, Paris, 1929).

21 David Gascoyne, *op. cit.*, p. xi.

22 Benjamin Péret, *Remove Your Hat*: poems selected and translated by David Gascoyne and Humphrey Jennings, *Contemporary Poetry and Prose* Edition, No. 1 (London, June 1936). A second edition was announced in the August–September 1936 issue of *Contemporary Poetry and Prose*.

23 Benjamin Péret, 'That's No Good', *Contemporary Poetry and Prose*, No. 2 (June 1936), p. 24.

24 David Gascoyne, 'The Very Image', *Contemporary Poetry and Prose*, No. 10 (Autumn 1937), p. 35.

25 Humphrey Jennings, 'In Magritte's Paintings ...', *London Bulletin*, No. 1 (April 1938), p. 15.

26 Paul Nougé, 'Final Advice (to Humphrey Jennings)', *Ibid.*, p. 6.

27 Stories by Dylan Thomas which appeared in *Contemporary Poetry and Prose* were as follows: 'The Burning Baby' (in No. 1, May 1936, pp. 10–14); 'The School for Witches' (in Nos. 4–5, August–September 1936, pp. 95–100); 'The Holy Six' (in No. 9, spring 1937, pp. 18–26).

28 Humphrey Jennings, review of *Surrealism, Contemporary Poetry and Prose*, Nos. 7–8 (December 1936), p. 167.
29 Ed. Herbert Read, *Surrealism* (Faber, London, 1936; reissued, 1971).
30 Georges Hugnet, '1870–1936', *op. cit.*, p. 251.
31 *Ibid.*, p. 193.
32 Ibid., pp. 187–8.
33 *Ibid.*, pp. 188–9.
34 *Ibid.*, p. 200.
35 *Ibid.*, pp. 246–7.
36 *Ibid.*, p. 247.
37 *Ibid.*, p. 248.
38 *Ibid.*, p. 109.
39 Hugh Sykes Davies, 'Surrealism at this Time and Place', *ibid.*, p. 168.
40 *New Road 1943*, ed. Alex Comfort and John Bayliss (Grey Walls Press, Billericay, 1943).
41 See Ivor Jacobs, 'Auden Aftermath', *Horizon* VII, 46 (October 1943), pp. 285–8; also letter to the editor from J. B. Brunius, E. L. T. Mesens, and Roland Penrose, *ibid.* (recto of end cover).
42 For example, more sympathetic appraisals have been made by Robin Skelton in his introduction to *Poetry of the Forties*, (Penguin Books, Harmondsworth, 1968), and by Derek Stanford in 'Thoughts on the Forties', *Poetry Review* (autumn 1969).
43 Francis Scarfe, *Auden and After: The Liberation of Poetry, 1930–41*, (Routledge, London, 1942), p. 155. In 'Writers and Apocalypse', the introduction to *The New Apocalypse* (1940), pp. 9–15, J. F. Hendry claimed that he and Henry Treece had formulated these principles during the previous winter.
44 G. H. Moore, 'The New Apocalypse: One Aspect of Romanticism' (unpublished thesis, Cambridge University, March 1946), pp. 8–9.
45 Ed. J. F. Hendry and Henry Treece, *The White Horseman* (Routledge, London, 1941).
46 Other anthologies of the New Apocalypse were: *The New Apocalypse* (Fortune Press, 1940), and *The Crown and the Sickle* (Staples, 1945).
47 *The White Horseman*, p. 30.
48 *Ibid.*, p. 31.
49 In his 'Myth and Social Integration' J. F. Hendry tended towards some theory of an organised socialist society, which he contrasted with Surrealist anarchy: 'Surrealism of course is a conglomeration of myths, corresponding to the political "order" or disorder, of anarchy. Apocalypticism represents rather the restoration of order to myth, individual and social, which in art should correspond to the political order of planned socialism' (p. 176).
50 *The White Horseman*, pp. 8–9.
51 Much of the movement's spirit was thought to stem from D. H. Lawrence. The title for the anthology derives from Lawrence's *Apocalypse* rather than directly from the *Book of Revelations*. The quotation from the title-pages is from Lawrence: 'The rider on the white horse! Who is he, then? . . . He is the royal me, he is my very self and his horse is the whole MANA of a man. He is my very me, my sacred ego, called into a new cycle of action by the Lamb and riding forth to conquest, the conquest of the old self for the birth of a new self.' (*ibid.*, p. v).
52 *Ibid.*, p. 64.
53 Norman MacCaig (from 'Nine Poems'), *ibid.*, p. 88.
54 G. S. Fraser, *ibid.*, p. 5.
55 *Ibid.*, p. 6.
56 *Ibid.*, p. 13.

57 *New Lines* was claimed by Robert Conquest to represent 'the restoration of a sound and fruitful attitude to poetry, the principle that poetry is written by and for the whole man, intellect, emotions, senses and all' (*New Lines*: *An Anthology* I (Macmillan, London, 1956), p. xiv).

58 *Ibid.*, p. xi–xviii.

59 *The Crown and the Sickle: An Anthology*, ed. J. F. Hendry and Henry Treece (King and Staples, London, 1946).

60 *How I See Apocalypse,* ed. Henry Treece (Lindsay Drummond, London, 1946).

61 *Ibid.*, p. 70.

62 *Ibid.*, p. 74.

63 *Ibid.*, pp. 77–8.

post-dada in english writing
1950–1980

Until the nineteen-fifties writing in Britain was able to resist successfully the worst effects of the anarcho-nihilism which to some degree had infected modernism in all the arts and which, after World War I, became a virulent disorder in Dadaism and Surrealism. Since the end of the Second World War, it can be argued, there has been a gradual, insidious spread into all levels of British intellectual and artistic life of those more destructive and negative attitudes inherent in the modern movement.

It would be too simplistic to trace the growth of a postwar society, generally more receptive to ideas of disillusionment and world-weariness, back to the economic austerities of the late nineteen-forties and early nineteen-fifties. The immediate postwar years, in Britain at least, were particularly buoyant and confident despite the privations and the suffering of the war and its aftermath. In politics, for example, until the onset of the Cold War there was a strong popular optimism that social justice and greater international co-operation were practically attainable ideas. Beneath this powerful outer expression of hope, it is true, there lurked disturbing awareness of the almost unbelievable horrors of the Nazi concentration camps, the deliberate mass-slaughter of civilians by both sides during the war, and an infinitely increased capacity for the destruction of most of mankind through nuclear weapons. But the prevailing mood in Britain was quite different from that which existed after World War I. There was neither frenetic gaiety nor bleak despair. Nor was there much consensus of

mood or styles in the arts.

NIHILISTIC EXISTENTIALISM

One of the few clearly discernible 'trends' of the postwar era was in the literature and the anarcho-nihilistic doctrines of Existentialism as presented through the works of Camus and Sartre. Translations of novels, plays and essays in ideas by both Albert Camus and Jean-Paul Sartre began to appear in Britain soon after the war. *The Outsider* (translated by Stuart Gilbert) and *Two Plays* by Camus appeared in 1946. The same publishers, Hamish Hamilton, brought out Eric Sutton's version of *The Age of Reason,* the first volume of Sartre's trilogy *Les Chemins de la Liberté* in 1947 and Stuart Gilbert's translation of *La Peste (The Plague)* in 1948. The following year John Lehmann Ltd produced the first English translation of Sartre's prewar novel *La Nausée* (re-titled *The Diary of Antoine Roquentin)* and Spearman issued Lloyd Alexander's translation of *Intimacy.* Anthony Bower's translation of Camus's *L'Homme Revolté (The Rebel)* was issued by Hamish Hamilton in 1953 when Iris Murdoch's *Sartre: Romantic Rationalist,* the first full-length study of Sartre's writing by a British philosopher, also came out.

The British literary establishment, such as it was, pressed forward to present these works and the new philosophy to the public. '[Camus] is a negative destructive force who shows up the unreality of bourgeois ethics' wrote Cyril Connolly in his 'Introduction' to *The Outsider.* Sir Herbert Read's 'Foreword' to *The Rebel* noted with approval the prominence and sympathy given to nihilistic and anarchistic elements in Camus's analysis of the spirit of rebellion in modern thought:

> **He reviews the history of this metaphysical revolt, beginning with the absolute negation of Sade, glancing at Baudelaire and the 'dandies', passing on to Stirner, Nietzsche, Lautréamont and the Surrealists. His attitude to these prophetic figures is not unsympathetic, and once more it is interesting to observe the influence of André Breton on the contemporary mind.** [1]

Serious readers were generally puzzled by the discrepancies between the noble stoicism of the Existentialist ethic which postulated absolute freedom for man, alone and 'abandoned' in an otherwise meaningless universe, and the apparently gratuitous violence and lack of human warmth in the novels and plays of Sartre and Camus. There was unresolvable conflict between the almost Kantian assertion of man's absolute freedom in the ethical realm – that man's *existence* precedes his *essence* as Sartre put it in his well-known lecture 'Existentialism is a Humanism' – or the view according to Camus in *The Rebel,* that the excesses of rebellion entailed a balancing humanising moderation[2]– and the dehumanised characters, hate-filled, directionless, and sordid, which were created by Sartre and Camus in their literary works. A

similar unresolved contradiction lay in the Existentialists' use of terms such as 'Being', 'freedom', and 'responsibility for others' on the one hand, and 'nothingness', 'absurdity', 'despair', and 'angst' on the other. All these concepts seemed to be necessary constituents of Existentialist thought.

Philosophy in British universities during the same period provided no defence against this form of Existentialism beyond asserting that it was not 'real' philosophy; no contemporary continental thought was 'real' philosophy. Real philosophy was presented as the history of Western thought up to its final apotheosis in British Empiricism. Two sets of current questions and approaches in British philosophy derived from early and later Wittgenstein and from A. J. Ayer's influential book *Language, Truth and Logic* (1936). Defence of positivistic attitudes, or the refutation of them, and Oxford-style linguistic analysis, which shared Ayer's view that most philosophical problems stemmed from linguistic confusions merely, were the predominant activities in the philosophy departments of British universities. The basic concepts of continental thinking were ridiculed as 'meaningless' by positivist and linguistic analyst alike. As a philosophy student in 1954 I can recall my delight when the great French philosopher, playwright and theologian Gabriel Marcel attended a philosophy seminar and asked what on earth British philosophers were doing playing about with words when there were important human problems to devote our minds and hearts to. None of the students had known until Marcel's visit that there were contemporary Christian Existentialists, but the greater and most welcome discovery was that a contemporary philosopher, and a formidable one, believed that meaningful debate about human issues was not only possible but the most important task of the philosopher.

Nihilistic Existentialism had a relatively long notoreity too in the popular press. The white-faced, black-garbed and morose men and women of *La Rive Gauche* were taken up by the newspapers, and guyed by the cartoonists and satirists of the mass-media for several years. As a consequence, some of the attitudes and representative figures of anarcho-nihilistic thought came to have popular interest and appeal to English readers. Garbled versions of the ideas of such figures as de Sade and Nietzsche began to percolate through the middlebrow levels of British cultural life. A way was prepared for the main infiltration of post-Dada, which was to come through the art movements of the nineteen-fifties and nineteen-sixties.

NEO-DADA

The final chapter of Hans Richter's *Dada: Art and Anti-Art* (1964/5) is on the whole a fierce tirade against those artists, especially in the USA, who made use of the styles of Dadaism to produce the commercially successful art-movements of the nineteen-fifties and

-sixties. Abstract Expressionism, assemblage, pop-art, op-art, kinetic art, happenings (including auto-destructive art-objects), and Minimalism – the styles of all those brief phases in the history of the visual and plastic arts since 1950 – have been traced back to early Modernism, particularly to Dadaism and Surrealism and the radical experimentalism of the nineteen-twenties. In his well-informed and enthusiastic study *Movements in Art since 1945* Edward Lucie-Smith has tracked the various styles of the new art in the West from Jackson Pollock's 'action paintings' of the late nineteen-forties to Mark Rothko's large abstracts of the nineteen-sixties; from the 'pop' paintings of the nineteen-fifties, including the collage pictures of the British painter Richard Hamilton, to the comic-strip paintings, 'portraits' of Coca-Cola bottles, and many other styles of the last two decades or so. Lucie-Smith has argued that 'all these movements represent a resifting and revaluation of ideas which were already known before the war', and that

Abstract expressionism is rooted in surrealism; assemblage and pop art reached beyond surrealism to dada; op art and kinetic art are founded upon experiments made at the Bauhaus; minimal art interestingly combines both dada and Bauhaus influences.[3]

Richter quoted numerous denunciations of so-called Neo-Dada by the old-guard Dadaists whose work was being adapted to forge a new aesthetic for the latest commercially minded fashions. Richard Huelsenbeck, for instance, deplored the sensationalism and hard commercialism of the new art: '"Neo-Dada has turned the weapons used by Dada, and later by Surrealism, into popular ploughshares with which to till the fertile soil of sensation-hungry galleries eager for business."[4]" (Huelsenbeck's view of the commercialism and shallow sensationalism of modern American art is shared and vigorously argued by the journalist Tom Wolfe whose short book *The Painted Word* (1975) is an informative, irreverent, and very amusing attempt to debunk 'the Great American Myth of Modern Art'). And Marcel Duchamp (identified by Richter as the 'Patron-saint of the Pop-people') wrote to Richter in 1962:

This Neo-Dada, which they call New Realism, Pop Art, Assemblages, etc., is an easy way out, and lives on what Dada did. When I discovered ready-mades I thought to discourage aesthetics. In Neo-Dada they have taken my ready-mades and found aesthetic beauty in them. I threw the bottle-rack and the urinal into their faces as a challenge and now they admire them for their aesthetic beauty.[5]

Neither Richter nor the group of original Dadaists who rejected Neo-Dada so angrily gave a coherent set of reasons for their dislike of the new art. Duchamp's letter was clearly directed against a revival of 'aesthetics' in Neo-Dada while Huelsenbeck despised its concern with sensation and cash. Richter himself, taking up a curiously ambivalent

stance, found it dehumanising and nihilistic, but perhaps justifiably so: If the new Dadaism, which belongs to this fate-ridden age, finds such a powerful echo in people's minds, it must be because some 'inner voice' answers its call – even if that voice is the voice of nothingness.[6]

Similar contradictions and confusions are to be found in a lecture 'The Limits of Permissiveness', which Sir Herbert Read gave a few months before his death in 1968. Read seems to have wanted to argue that the artists of the modern movement, including Dadaists and Surrealists, shared a common concern for a stylistic integrity which can be attained only through the essential sensibility and discipline of art. Because they were attempting to break away from the stylistic principles of their modern masters the new artists had fallen into formlessness and incoherence:

> **Contemporary nihilism in art is simply a denial of art itself, a rejection of its social function. The refusal to recognize the limits of art is the reason why as critics we must withhold our approval from all those manifestations of permissiveness characterized by incoherence, insensibility, brutality and ironic detachment.[7]**

Oddly, most of Read's lecture was devoted to an ill-judged attack on Joyce's *Ulysses* and *Finnegan's Wake* and all Pound's *Cantos*. In Ezra Pound, according to Read, it was possible to trace growing confusion and incoherence, which were present even in the first forty-one *Cantos*. As in Joyce, a decline towards absolute confusion in Pound's later works was traced to a probable 'softening of the brain'. Artists such as Beckett, who have followed the stylistic examples of Joyce and Pound have imitated a mere 'stammering confusion'. It is curious (and sad) that Read, unlike Duchamp and Richter, should have been able to forget the nihilistic origins, intentions, and productions of Dadaism and Surrealism. These movements contained much that can only be described as incoherent, insensible, brutal, and detached. It is sadder that Read should have failed to see the profound human, and humanising, compassion of *Ulysses,* of many of Pound's *Cantos* (early and late), and in much of Beckett's work, despite the latter's bleak view of the world in which people live out their ultimately hopeless and painful lives.

Notwithstanding the attempted dissociation from it by some of the Dadaist and Surrealist old-guard, there is little doubt that the new art in the USA after 1945 was another major source here of anarcho-nihilistic theory, including both Dadaism and Surrealism. Lucie-Smith identified the source of the invasion as the art-schools and colleges where the latest art fashions were always quick to arrive:

> **Here, the post-war period saw a great expansion in the number of art-schools, to the point where these began to offer a liberal education which rivalled that to be got from the universities ...**

In Britain, an art-school education tended to be freer than its university equivalent; it demanded less formal study, but a greater degree of intellectual flexibility. Because it centred upon visual phenomena, it was international rather than national in its emphasis: there was no question of teaching English art as universities taught English literature or English history.[8]

Among the influential critical works introduced into our art colleges from the USA were the scholarly editions of Dada artists produced by Robert Motherwell. Motherwell, himself a painter and a champion of both radical modernism and, from its beginnings, the new art, edited Hans Arp's *On my Way* (1948), a collection of essays and poems by the Zürich and Cologne Dadaist, and Max Ernst's *Beyond Painting* (1948), containing texts by Ernst himself and by several other Surrealist writers of the nineteen-twenties. Motherwell's most important contribution to the foundation-theory of Neo-Dada, however, was his collection *The Dada Painters and Poets: An Anthology* (1951).[9] This book contained a very extensive critical bibliography of Dadaism by Bernard Karpel, as well as manifestos, speeches, and reminiscences by the Dadaists and their apologists, including Richard Huelsenbeck's 'En Avant Dada' (1920), Kurt Schwitters' 'Merz' (1920), 'Seven Dada Manifestoes' by Tristan Tzara (1916–1920), George Ribemont-Dessaignes' 'History of Dada' (1931), and George Hugnet's 'The Dada Spirit in Painting' (1932–1934). Another American book which was well-known in Britain was Alfred H. Barr's *Fantastic Art, Dada, Surrealism* (1947), a study which developed from the catalogue of the Winter 1936/1937 Exhibition held at the Museum of Modern Art in New York. Some critics have argued that the arrival of several of the Surrealists in America during the late nineteen-thirties had little direct effect on American art (despite Jackson Pollock and Robert Motherwell's obvious debts to both Dadaism and Surrealism, for example). Whatever the truth of this view there was certainly a growing body of theoretical literature from the United States which was to find its way to our art-schools and, from there, to a wider audience. As Lucie-Smith pointed out:

practically every major pop-group in Britain since the rise of the Beatles has had some kind of link with an art-school. Many of the musicians began to play when they were art students. Popular music took over the modern art life-style; and where the musicians led, the fans followed.[10]

It is a droll paradox of modern higher education that when the universities, through an irresponsible philosophical insularity, were allowing a nihilistic form of French Existentialism to take root here unchallenged, the art-schools were enthusiastically importing from the USA theories of anarcho-nihilism which underlie the new creative methods in the visual and plastic arts and the new directions in the mass-media.

POST-DADA, POP-POETRY AND THE
LITERARY UNDERGROUND

Increasing knowledge in Britain of the theories and activities of Dadaism, Surrealism, and the experimental modernism of De Stijl and the Bauhaus in the nineteen-twenties has encouraged a few writers to take a fresh and serious interest in the creative possibilities offered. British artists who have acknowledged direct debts to literary Dadaism or Surrealism include the novelist Alan Burns, the poet and critic Christopher Middleton, and the poet and designer John Digby. [11] More will be said later about the work of Christopher Middleton. John Digby has provided disturbingly effective Ernst-like collages to accompany his 'Surrealist' poems – the better ones of which, in my view, owe nothing of their quality to either Surrealist theory or practice. These writers, and a few others, can be said to have taken the aesthetic possibilities of Dadaism and Surrealism more or less seriously with the result that their work has greater substance and value than most of the British writing produced under the influence of French Surrealism in the nineteen-thirties.

Concrete (or visual) and phonic poets of the sixties and seventies acknowledged a debt to the experimental work of Dadaists such as Hugo Ball and Kurt Schwitters. Some of them have been able to create interesting and expressive work, despite the obvious dangers and limitations inherent in their media. The visual poems of writers such as Ian Hamilton Finlay (about whom more will be said later in the chapter) as well as Edwin Morgan, Dom Sylvester Houédard, John Furnival, Stephen Bann and others owe something also to contemporary artists working in other countries within the tradition of experimental modernism. The Brazilian Noigandres group, including Decio Pignatari and the brothers Haraldo and Augusto de Campos, and many individuals in the USA, Germany, France, Scandinavia and elsewhere co-operated during the sixties to produce a body of work which was a praiseworthy attempt to cross national frontiers as well as traditional barriers of artistic media. [12]

Phonic poetry made a bright and impressive international start too with the work of the English writer Bob Cobbing, associated closely with that of the ebullient and amusing Austrian Ernst Jandl and the Frenchman Henri Chopin. Cobbing's *ABC of Sound Poetry* (1965) did indeed suggest new possibilities, both expressive and entertaining, in experiments with basic speech sounds. Unfortunately, Cobbing's work has moved into the realm of the incoherent and ultimately trivial as he has become more conscious of (and imitative of) the anarchic and destructive ancestry of his experiments.

In his book *Revolt into Style: The Pop Arts in Britain* (1970), George Melly, the jazz-performer and leading advocate of Surrealism in postwar Britain, suggested that 'pop art' developed first in this country: 'It is still possible to write that the idea of pop art was evolved

at the Insititute of Contemporary Arts in London between 1952 and 1962.'[13] From the start literature was a poor relation in comparison with the productions of the pop visual artists and the pop music groups. Melly saw this as an early manifestation of the 'will to classlessness' of the new movement:

> **The bias of pop towards a visual or musical, rather than a literary, form of expression is significant here: in part no doubt dependent on the development of non-literary media like television, but equally linked to the rejection of an educational structure in which social origin is revealed through the manner of verbal communication.[14]**

Melly's judgement on the artistic limitations of 'pop' culture was often more bitingly derisive than even that of some of the former Dadaists was on Neo-Dada or than Sir Herbert Read's was on the whole direction of the arts postwar:

> **There is, however, a less sympathetic side to the anti-literary prejudice of British pop-culture, a smearing by association of traditional cultural standards, a refusal to admit to any form of moral judgement on the flimsy grounds that it must be a class judgement at the same time, a deification of sensation at an immediate level which is itself profoundly pessimistic.[15]**

His final pronouncements on the kind of 'pop poetry' written under the influence of 'automatism' or drugs sounds even more artistically traditionalist, critically responsible, and even elitist:

> **When drunk or drugged everything certainly seems more significant (so do those absurd statements which spring into the mind on the borders of sleep). Re-read later, most of these discoveries usually turn out as dull as those stones which small children insist on bringing home from the seaside because, wet with spray and reflecting the marine light, they had seemed the essence of mysteriousness and meaningful beauty ...**
>
> **There is in fact no easy access to poetry and it is the pop poets' refusal to admit to this which has driven the traditional critics to dismiss pop poetry out of hand.[16]**

An important representative figure in the development of both 'pop-poetry' and in the creation of a would-be-subversive 'Underground' movement in British art is the Liverpool poet Adrian Henri. Henri's capacity to bring like-minded artists into a group and to spread his quite considerable knowledge of the early modernists led Melly to liken him to a 'scouse equivalent of Apollinaire'. Henri's own poetry confirms the links between pop-poetry and other features of the whole pop-culture, especially the visual arts and Jazz. In 'Notes on Painting and Poetry', an essay which appeared at the end of his collection *tonight at noon* (1968), Henri wrote:

As a poet I am interested in how far poetry can be pushed in different directions and still remain poetry. (This is, as I have suggested above, very much a painter's ethic.) Can a poem be a letter? a news item? a cutup of disparate material? a complete typographic statement that couldn't be read out? At one time I tried writing 'poems without words' simple action-pieces or instructions for the audience to see if it was possible to create a poetic image without verbalising at all.[17]

Henri acknowledged, what the above passage supports, that pop artists generally 'are of course working in a direct line of descent from the Dada/Surrealist tradition'.[18] His poems, like those of other pop writers, demonstrate this derivative quality. What they also demonstrate is that, as the title of Melly's book suggests, old-style Dada and Surrealist 'revolt' has degenerated into a pseudo-revolutionary, second-hand 'style' which is generally glib, lacking in deep feeling, and capable of totally banal sentimentality even where it draws upon the methods of its subversive heroes.

Henri's heroes are proclaimed in several of his poems including one with the title 'Me'[19] in which he names over ninety writers, musicians, radical politicians and philosophers, and film or television stars in answer to the question, 'If you weren't you, who would you like to be?' The range of his sympathies may be appreciated from the various names which make up the poem, as diverse as Marx, Miles Davis, Stravinsky, St John of the Cross and the Marquis de Sade, for example. 'Manchester Poem', a part of 'Love Poem', a 'work in progress', reveals a more consistently radical collection of patron saints, though the cultural levels are almost as varied, figures such as Picabia, Max Ernst and Apollinaire appearing alongside the Beatles, Bartók and Dylan Thomas.

Dadaist and Surrealist, jazz and pop-music, pop-art and artists with anarchic life-styles, all these influences are found in the poems too, as in 'Car Crash Blues or Old Adrian Henri's Interminable Talking Surrealistic Blues', in 'Poems Without Words', in a cut-up poem made from Milton's sonnet XVIII, an article from the *TV Times*, and a CND leaflet,[21] and in 'Pictures from an Exhibition'. The last-named of these contains imitations in words of paintings shown at the Tate Gallery's 1964 exhibition 'Painting and Sculpture of a Decade 54–64'.

Occasionally Henri writes a short poem which has both controlled (if not quite strict) form and a genuine charm:[22]

HAIKU
(for Elizabeth)

morning:
your red nylon mac
blown like a poppy across Hardman St.

But Henri's charm is more often superficial and, in the longer rambling (interminable) poems especially, his intended radicalism

sinks into mere gestures towards the poetic and the subversive. Flat, formless, empty of ideas and feeling, Adrian Henri's poems confirm Melly's judgement that in the poets as well as the pop-musicians 'most pop talent is, in the traditional sense, under-educated, improvisational rather than thoughtful'.[23] A quasi-Surrealist poem, 'The Blazing Hat', Part Two', reveals the gauche sentimentalism which I referred to earlier. The poem ends:[24]

> **This is the morning that we saw a 4-year-old boy**
> **whipping an imaginary blonde lovely**
> **This is the morning that Death was a letter**
> **that was never scented**
> **This is the morning that the poet reached out for the**
> ** rolled-up Financial Times**
> **followed by a dreadful explosion**
> **This is the morning that you woke up 50 miles away**
> ** seeing sunlight on the water**
> **and didn't think of me**
> **This is the morning that I bought 16 different kinds of artificial**
> **lilies-of-the-valley**
> **all of them smelling of you**
> **This is the morning that we sat and talked**
> **by the embers of the blazing hat.**

The tameness of Henri's sometimes amusing pseudo-revolutionary poems (and of the Liverpool 'pop-scene' generally) is cruelly underlined by any comparison with the London-based 'Underground'. A history of the Underground is traced in a well-informed but occasionally ill-tempered and unreasonably argued book *Bomb Culture* (1968) by Jeff Nuttall who was himself a leading figure in the movement. The Underground was a loosely organised group or series of groups, and included at various times poets formerly of the Liverpool scene, writers associated with Michael Horovitz and his *New Departures* and *Live New Departures*, and with Bob Cobbing, the bookshop Better Books, and the Writers Forum. Stylistically these writers of the sixties can be linked with the pop-culture and the Neo-Dada techniques of the fifties. However, some of the performances in public and the uses of Dadaist methods reached levels of shocking violence, hysterical anti-bourgeois virulence, and anti-art which have been equalled this century only by Dadaism and Surrealism at their most extreme. Important, if improbably paired, precursor heroes of the Underground were William Blake and the Marquis de Sade. This mixture of romantic mysticism and sadism also connects the Underground with American 'Beat' literature, especially with such writers as Allen Ginsberg and William Burroughs.

Nuttall's *Bomb Culture* traced the development of this complex movement from the protest movements of the fifties. The 'failure' by the early sixties of the Campaign for Nuclear Disarmament was seen by Nuttall – and doubtless by his colleagues in the Underground – as

the reason and the justification for developing new levels of anguished and uncontrolled violence in the arts, with an alternative life-style more radical than 'pop' and more destructively nihilistic than anything seen in Europe since Dadaism. One section of Nuttall's book is sufficient to demonstrate the irrational thinking which lay behind the bomb culture phenomenon of the sixties.

The section to which I refer is one in which the artists of the 'bomb culture', de Sade and the infamous Moors murderers were linked together so that all belonged to the same diseased ethos. All shared Ian Brady and Myra Hindley's guilt for their bestial crimes:

> **Romantics, Symbolists, Dada, Surrealists, Existentialists, Action painters, Beat poets and the Royal Shakespeare Company had all applauded de Sade from some aspect or other. To Ian Brady de Sade was a licence to kill children. We had all, at some time, cried 'Yes yes' to Blake's 'Sooner murder an infant in its cradle than nurse an unacted desire.' Brady did it.**[25]

The writers of the Underground, Nuttall suggested, had come near to the state of mind found in Brady and Hindley:

> **There was the sick sense of humour – the grafting of jolly Christmas songs onto the end of the tape of little Leslie Downey whimpering, pleading and screaming; Brady's remark, 'He's a brainy bastard, isn't he?', as he and Smith carried the butchered Evans upstairs. Both ideas worthy of the best sick comedians. Jokes that not only said, 'We are ill' but also said, 'We are ill and so what. We love it.' it was precisely that step that we were all trying to take in our humiliation and despair.**[26]

What Nuttall means about the Underground is best illustrated perhaps by his description of some of the 'Happenings' of the sixties in which he and his fellow artists and writers were involved:

> **When Brady and Hindley were carrying out their first murder plans Otto Muhl and Herman Nitsch had already carried out their first ceremonials with entrails, flesh and smeared food. Keith Musgrove and I were discussing publicly disembowelling a human corpse and hurling the guts at the audience. Nitsch lamented the fact that corpses were available to medical students but not to artists. So did we. Del Foley showered the audience with offal at the first Notting Hill Gate festival, and I, with Musgrove and other members of the sTigma team, did a fake disembowelling in Better Books basement. 'I thought you'd murdered her', said Tony Godwin. 'It'll come to that', said John Calder.**[27]

Just in case the reader should wish to agree with Pamela Hansford Johnson that 'Brady and Hindley were the obscene emanation of a widespread sickness in society', Nuttall assured us that Brady and Hindley were 'scapegoats' for society's general guilt, a guilt which excuses, presumably, the obscene attitudes and behaviour of Muhl, Nitsch, Del Foley, Musgrove, and Nuttall just described above:

Brady was a footling amateur, a whimsical eccentric, compared with any decorated, lauded US bomb crew in the Vietnam war, that any judge and jury in support of one and condemnation of the other is the sickest joke of all, that if the Vietnam bombing and the bomb are a fair price to pay for the free trade of the West and the survival of Communism, then our journey to the deepest place of hell, though intolerably expensive, did not cost so dear.[28]

It is one thing to suggest that the Moors murders, the H-bomb, and the bombing in Vietnam are equally horrific. It is something else to propose that art has licence to adopt the spirit of such horrors too. Only a mind hell-bent on a new nihilism could so confuse the issues. That de Sade, the Dadaists of 1916, and the Surrealists of the twenties should be cited as models for their attitudes of mind tells us everything we need to know about the destructive irrationality of the Underground.

The poems found in Michael Horovitz's collection *Children of Albion: Poetry of the 'Underground' in Britain* (1969)[29] and in his *New Departures*[30] do not all fall into the category of 'bomb culture' in the extremist style described in Nuttall's book, though, as in pop-poetry, there is very little of real poetic worth or maturity. Many of the Underground writers performed their work in public and it is sometimes argued that, like pop-poetry, such work is 'betrayed' in print. This argument is true, but only in the sense that the printed words usually confirm the banal emptiness of the poem performed live.

A DISTINCTION OF NEO-MODERNISMS

In a well-known essay ('Modernisms'),[31] first published in 1966, Frank Kermode made a characteristically bang-up-to-date, wide-ranging, and probing examination of contemporary usage of the term 'Modernism'. Professor Kermode argued that fundamental distinctions must be made between the artistic quest for order and the artistic making of an order. The neo-moderns had moved away from the former and in this way they differed from most artists of the past, including many of their 'palaeo-modernist' ancestors. Neo-modern rejection of order could be traced back to those would-be nihilists, the Dadaists, and to such precursors of Dadaism as Guillaume Apollinaire:

There seems to be much agreement that the new rejection of order and the past is not quite the same thing as older rejections of one's elders and their assumptions. It is also agreed that this neo-modernist anti-traditionalism and anti-formalism, though anticipated by Apollinaire, begins with Dada. Whether for the reason that its programme was literally impossible, or because their nihilism lacked ruthlessness, it is undoubtedly true, as Harold Rosenberg has argued, that Dada had many of the characteristics of a new art movement, and that its devotees treated it as such, so in some measure defeating its theoretical anti-art programme.[32]

As we saw in Part II of this book, few of the British 'palaeo-Modernists'

were able to be so loftily detached from the provocative and destructive activities of Dadaism as Professor Kermode managed to be in this passage. For Percy Wyndham Lewis, for example, Dadaism (and all it was to lead to), far from being a new art movement, was the principal betrayer of the Modern Movement in painting and literature. A growing public for new art had been turned off art altogether by the antics of the Dadaists and Surrealists. It may be argued that Lewis, deeply pessimistic and writing in the period between two great wars, was in no position to be objective, nor was he able to foresee such manifestations of post-Dada art as Abstract Expressionism, the New York School of Poets, Pop Art, the Underground, and concrete/phonic poetry. I believe that these 'new arts' would have confirmed his view that Modernism was betrayed by Dadaism and Surrealism. However, Lewis's judgements should be weighed within the context of the pre-1914 art movements which he did know, especially the School of Paris. The Arts Council's exhibition 'Paintings from Paris' (1978–1979) must have brought home to its visitors the marvellous variety, the energy, the hopeful vitality, and especially the humanity of the School of Paris. The binding genius of that school of painters and poets was Guillaume Apollinaire. And although it is true that Apollinaire – who wrote *L'Antitradition Futuriste* and scandalised Paris with his pornographic writings – 'anticipated' some Dada attitudes, it would be an error to regard him simply as a precursor of Dadaism. No Dadaist, or Surrealist, writer would ever have written the lines:

Nous ne sommes pas vos ennemis
Nous voulons vous donner de vastes et d'étranges domaines
Où le mystère en fleure s'offre à qui veut le cueillir
Il y a là des feux nouveaux des couleurs jamais vues
Milles phantasmes impondérables
Auxquels il faut donner de la réalité

Apollinaire's brand of provocation was a necessary leavening within his naturally good-humoured and hopeful personality. In the same way the School of Paris 'contained' Apollinaire's brand of anti-traditionalism and anti-formalism as it also contained the taunting spirits of Rimbaud and Jarry. The exuberance and good-nature of Apollinaire and of most of the art-movements which he championed more than counterbalanced any tendency towards the destructive. Dadaism too had devotees (Schwitters and Arp, for example) who were never really anti-art, and several of the Dadaists had a natural sense of good-humour and high spirits, but in the period between 1916 and 1922 creativity and fun were completely overshadowed by the manifestations of nihilistic and irrational hysteria. As Wyndham Lewis argued, by the mid-1920s the vision and the *will to play* which had permeated successive art movements from Expressionism to Futurism had disappeared entirely, and apparently for ever. The

post-war was totally different from the pre-war. Since 1920 in Europe, and since the end of World War II in Britain, a joyless, violent and destructive spirit, one which has tended to be anti-human and despairing about the future, has permeated the arts. It is to be found not only in the work of such writers as Albert Camus and Jean-Paul Sartre, but also in the grim metaphysical stance of an English poet such as Ted Hughes, or in the hate-filled plays of Harold Pinter, or in the cynical novels of Kingsley Amis, to name but three highly 'popular' or fashionable British writers. In such a context it is a paradox that some of the artists working along the experimental tradition from European Modernism – Dadaism and the Bauhaus included – have produced excitingly original work and even work which affirms more traditional values in art.

IAN HAMILTON FINLAY

In the early 1960s Ian Hamilton Finlay (b.1925) decided to abandon traditional syntax and structures in his poetry. By the end of the decade he had discovered new creative directions and a distinctive poetic language. Like Augusto de Campos of the Brazilian Noigandres group and Eugen Gomringer in Germany, Finlay had developed his individual language by finding kinship with pioneers of experimental modernism from whom there is an unbroken tradition of exploration into new possibilities of shaping expression. Occasionally he has used labels such as 'Fauve' or 'Suprematist' to characterise some of his work in the new manner; among Modernists to whom he has paid tribute directly or indirectly are Seurat, Picasso, Juan Gris, Malevich, Kandinsky, and, inevitably Apollinaire.

Finlay's poetry is at once 'minimalist' and expansive. Words, letters, and even numbers are explored as objects or signs which may be reorganised in typographical space so that we may see new scope in them as poetic language. Not all his experiments have come off with equal success of course, but when they have worked Finlay has produced compressed expressions of unusual power and beauty, as well as wit and humour. His minimalist modes produced critical misunderstanding and abuse from the beginning; his work has been dismissed as naive and 'twee' by more hostile British critics. Because his poems are often worked out in unconventional materials, including slate, metal, wood, glass, embroidery and concrete, some literary critics have committed a 'category' fallacy by banishing his work to distant plastic or visual realms. His close collaboration with various artists/craftsmen who have realised his conceptions in the materials of their own media has also been a cause of critical confusion or uncertainty. 'Reading' a poem by Finlay, even the most minimal and apparently simple, requires critical openness, along with some willingness to make the effort to break through traditional barriers of media and method.

It is true too that Finlay has employed some methods akin to those

used by the Dadaists and by the more irresponsible neo-Modernists. His work of the late 1960s and early 1970s contains 'found' elements, for example. Newspaper headlines, names given by trawlermen to their boats, and – most provocatively perhaps – fishing boat port registration letters and numbers were basic material for many of Finlay's poems during this phase. The newspaper *Fishing News* provided these magical 'found' headlines which were incorporated into card-poems:

FROM 'THE ILLUMINATIONS OF FISHING NEWS'

'OCEAN STARLIGHT TOWED OFF ROCKS'

FROM 'ΤΑ ΜΥΘΙΚΑ OF FISHING NEWS'

'ZEPHYR JOINS AVOCH FLEET'

Names chosen by trawlermen for their fishing-boats are not chosen at random; Finlay has recognised that given the restriction of two or three words a fisherman naturally and skilfully chooses something of significance. Names for the sea and sky in all moods, the names of girls, desires of all kinds – these are poetic stuff in themselves, and they becomes rich material for a kind of collage poetry in Finlay's

work. For example, two boat names placed together[33] may be full of meanings; tender love and the hard-headed commercial realities of the fishermen's trade are completely interlocked here:

BE IN TIME
FRUITFUL VINE

Another set of names can become a fisherman's love lyric:

Green Waters
Blue Spray
Grayfish

Anna T
Karen B
Netta Croan

Constant Star
Daystar
Starwood

Starlit Waters
Moonlit Waters
Drift

Three boats – envisaged as '3 Blue Lemons' (in a tidal bowl, Peterhead) – are at once a sort of still life made by Juan Gris and a message about natural beauty:

ANCHOR OF HOPE
DAISY
GOOD DESIGN

'Sea Poppy 1' is a flower-shaped arrangement of boat letters and numbers, the 'meaning' of which becomes clearer when we appreciate that letter groups evoke ports of origin, so that, for instance, AH stands for Arbroath, UL for Ullapool, and BCK for Buckie.

Most of these early works were created by Finlay's own Wild Hawthorn Press (including the magazine *Poor Old Tired Horse)*, though Stuart Mills's Tarasque Press (and his magazine *Tarasque*) and the Cambridge experimental modernist magazine *Form* were active on behalf of Finlay's talent. In his constant exploration of the relationship between shapes and textures in letters and natural objects and landscapes Finlay's poetry attained quite original lyrical and evocative intensity. Many of Finlay's works, particularly those created in more durable materials, were created for his garden at Stonypath – a farm on the Pentland Hills. Here Finlay has created a landscape which is at once a home for his poems and a display gallery to demonstrate the possibilities of his art.[34] These earlier poems made lyrical connections between land, sea, and sky. They also proposed the

possibility of order – an order which man can shape for himself and also the order which Finlay believes lies in and beneath the world of things. His values are Christian, conservative, and classical. Despite his radical methods, he is a traditionalist who believes in such unfashionable concepts as beauty and craftsmanship. His uncompromising integrity as man and artist has cost him much trouble in the sloppier circles of contemporary art.

In the Stonypath garden there are sundials and other objects in stone or wood which bear brief inscriptions. The effect is like that of passing through one of the great formal gardens of Italy, brought down to a much more human and domestic scale. At least, this was the case until Finlay accepted the challenge to his medium by embarking on the exploration of the minimal epic! Some of his earlier inscriptions had, as I have already suggested, a depth of lyrical expression which suggested classical models. An inscription on a marble 'cloud-form':

THE CLOUD'S ANCHOR
swallow

is a rich complexity of meanings. Clouds are *not* marble, and cannot be held in stone (or art). The swallow, which is anchor-shaped in flight, dives from the boat-like cloud into the blue sky/sea. But the bird cannot anchor the substantial cloud-boat, and we are left with a poignant sense of man's and the artist's struggle to hold time.

Finlay's work of the mid- and late-1970s has been a development of several strands of the earlier work extended from lyrical into epic dimensions. Great heroic battles of World War II, the weapons of both world wars, the uniform, flags, and military insignia have all become disturbing yet appropriate features of this new poetry. Some of Finlay's epic poems were shown at the Arts Council Exhibition in London's Serpentine Gallery during the Autumn of 1977. There, the rooms were organised to show different aspects of the new developments in his art. For example, the first room was a 'Neo-classical' interior where the visitor was invited to contemplate many sculpted and inscribed objects. Renaissance-style emblems had been employed anew in order to celebrate and mourn the heroism of the warfare of our age. This was disturbing in at least two ways. Can modern warfare be commemorated as classical and Renaissance battles could be? And can the minimalist techniques of the epigram and emblem bear the burden of such commemoration? Many of Finlay's critics failed to distinguish these questions from each other, with the result that important critical issues were fudged. The weapons of mass-destruction – fighting-planes, aircraft-carriers, tanks, artillery – were linked by Finlay to their classical counterparts, so that he at least was asking the questions, posing the problems for himself.

In another room of the exhibition was a large tableau in which the visitor was asked to ponder the decisive Battle of Midway (June 1942)

in terms of several related emblems. Doomed Japanese and American aircraft-carriers had been transformed into bee-hives, their aircraft into bees, and the battle into a burning garden apiary, the fire fuelled by the honey/petrol. The provocative artificiality of this construction caused strong critical abuse at the time, much of it unconsidered and insolent. What was required, as usual, was a little critical modesty along with a modicum of faith – or at least willing suspension of disbelief – in the artist's integrity. Only after the visitor has discovered for himself (as perhaps he should have known already) how decisive the Midway Battle was in World War II, and also how heroically – in the best classical sense – it was fought, would it have been possible for him to start to pass judgement on the appropriateness of Finlay's realisation.

CHRISTOPHER MIDDLETON

Christopher Middleton's 'neo-Modernism' is founded on wide and deep knowledge of the extremer modes of Western Modernism,[35] and his sympathetic assimilation of many radical theories, styles, and techniques had made him potentially the most dazzlingly versatile of contemporary English poets. Unfortunately, the more serious impulses of the 'will to play' in Middleton the artist are often thwarted by a recurring nihilistic unconcern, beyond despair even, from which he has wished to be delivered ('Holy Cow'):[36]

> **Also go to me
> who am answerable,
> but walk a street through ruin
> without so much
> as the faint torchlight
> of dejection.**

Middleton's voyages around this central Limbo have taken him through many realms of media and mood. Even the earliest volumes, including *torse 3: Poems 1949–1961* (1962) and *Our Flowers & Nice Bones* (1969), showed a European sensibility which was developing towards the experimental modes offered by neo-Dada, though there was also a strong balancing traditional sense of craftsmanship.

His best collection to date, *The Lonely Suppers of W V Balloon* (1975), reprints 'The Fossil Fish' (1970) and *Briefcase History* (1972). The fifteen 'micropoems' of 'The Fossil Fish' show the range of Middleton's capacity for subtle language play, both sensitive and amusing. One poem makes telling use of semantic dislocation:[37]

> **village quote idiot unquote
> look a walking often takes
> long at you
> stops & slow hows
> he comes through**

**screwy? clutched in
his one scrotum hand the other
crumpled hugs a fingering book**

Another delicately fuses together sensual images and cold geometry:[38]

**shorts white
at the sharp angle of
trim bronze legs
to a melon balanced
in one palm she subtends her
equilateral nose
deepening the hidden
rose of that sphere
between cone & cone**

The whole sequence is brilliantly successful play, the serious 'game' of art.

Throughout *The Lonely Suppers of W V Balloon* (as the title-poem's 'found' title suggests) we are made aware of the constant voyaging through many lands and times, even into pre-history. There are a few 'experimental' poems, including an attractive kaleidoscopic lyric ('A Cart with Apples') and a cut-up montage ('Chanel Always Now'), but the more moving poems in the collection seem to spring directly from the author's vulnerable self; these include 'Nine Biplanes', a poem which may be recommended as one of the most successful Surrealist-style poems ever written by an English poet. It is interesting that the poems which are simplest in form and diction generally gain in direct emotional impact.

Pataxanadu and Other Prose (1977) is a collection of short pieces which take their inspiration from several European and American Minimalist/Modernist sources, including Dadaist nihilism at its blankest, Surrealist black humour at its most irrational, and Franz Kafka in his bleakest masochistic moods. The title-work, 'Pataxana-du', is uneven in quality because the persona here seems nearly all the time to be walking 'a street through ruin/without so much/as the faint torchlight/of dejection'. This is not to deny that there is a good deal of zany humour in five of the pieces which borrow a technique of vocabulary substitution from Raymond Queneau. These pieces, originating in Malory, Melville, Urquhart, Charles Doughty, and Swift, share the theme of journeying. Middleton's treatment makes them wild journeys into bizarre linguistic regions, as in his transformation of Swift:

I had not germinated far when I mechanized one of these crawlers fugato in my water, and colouring up to me dippily. The uberous monopode, when he secreted me, distended several ways every favour of his virtue, and stood as at an obligato he have never secreted before; then, applauding more naughtily, liberated his forehead, whether out of curaçao or miscarriage, I could not tease.[39]

The theme of journeys continues throughout the twenty-one pieces of the sequence. Middleton's inventiveness is both fascinating and exasperating. He can move suddenly and with apparent artistic lack of concern from sensitive evocation ('The Spaniards Arrive in Shanghai') and superb political satire ('The Great Duck') to the most outrageous bad taste ('Getting Grandmother to Market' and 'Adelaide's Dream'). The minimal prose and poems of *Pataxanadu* are a self-conscious display of enormous talent and vitality.

Like all Middleton's poems and imaginative prose-pieces, *Pataxanadu* shows different versions – the creative and the destructive – of post-Modernism at work in the one artist. Christopher Middleton's achievements in the creative mode make him one of the most stimulating and provocative of English writers since World War II. New explorations into experimental and formalist modes, an inventive and amusing wit, and a genuine sense of art as game have to be balanced against the anti-art and bitter cynicism of post-Dada. Only the former of these versions of the neo-modern seems to me to be in the tradition of fully humane and creative Modernism.

NOTES

1 Sir Herbert Read, 'Foreword', Albert Camus, *The Rebel*, translated by Anthony Bower (Hamish Hamilton, London, 1953), p. 8.
2 'Whatever we may do, excess will always keep its place in the heart of man, in the place where solitude is found. We all carry within us our places of exile, our crimes and our ravages. But our task is not to unleash them on the world: it is to fight them in ourselves and in others', Albert Camus, *ibid.*, p. 268.
3 Edward Lucie-Smith, *Movements in Art since 1945* (Thames & Hudson, London, 1969), p. 11.
4 *Dada: Art and Anti-art*, p. 211.
5 *Ibid.*, pp. 207–8.
6 *Ibid.*, p. 204.
7 Sir Herbert Read, 'The Limits of Permissiveness', in ed. Peter Abbs, *The Black Rainbow* (Heinemann, London, 1975), p. 17.
8 *Movements in Art since 1945*, p. 21.
9 Robert Motherwell ed. *The Dada Painters and Poets: An Anthology*, (Wittenborn, Schultz, New York, 1951; second printing 1967; Documents of Modern Art, No. 8).
10 *Movements in Art since 1945*, p. 22.
11 Alan Burns's 'Surrealist' books include: *Dreamerika! A Surrealist Fantasy*, (Calder and Boyars, London, 1972); *Europe After the Rain*, (Calder and Boyars, London, 1965); *Celebrations* (Calder and Boyars, London, 1967); *Babel* (Calder and Boyars, London, 1972). John Digby's collections include: *The Structure of Bifocal Distance* (Anvil Press, London, 1974); *Sailing Away from Night* (poems and collages) (Anvil Press, London, 1978).
12 Some of the best-known international anthologies of concrete poetry are: Emmett Williams (ed.), *An Anthology of Concrete Poetry* (Something Else Press, New York, 1967); Stephen Bann (ed.), *Concrete Poetry: An International Anthology* (London Magazine Editions, London, 1967).
13 George Melly, *Revolt into Style: The Pop Arts in Britain* (Penguin Books, Harmondsworth, 1972, p. 13).
14 *Ibid.*, p. 20.

15 *Ibid.*
16 *Ibid.,* pp. 209–10.
17 Adrian Henri, 'Notes on Painting and Poetry', *tonight at noon* (Rapp & Whiting, London, 1968, p. 66).
18 *Ibid.,* p. 63.
19 Adrian Henri, 'Me', *The Mersey Sound,* (Penguin Modern Poets 10), Penguin Books, Harmondsworth, 1967, pp. 27–8.
20 Adrian Henri 'Love Poem' (sections from 'a work in progress'), *ibid.,* pp. 39–40.
21 Adrian Henri, 'On the Late Late Massachers Stillbirths and Deformed Children a Smoother Lovelier Skin Job', *Ibid.,* pp. 22–3.
22 Adrian Henri, 'Haiku', *tonight at noon,* p. 49.
23 George Melly, *op. cit.,* p. 228.
24 Adrian Henri, 'The Blazing Hat, Part Two', *The Mersey Sound,* pp. 33–4.
25 Jeff Nuttalll *Bomb Culture* (Paladin Books, London, 1970), p. 127. (First published by MacGibbon & Kee, London, 1968).
26 *Ibid.,* pp 128–129.
27 *Ibid.,* p. 129.
28 *Ibid.,* p. 130.
29 Ed. Michael Horovitz, *Children of Albion: Poetry of the 'Underground' in Britain* (Penguin Books, Harmondsworth, 1969).
30 See especially *New Departures* (Double Double Number, 7/8 and 10/11): ed. Michael Horovitz (New Departures, 1975). (Fourfold Visionary Number).
31 Frank Kermode, 'Modernisms: Cyril Connolly and Others', *Encounter* XXVI, 3, (March 1966), pp. 53–8; 'Modernisms Again: Objects, Jokes and Art', *Encounter* XXVI, 4 (April 1966), pp. 65–74.
32 Frank Kermode, *ibid.,* p. 66.
33 Ian Hamilton Finlay, '2, FROM THE YARD OF THOMAS SUMMERS & CO. FRASERBURGH, SCOTLAND (FR. 64 & FR. 195)' (Wild Hawthorn Press, Dunsyre; 1968).
34 See Ian Hamilton Finlay and Dave Paterson, *Selected Ponds* (The West Coast Poetry Review, Nevada, 1975).
35 See Christopher Middleton, *Bolshevism in Art and Other Expository Writings* (Carcanet, Manchester, 1976).
36 Christopher Middleton, 'Holy Cow', *The Lonely Suppers of W V Balloon* (Carcanet New Press, Cheadle, 1975) p. 23.
37 *Ibid.,* p. 55.
38 *Ibid.,* p. 56.
39 Christopher Middleton, *Pataxanadu & Other Prose* (Carcanet New Press, Manchester, 1977) p. 55.

AFTERWORD

This book has attempted to trace the path of literature in Britain – poetry, in particular – and British literary criticism as it ran alongside or into the tracks of Dada-Surrealism. The focus has been British response, negative or positive, and, therefore, there has been no endeavour to assess fully the many products in Europe and elsewhere of post World War I extremist Modernism. For example, the achievements of individual French Surrealist poets have not been judged. The collected works of Paul Eluard, André Breton and Tristan Tzara, to name only three of the major figures of Surrealism, contain poems of undoubted imaginative power. Nor has there been any systematic endeavour to weigh the value of works in media other than literature which have been produced under the influence of Dadaism and Surrealism. Very few critics would dismiss as 'inferior' the films of Luis Buñuel or the Surrealist paintings of Picasso, for example.

That in practice Dadaism and Surrealism have had stimulating effects on the arts in Britain is shown in the evocative paintings and drawings of Paul Nash, Ceri Richards, Francis Bacon and Henry Moore; in the sculpture of Moore and McWilliam; in some of the films of Humphrey Jennings; and even in the popular and zany humour of such British television series as *Monty Python's Flying Circus*. That such effects have frequently been imaginative, lyrical and funny – as well as bizarre, malicious and violent – cannot be denied. British poetry too has sometimes made use of the creative possibilities inherent in even the most destructive movements of later Modernism.

As has been seen, the experimental works of Ian Hamilton Finlay, Edwin Morgan and Christopher Middleton reveal a balance of the creative over the merely anarchic and destructive which places them, for me, in the adventurous and confident tradition of early Modernism.

Close study of the relationship between British literature and late-Modernist extremism, in terms of anarchic ideas and attitudes, has shown the formation of a gulf between Britain and other Western countries. This gulf has been narrowing in recent years. The anarcho-nihilistic views which underpinned Dadaism and Surrealism have eaten insidiously into British culture during the past half-century. The destructive elements present in Modernism, particularly in literature, were resisted for several decades by a responsible if conservative (Right and Left) literary establishment here. Gradual loss in power and prestige of all 'establishments' has brought about an erosion of traditional defences against violent and negative extremisms in our society. Present social attitudes suggest that we are growing further away from responsible consensus in all spheres of our lives, including the arts.

There is, however, wrong-headedness and insular narrowness in the conservatism which has mustered during recent years to fight the encroaching anarchy. In poetry and the criticism of poetry, especially, there has been much post-*Scrutiny*-style priggishness and downright Philistine stupidity. Despite the number of contemporary European writers available to readers of English in excellent translations and despite the lip-service paid to the more famous American moderns, it is puzzling to find so little evidence of actual influence from such sources in contemporary British writing. There are honorable exceptions, of course; for instance, Charles Tomlinson, Thom Gunn, Peter Levi and the much neglected Basil Bunting exemplify the truth that British writing is capable of absorbing many of the qualities which make the best American and European writers so exciting to read. These qualities include, at the least, a seriousness about literary technique and about ideas in general. Two puzzles about British writing and criticism since the end of World War II are difficult to solve. First, why is there a separation of a British poet's apparently genuine enthusiasm for the technical and, therefore, expressive innovations of, say, T. S. Eliot, Ezra Pound and William Carlos Williams, from the same British poet's own poetry? Donald Davie's crusading zeal for Ezra Pound contrasted with Davie's own verse is an outstanding example of this strange phenomenon. The answer may lie partly in different levels of poetic talent, but this cannot account for the completely different poetic realms of Davie's sparse and tightly controlled medium and Pound's restlessly inventive and wide-ranging explorations into shaped meaning for which Davie has shown such perceptive enthusiasm. It would seem that poetry in Britain has lost some of its will and capacity to absorb into the existing literary medium what is admired in other languages.

The second puzzle is that genuine British modernity, wherever it has been achieved in poetry, has either been regarded as a curious dead-end or unfairly traduced as non-poetry. Again, the name of Basil Bunting comes to mind, but there are also David Jones and Dylan Thomas. The failure of British critics generally to appreciate the modernity and seriousness of the early poems and stories of Dylan Thomas, who most successfully combined traditional and Modernist elements in his quest for a solution to serious metaphysical questions, is simply astonishing. Any future revitalisation of British poetry, to be fully effective, will require more serious study of modern foreign literatures and a reconsideration of real achievements in literary Modernism here; it will require also a serious critical analysis of our positivistic empiricism which has been perhaps the greatest stumbling block to the lyrical imagination in all the arts in Britain during the twentieth century.

This book has been written in an effort to discover and understand British critical and creative response to Modernist extremisms in the period since World War I. As such, it has been a study of what some contemporary British critics[1] have assumed, incorrectly, to be a simple negative and insular reaction or series of reactions against all things new or foreign. The reaction, as we have seen, was neither insular nor negative. But what I have tried to argue in this brief afterword is that the positive response in the 1920s by our most intelligent critics and writers to European nihilist art – the revival in modernist terms of a British 'tradition-root' – was not a success either. Our tradition-root needs constant stimulation and enrichment from outside the tradition. As Wyndham Lewis argued, Dadaism and Surrealism betrayed Modernism because they widened the gap between Modernist art and its potential public. Their foundation on anarcho-modernist principles caused British literature to turn inward and away from any creative development of pre-1918 Modernism. The history of the fortunes of Dadaism and Surrealism in Britain is a mirror of the cultural forces at work in the western world since the end of World War I.

NOTE

1 See, particularly, Alfred Alvarez, 'The New Poetry', or Beyond the Gentility Principle', *The New Poetry*, Penguin Books, Harmondsworth, 1962, pp. 17–28.

PRIMARY SOURCES

Adam, L. *Primitive Art,* Penguin Books, Harmondsworth, 1940.
Aldington, Richard (translator) 'The Songs of Maldoror', I, by The Comte de
 Lautréamont (Isadore Ducasse), *The Egoist,* I, 19, 1 October 1914, pp.
 370–4; I, 20, 15 October 1914, p. 385; I, 21, 2 November 1914, pp. 409–10; I,
 22, 16 November 1914, pp. 423–4; II, 1, 1 January 1915, pp. 12–13. *Images
 of War,* Allen and Unwin, London, 1919. 'Letter to the Editor', *The
 Athenaeum,* 7 November 1919, p. 1163. 'Bodies', [poem] *The Anglo-French
 Review,* III, 2, March 1920, p. 137. 'French Periodicals', *The Criterion, I, 4,
 July 1923, pp. 421–2. Literary Studies and Reviews,* Allen and Unwin,
 London, 1924. *Life for Life's Sake,* Cassell, London, 1968.
Alvarez, Alfred *The New Poetry,* Penguin Books, Harmondsworth, 1962.
Anderson, Margaret *My Thirty Years' War,* Alfred A. Knopf, London, 1930.
 (editor), *The Little Review Anthology,* Hermitage House, New York, 1953.
Aragon, Louis [Report of Paris Congress Speech], *Left Review,* I, 11, August
 1935, p. 473. [Interviewed by Derek Kahn], 'French Writers and the
 People's Front', *Left Review,* II, 8, May 1936, pp. 378–80.
Arensberg, Walter Conrad 'Partie d'échecs entre Picabia et Roché', *391,* No. 7,
 New York, August 1917.
Arp, Hans *On My Way: Poetry and Essays 1912–47,* Wittenborn, Schultz, New
 York, 1948. *[Documents of Modern Art,* No. 6, edited by Robert Motherwell].
Auden, W. H., (J)ohn (B)ull, 'Honest Doubt', *New Verse, 21, June–July 1936,
 pp. 14–16.*

Ball, Hugo 'Fragments from a Dada Diary', Transition 25, Fall 1936, pp. 73–6.
Beaumont, Cyril W. *The Diaghilev Ballet in London: A Personal Record* [First
 edition (Putnam) 1940], third edition Adam and Charles Black, London,
 1951.
Belgion, Montgomery 'Meaning in Art', *The Criterion,* IX, 35, January 1930,

pp. 201–16. 'Books of the Quarter' (Review of *Music at Night)*, *The Criterion*, XI, 43, January 1932, p. 373.

Bigsby, C. W. E. *Dada and Surrealism*, Methuen, London, 1972.

Blunt, Anthony 'Rationalist and Anti-rationalist Art', *Left Review*, II, 10, July 1936, pp. iv-vi *(Surrealism Supplement)*

Bolliger, Hans *See* Verkauf, Willy, *Dada: Monograph of a Movement* (co-editor).

Bradbury, Malcolm 'A Review in Retrospect', *London Magazine*, October 1961; also as Introduction to reprint of *The Calendar of Modern Letters*, F. Cass, 1966, pp. vii-xix.

Breton, André (with Phillipe Soupault), *Les Champs Magnétiques*, Au Sans Pareil, Paris, 1920. 'Pour Dada', *La Nouvelle Revue Française*, XV, 1, August 1920, pp. 208–15. 'Surrealism, Yesterday, To-day and To-morrow'. Translated into English by E. W. Titus. *This Quarter*, V, 1. (Surrealist Number), Paris, September 1932, pp. 7–44. *What is Surrealism?* Translated by David Gascoyne, from *Qu'est-ce que le Surréalisme* (1934), Faber, London, 1936. [Criterion Miscellany No. 43]. *Anthologie de l'Humour Noir* (1937). Revised edition edited by Jean-Jacques Pauvert, Paris, 1966. *Manifestes du surréalisme* (1924–1929), Gallimard, Paris, 1969. *Selected Poems*. Translated by Kenneth White, Cape, London, 1969.

Bronowski, Jacob (editor) 'Cambridge Experiment: A Manifesto of Young England', *Transition 19–20*, June 1930, pp. 106–38.

Brooke, Rupert *The Letters of Rupert Brooke* (edited by Sir Geoffrey Keynes), Faber, London, 1968.

Browder, Clifford *André Breton: Arbiter of Surrealism*, Librarie Droz, Geneva, 1967.

Brunius, J. B., E. L. T. Mesens and Roland Penrose 'Letter to the Editor', *Horizon*, VIII, No. 46, October 1943 (recto of back cover).

Buffet-Picabia, Gabrielle 'Arthur Cravan and American Dada', *Transition* 27, Paris, Spring 1938, pp. 314–21. 'Some Memories of Pre-Dada: Picabia and Duchamp' (1949). Translated by Ralph Manheim in Robert Motherwell (editor) *The Dada Painters and Poets: An Anthology*, pp. 255–67.

Buñuel, Luis and Salvador Dali 'An Andalusian Dog (Scenario)', *This Quarter*, V, 1 ('Surrealist Number'), September 1932, pp. 149–57.

Camus, Albert *The Rebel*, Hamish Hamilton, London. 1953 (translated from the French *L'Homme Revolté* by Anthony Bower).

Caws, Mary Ann *The Poetry of Dada and Surrealism*, Princeton University Press. N. J. 1970.

Cheney, Sheldon 'Why Dada?', *The Century Magazine*, New York, May 1922, pp. 22–9.

Clearfield, Andrew 'Pound, Paris and Dada', *Paideuma*, VI, 2, Fall 1977, pp. 113–39.

Cocteau, Jean *Cock and Harlequin: Notes Concerning Music by Jean Cocteau*. Translated by Rollo H. Myers, The Egoist Press, London, 1921.

Coffey, Brian Reviews of A. Breton, *Position Politique du Surréalisme* and David Gascoyne, *A Short Survey of Surrealism*, *The Criterion*, XV, 60, April 1936, pp. 506–11.

Comfort, Alex and John Bayliss (editors) *New Road 1943*, Grey Walls Press, Essex, 1943.

Connolly, Cyril ('Palinurus') *The Unquiet Grave*, Hamish Hamilton, London, 1944.

Cooper, Douglas *Picasso Theatre*, Wiedenfeld and Nicholson, London, 1968.

Coutts-Smith, Kenneth *Dada*, Studio Vista, London, 1970.

Cravan, Arthur *See Maintenant* (editor).

Davie, Donald 'Ezra Pound Abandons the English' *Poetry Nation* 4, 1975, pp. 75–84.

Davies, Hugh Sykes 'Music in an Empty House', *Experiment*, I, 1, November 1928, pp. 31–2, (and in *Transition* 18, November 1929, pp. 39–40). 'The Primitive in Modern Art', *Experiment*, No. 3, May 1929, pp. 29–32. 'Localism', *Transition* 19–20, June 1930, pp. 114–6. 'Books of the Quarter', *The Criterion*, XI, 43, January 1932, pp. 344–6 (review of J. Middleton Murry's *Countries of the Mind*). 'American Periodicals' *The Criterion*, XI, 45, July 1932, pp. 772–5. 'Banditti: From the Biography of Petron', *The Criterion*, XIII, 53, July 1934, pp. 577–80. *Petron*, Dent, London, 1935. 'Sympathies with Surrealism', *New Verse*, No. 20, April–May 1936, pp. 15–21.

del Renzio, Toni *Incendiary Innocence* ('An Arson Pamphlet'), privately printed, London, 1944.

Dent, Edward J. 'The Cat and the Kettle', *The Athenaeum*, 4709, 30 July 1920, p. 153

Doesburg, Theo van ('I. K. Bonset') 'Towards a Constructive Poetry' *[Mécano, 4–5 White issue]*. Translated by Ita and Otto van Os, *Form*, 4 April 1967, pp. 31–2.

Duchamp, Marcel 'The Bride Stripped Bare by her Own Bachelors, Even'. Translated into English by J. Bronowski, *This Quarter*, V, 1, ('Surrealist Number'), September 1932, pp. 189–92. *The Essential Writings of Marcel Duchamp*. Edited by Michael Sanouillet and Elmer Peterson. Thames & Hudson, London, 1975.

Eliot, T. S. 'Reflections on *Vers libre*', *T. S. Eliot: Selected Prose*. Edited by John Hayward. Penguin Books, Harmondsworth, 1953, pp. 86–91. [From *New Statesman*, March 1917]. 'Tradition and the Individual Talent', *The Egoist*, VI, 4, September 1919, pp. 54–5, and VI, 5, October 1919, pp. 72–3. 'The Romantic Englishman, the Comic Spirit, and the Function of Criticism', *The Tyro*, No. 1, 1921, p. 4. 'Notes on Current Letters: The Lesson of Baudelaire', *The Tyro*, No. 1, 1921, p. 4. 'The Three Provincialities', *The Tyro*, No. 2, London, 1922, pp. 11–13. 'Books of the Quarter' (review of Sherard Vines' *Movements in Modern English Poetry and Prose*, O.U.P.), *The Criterion*, Volume VIII, No. 31, December 1928, p. 362. 'Books of the Quarter' (review of Louis Aragon's *La Chasse au Snark*), *The Criterion*, VIII, 33, July 1929, p. 765.

Eluard, Paul *Thorns of Thunder*, edited and with an introduction by George Reavey; Preface by Herbert Read; translations by Samuel Beckett, David Gascoyne, and others. Europa Press and Stanley Nott, London, 1936.

Fifoot, Richard *A Bibliography of Edith, Osbert and Sacheverell Sitwell*, (The Soho Bibliographies), Hart-Davis, London, 1963.

Flint, Frank Stewart *In the Net of the Stars*, Elkin Matthews, London, 1909. 'French Chronicle', *Poetry and Drama* I (1913), 1, pp. 76–84; 2, pp. 217–31; 3, pp. 357–62; 4, pp. 473–84. 'French Chronicle', *Poetry and Drama* II (1914), 5, pp. 97–106; 6, pp. 211–20; 7, pp. 302–4; 8, pp. 393–403. *Cadences*, Poetry Bookshop, London, 1915. 'French War Poets' (unsigned) *The Times Literary Supplement*. 2 October 1919, pp. 521- 2. 'Some French Poets of Today' *The Monthly Chapbook* (edited by H. Monro), I, 4, October 1919, pp. 1–40. '"Parade" at the Empire' (unsigned) *The Times* Newspaper (London) Saturday 15 November 1919, p. 10. 'The Dada Movement', [Review of Tristan Tzara *Vingt-Cinq Poèmes]* (unsigned), *The Times Literary Supplement*, 29 January 1920, p. 66. 'Letters to the Editor', *The Athenaeum*, 14 November 1919, p. 1200; *The Athenaeum*, 21 November 1919, p. 1237. 'Presentation: Notes on the Art of Writing; on the Artfulness of Some Writers; and on the artlessness of Others', *The Chapbook*, (edited by H. Monro), II, 9, March 1920, pp. 17–24. *Otherworld: Cadences*, Poetry Bookshop, London, 1920. 'The Younger French Poets', *The Chapbook* (edited by H. Monro), II, 17, November 1920, pp, 3–32. 'French Periodicals',

The Criterion, III, 9, October 1924, pp. 157–9. 'French Periodicals', *The Criterion,* III, 12, July 1925, pp. 601–2. (in 'Foreign Periodicals') 'French Periodicals', *The Criterion,* IV, 2, April 1926, pp. 404–10. Review of *Adieu, Beau Désordre,* by Denis de Rougemont, *The Criterion,* IV, 3, June 1926, pp. 624–5. 'Verse Chronicle', *The Criterion,* XI, 45, 1932, pp. 684–9.

Fluchère, Henri 'Surréalisme', *Scrutiny, I, 3, December 1932* (F. R. Leavis made slight alterations to this article).

Ford, Ford Madox 'Starting a Review', in 'Selected Memories', The Bodley Head Ford Madox Ford, Volume I, London, 1962, pp. 309–18.

Fowlie, Wallace *Climate of Violence: The French Literary Tradition from Baudelaire to the Present,* Secker & Warburg, London, 1969.

Fraser, George Sutherland 'Apocalypse in Poetry', *The White Horseman,* Routledge, London, 1941, pp. 3–31. *Ezra Pound,* Oliver and Boyd, Edinburgh and London, 1960.

von Freytag-Loringhoven, Baroness Else 'Klink-Hratzvenga', *The Little Review,* VI, 10, March 1920, pp. 11–12.

Galantière, Lewis 'Recent French Books', *This Quarter,* I, 1, Paris, 1925, p. 202.

Gascoyne, David 'Premier manifeste anglais du surréalisme', *Cahiers d'Art,* X, 1935, p. 106. *A Short Survey of Surrealism,* Cobden-Sanderson, London, 1935, New Impression, Frank Cass and Co. Ltd., London, 1970. *Man's Life is This Meat,* Parton Press, London, 1936.

Gershman, Herbert S. 'Futurism and the Origins of Surrealism', *Italica,* XXXIX, 2, June 1962, pp. 114–23.

Giacometti, Alberto 'Poem in Seven Spaces'. Translated by David Gascoyne, *New Verse,* 6, December 1933, p. 8.

Goldring, Douglas 'English Literature and the Revolution', *Coterie* 3, December 1919, pp. 69–73.

Grant, Joy *Harold Monro and the Poetry Bookshop,* Routledge and Kegan Paul, London, 1967.

Graves, Robert *Poetic Unreason,* Cecil Palmer, London, 1925. *Contemporary Techniques of Poetry, A Political Analogy (The Hogarth Essays, No VIII),* Hogarth Press, London, 1925. *Goodbye to All That,* Cape, London, 1929, revised edition, Cassell, London, 1957.

Gray, Cecil 'Notes and Reviews', *The Calendar of Modern Letters,* II, 12, February 1926, (unsigned review of *This Quarter,* No. 2), pp. 433–4.

Grigson, Geoffrey 'The Danger of Taste', *New Verse,* No. 4, July 1933, pp, 1–2. 'Books Lately Published', (unsigned), *New Verse,* 23, Christmas 1936, p. 26.

Gross, John *The Rise and Fall of the Man of Letters: English Literary Life since 1800,* Weidenfeld and Nicolson, London, 1969; Penguin Books, 1973.

Hahn, Otto *André Masson,* Thames and Hudson, London, 1965 (Translated from the French by Robert Erich Wolf).

Harding, James *The Ox on the Roof: Scenes from Musical Life in Paris in the Twenties,* Macdonald, London, 1972.

Harvey, J. Brian 'Four Poets', *Left Review,* II, 10, July 1936, pp. 530–1.

Hastings (Lord) 'The Surrealists' (Review of *A Short Survey of Surrealism* by David Gascoyne), *Left Review,* II, 4, January 1936, pp. 186–7.

Hendry, J. F. (editor), *The New Apocalypse,* The Fortune Press, London, 1940. 'Writers and Apocalypse', *The New Apocalypse,* The Fortune Press, London, 1940, pp. 9–15. And Henry Treece (editors), *The White Horseman,* Routledge, London, 1941. And Henry Treece (editors), *The Crown and the Sickle: An Anthology, King and Staples, London, 1945.*

Henri, Adrian *The Mersey Sound,* (Penguin Modern Poets 10), Penguin Books, Harmondsworth, 1967. *tonight at noon,* Rapp and Whiting, London, 1968, 'Notes on Painting and poetry', *tonight at noon,* Rapp and Whiting, London, 1968, pp. 63–81.

Heppenstall, Rayner, 'Books of the Quarter: (Review of Hugh Sykes Davies's *Petron*), *The Criterion*, XV, 59, January 1936, pp. 332–5.

Hesse, Herman 'Recent German Poetry', *The Criterion*, I, 1, October 1922, pp. 89–93.

Holms, J. F. 'Among New Books', *The Calendar of Modern Letters*, I, 4, June 1925, pp. 333–4.

Holroyd, Michael *Lytton Strachey: A Biography*, Penguin Books, Harmondsworth, 1971.

Howarth, Herbert *Notes on Some Figures Behind T. S. Eliot*, Chatto and Windus, London, 1965.

Huelsenbeck, Richard (with Marcel Janco and Tristan Tzara), 'L'amiral cherche une maison à louer', *Cabaret Voltaire*, Zürich, June 1916. *En Avant Dada: Eine Geschichte des Dadaismus* (1920). Translated by Ralph Manheim in Robert Motherwell (editor), *The Dada Painters and Poets: An Anthology*, pp. 23–47.

Huelsenbeck, Richard 'Dada Lives'. (Translated from the German by Eugene Jolas), *transition*, 25, Paris, Fall 1936, pp. 77–80. *Dada: Eine Literarische Dokumentation*, Rewohlt Verlag, Hamburg, 1964.

Hughes, Glenn *Imagism and Imagists*, Stanford University Press, California, 1931.

Hugnet, Georges '1870 to 1936', in (editor) Herbert Read, *Surrealism*, pp. 185–251. *L'aventure Dada, 1916–1922*, Galerie de L'Institut, Paris, 1957.

Hunt, Sidney 'Two poems', *transition* 2, May 1927, pp. 134–5. 'London Letter (London, September 1929)', *Blues* 7, Fall, 1929, pp. 39–40. 'July 5th 1929', *Blues* 8, Spring 1930, p. 25. 'Two Seen and one Dreamed', *transition* 19–20, June 1930, p. 217.

Hutt, S. A. 'Jolas' Julep', *Left Review*, I, 12, September 1935, p. 528.

Huxley, Aldous 'The Subject-Matter of Poetry', *The Chapbook* III, 9, March 1920, pp. 11–16. ('Autolycus'), 'Water Music', *The Athenaeum*, 4712, 20 August 1920 (Reprinted in *On the Margin* (1923), pp. 39–44). *On the Margin*, Chatto and Windus, London, 1923. *Point Counter Point*, Chatto and Windus, London, 1928. *Letters of Aldous Huxley* (edited by Grover Smith), Chatto and Windus, London, 1969.

Huxley, Julian (editor), *Aldous Huxley: A Memorial Volume*, Chatto and Windus, London, 1965.

International Surrealist Bulletin No. 4, A. Zwemmer on behalf of the International Surrealist Exhibition, London, 1936.

Jackson, T. A. 'Marxism: Pragmatism: Surrealism – a Comment for Herbert Read', *Left Review*, II, 11, August 1936, pp. 365–7.

Janco, Marcel (with Richard Huelsenbeck and Tristan Tzara), 'L'amiral cherche une maison à louer', *Cabaret Voltaire*, Zürich. June 1916.

Janco, Marcel See Verkauf, Willy *Dada: Monograph of a Movement* (co-editor).

Jeanneret, Albert *'Parade', 'Le Sacre du Printemps', 'L'Esprit Nouveau* 4, 1921, pp. 449–56.

Jennings, Humphrey and G. F. Noxon, 'Rock Painting and La Jeune Peinture', *Experiment* 7, Spring 1931, pp. 37–40. (Review of *Surrealism*, edited by H. Read), *Contemporary Poetry and Prose*, 7/8, December 1936, pp. 167–8. 'In Magritte's Paintings . . .' *London (Gallery) Bulletin* 1, April 1938, p. 15.

Jolas, Eugene and Elliot Paul, 'Suggestions for a New Magic', *transition* 3, June 1927, pp. 178–9. And Robert Sage, 'First Aid to the Enemy', *transition* 9, December 1927, pp. 160–76. 'Literature and the New Man', *transition* 19–20, June 1930, pp. 13–19. 'The Dream', *transition* 19–20, June 1930, pp. 46–7. 'What is the Revolution of Language', *transition* 22, February 1933, p. 125.

Kahn, Derek 'French Writers and the People's Front: Louis Aragon inter-

viewed, *Left Review* II, 8, May 1936, pp. 378–80.

Kermode, Frank 'Modernisms: Cyril Connolly and Others', *Encounter* XXVI, 3, March 1966, pp. 53–8. 'Modernisms Again: Objects, Jokes and Art', *Encounter* XXVI, 4, pp. 65–74.

Knox E. V. (of *Punch*), *Parodies Regained*, Methuen, London, 1921.

Kochno, Boris *Diaghilev and the Ballets Russes* (translated from the French by Adrienne Foulke), Allen Lane, The Penguin Press, 1971.

Lautréamont, Comte de (Isadore Ducasse), *The Lay of Maldoror* (translated by John Rodker), The Casanova Society, London, 1924.

Lawrence, D. H. *The Letters of D. H. Lawrence*. Edited by Aldous Huxley, Heinemann, London, 1932.

Leavis, F. R. *New Bearings in English Poetry*, Chatto and Windus, 1932, Penguin Books, 1963.

Lefranc, Jean 'Le Crise Dada' (in French), *Anglo-French Review*, III, 5, June 1920, pp. 443–6.

Lehmann, John *New Writing in Europe*, Penguin Books, London, 1940. *The Whispering Gallery, Autobiography I*, Longmans, Green, London, 1955. *A Nest of Tigers: Edith, Osbert and Sacheverell Sitwell in their times,* Macmillan, London, 1968.

Les livres Surréalistes ainsi que les publications surréalistes (Booksellers Catalogue), Libraire José Corti, Paris, 1931–32.

Lewis, Percy Wyndham 'What Art Now?' *The English Review*, April 1919, pp. 334–8. 'Essay on the Objective of Plastic Art in our Time', *The Tyro*, 2, 1922, pp. 21–37. *Blasting and Bombadiering*, Eyre and Spottiswoode, London, 1937.

Lidderdale, Jane and Mary Nicholson *Dear Miss Weaver: Harriet Shaw Weaver 1876–1961,* Faber, London, 1970.

Lindsay, Jack *Meetings with Poets*, Frederick Muller, London, 1968.

Lloyd, A. L. 'Surrealism and Revolutions', *Left Review* II, 16, January 1937, pp. 895–8.

Lucie-Smith, Edward *Movements in the Arts Since 1945*, Thames and Hudson, London, 1969. 'The Other Poets of the First World War', *The Critical Survey* IV, 2, Summer 1969, pp. 101–6. (Editor), *Experimental Poetry I 1870–1922,* Rapp and Whiting, London, 1971.

Madge, Charles 'Surrealism for the English', *New Verse* 6, December 1933, pp. 14–18. Review of *Petite Anthologie Poétique du Surréalisme* ('The Meaning of Surrealism'), *New Verse*, 10, August 1934, pp. 13–15. Review of David Gascoyne, *A Short Survey of Surrealism, New Verse*, 18, December 1935, pp. 20–1.

Marinetti, Filippo Tomasso 'Wireless Imagination and Words at Liberty' (translated by Arundel del Re), *Poetry and Drama* I, September 1913, pp. 319–26.

Maritain, Jacques 'Poetry and Religion' (translated by F. S. Flint), *The Criterion* V, 1, January 1927, pp. 7–22 and V, 2, May 1927, pp. 214–30.

Martin, Marianne W. *Futurist Art and Theory 1909–1915*, Clarendon Press, Oxford, 1968.

Matthews, J. H. 'Surrealism and England', *Comparative Literature Studies*, I, 1, University of Maryland, 1964, pp. 55–72. *An Introduction to Surrealism*, Pennsylvania State University Press, 1965.

Melly, George *Revolt into Style: The Pop Arts in Britain*, Penguin Books, Harmondsworth, 1972.

Middleton, Christopher *The Lonely Suppers of W. V. Balloon*, Carcanet, Manchester, 1975 , *Pataxanadu and Other Prose*, Carcanet, Manchester, 1977.

Monro, Harold 'Futurism and Ourselves' ('Varia'), *Poetry and Drama*, I, 4, December 1913, p. 390.

Monro, Alida ('Recorder') 'A Bibliography of Modern Poetry', *The Chapbook*, II, 12, June 1920 pp. 3–47.

Moore, G. H. 'The New Apocalypse: One Aspect of Romanticism', unpublished dissertation, Emmanuel College, Cambridge, March 1946.

Moore, Nicholas 'Poem', *Seven*, No. 3, Winter, 1938, p. 26.

Motherwell, Robert (editor) *The Dada Painters and Poets: An Anthology*, Wittenborn, Schultz, New York, 1951. Second printing, 1967. [*Documents of Modern Art*, No. 8]

Muir, Edwin 'The Zeit Geist', *The Calendar of Modern Letters*, II, 8, October 1925, pp. 112–18.

'The Present State of Poetry', *The Calendar of Modern Letters*, II, 11, January 1926, pp. 322–31.

Murry, John Middleton 'On Fear: And On Romanticism', *The Adelphi*, I, 4, September 1923.

Myers, John Bernard 'The Impact of Surrealism on the New York School', *Evergreen Review*, IV, 12, March-April 1960, pp. 75–85.

Myers, Rollo H. 'Letter to the Editor', *The Athenaeum*, No. 4711, 13 August 1920, p. 221. *Modern Music: Its Aims and Tendencies*, Kegan Paul, London, 1923.

Norman, Charles *Ezra Pound*, Funk and Wagnalls, New York, 1960, revised edition, 1969.

Nougé, Paul 'Final Advice' (to Humphrey Jennings), *London (gallery) Bulletin* 1, April 1938, pp. 5–6.

Nuttall, Jeff *Bomb Culture*, Paladin, 1970 (first published by MacGibbon and Kee, London, 1968).

O'Connor, Philip 'Blue Bugs in Liquid Silk', *New Verse* 25, May 1937, p. 12. *Memoirs of a Public Baby*, British Book Center, New York, 1958.

Paul Elliot 'The New Nihilism', *transition* 2, May 1927, pp. 164–8.

Perét, Benjamin *A Bunch of Carrots*. Selected and translated by David Gascoyne and Humphrey Jennings. Parton Press, London, 1936. *Remove Your Hat*. Selected and translated by David Gascoyne and Humphrey Jennings. Parton Press, London, 1936.

Pound, Ezra 'Elizabethan Classicists', *The Egoist*, IV, 8, September 1917, V, 1, January 1918. 'The Island of Paris: A Letter', *The Dial*, LXIX, October 1920, pp. 406–8. 'Paris Letter', *The Dial*, LXXI, October 1921, pp. 456–63. 'Epstein, Belgion and Meaning', *The Criterion*, IX, 36, April 1930, pp. 470–5. *The Letters of Ezra Pound (1907–1941)*. Edited by D. D. Paige. Faber, London, 1951. *Literary Essays of Ezra Pound*. Edited with an introduction by T. S. Eliot. Faber, London, 1954. *Pound/Joyce: The Letters of Ezra Pound to James Joyce*. Edited by Forrest Read. Faber, London, 1968. *Selected Poems*, Faber, London, 1969.

Quennell, Peter 'Surrealism and Revolution', *New Statesman and Nation*, VI, 131, (new series), 26 August 1933, pp. 237–8. 'Books of the Quarter' (review of Tzara, *De nos oiseaux*), *The Criterion*, IX, 35, January 1930, pp. 359–61. 'Books of the Quarter', *The Criterion*, XIII, 53, July 1934, pp. 696–9.

Ray, Man, John Levee and others ' "Then and Now": The Expatriate Tradition', *The Paris Review* 33, winter–spring 1965, pp. 158–70.

Ray, Paul C. *The Surrealist Movement in England*, Cornell University Press. N.Y., 1971.

Read, Herbert 'American Periodicals', *The Criterion*, III, 9, October 1924, pp. 151–4.

'Psychoanalysis and the Critic', *The Criterion*, III, 10, January 1925, pp. 214–30. 'American Periodicals' (in 'Foreign Reviews'), *The Criterion*, IV, 4, October 1926 (on *The Little Review*), p. 793. (Editor) *Surrealism*, Faber, London, 1936; reissued 1971. 'Surrealism – the Dialectic of Art', *Left*

Review, II, 10, July 1936, pp. ii–iii (Surrealism Supplement). And Hugh Sykes Davies 'Surrealism – Reply to A. L. Lloyd', *Left Review*, III, 1, February 1937, pp. 47–8. 'Foreword', Albert Camus, *The Rebel*. Translated by Anthony Bower. Hamish Hamilton, London, 1953, pp. 7–10. *A Concise History of Modern Painting*, Thames and Hudson, London, 1959. *Arp*, Thames and Hudson, London, 1968.' The Limits of Permisiveness', in Peter Abbs (editor), *The Black Rainbow*, Heinemann, London, 1975, pp. 4–18.

Reavey, George 'Notes on Phonic Poetry', *Experiment* 6, October 1930, pp. 16–17.

Ribemont-Dessaignes, Georges 'History of Dada', *The Dada Painters and Poets: An Anthology*, Wittenborn, Schultz Incorporated, New York, 1951, pp. 99–122.

Richter, Hans *Dada, Art and Anti-Art*, Thames and Hudson, London, 1965. (Translated from the German by David Britt).

Rickword, Edgell *Rimbaud, the Boy and the Poet*, Heinemann, London, 1924. 'Among New Books', *The Calendar of Modern Letters*, I, 4, June 1925, p. 336 (unsigned review of Breton's *Manifeste du Surréalisme* and *Poisson soluble*). 'Notes for a Study of Sade', *The Calendar of Modern Letters*, II, 12, February 1926, pp. 421–31. 'Notes and Reviews', *The Calendar of Modern Letters*, II, 12, February 1926 (unsigned review of *The New Criterion*), pp. 432–3. 'The Lautréamont Affair', in 'Notes and Views', *The Calendar of Modern Letters*, III, 2, 1926, pp. 154–6 (unsigned review of *Le Disque Vert*).

Rivière, Jacques 'Reconnaissance à Dada', *La Nouvelle Revue Française, XV, 1*, August 1920, pp. 216–37. 'Notes on a Possible Generalisation of the Theories of Freud', translated by F. S. Flint, *The Criterion*, I, 4, July 1923, pp. 329–47.

Roberts, Michael (editor), *New Signatures*, Hogarth Press, London, 1932. Third (revised) edition, 1934. [Hogarth Living Poets, No. 24]. Review of Herbert Read (editor), *Surrealism*. 'Books of the Quarter', *The Criterion*, XVI, 64, April 1937, pp. 551–3.

Rodker, John ' "Dada" and Else von Freytag von Loringhoven', *The Little Review*, VII, 2, July-August 1920, pp. 33–6. 'La littérature Anglaise d'Aujourd'hui', *L'Esprit Nouveau* 4, 1921, pp. 476–7.

Ross, Robert H. *The Georgian Revolt, Rise and Fall of a Poetic Ideal 1910–1922*, Faber, London, 1967.

Sanouillet, Michel *DADA 1915–1923*, Methuen, London, 1969: *(Dada à Paris*, Pauvert, Paris, 1965).

Sartre, Jean Paul 'Self-Deception', Walter Kaufmann (editor), *Existentialism from Dostoevsky to Sartre*, Meridian Books, New York, 1956, pp. 241–70.

Scarfe, Francis *Auden and After: The Liberation of Poetry, 1930–41,* Routledge, London, 1942.

Schimanski, Stefan and Henry Treece (editors), *A New Romantic Anthology*, Grey Walls Press, London, 1949.

Schinz, Alfred 'Dadaism', *The Bookman*, LV, 2, New York, April 1922, pp. 103–5.

Seymour-Smith, Martin *Bluff Your Way in Literature*, Wolfe, London, 1966.

Shattuck, Roger *The Banquet Years, The Origins of the Avant-Garde in France: 1885 to World War I*, Cape, London, revised edition, 1969.

Shaw, Walter Hanks 'Cinema and Ballet in Paris', *The Criterion*, IV, 1, January 1926, pp. 178–84. 'The Contemporary French Theatre: A Short Survey' in *The Criterion*, VI, 3, September 1927, pp. 250–7.

Sinclair, May 'The Poems of F. S. Flint', *The English Review*, January 1921.

Sitwell, Edith *Clowns' Houses*, Blackwell, Oxford, 1918. 'The Lady with the Sewing Machine', *Art and Letters*, II, 1, 1919, p. 8. *Children's Tales (from the Russian Ballet)*, Leonard Parsons Ltd, London, 1920, Duckworth (reissue), London, 1928. Review of *Georgian Poetry, 1918–1919, Art and*

Letters, III, 1, winter 1920, p. 49. *The Wooden Pegasus*, Blackwell, Oxford, 1920. *See* Rimbaud, Arthur *Les Illuminations*. Put into English by Helen Rootham, Faber, London, 1932. Introductory essay by Edith Sitwell. *Collected Poems*, Macmillan, London, 1957. *Taken Care Of: An Autobiography*, Hutchinson, London, 1965. And William Walton *Façade: An Entertainment*, Oxford University Press, 1972. Introduction ('Façade') by Sacheverell Sitwell.

Sitwell, Osbert 'Te Deum' and 'Church Parade', *Art and Letters*, II, 1, winter 1918–19, pp. 1–3. *Who Killed Cock Robin?*, C. W. Daniel, London, 1921. With Edith and Sacheverell *Trio: Dissertations on Some Aspects of National Genius*, Macmillan, London, 1938. *Great Morning*, Macmillan, London, 1948. *Laughter in the Next Room*, Macmillan, London, 1949.

Sitwell, Sacheverell 'London Letter' ('England – Our London Letter Door') *De Stijl* 4–5, June 1921, pp. 75–80.

Smith, Grover (editor), *Letters of Aldous Huxley*, Chatto and Windus, London, 1969.

Smith, Janet Adam 'Books of the Quarter', *The Criterion*, XV, 61, July 1936, pp. 730–4.

Soupault, Philippe (with André Breton), *Les Champs Magnétiques*, Au Sans Pareil, Paris, 1920.

Squire, J. C. 'Editorial Notes', *The London Mercury*, I, 4, February 1920, pp. 385–8. 'New and Recent Periodicals', *The London Mercury*, III, 16, February 1921, p. 359.

Stead, C. K. *The New Poetic: Yeats to Eliot*, Hutchinson, London, 1964.

Steegmuller, Francis *Apollinaire: Poet Among the Painters*, Hart-Davis, London, 1963. *Cocteau: A Biography*, Macmillan, London, 1970.

'Surrealists get the Bird', *New Verse* 19, February-March 1936, pp. 20–1.

Tashjian, Dickran *Skyscraper primitives: Dada and the American avant-garde, 1910–1925*, Wesleyan University Press, Middletown, Connecticut, 1975.

Thibaudet, Albert 'A Letter from France: The Young Reviews', *London Mercury*, I, 5, March 1920, pp. 622–4.

The Times Literary Supplement 'New Foreign Books'. (*Les Animaux et leurs hommes* by Eluard), (unsigned), 22 April 1920, p. 255.

The Times Literary Supplement review of Isadore Ducasse (unsigned), 16 June 1921, p. 389.

The Times Literary Supplement review of *Louis Aragon, Anicet*, unsigned but probably by Salvador de Madariaga, 28 July 1921, p. 478.

The Times Literary Supplement Review of Jarry (unsigned), 2 February 1922, p. 74.

Titterton, W. R. 'The Madness of the Arts', *The English Review*, December 1920 (Part I), pp. 481–6. January 1921 (Part II), pp. 1–5. *The Madness of the Arts*, Erskine, Macdonald, London, 1921.

Titus, Edward W. 'Editorially', *This Quarter*, V, 1, ('Surrealist Number'), Paris, September 1923, p. 6.

Tomkins, Calvin *The World of Marcel Duchamp*, Times Incorporated, New York, 1966.

Treece, Henry 'An Apocalyptic Writer and the Surrealists', *The New Apocalypse*, Fortune Press, London, 1940, pp. 49–58. And J. F. Hendry (editors), *The Crown and the Sickle: An Anthology,* King and Staples, London, 1946. *How I See Apocalypse*, Lindsay Drummond, London, 1946.

Trevelyan, Julian 'Dreams', *transition* 19–20, June 1930, pp. 120–3.

Tyler, Parker 'Sonnet', *Blues,* I, 2, March 1929, pp. 50–1.

Tzara, Tristan (with Richard Huelsenbeck and Marcel Janco), 'L'amiral Cherche une Maison à Louer', *Cabaret Voltaire*, Zürich, June 1916.

Tzara, Tristan *La Première Aventure Céleste de M. Antipyrine*, Collection Dada, Zürich, 1916. *Vingt-cinq Poèmes*, Collection Dada, Zürich, 1916.

'Zürich Chronicle'. Translated by Ralph Manheim in (editor) Robert Motherwell, *The Dada Painters and Poets: An Anthology*, pp. 235–42. Also in Hans Richter, *Dada: art and anti-art*, pp. 223–8. *Morceaux Choisis*, Bordas, Paris, 1947. *Tristan Tzara: Sept manifestes Dada* [Quelques dessins de Picabia], Jean-Jacques Pauvert, Paris, 1963.

Vaché, Jacques *Lettres de Guerre* (Préface d'André Breton), Au Sans Pareil, Paris, 1919. Letter to André Breton, (dated 18.8.17), *Anthologie de l'Humour Noir*, Pauvert, Paris, 1966, pp. 380–1.

Verkauf, Willy (editor) *Dada: Monograph of a Movement*, Alec Tiranti, London, 1957 (Co-editors, Marcel Janco and Hans Bolliger).

Waldberg, Patrick *Surrealism*, Thames and Hudson, London, 1965. *(Le Surréalisme*, Skira. Geneva, 1962).

Wees, William C. *Vorticism and the English Avant-Garde*, Manchester University Press, 1972. (University of Toronto Press, Canada, 1972).

West, Alick 'Surréalisme in Literature', *Left Review*, II, 10, July 1936, pp. vi-viii. (Surrealism Supplement).

Wilson, Edmund 'The Aesthetic Upheaval in France: The Influence of Jazz in Paris and Americanization of French Literature and Art'. *Vanity Fair, New York, February 1922*.

Woolf, Leonard *Downhill All The Way: An autobiography of the years 1919 to 1939*, The Hogarth Press, London, 1967.

Wilson, Edmund *Axel's Castle: A Study in the Imaginative Literature of 1870–1930*, Scribner's, New York, 1931.

PRIMARY SOURCES — PERIODICALS

The Adelphi Editor J. Middleton Murry. Vol. I, No. 1, June 1923 – Vol. IV, No. 11. May 1927.

The New Adelphi Editor J. Middleton Murry. Vol. I, No. 1 (1927) – Vol. III, No. 4, June 1930.

THE ADELPHI (New Series) Editors Max Plowman and Richard Rees. Vol. I, No. 1, October 1930 – Vol. XXXI, No. 4, September 1955.

The Anglo-French Review Editors Henry D. Davray and J. Lewis May. Dent, London, February 1919–July 1920.

Arson: An Ardent Review Editor Toni del Renzio. One issue, London, March 1942.

Art and Letters Editors Charles Ginner, Harold Gilman, Frank Rutter and Osbert Sitwell. Vol. I, No. 1–Vol. III, No. 2. London, July 1917–Spring 1920.

The Athenaeum Editor J. Middleton Murry. London, 1919–1921.

Blast Editor P. Wyndham Lewis, Nos. 1–2, London, June 1914–July 1915.

The Blind Man Editors Marcel Duchamp, Henri-Pierre Roché and Beatrice Wood. Two Issues: No. 1, 10 April 1917; No. 2, May 1917.

Blues Editors Charles Henri Ford, Kathleen Tankersley Young and Parker Tyler. Nos. 1–9, USA, 1929–1930.

Cabaret Voltaire Editor Hugo Ball. One issue, Zürich, June 1916.

The Calendar of Modern Letters Editors Edgell Rickword and Douglas Garman. Vol. I, No. 1–Vol. IV, No. 2, London, March 1925–July 1927.

Le Cannibale Editor Francis Picabia. 1–2, Paris, 25 April and 25 May 1920.

The Chapbook Editor Harold Monro. Nos. 1–40, London. July 1919–1925.

Contemporary Poetry and Prose Editor Roger Roughton. 1–10, London, May 1936–Autumn 1937.

Coterie Editor Chaman Lall (later Russell Green). Nos. 1–7, May Day 1919–winter 1920–21.

The Criterion Editor T. S. Eliot, London, 1922–1939. Collected Edition, Faber, London, 1967.

DADA Editor Tristan Tzara. Nos. 1–4/5, Zürich, 1917–1919; No. 6 *(Bulletin Dada)* Paris, February 1920; No. 7 *(Dadaphone)* Paris, March 1920.
Der Dada Editors Raoul Hausmann, George Grosz and John Heartfield. Nos. 1–3, Berlin, 1918–1919.
De Stijl Editor Theo van Doesburg. Nos. 1–89 (75 issues), Holland, 1917–1928.

The Egoist: an individualist review. Editors Harriet Shaw Weaver and others, Vols. I–VI, 5. London, 1914–1919.
The Enemy Editor Wyndham Lewis. Nos. 1–3, London, 1927–1929.
The English Review 1908–1937, editor Ford Madox Hueffer (1908–1910) (later Austin Harrison), (Vol. I, No. 1, December 1908).
L'Esprit Nouveau Editors Paul Dermee and others. Nos. 1–28, Paris, 1920–25. Reprinted by Da Capo Press, New York, 1968.
Experiment Editors W. Empson, J. Bronowski and others. Nos. 1–7, Cambridge, November 1928–spring 1931.

Form Editors Philip Steadman, Mike Weaver (USA), Stephen Bann, Nos. 1–10, Cambridge, 1966–1969.

Left Review Editors Montagu Slater, Amabel Williams-Ellis, T. H. Wintringham, Edgell Rickword and Randall Swingler. Vol. I, No. 1'-Vol. III, No. 16, London, October 1934–May 1938.
Life and Letters Editor Desmond MacCarthy (later Hamish Miles). Vol. I, No. 1–Vol. XII, No. 64, London, June 1928–April 1935.
Life and Letters Today Editors Robert Herring and Petrie Townshend. Vol. XIII, No. 1–Vol. LXIV, No. 151, London, September 1935–March 1950.
Littérature Editors Louis Aragon, André Breton, Philippe Soupault. 1–20 (first series) March 1919–August 1921; 1–13 (new series) March 1922–June 1924.
The Little Review Editors Margaret Anderson, Jane Heap (jh), Ezra Pound, John Rodker, Francis Picabia and others. New York, 1914–1929.
The London Bulletin Editors E.L.T. Mesens, Roland Penrose and others. No. 1–No. 18/20, London, April 1938–June 1940.
The London Mercury Editor J. C. Squire (later R. A. Scott-James), Vol. I, No. 1–Vol. XXXIX, No. 234, London, November 1919–April 1939.

Maintenant Editor Arthur Cravan. Five issues, Paris, 1912–15.
Mécano Edited Theo van Doesburg, 1–4, Leiden, 1922–23.
Minotaure: Revue Artistique et Littéraire Editors Albert Skira and E. Teriade. Paris, May 1933–1939 (Arno series of contemporary art, I, 4 volumes, USA, 1968).
New Verse Editor G. Grigson. Nos. 1–32 and New Series–Vol. I, No. 2, London, January 1933–39.
New Writing Editor John Lehmann. Nos. 1–5, London, spring 1936–spring 1938.

Programme Editors Kenneth Allott and Alan Hodge. Oxford, 1935–36.
Proverbe Editor Paul Eluard. Nos. 1–6, Paris, 1920–21.

Ray Editor Sidney Hunt. Nos. 1–2, London, 1927.
Rongwrong Editors Marcel Duchamp, Henri-Pierre Roché and Beatrice Wood. One issue, New York, May 1917.

Scrutiny Editors L. C. Knights, F. R. Leavis, and others. Vol. 1–19, Cambridge, 1932–1953. Reissue (20 volumes), Cambridge University Press, 1963.

This Quarter Editors J Walsh and Ethel Moorhead (later Edward Titus). Paris, Monaco and elsewhere, 1925–32.
391 Editor F. Picabia. Nos. 1–4, Barcelona, January–March 1917; Nos. 5–7, New York, 1917; No. 8, Zürich, 1919; Nos. 9–19, Paris. 1919–1924.
Translantic Review Editor Ford Madox Ford. Vols. I and II, Paris, January 1924–January 1925.

transition Editors Eugene Jolas and Elliot Paul. Nos, 1–27, Paris, April 1927–April/May 1938.
291 Editor Alfred Stieglitz. Nos. 1–12, New York, 1915–16.
The Tyro Editor P. Wyndham Lewis. Nos. 1–2, London, 1921–22.

Wheels Editor Edith Sitwell. Six issues. London, 1916–22.

Z Editor Paul Dermée. One issue, Paris, March 1920.
Der Zeltweg Editors Flake, Serner and Tzara. One issue, Zürich, October 1919.

SELECTED SECONDARY MATERIAL

Ades, Dawn *Dada and Surrealism Reviewed*, with an introduction by David Sylvester and a supplementary essay by Elizabeth Cowling, Arts Council of Great Britain, London, 1978.
Aldington, Richard *French Studies and Reviews*, Allen and Unwin, London, 1926.
Alexandrian, Sarane *Surrealist Art*. Translated by G. Clough, *(L'Art Surréaliste*, Fernand Hazan, Paris, 1969). Thames and Hudson, London, 1970.
Alquié, Ferdinand *Philosophie du Surréalisme* Flammarion, Paris, 1955.
Apollinaire, Guillaume *Calligrammes: Poèmes de la Paix et de la Guerre (1913–1916)* Editions Gallimard, Paris, 1966.

Balakian, Anna *Literary Origins of Surrealism*, new edition, University of London Press, London, 1967 (King's Crown Press, New York, 1947). *André Breton: Magus of Surrealism*, Oxford University Press, New York, 1971. *Surrealism: The Road to the Absolute*, revised edition, Unwin Books, London, 1972 (Noonday Press, New York, 1959).
Ball, Hugo *Die Flucht aus der Zeit*, Von Duncker and Humblot, Munich and Leipzig, 1927.
Bann, Stephen Editor, *Concrete Poetry: An International Anthology*, London Magazine Editions, London, 1967.
Barr, Alfred H. Editor, *Fantastic Art, Dada, Surrealism*, Museum of Modern Art, New York, 1947.
Blunt, Anthony 'Post-Cubism'. *The Spectator*, CL, 5, 470, 28 April 1933, pp. 603–4.
Breton, André *Le Manifeste du Surréalisme*, KRA, Paris, 1924 (with *Poisson Soluble)*. *Légitime Defense*, Editions Surréalistes, Paris, 1926. *Le Surréalisme et la Peinture*, Gallimard, Paris, 1928. *Nadja* (1928), revised edition, Gallimard, Paris, 1964. *Les Vases Communicants*, Editions Cahiers Libres, Paris, 1932.

Carroll, Lewis *La Chasse au Snark*, [traduit par L, Aragon], Chapelle-Réanville, Paris, 1929.
Caws, Mary Ann *Surrealism and the Literary Imagination* (A study of Breton and Bachelard). Mouton & Co., The Hague/Paris, 1966.
Cinquant' Anni a Dada: Dada in Italia, 1916–1966, Galleria Schwarz, Milan, 1966.
Cocteau, Jean *Le Cap de Bon Espérance: Poème*, Editions de la Sirène, Paris, 1919.
Connolly, Cyril *The Modern Movement*, Deutsch and Hamilton, London, 1965.
Crosland, Margaret *Jean Cocteau*, Peter Nevill Ltd, London, 1955.

Daiches, David *The Present Age After 1920*, Cresset Press, London, 1958.
Davie, Donald *Articulate Energy: An Inquiry into the Syntax of English Poetry*, Routledge, London, 1955.

Eliot, T. S. 'Marivaux', Art and Letters, II, 2, spring 1919, pp. 80–5.
Ernst, Max *Beyond painting and other writings by the artist and his friends*, Wittenborn, Schultz, New York, 1948. (Documents of Modern Art, No. 7,

editor R. Motherwell).

Esslin, Martin *The Theatre of the Absurd*, revised edition, Pelican Books, 1968.

Evans, B. Ifor, *English Literature Between the Wars*, Methuen, London, 1948.

Finlay, Ian Hamilton and Dave Paterson, *Selected Ponds*, The West Coast Poetry Review, Nevada, 1975.

Fowlie, Wallace *Age of Surrealism*, new edition, Indiana University Press, 1960.

Fraser, G. S. *The Modern Writer and His World,* Derek Verschoyle, London, 1953; Penguin edition, 1964.

G. Editor Hans Richter and others. Nos. 1–5/6, Germany, 1923–1926.

Gershman, Herbert S. *The Surrealist Revolution in France* with *A Bibliography of the Surrealist Revolution in France,* University of Michigan Press, Ann Arbor, Michigan, 1969.

Goldring, Douglas *Odd Man Out*, Chapman and Hall, London, 1935. *The Nineteen Twenties*, Nicholson and Watson, London, 1945.

Graves, Robert *On English Poetry*, Heinemann, London, 1922. *The Meaning of Dreams*, Cecil Palmer, London, 1924. *The Crowning Privilege*, Cassell, London, 1955.

Grigson, Geoffrey *The Crest on the Silver: An Autobiography*, Cresset Press, London, 1950. 'A Man of the Thirties', *Poems and Poets*, Macmillan, London, 1969.

Haftmann, Werner *Painting in the Twentieth Century*, Lund Humphries, London, 1961, new edition, 1965.

Hays, H. R. 'Surrealist Influence on Contemporary English and American Poetry', *Poetry*, Chicago, July 1939, pp. 202–9.

Horovitz, Michael (editor), *Children of Albion: Poetry of the 'Underground' in Britain*, Penguin Books, Harmondsworth, 1969. (editor), *New Departures* (Double Double Number, 7/8 and 10/11: Fourfold Visionary Number), New Departures, 1975.

Huelsenbeck, Richard, *Phantastische Gebete*, Collection Dada, Zürich, 1916. *Schlaben Schalomai Schalamezomai*, Collection Dada, Zürich, 1916.

Jean, Marcel and Arpad Mezei, *The History of Surrealist Painting*. Translated Simon Watson-Taylor *(Histoire de la peinture surréaliste)*, Editions du Seuil, Paris, 1959, Weidenfeld and Nicholson, London, 1967.

Jennings, Humphrey *Humphrey Jennings 1907–1950: A Tribute*, Humphrey Jennings Memorial Fund Committee, London, 1960.

Karsavina, Tamara *Theatre Street*, Constable, London (first edition Heinemann Ltd, 1930). Revised and Enlarged Edition 1948.

La Nouvelle Revue Française Editor Justin O'Brien, Farrar, Straus and Cudahy, New York, 1958.

Lambert, Constant *Music Ho! A Study of Music in Decline*, Faber, London, 1934 (revised edition, 1937).

Lemaitre, Georges *From Cubism to Surrealism in French Literature*, Harvard University Press, Cambridge, Mass., 1947.

Levy, Julien *Surrealism*, The Black Sun Press, New York, 1936. (reprinted Arno/Worldwide, New York, 1968).

Lewis, Percy Wyndham *The Art of Being Ruled*, Chatto and Windus, London, 1926. *The Wild Body*, Chatto and Windus, London, 1927. *The Lion and the Fox: The Role of Hero in the Plays of Shakespeare*, Grant Richards, London, 1927. *Time and Western Man*, Chatto and Windus, London, 1927. *Rude Assignment*, Hutchinson, London, 1950. *Wyndham Lewis on Art*, (Collected Writings 1913–1956). Edited by Walter Michel and C. V. Fox, Thames and Hudson, London, 1969.

Lippard, Lucy R. (editor), *Surrealists on Art*, Prentice-Hall, New Jersey, 1970.

(editor), *Dadas on Art*, Prentice-Hall, New Jersey, 1971.

Matthews, J. H. (editor), *An Anthology of French Surrealist Poetry*, University of London Press, London, 1966.

Merz Editor Kurt Schwitters. Nos. 1–24, Hanover, 1923–1932.

Middleton, Christopher *Bolshevism in Art and Other Expository Writings*, Carcanet, Manchester, 1976.

Myers, Rollo *Modern French Music Its Evolution and Cultural Background from 1900 to the Present Day*, Blackwell, Oxford, 1971. [Blackwell's Music Series].

Nadeau, Maurice *The History of Surrealism (Histoire du Surréalisme*, Editions du Seuil, Paris, 1954), translated Richard Howard, Cape, London, 1968.

Pound, Ezra 'George Antheil', *The Criterion*, II, 7, April 1924, pp. 321–31.

Praz, Mario *The Romantic Agony*, translated from the Italian by Angus Davidson, Oxford University Press, 1933.

Raymond, Marcel *Du Baudelaire au Surréalisme*, R. A. Correa, Paris, 1933. Translated from the French and published as a University Paperback, with Bibliography by S. I. Lockerbie, Methuen, London, 1970.

Read, Herbert *Reason and Romanticism*, Faber and Gwyer, London, 1926. *Poetry and Anarchism*, Faber, London, 1938. *The Philosophy of Anarchism*, Freedom Press, London, 1940. *A Coat of Many Colours: Occasional Essays*, Routledge, London, 1945. *The Philosophy of Modern Art*, Faber, London, 1952. *Anarchy and Order: Essays in Politics*, Faber, London, 1954.

Richter, Hans *Dada, 1916–1966* (Documents of the international Dada movement), Goethe-Institut, Munich, 1966.

Rimbaud, Arthur *Les Illuminations*. Put into English By Helen Rootham, with an introductory essay by Edith Sitwell, Faber, London, 1932.

Rivière, Jacques *The Ideal Reader: Selected Essays by Jacques Rivière*, edited and translated by Blanche A. Price, Harvill Press, London, 1960.

Rubin, William S. *Dada, Surrealism and their Heritage*, Museum of Modern Art, New York, 1968 (W. H. Allen, London, 1968).

Skelton, Robin (Editor), *Herbert Read: A Memorial Symposium*, Methuen, London, 1970.

Starkie, Enid *From Gautier to Eliot: The Influence of France on English Literature, 1851–1938*, Hutchinson, London, 1960.

Stewart, Jean *Poetry in France and England*, The Hogarth Press, London, 1931 (Hogarth Lectures, No. 15).

Symons, Julian *The Thirties: A Dream Revolved*, The Cresset Press, London, 1960.

Treece, Henry (Editor), *Herbert Read: An Introduction to his Work by Various Hands*, Faber, London, 1944.

Vines, Sherard *Movements in Modern English Poetry and Prose*, Oxford University Press, Tokyo, 1927.

Vivante, Leone 'The Misleading Comparison between Art and Dreams', *The Criterion*, IV, 3, June 1926, pp. 436–53.

Williams, Emmett (Editor), *An Anthology of Concrete Poetry*, Something Else Press, New York, 1967.

Wolfe, Tom *The Painted Word, Farrar, Straus & Giroux, New York, 1975*.

I am indebted to the following individuals and publishers for permission to use copyright material, as shown:

From Richard Aldington, 'Bodies', *The Anglo-French Review* III, 2, March, 1920; *Life for Life's Sake*, Cassells, 1968; 'The Blood of the Young Men', *Images of War*, Cassells, 1919; 'The poet and his age', *Literary Studies and Reviews*, Allen and Unwin, 1924. Reprinted by permission of Allen & Unwin and the Literary Estate of Richard Aldington. From Sarane Alexandrian, *Surrealist Art* (translated by Gordon Clough), Thames & Hudson, 1970. Reprinted by permission of Thames & Hudson. From Margaret Anderson, *My Thirty Year's War*, Knopf, London, 1930. Reprinted by permission of Alfred A. Knopf Inc. From Louis Aragon, 'French Writers and the People's Front', *Left Review*, I, 11, Lawrence & Wishart, August 1935. Reprinted by permission of Lawrence & Wishart. From Hugo Ball, *Flucht aus der Zeit* in *The Dada Painters and Poets: An Anthology* (edited by Robert Motherwell, translated by Ralph Mannheim), Wittenborn, Schultz, New York, 1951. Reprinted by permission of Wittenborn Art Books Inc. From Cyril W. Beaumont, *The Diaghilev Ballet in London* (3rd edition), Black, 1951. Reprinted by permission of A. & C. Black. From André Breton, 'Pièce Fausse' (reproduced in *The Chapbook*, London, 1920); 'Les Champs Magnétiques', 1921 (in André Breton, *Selected Poems*, Cape, 1969). Reprinted by permission of the Estate of André Breton and Librairie Gallimard. From Rupert Brooke, *The Letters of Rupert Brooke*, edited by Sir Geoffrey Keynes, Faber, 1968. Reprinted by permission of Faber and Faber. From Gabrielle Buffet-Picabia, 'Some Memories of pre-Dada', in *The Dada Painters and Poets: An Anthology* (as above). From Andrew Clearfield, 'Pound, Paris, and Dada', *Paideuma* VI, 2, Fall 1977. Reprinted by permission of the editors of *Paideuma* and Andrew Clearfield. From Robert Conquest, 'Introduction', *New Lines*, Macmillan, 1956. Reprinted by permission of Robert Conquest. From Hugh Sykes Davies, 'Music in an empty House', *Experiment* I, 1, November 1928. Reprinted by permission of Hugh Sykes Davies. 'Surreal-

ism at this time and place', *Surrealism* edited by Herbert Read), Faber, 1936. Reprinted by permission of George Allen & Unwin. From T. S. Eliot, 'Appendix', *Notes towards the Definition of Culture*, Faber, 1948; 'Tradition and the individual talent', *The Egoist* VI, 5, 1919; 'Note', *The Criterion*, July 1923; 'Notes on Current Letters: The Lesson of Baudelaire', *The Tyro* No. 1, 1921; and 'Preface', *The Criterion* (Collected Edition), Faber, 1967. Reprinted by permission of Mrs V. Eliot and Faber & Faber Ltd from uncollected writings of T. S. Eliot © Mrs Valerie Eliot 1981. From Ian Hamilton Finlay, 'Ocean Starlight Towed Off Rocks'; 'Shetland Boats Turn to Scallops'; 'Zephyr Joins Avoch Fleet'; '2, From the Yard of Thomas Summers & Co.' (1968); 'Drift'; '3 Blue Lemons (in a tidal bowl, Peterhead)'; and 'The Cloud's Anchor, Swallow'. Reprinted by permission of Ian Hamilton Finlay. From F. S. Flint, 'Some French Poets of Today', *The Chapbook* I, 4, 1919; 'The Younger French Poets', *The Chapbook* II, 17, 1920; Review of *Les Feuilles Libres*, *The Criterion* III, 9, October 1924; Review of *Le Disque Vert*, *The Criterion* III, 12, July 1925; and 'French Periodicals', *The Criterion* IV, 2, April 1926. Reprinted by permission of F. S. Flint's daughter, Mrs Ianthe Price. 'The Dada Movement' [unsigned], *Times Literary Supplement*, 29 January 1920. Reprinted by permission of Mrs Ianthe Price and Times Newspapers Ltd. From Ford Madox Ford, 'Starting a Review' in 'Selected Memories', *The Bodley Head Ford Madox Ford*, Vol. I, 1962. Reprinted by permission of The Bodley Head. From G. S. Fraser, 'Apocalypse in Poetry', *The White Horseman*, Routledge, 1941. Reprinted by permission of Mrs. Eileen Fraser. From David Gascoyne, translation of Alberto Giacometti, 'Poem in Seven Spaces', *New Verse* 6, 1933; translation of Benjamin Péret, 'That's No Good', *Contemporary Poetry and Prose*, No. 2, 1936; translation of André Breton, *What is Surrealism?*, Faber, 1936. The poem, 'The Very Image (for René Magritte)', *Contemporary Poetry and Prose*, No. 10, 1937. Reprinted by permission of David Gascoyne. From Joy Grant, *Harold Monro and the Poetry Bookshop*, Routledge & Kegan Paul, 1967. Reprinted by permission of Routledge & Kegan Paul and the University of California Press. From Robert Graves, *Goodbye to All That*, Cape, 1929; *Contemporary Techniques of Poetry: A Political Analogy*, Hogarth Press, 1925. Reprinted by permission of Robert Graves. From Geoffrey Grigson, 'The Danger of Taste", Editorial, *New Verse* 4, July 1933; 'Books Lately Published', *New Verse* 23, Christmas 1936. Reprinted by permission of Geoffrey Grigson. From J. Brian Harvey, 'Four Poets', *Left Review* II, 10, Lawrence & Wishart, July 1936. Reprinted by permission of Lawrence & Wishart. From Lord Hastings, 'The Surrealists', *Left Review* II, 4, Lawrence & Wishart, January 1936. Reprinted by permission of Lawrence & Wishart. From Adrian Henri, *The Mersey Sound* (Penguin Modern Poets 10), 1967; 'Notes on Painting and Poetry', *tonight at noon*, Rapp & Whiting, 1968; 'Haiku', *tonight at noon*, 1968. Reprinted by permission of Adrian Henri. From J. F. Hendry, 'golgotha', *The White Horseman* (edited by J. F. Hendry and Henry Treece), Routledge, 1941; 'Myth and Social Integration', *ibid*. Reprinted by permission of J. F. Hendry, who wishes to make it clear that the early poem 'golgotha' has been discarded by him and will have no place in any collected edition of his works. From Michael Holroyd, *Lytton Strachey: A Biography*, William Heinemann Ltd, 1971. Reprinted by permission of William Heinemann Ltd. From Georges Hugnet, '1870–1936', *Surrealism* (edited by Herbert Read), Faber, 1936. Reprinted by permission of George Allen & Unwin. From Aldous Huxley, *Letters of Aldous Huxley*, edited by Grover Smith, Chatto & Windus, 1969; 'The Subject-Matter of Poetry', *The Chapbook* III, 9, March 1920; 'Water Music', *On the Margin*, Chatto & Windus, 1923; and *Aldous Huxley: A Memorial Volume* (edited by Julian Huxley), Chatto & Windus, 1965. Reprinted by permission of Mrs Laura Huxley, with Chatto & Windus Ltd and Harper & Row Inc. From Frank Kermode, 'Modernisms Again: Objects, Jokes and Art', *Encounter* XXVI, 4, April 1966. Reprinted by permission of Professor Frank Kermode. From E. V.

Knox, 'Spokes', *Parodies Regained*, Methuen, 1921. Reprinted by permission of Methuen & Company Ltd. From P. Wyndham Lewis, What Art Now?', *The English Review*, April 1919; *Blasting and Bombardiering*, Eyre & Spottiswoode, 1937; *Wyndham Lewis the Artist*, Laidlaw & Laidlaw, 1939; *The Enemy* 1, 1927; *The Enemy* 2, 1928, and *The Enemy* 3, 1929. Reprinted by permission of the Estate of Mrs G. A. Wyndham Lewis. From Jack Lindsay, *Meetings with Poets*, Muller, 1968. Reprinted by permission of Jack Lindsay. From A. L. Lloyd, 'Surrealism and Revolutions', *Left Review* II, 16, January 1937, Lawrence & Wishart. Reprinted by permission of Lawrence & Wishart. From Edward Lucie-Smith, 'The Other Poets of the First World War', *Critical Survey* IV, 2, Summer 1969. Reprinted by permission of the editor, Professor C. B. Cox; *Movements in Art since 1945,* Thames & Hudson, 1969. Reprinted by permission of Thames & Hudson. From Norman MacCaig, 'He walked in, the buccaneer with the lace collar . . .', *The White Horseman*, edited by J. F. Hendry and Henry Treece, Routledge, 1941. Reprinted by permission of Norman MacCaig who wishes to make it clear that this early poem has been discarded by him and will have no place in any collected edition of his works. From Charles Madge, 'Surrealism for the English', *New Verse* 16, December 1933. Reprinted by permission of Charles Madge. From J. H. Matthews, *An Introduction to Surrealism*, Pennsylvania State University Press, University Park, 1965. Reprinted by permission of Pennsylvania State University Press. From George Melly, *Revolt into Style*, Penguin Books, 1972. Reprinted by permission of George Melly. From Christopher Middleton, poems from *The Lonely Suppers of W. V. Balloon*, Carcanet New Press, 1975; and prose extract from *Pataxanadu and other Prose*, Carcanet New Press, 1977. Reprinted by permission of Carcanet New Press. From Jeff Nuttall, *Bomb Culture*, MacGibbon & Kee, 1968. Reprinted by permission of Jeff Nuttall. From Ezra Pound, *Literary Essays of Ezra Pound*, edited by T. S. Eliot, copyright 1918, 1920, 1935 by Ezra Pound; *The Letters of Ezra Pound to James Joyce*, edited by Forrest Read, copyright 1967 by Ezra Pound; *The Letters of Ezra Pound (1907–1941)*, edited by D. D. Paige, copyright 1950 by Ezra Pound; 'The Island of Paris: a letter', *The Dial* LXIX, October 1920, all rights reserved; 'Poems of Abel Sanders', *The Little Review* VIII, Autumn 1921, all rights reserved; 'Ode pour l'Election de son Sepulchre' in 'Hugh Selwyn Mauberley', *Ezra Pound: Selected Poems*, edited by T. S. Eliot, Faber, 1959, copyright 1926 by Ezra Pound; 'Epstein, Belgion and Meaning', *The Criterion* XI, 36, April 1930, Faber. Reprinted by permission of the Ezra Pound Literary Property Trust, Faber & Faber Ltd, and New Directions, New York. From Paul C. Ray, *The Surrealist Movement in England*, © Cornell University, 1971. Reprinted by permission of the Publisher, Cornell University Press. From Sir Herbert Read, 'Introduction', *Surrealism*, Faber, 1936. Reprinted by permission of George Allen & Unwin and the Literary Estate of Sir Herbert Read. 'Surrealism – The Dialectic of Art', *Left Review* II, 10, July 1936, Lawrence & Wishart. Reprinted by permission of Lawrence & Wishart. 'The Limits of Permissiveness' in *The Black Rainbow*, edited by Peter Abbs. Heinemann, 1975. Reprinted by permission of the Literary Estate of Sir Herbert Read. From Edgell Rickword, *Rimbaud: The Boy and the Poet*, Heinemann, 1924; 'Among New Books', *Calendar of Modern Letters* I, 4, June 1925; and 'The Lautréamont Affair', *Calendar of Modern Letters* III, 2, July 1926. Reprinted by permission of Dr Edgell Rickword. From Hans Richter, *Dada; Art and Anti-Art*, Thames & Hudson. Reprinted by permission of Thames & Hudson. From Professor G. H. Moore, *The New Apocalypse: One Aspect of Romanticism*, unpublished thesis, Cambridge University, March 1946. Reprinted by permission of Professor G. H. Moore. Robert H. Ross, *The Georgian Revolt: Rise and Fall of a Poetic Ideal 1910–1922*, Faber, 1967. Reprinted by permission of Faber & Faber Ltd and Southern Illinois University Press. From Sir Sacheverell Sitwell, 'London Letter', *De Stijl*, June 1921. Reprinted by permission of Sir Sacheverell

Sitwell. From Dame Edith Sitwell, 'The Lady with the Sewing Machine', *Art and Letters* II, 1, 1919; 'Mariner Man' and 'Trio for Two Cats and a Trombone', *Collected Poems*, Macmillan, 1957; *Children's Tales (From the Russian Ballet)*, Leonard Parsons Ltd, 1920 (reissued Duckworth, 1928); Review of *Georgian Poetry, 1918–1919*, *Art and Letters* III, 1, 1920. Reproduced by permission of Francis Sitwell. From Osbert Sitwell, 'Te Deum', *Art and Letters* II, 1, 1918–19. Reprinted by permission of the Estate of Sir Osbert Sitwell. From Sir Sacheverell, Dame Edith, and Osbert Sitwell, *Trio: Dissertations on Some Aspects of National Genius*, Macmillan, 1938. Reproduced by permission of the Sitwell family. From C. K. Stead, *The New Poetic: Yeats to Eliot*, Hutchinson, 1964. Reprinted by permission of Hutchinson Publishing Group. From Julian Trevelyan, 'Dreams', *Transition* 19–20, June 1930. Reprinted by permission of Julian Trevelyan. From Tristan Tzara, 'Zürich Chronicle', *The Dada Painters and Poets: An Anthology*, as above. Unsigned review (by F. S. Flint), '"Parade" at the Empire', *The Times*, 15 November 1919. Reprinted by permission of Times Newspapers Ltd.

Every attempt has been made to trace all owners of copyright material. Apologies are offered unreservedly for any omissions of acknowledgements where these are due.